Always Reaching
The Selected Writings of Anne Truitt

Always Reaching
The Selected Writings of Anne Truitt

Edited by Alexandra Truitt
Foreword by Miguel de Baca

YALE UNIVERSITY PRESS
New Haven and London

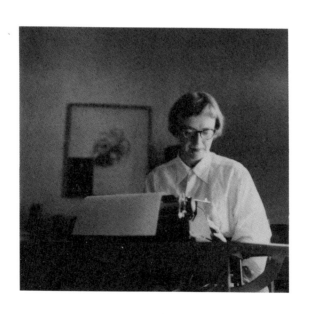

Also by Anne Truitt

*Daybook*
*Turn*
*Prospect*
*Yield*

## Contents

ix    Preface | Alexandra Truitt
xiv   Foreword | Miguel de Baca

2    [I am always reaching . . .], July 1946
4    [I sometimes wonder . . .], c. 1947
5    Journal Excerpts, 1948–49
25   Mrs. Fitzgerald, c. 1950
29   Translating *Marcel Proust and Deliverance from Time* in 1953
31   1963 André Emmerich Exhibition
36   Leaving for Japan in 1964
38   On James Lee Byars
42   Japan Interview, 1964
45   Letter to Ralph Truitt, 1965
47   Letter to Clement Greenberg, 1965
63   On Tony Caro
64   Letters to Louisa Jenkins, 1966–67
88   On David Smith
91   Letter to André Emmerich, 1966
92   A Conversation with Walter Hopps, 1973
133  Artist Talk, Baltimore Museum of Art, 1975
136  Interview with Howard Fox, 1975
160  Artist Talk, The Madeira School, 1975
166  Artist Statement, 1976
168  Artist Talk, Yale University, 1976

| | |
|---|---|
| 180 | Letter to E. A. Carmean, 1976 |
| 183 | Artist Talk, George Washington University, 1977 |
| 186 | Keynote Address, University of Maryland, 1978 |
| 193 | Artist Talk, Australia, 1981 |
| 195 | Willa Cather Lecture, Lincoln City Library, 1985 |
| 199 | Commencement Address, Kansas City Art Institute, 1987 |
| 203 | Journal Excerpts, 1987–89 |
| 242 | Visiting Artist Lecture, Boston, 1988 |
| 254 | "Painted Lady of Paris": Review of *Utrillo's Mother*, 1989 |
| 258 | Canada Journal, 1989 |
| 283 | Interview with Jack Burnham, 1990 |
| 298 | "A First Impressionist": Review of *Berthe Morisot*, 1990 |
| 303 | "An Art of Stone": Review of *Noguchi East and West*, 1992 |
| 307 | On Persistence, 1993 |
| 308 | "Charmed Magic Casements": Review of *Utopia Parkway*, 1997 |
| 312 | "Grand Allusion": Interview with James Meyer, 1997 |
| 322 | The Title Tapes: An Excerpt, 1997–98 |
| 348 | Visiting Artist Lecture, Bryn Mawr College, 1998 |
| 358 | Studio Notes, 2001 |
| 360 | Letter to Alexandra Truitt, 2003 |
| | |
| 365 | Selected Chronology |
| 376 | Selected Bibliography |
| 386 | Index |
| 394 | Credits and Copyrights |

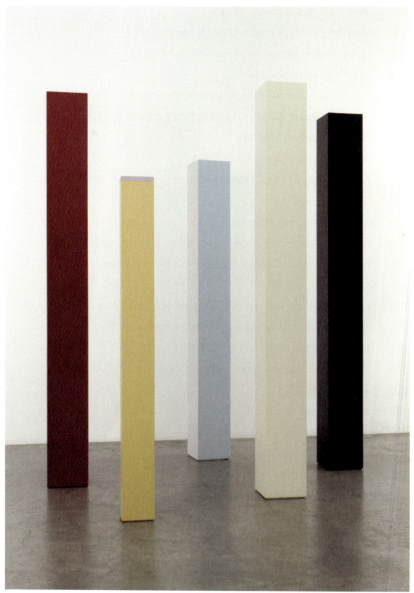

From left: *Return*, 2004; *Harvest Shade*, 1996; *First Spring*, 1981; *Threshold*, 1997; *Twining Court II*, 2002.

*viii*

# Preface
Alexandra Truitt

The impact of Anne Truitt's art is usually attributed to its formal qualities, particularly its bold use of geometry and color, in which she charted a new direction for sculpture in the early 1960s. But the inspiration for her art was always fundamentally personal: a lifetime of her own memories and sensations. This core creative impulse — to translate the inner workings of her mind into a symbolic language — predates her art. "I am always reaching toward meaning," she wrote in the 1946 entry that opens this volume. In the years after her graduation from Bryn Mawr, where she studied literature while completing a BA in psychology, writing was the core of her creative activity. Among the earliest entries in this collection are excerpts from a journal she kept in 1948 and 1949. Though written more than a decade before her first artistic breakthrough, she was already engaged with the themes that would occupy her for the rest of her life: the creative struggle and its occasional triumphs, her encounters with the divine in the everyday, and the inevitability of death and loss.

In the decades to follow, as Truitt continued this practice of organizing her thoughts on the page, her writing became ever more entwined with her studio practice. In the same way that her art alternated between drawing, painting, and sculpture, her writing grew to encompass journal entries, book reviews, public lectures, correspondence with friends and fellow artists, and recorded conversations with art historians and curators.

In 1987, when Truitt made the first donation of her papers to Bryn Mawr, the special collections librarian Leo Dolenski asked her to write a concise commentary for each group of writings and implored her not to destroy her early poetry and prose. In her comments on these early writings, she said,

> It has taken great self-control not to destroy all this writing, which seems full of emotional self-indulgence. I have read it with astonishment. I had honestly forgotten that I had ever

kept a journal, so that was a big surprise, as was the immense amount of writing I seem to have churned out — to little avail. The principal virtue of retaining it is, I guess, that it conveys the atmosphere of my mind — if that should ever be of interest to anyone. Looked at objectively, it seems to me that my work in art played back into my writing when I began to write again in 1974: informed it with structure it never previously had.[1]

In 1973, under the guidance of Walter Hopps, I began to inventory my mother's art and organize her records. It wasn't until I was packing the many boxes for the initial Bryn Mawr donation that I began to appreciate the considerable scope and range of her writings. Since then, encouraged by the sheer volume and variety of material, I came to the decision that certain pieces could be compiled as a companion to the three memoirs published during her lifetime — *Daybook* (1982), *Turn* (1986), and *Prospect* (1996) — as well as *Yield*, the fourth and final volume published posthumously in 2022.

Those four books, with their clear writing and characteristic honesty, introduced Truitt to new audiences, and established a literary reputation in tandem with that of her art. Collected here for the first time is a representative selection of Truitt's other writings. Spanning more than fifty years, it includes journal entries, letters, lectures, talks, and reviews, as well as excerpts of conversations that illuminate her working practice as an artist, author, and teacher. This wide-ranging collection confirms her reputation as a voracious reader of fiction and nonfiction alike, and her deep interest in culture, science, spirituality, and history. In addition to the nearly seventy-five boxes of papers now at Bryn Mawr, more than half of which are devoted to Truitt's writing and correspondence, this volume also draws from privately held material. I was initially tempted to organize these writings thematically, but a chronological approach ultimately emerged as the best way to convey both the arc of her life and the evolution of her thinking. Thus, the writings in the book are organized according to the

---

1. Anne Truitt, untitled and undated typewritten note, box 1, folder 2, Anne Truitt Papers, Special Collections Department, Bryn Mawr College Library.

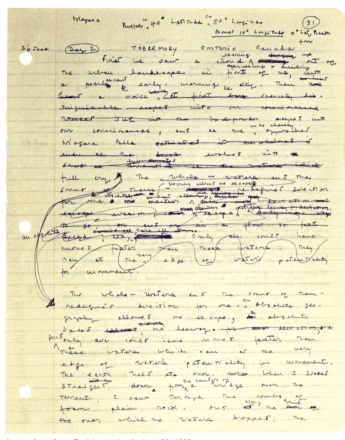

A page from Anne Truitt's notebook, June 26, 1989.

chronology of Truitt's life. While that ordering principle largely conforms with the order in which the entries were written, there are some exceptions, specifically the 1987 commentaries that Truitt wrote at the time of the Bryn Mawr donation, which I've opted to place earlier in the book at the relevant points along the artist's timeline. My hope is that this volume will serve as an important resource for scholars but equally be of interest to more general readers who may be acquainted with the published journals and want to know more about Truitt and this period of art history.

Although sometimes judiciously abridged, the selections presented here are wholly characteristic and revelatory of Truitt's authentic voice in each genre. For example, the "Letters to Louisa Jenkins, 1966–67" entry represents just a small portion of their entire correspondence but still manages to convey the remarkable breadth of subject matter the two artists discussed. Similarly, "Artist Talk, Yale University, 1976," was selected over many other illustrated talks Truitt gave from the 1970s onward, as it is distinctively comprehensive both in the range of work covered and the key themes discussed.

Keeping a journal was integral to Truitt's understanding of her work, her studio practice, and her motivations. Among the journals included in this collection, the "Canada Journal, 1989," entry reaffirms Truitt's practice of situating herself along geographic coordinates — a still underexplored aspect of her sculpture that her working drawings reveal.

Truitt believed in equality, and she wanted to be judged alongside her male and female peers as both an artist and writer. She wrote honestly about her direct experiences of inequality in a male-dominated world, and about the specific actions she took in response. Examples covered here include bringing a salary-discrimination lawsuit against the University of Maryland in 1983 (a suit unsupported by her colleagues and only dropped on appeal when it became too costly and protracted to proceed); her decision in 1976 to refuse an honorarium for a talk at Yale University after she was introduced by the head of the art department as a "woman artist"; her 1976 letter to E. A. Carmean, in which she unabashedly sets the National Gallery curator straight about a number of issues related to her work; and her ultimate rejection of Clement Greenberg's highly prescriptive tutelage.

This collection provides close insight into Truitt's development as an artist and intellectual, as well as her reflections on other artists and

writers, including James Lee Byars, David Smith, Anthony Caro, Isamu Noguchi, Édouard Manet, Marcel Proust, Zelda Fitzgerald, Leo Tolstoy, Jane Austen, and Pierre Teilhard de Chardin. Taken as a whole, this survey of five decades of Truitt's writing confirms her candor, resilience, and firm faith in artistic vision. As she would write toward the end of her life in the journal *Yield*, "Like all attentive lives, the life of an artist *is* worth living."[2]

⋯

Compiling a volume of this scope would not have been possible without the professionalism, patience, and friendship of numerous people.

Anne Truitt's papers are held in the Special Collections, Canaday Library, Bryn Mawr College, Bryn Mawr, Pennsylvania. I would especially like to acknowledge the invaluable assistance so kindly provided by Eric Pumroy, the Seymour Adelman Director of Special Collections, and Marianne H. Hansen, the Curator/Academic Liaison for Rare Books and Manuscripts.

I'm grateful to Katherine Boller, Heidi Downey, and the rest of the editorial team at Yale University Press, New Haven, for their diligence and care with this material, and for their unwavering commitment to Truitt's writings.

At Matthew Marks Gallery, New York: Matthew Marks; Jacqueline Tran, Senior Director; Cory Nomura, Director; and Sean Logue, Head of Archives & Photography.

Miguel de Baca for his perspicacious foreword, and his generosity and fellowship, particularly during long research visits to Bryn Mawr and Japan.

At Joseph Logan Design, New York: Joseph Logan and Katy Nelson for a design that perfectly complements Truitt's work.

Friends and family: Kristin Baker, Elise Chang, Jem Cohen, John Dolan, Craig Garrett, Susan Heffner, Mark Hussey, Alastair Kusack, Sam Kusack, Megan LeBoutillier, Jerry Marshall, James Meyer, Thomas Nash, Patsy Orlofsky, Neil Printz, Mary Truitt, and Sam Truitt.

And I would particularly like to thank Charles Gute, whose careful and insightful editorial assistance firmly brought these writings together.

---

2. Anne Truitt, *Yield: The Journal of an Artist*, ed. Alexandra Truitt (New Haven: Yale University Press, 2022), 134.

## Foreword
## Miguel de Baca

I first saw Anne Truitt's sculptures in person at the exhibition "A Minimal Future? Art as Object 1958–1968" at the Museum of Contemporary Art, Los Angeles, in 2004. I remember, as I walked through the galleries, that I was completely felled by *Hardcastle* (1962), a tall, rectangular black plinth on a short black base, apparently (but not actually) supported by red sloping struts on its reverse. I felt a sense of urgency behind the meaning of it but did not know what exactly that was. My heartbeat sped up; this was minimalism as I hadn't come to expect. I had been taught that the minimal art of the 1960s, such as that of Donald Judd, Dan Flavin, and Carl Andre, was meant to inspire little in the way of emotion.

In that moment, Truitt's art revealed to me that the act of viewing even radically simplified forms is inseparable from the nuances of broader human sensation. Naturally, when we see things out in the world, we attach memories and emotions to them, consciously or subconsciously. When I learned that Truitt had made *Hardcastle* to evoke a fatal car crash she remembered from her childhood in rural Maryland, it made sense to me, because the sculpture stirred in me similarly grave feelings. Truitt's memory is not mine, of course, but I found it remarkable that *Hardcastle* reveals just enough visual information to translate the memory's emotional force to the viewer. In my dissertation on this pioneering artist, and the monograph that followed, I had the privilege of studying how her work engages a dialogue between minimalism and ideas within and beyond the history and theory of art.

In researching Truitt, I was pleased to encounter a wide range of references in her books and unpublished manuscripts and letters. I came to know and admire an artist of great erudition, one devoted to the formal qualities of her sculptures, paintings, and works on paper and dedicated to practicing her own authorship throughout her lifetime. Truitt began drafting dozens of short stories and poems in the 1940s. In the 1950s, she

translated secondary literature on the French author Marcel Proust and, in the process, became a devotee of his works that are famously about the sensory provocations of memory. Truitt's reflections on Proust can provide pointed insight into her sculptures as well, especially the early works, such as *Hardcastle*, as I have studied at length in my book. In the last half of her life, Truitt wrote the well-known and highly regarded artist journals *Daybook*, *Turn*, and *Prospect*, and she kept assiduous notes for a fourth volume, *Yield*, published posthumously in 2022. To add to this, throughout her life she was an avid letter writer, waking up before dawn to pen correspondence. We must understand that Truitt the visual artist is also Truitt the author: they are one and the same.

*Always Reaching: The Selected Writings of Anne Truitt* will supply generations of scholars, artists, and art enthusiasts with access to Truitt in her own words. The chronological organization of this book gives readers a sense of her evolution as an author and an artist. Journal entries reveal the artist's relationship to herself: her inner monologue about life, work, and her place in the world. By contrast, her letters afford us a sense of her community with others. While it is true that Truitt had privileged access to some of the twentieth century's most highly regarded critics, such as Clement Greenberg, and artists, such as Kenneth Noland and David Smith, it is perhaps even more fascinating how she identified with lesser-known figures, especially women who also forged new paths in the sixties and beyond. For instance, not enough is yet studied about Truitt's profound friendship with Louisa Jenkins, a mosaicist and Catholic mystic in Big Sur, California, revealed in letters that are for the first time given public emphasis in this collection. As the artist's career progressed, we also encounter the public-facing Truitt: the Truitt of interviews, lectures, and addresses, in which she places herself within the greater context of art history. Readers may be surprised to see Truitt's published reviews of biographies of Isamu Noguchi, Berthe Morisot, and Joseph Cornell. These are artists with whom Truitt, as a mature artist, could recognize a certain kinship. She concludes her commentary on the Cornell book with words that could just as well have been written about her: "It is a meticulously researched and deeply considered examination of how Joseph Cornell's daily life contributed to his imaginative life—the only real life he knew."

Among the entries is an excerpt from the remarkable "Title Tapes," transcribed interviews between the artist and her daughter, Alexandra, from late 1997 to 1998. Truitt commonly titled her sculptures after places and people from her memory, and these interviews provide rich source material and a rare window into the artist's thought process, from concept to execution. For some, the ability to tie the artist's abstract visual work to reality might be comforting. But knowing Truitt the author, the titles are so much more than indexes to a fixed autobiography; they are invitations to contemplate further, like *Hardcastle*, to see an art deeply connected to life as we experience it—to yours, to mine, to what we see and feel, and to that which connects us to others across time and place.

# Selected Writings

## July 1946

I am always reaching toward meaning, seeking in every act, every observation, to discover, as one moving rapidly past a grilled garden gate, the expanse behind the phenomenon — the perspective within which the phenomenon has a place. Thus the world of the senses has become for me a grill through which — and into which — I peer with ever increasing intensity. I seek through heightened perceptions of all things to comprehend, simultaneously, the essence of each thing and its place in a hypothesized perspective. There are moments when this seems possible, times when a glance suffices, or appears to suffice, to gain penetration into what lies behind the facade. At these times the intensity is unbearable; and it is at these times that temptation rises. There is the temptation to turn away, either through weariness of heart, through fear, or through an inability to incorporate the tension without bursting.

If it should happen that I am cut off from the light, from all that ordinarily makes life worth living — the love, children, days and nights of peace and joy, the sharing of life in two closer than one — if I should be cut off, then my way must lie ever more toward the insights achieved and upheld in darkness, in the fusion of darkness and light. The path lies that way inevitably, but if I am cut off I must walk it alone, not in bitterness, but in wider circles and with faith. If I no longer can rely on companionship and the healing quality of love without limitation, then my way will lie in the more varied, and more lonely, ways of those who walk and search — and do not find, save perhaps rarely, that for which they seek.

*Untitled typewritten page dated July 1946, found among pages of early poetry and prose, box 1, folder 9, Anne Truitt Papers, Special Collections Department, Bryn Mawr College Library.*

I shall have to learn self in an identification only, less and less of the self who has always risen singing in the morning and enjoyed sheets in the wind. Yet in some way I am so tied to the earthiness and everydayness of these things that I doubt if I can follow the path that I may be forced to take. Perhaps my strength and single-mindedness are lacking, and I will be unable to stand and wander always alone, unanchored by the sheets drying in the sun. In a sense my strength comes exactly from those homely things; the roots of my life are not in ideas, but in an essence that things and activities have for me. Basic to the universe are the gettings up and goings to bed of the people who are its inhabitants.

c. 1947

I sometimes wonder if those people who make the best artists, or indeed artists regardless of worth, are not those for whom childhood remains overwhelmingly vivid. Although this appears at first glance to suffer from the fallacies of nostalgia and oversimplification, I can account in no other way for the extraordinarily compelling urge toward the unity of simplicity that appears to underlie the artist's anlage toward universal understanding. The limited sensate world, presided over by deities directly concerned with daily guidance and welfare, the mystery of ever-new experience, and the steep curve of growing knowledge that characterizes the child's environment broaden with age. But if this has been a period of great interest for him, either because of intense frustration or gratification, he continues to view his widening horizon with the same basic emotions with which he first picked a violet.

*Untitled typewritten page, undated, box 1, folder 11, Anne Truitt Papers, Special Collections Department, Bryn Mawr College Library.*

## Journal Excerpts, 1948–49

*I am astonished, and taken aback, to find these pages. Would have sworn that I had never kept a journal of any sort whatsoever except on a trip to England when I was ten years old.*

*Interesting to me — the difference between these pages and Daybook.*

*This business of going through these meanderings of a young woman is humbling. I had honestly forgotten how much and how waywardly I tried to write, for so many years.*

— Anne Truitt, 1987

February 5, 1948

Even before starting to write this I had to light a cigarette. By such a degree has my reluctance to write grown. And it is because of this that I am beginning to keep this journal. I hope that if I merely write every morning in unconnected style, write any words, no matter how nonsensical or how uninteresting, that a flow will be started.

I can remember, not very many months ago, when I always had the feeling that somewhere within me something was growing; and, furthermore, that whenever I wished I could tap this source without trouble or

---

*The epigraph above is from a typewritten cover sheet that Truitt wrote to accompany the 1948–49 journal at the time of its donation to Bryn Mawr College. That document and the journal itself are held in box 1, folder 16, Anne Truitt Papers, Special Collections Department, Bryn Mawr College Library.*

particular pain. I believe that this idea began with the juxtaposition of the death of Mother and the writing of an analysis of Rainer Maria Rilke in my junior year of college. (Just now I am badgered with doubts as to the use of this process. Have decided to write it all out anyway since no other path as valid presents itself.)

At the time I spoke of, in my junior year of college, I was obsessed with the idea of MYSELF as a citadel, an inner stronghold for which the experience of my life would on the one hand provide nourishment and on the other build more and more intactly. Never, I felt, could it be invaded or destroyed. The secret of this inviolability lay, I felt, in my consciousness of its existence, in my unwavering belief that this was my only strength, and that because of this consciousness I was superior to the outrage of common terror. From the year 1943, when I graduated with the loss of my honors (my first overt failure) until the year 1947, when I married James and finally was yanked from this citadel, this formula for my life underwent drastic attack.

The nature of this attack was ordinary in the extreme, yet, because of my strong defenses, maintained without break essentially from the age of about twelve or thirteen, it was new to me. Even friendship became a new concept. And in November of 1944, at the age of twenty-three, the essential helplessness of all human beings hit me with the impact of terror. These years were spent in a futile attempt to bolster, and at the same time adapt, the defenses so that the citadel would stand. The attempt failed miserably. But god knows I tried, and struggled on the hook of an infantile concept of safety in inviolacy.

I think a good deal about the days I spent in the Dickensons' apartment in the West End of Boston right after the end of the war. A cold-water flat behind Massachusetts General. The smell of their apartment, the filling of the can of kerosene for heat every night, the bitter cold of the mornings blended with the smell of kerosene, the solitary meals, the freedom of being alone after living in a morass of personal relations, and the awful solitude and anonymity of the city. It is only with an effort that I can bring myself to think of it. A horrible feeling of sadness beyond any encirclement pervades my recollection. None of the colors are clear. I remember particularly one evening when I went out into the street. Turning to the left

from the smelly and hideously green doorway, I walked about a hundred yards to where Brighton Street ended in Allen Street. On the corner I stood and looked out toward the river, which was a narrow strip on the other side of the small green park, which lay, in turn, beyond Charles Street. I stood under the street lamp on this corner. Around me played a group of about eight children. They were roller-skating in the fading light, yelling at one another, and appeared, like photographs in very fast motion, to blend into streaks of gray matter. As I stood there, I was, by virtue of their rapid movement and the shifting ground of their play, in the midst of the group, then out of it, then within it again. Suddenly, and without warning, I felt invisible — as if my inner lack of structure and meaning had become manifest in my body, which at that moment had ceased to exist. I was both frightened and pleased, as if I had at last succeeded in dying.

This whole problem of how to die, or rather how to make manifest one's spiritual death, was one that absorbed me continually during this period. I think it was for this reason that I wandered in the streets, gazing about me, up at buildings, across the streets, down the vistas of side alleys, at the contours of buildings beyond, never looking at my feet or where they were taking me, absorbed always in the externals of objects before my eyes. I became passionately interested in shape and texture, in pattern and the juxtaposition of lines and colors. I yearned for a camera. I felt creative, yet at the same time dead at center, so that I knew that I could create nothing beyond the reproduction of shape and form — my mind and soul had become, in fact, precisely like a camera, capable of reproduction but not of the re-creation of essence. Lost, restless, without purpose or hope of purpose. Rebelling against the necessity of human pleasure, human fulfillment, because this seemed so empty, so irrelevant to the essential nature of the hopelessness of human fate.

I wonder now whether this whole period wasn't a kind of delayed immaturity, almost infantilism, the most pure form of escape. No responsibility because responsibility implies the joining of one's life with that of those around you in common endeavor; no hope because of the constant despair, the vacuum of lost comfort. Perhaps this was the emotional comprehension of what I had first realized intellectually in November of 1944 — the helplessness of being human.

I am absorbed in the past. James dreams of the present, I always of the past. I feel as if I had within me not a mass of growth but a mass of undigested material, so emotional in tone and so painful that I cannot bring it forth in any form except in the form of anxiety. This, I think, is what inhibits my writing, save for rare instances in which some part of it comes out whole. It is this problem that I must bring my energies to solve.

I have sometimes wondered why I never broke down into neurosis during this time when all was lost. I think that my writing saved me from that, this and friendship with my sister Harriet and, later, the wholeness of James. And also a certain robustness that I have myself: a will to survive, or rather, a will not to dissolve. And an objectivity that always recognizes the other side of the fence.

I feel sometimes that my whole life is an unreality in that I have not mastered the language of reality, the language of commonness. It is in this way that I am related to James more basically than in any other way, I think — aside from the strange compulsion toward him, which is purely emotional and the strongest and deepest emotional experience of my life. The emotional reality with him so baffled me at first that I felt I had been transported to an entirely new world, a frame of reference so foreign to me that I was lost again. But lost in a new sense, for I began to comprehend that I could learn with him to know this new reality. And so I have begun to do, in a healthy and wonderful way. But the old remains with me and must be handled before I can come fully out. The truth of the matter is that I want to be through with it all, get it out, and build up on a new, and stronger, basis.

Again am attacked by idea of futility. And by the necessity again. Will do this every morning and see what happens.

June 26

It is almost impossible to recapture the freshness of impressions, and I do not suppose that I have been given any special talent that will enable me to do it with a degree of success. Nevertheless, here goes, without formality.

The cocktail party was not particularly unusual, its sole claim to distinction being the dubious one of being held in a room that shared with

a few hundred others in the city a striking view. On the twentieth floor, it overlooked the roofs of all the buildings in its immediate vicinity, the exception being a tower slightly to the right of the window, which at this twilight hour was already burgeoning with lights. The interstices of the variously tan-black roofs were filled with what appeared to be violet mist, swathed delicately about the often-harsh lines of chimneys. Immediately below was a small green park picked out by semicircular benches (white) like nail parings scattered carelessly about, but with a curiously formal decorative effect when seen from above. People appeared to be totally insignificant, possibly one reason why the place had been selected by those who lived there. The host gave the impression of being taller than he was, possibly because his trousers, supported by a broad, handsome leather belt, hung low on his hips. A thin face, brown as if dipped in tea. A brush of hair, between the strands of which light was visible. Nicely formed hands with bitten nails, which gave me pleasure since it proved decisively that he too was vulnerable. Moving awkwardly about, he made appropriate hostly comments indicating that he wished everyone to feel at home.

As indeed they did. The two older women, related, it turned out, to the new bride who was hostess, sat complacently on the small green sofa and chatted with one another as behooved them, the representatives of a generation that had long ceased to interest the majority of the guests. One wore a large pink hat, the other a small pink coat. Less decorously disposed, the rest of the party draped themselves about with a degree of comfort hardly compatible with the ostensible accommodations for the human form. There was the young advertising man who worked in the same company as the host. Drink in one hand, cigarette in the other, he discoursed on the beauty and utility of carrot slicers. Despite this apparent paucity of intellect, however, he was remarkably polite and lit cigarettes with a speed which would have been the envy of a ferret. Hardly attractive but pleasant enough, and assuredly one of those young men for whom it could have been superficially said that the war had been an excellent thing. It had divorced him from his eternally mediocre young manhood, bestowed upon him the status of army, and led to his taking unto himself a wife, largish, brown and blonde, and typical of a million others raised on orange juice and infrequent, regretful spankings. She was attended now by two young men with whom she carried

on an animated conversation, the subject of which was not clear but which obviously was a source of great pleasure to them all. One of those conversations in which all the referents are so firmly based on intimacy that if recorded it would be meaningless except by genre definition.

But all of these people were blanched to their proper place by the bride, to whom eyes turned at frequent intervals as if attached to reins that she held, careless and unnoticing, in her hand. Or perhaps in her navel, since it was to her body that they turned. And rightfully so, for she was gowned (there is no other word) in the elegance of high fashion and further decorated by several strands of pearls and her own native assumption of attraction. She was not beautiful, but beauty in the abstract appeared so much of an irrelevancy in her own estimation of herself that she was accepted at face value. Pert mouth, large dark eyes, and quantities of dark hair smoothly drawn from its single beginnings etched lightly about her oval face, from which the chin jutted abruptly and interestingly large. Her manner was smooth and a little distrait. She had lived with her husband several years before their marriage two weeks prior to the party. It was impossible to tell what she was thinking.

The bus driver this morning called me down for not knowing the correct bus fare. Then to another woman said, "One half don't know how the other half live." This hurts but is just.

On the way home, another bus driver discussed inflation and let me out right in front of my door.

June 28

Just finished hanging some pictures. Becoming settled. Feel as blank as a fish on a platter.

Speaking of which, bought a cookbook for fifty cents: *Wait a Minute*. Designed for those women who never have time to cook, but nevertheless never fail to impress all their guests as perfect. The *Vogue* ideal. Very tedious, but the most demanding type of competition for the "modern woman."

Looked up the word "sapping" today. Sap is a tunnel. Wonder how it also became synonym for idiot in American slang. Perhaps from the energy sapped from one by idiots.

Reading a book about McSorley's tavern.[1] Strange that New York (as I read the other day) has no history in the strict sense of the word, only traditions of perhaps twenty years or so (except McSorley's.) Unlike Boston, which feeds on its history and never forgets that it was once the only city of pretension in the United States. It will be changed, as I hear that several new buildings have gone up, completely altering the skyline. But at least the green Buddha of the New England Mutual Company will still be there. Always when I think of it I see it from the bridge over the Charles, the one near the hospital with its four great towers, the balconies of which always harbor men urinating or couples making shift at love. Also the cathedrals in the water at night, and the tunes that can be whistled to their kaleidoscopic reflections. Yet the place is so full of pain that in some ways I do not wish to return soon.

December 30

Have decided to write down all details of Mrs. F. without order or respect to style. I must be one of those who have to rework endlessly, and I've always prided myself on facility! It is nice to think that [Cyril] Connolly thinks those who have difficulty in creating characters write best. But that's probably an extension of himself. Hope that if I put down all details, she will emerge. Then can redo her, like Sarah.[2] Have a feeling I must get away from truth.

Outside it's still darkish. Window across the way is lighted, and visible at their morning toilets are a man and a small boy. They move in what appears to be a stately dance around the brass bed. Now the dance becomes less dignified, and is obviously coming to an end. The man has donned a red shirt and now shoves a cap on his head with a grand gesture straight up through the upraised elbow. Now the man has departed, evidently downstairs where his wife must be cooking breakfast — there is a light shining

---

1. *McSorley's Wonderful Saloon* by Joseph Mitchell, originally published in 1943.
2. Title character in an unpublished work of short fiction, which also includes the character "Mrs. F" mentioned earlier.

out onto the tin roof of the outhouse, evidently its reflection diverted by some invisible force. Two children play in the lighted window. They appear to be dressed in billy-boys. They lash at one another with eager arms.

January 1, 1949

First day of new year.
    Someone with choreographic talent should really do a satire on dull parties. The posturing in corners, the abrupt small interchanges seized desperately in the corners of the room, for no one uncomfortable at such a party ventures into the center of the room without at least three companions, without some semblance of warm interest exhibited by three others in the vast wealth he has to offer conversationally. The glasses clutched in hands, riding on the anchor of their drinks, they will come forth for a small gavotte, quickly ended by departures neatly timed as thirty minutes from arrivals. There is always one lone woman, clothed in a sensible suit, with glasses preferably, lank hair, a cigarette, and usually gloves somewhat damp in the middle from being clutched. Also the small quick man who gazes sardonically about, hoping that someone will notice his keen eyes and superb nonchalance. And the little woman in harried black with the husband in tow. She is desperate, and will sometimes break the stalemate by forcibly introducing herself to the nearest victim, and willing victim he is. For the English are right to believe that "noise is more manageable than silence."
    Tonight the Smiths. Curiously tight family, ostensibly friendly toward one another. Yet why does the eldest son, recently divorced, not venture to tell his parents he would prefer not to live at home? Might make a good story. Attempt to decide to leave, decision, method of breaking, and final denouement revealing, possibly to one of those Somerset Maugham observers, the undercurrents that are the real ties of the "HOME." Might be interesting to take it from Mother's point of view. Like a Henry James story, all smooth, glassy with perfection until three sentences later one finds oneself embroiled in evil.

January 7

Last six days: "Sarah." Completed last night. God knows if it's "good" or not, but for me anyway it's a step in the right direction. Can feel the bit between my teeth once more.

Have new theme cooking. Girl, intelligent, good job as copywriter, lives in apartment of "clever sort," well liked by numerous friends. Twenty-eight years old. Party for the choice of a mate essentially. Chooses, he recognizes what she wants, she gets drunk partially with expectation, then recognizes after others have gone that the man is not drunk but excruciatingly embarrassed. Tidies up ashtrays, tied in with remark of one of her friends, "the sort of girl always washes the ashtrays before going to bed."

Saw man at end of train as we left Penn Station this morning. The advantage of writing is that one sees all, not just the facet presented to the fallible eye. Read Connolly's *Enemies of Promise* on train. But where are the natural writers, the ones who write, like Faulkner, with no one in mind but God and the devil and themselves, or just themselves? A great mistake to take Connolly too seriously.

January 28

Last night with Hope and Tony Carnelli to see his pictures. They seem immature to me on the whole, with the exception of the portrait of his wife — a beautifully tender and well-constructed piece of work. Perhaps the only painting we saw that he felt deeply.

"The Woman" back from *Partisan Review* today. No more than she deserves. Must look up address of *Erotica*. Interesting slip: mean *Neurotica*!

February 4

Just sent "Sarah" off to the *Atlantic Monthly*. Feel like a parent bereft, or felt like one until I saw Jean Randolph with her new adopted child. All art is but a substitute for life.

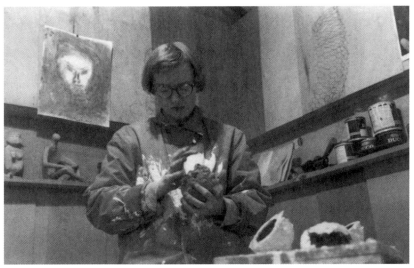
Anne Truitt in her studio, Dallas, Texas, 1950.

Registered at the Institute of Contemporary Art today for sculpture. Taught by [Alexander] Giampietro, according to Robert Richman a good man. He took really a good deal of trouble to be nice to me, from whom, god knows, he could expect nothing. (Except perhaps through James, and he was nice before he knew my name.) He has that immediate sympatico quality that artists always have: one never has to explain, so that one feels understood even though the artist may translate your meaning into his own language and in doing so distort your meaning; but not your intent. Richman had, in addition, a father-of-the-herd instinct — if I may so bastardize Freud. Asked to see my writing. Obviously really cares about "art." Must get to "Pauline"[3] now.

February 9

Began sculpture at Institute of Contemporary Art yesterday. Alexander Giampietro, who teaches beginners, a classical type of sculptor: shortish, with a skin stuffed with flesh, a cap of close-cropped black hair, nibbled at the ends as if by mice, a small beard. He uses all the space around him with a freedom beautiful to behold. Also an excellent critic, is perhaps somewhat active in his chipping at others' statues: but perhaps not. Has done nothing like that to my meager clay creations, namely:

1. A woman in sorrow fleeing with her child. She knows that she is unable to move, but knows equally that she must flee. This is a typical beginning for one who thinks with words rather than in the plastic medium.

2. Abstract, obviously more approved by Giampietro. And by myself, more of a relief from writing. My eyes begin to improve, see shapes more clearly. But am still a dolt.

---

3. Title of a short story Truitt began working on in 1947.

A curious lassitude, not unpleasant, overcomes me at intervals followed by a feverish excitement and creative urge. Lassitude is stronger and as beguiling an emotion as I've ever had. Must be akin to the first intimation of death, so gentle that surely no one could be afraid.

March 3

Just took Father from the nursing home to Mrs. Wilcox's in the country about thirty minutes drive from here. He is an old man now, acting as he used to when it was no effort for him to do so. The skin on his neck hangs in folds, the back of his head is shrunken, its creases no longer instinct with innocent appreciation of a healthy flow of blood. He has developed the mannerisms of an old man; for instance, he places a finger contemplatively on the bridge of his nose when he makes an initiating statement in conversation. Most of these are about his condition. If the talk is about the weather, he will remark that his ears are full of wax, Dr. Thompson is having him put oil in them regularly in an attempt to clear them out. Or his eyes have been troubling him, or, more unfortunately, his bladder.

    Above all, he is heartrending. If he would give up, get old, cross, nasty, unbearable — but no, his personality's true sweetness emerges so clearly now that its only achievement can be the wringing of one's heart. On the way out in the car he kept saying, "This is an adventure!" An adventure for an old man to leave a nursing home and take room and board in the country. His hands, shiny and weak (how well I remember them when they were strong, usually freckled slightly, the nails bitten to the nub of flesh: the other night he showed me that they were growing in now: he has had two manicures!), he lit a cigarette. Putting it out of the window took him a whole minute: he must get his hand holding it far enough out, is it, yes it must be, he holds it there as if time will ensure its position, then releases the cigarette stub reluctantly. The hand moves back to his lap, triumphant.

    When I left him he cried, his face crumpled. Desolate, alone, his face moving in an agony that he could no longer comprehend, he waved us

out of sight. I think Father is someone who could not live well; but he will die well.

He has always been a child, and when in trouble, of no matter what kind, he turns as naturally to me as a child. His whole face and being in the outstretched hand, in the eyes, in the immobile body waiting, waiting. His actions have always been initiated from without; he doesn't comprehend what comes from within, and has indeed been treated badly by his inside. He is at his best in a simple exchange with his environment. Then, delightfully mobile, responsive, spontaneous, happy, his body sparkling with the pleasure of motion, as he danced out what was demanded.

During Mother's long illness and death he was magnificent.

Afterward he drank, was depressed, adjusted slowly, beguiled his loneliness as best he could. But the outer spring was gone. This is the end of that.

He was always so polite to me when I was a child. I can never remember his treating me other than considerately, and he took pains that we should have happy memories of childhood. Heaven knows that these were cancelled out by his inadequacies, so particularly glaring when contrasted with Mother's logical rationality. He used to arrange that we had birthday parties like other children. But these embarrassed us, for the other fathers seemed not to care about such matters.

March 8

This has been a heavenly spring day. A shower, and since then swift changes from dark gray to brilliant sunshine, changes so rapid that they appeared to be borne on the high wind that scooted continuously between buildings and the branches of trees and leaves of grass.

Father in for lunch. Taking a nap in the chair before the fire (he is easily cold now), his body is wasted. Strange to remember how sturdy and vigorous his actions used to be. His legs now lie slack where they used always to spring firmly from his waist. His hands fumble pitifully. He ignores all these things. Whether on purpose or not I cannot fathom. If so, then the pretense is magnificent.

Trick between us is that he not become dependent. He said complacently today that he intends to spend almost all his time here. Added a question about my opinion as to whether this house will be cool in summer!

This morning on a walk someone said, "Good morning." He said, "Good morning and goodbye," as he reported it. Man is raking leaves.

The other day, regarding Mrs. Terry, whose son killed himself last month. "I did not write her. I had nothing to say, and she will know how I feel."

Father may be a novel.

March 19

Been working on beach until three days ago. Then, after about four days of block, began suddenly rewriting "Pauline." "Sarah" has returned for the fourth time, and I've concluded that she was good but not good enough. Rewrote her yesterday, excluding part of mother's life in flashback. Think it infinitely improved. Will continue rewriting her, and also "Pauline." Will leave beach until it opens up.

Odd how slowly I work. Must not get discouraged. Also, *A Room with a View*: must learn, god knows how, to be totally objective, without bitterness, envy, or a "cause." Never compromise reality in any way. Great fun. And terrible.

Have been reading Charles Williams: *Descent into Hell*. He points out that the good is terrible: "Are our tremors to measure the Omnipotence?"

Reminds me of that experience in Cambridge. November night of that most agonizing of Novembers, 1946. Walking late at night in fog, coat thrown open, walking very fast: heaven knows how I thought I'd escape. Lights dim in the fog on both sides of the river, like great blurred chrysanthemums suspended underwater. Walked out on the bridge, the one that crosses in front of Leverett House. Stopped in the middle and stayed there a long time, leaning over the broad stone rail, watching the dim river below and the gray mist above.

I had been thinking almost exclusively of search for a universal truth, any universal, not necessarily God in the Episcopalian sense of

my childhood (those prayers, spoken each evening, the quiet opened bed in front of one, the cold floor, the warmth of Mother's skirt) but some principle in the light of which the experience of sheer desperation, which appeared to me the crowning characteristic of man, would be granted significance. I felt myself moving continually away from men, from everyone, my identity became clearer and clearer, but in a special way. Not a human identity. I was frightened, or not so much frightened, until after this evening, as baffled, eager and baffled, always pressing forward, convinced that my path lay only there, narrowing myself into it — gathering myself into a coiled mass as for some tremendous leap into space.

(As I write, I am shivering.)

This leap, I believe, took place that night. I thought and thought until time became meaningless, lost as was the world about me. Carelessly, without premeditation, I raised my head and glanced at the sky. By some chance formation of clouds, a light struck through them (though as far as I remember there was no moon that night), and as it did so, the light, vague yet clear, diffused plainly through the clouds that moved slowly in the wind high above the ground, I was overcome by the conviction that I was in touch with the power for which I had sought so long. And with this conviction came a terror such as I have never known before or since. "The Lord God is a terrible God" ran through my mind, and its truth overwhelmed me, wondering. (My whole body is cold writing now. I have thought of it little since then, of this particular experience.) The terror was so compelling that I must have remained transfixed for several minutes, reduced to a state in which I comprehended for the first time a magnitude so far beyond my scope that the only response I possessed of any like adequacy was terror.

The interesting point is that, even in my terror, I felt that were I willing to go further, to advance in the face of this feeling, I could do so. But the fear that I might indeed be chosen among men by this power was more than I could bear. So that ultimately I turned away not because of my own terror in a personal sense, but because the implications of acceptance were beyond my strength.

As far as I know the above is a true account. I have thought little of it: later came a little more of like nature, though not as overwhelming. I cannot believe that it was a neurotic manifestation; I was undoubtedly raised to a

high pitch of sensitivity, otherwise normal enough, job in bookstore, etc. Strangely enough, the most neurotic periods are those in which nothing really important happens in the spirit. One is too self-centered. Yet, just beyond the neurotic, one can come out on the other side, so to speak, into the universal from the most personal. In any case, there it stands.

V. Woolf points out that all great woman writers have been childless. Comforting, but fact remains. Jealousy, that snake more horrible than fear, is what I have the most trouble with. Getting a little better though. This, above all, is the fact I must accept without cringing or compromise. And, after all, books are not bad substitutes.

March 20

Sculpted six hours today. Finished first "free form" and am, on the whole, disappointed in it. But perhaps better so, and at any rate it is something completed. Am doing head now. Shall call it *Zoroaster*: "You, my dear." Aaron (sculptor big shot, who usually comes in, looks cryptically, makes a cheery remark indicating the continuation of hands-off technique) came in as I worked on him, nodded his head quickly, said, "That's good," or something to the effect. Feel as if have received accolade.

Lay in grass in garden. Young birds eat young rose buds.

Charles Williams describes spiritual reality as "an infinitely alien arrangement of infinitely familiar things." Couldn't be described better.

I like old idea that this is death, this that we call life. We live only to discover the particular symbols here to match our innate knowledge. Suppose we came with that knowledge; then we would create from the material offered by life a likeness to what we already knew, thus making manifest to those less in touch with themselves the reality nonetheless innate in them. A great work of art would hold a mirror to that reality, translating it into this life in such a way that people can translate it back into reality, and hence come closer to that which they themselves are seeking.

This, it seems to me, is the basic test of all art: How real, in this sense, is it? Also it solves the old controversy about whether a thing is art if incomprehensible to all people. Ideally, yes; but a person's vision, either

of internal reality, the one brought with him, or of world reality, may be so chosen, so selected, that the first part of the act of creation is completed, but so idiosyncratically that others may not be able, or be able only with great difficulty, to translate it back.

Zoroaster: Shelley:

The Magus Zoroaster, my dead child,
Met his own image walking in the garden.
That apparition, sole of men, he saw.

March 21

I need to write simple action themes.

God I feel discouraged. This inability has always been my flaw; like a crack in a glass it has cut across every area of my life sooner or later. It was bound to come up. Must think and think about it. Funny that you can't write in peace at all. Always something new which you must, and no holds barred, push into further knowledge. More than ever before I am caught in a horrible trap. I have to express all of this stuff or I shall be shaken apart. Or shall die, or again wish to die. Or is it all a hallucination? That way lies madness . . . In any case, must learn to write or shall be in bad way. Sculpture now takes its place: if I can learn to do that with a minimum of frustration, I can have a safety valve through which some of the tension can drain off. It mounts unbearably.

Must delve into reasons for my inadequacy in action. Was it because actions for which I was inadequate were demanded of me too young, when my only recourse if I wished to avoid failure, and subsequent loss of love, was to avoid the action? This strikes me as sensible. God knows too much was demanded of me too young.

Have started thinking of action, why people act, toward what they move and how they act, how they go about attaining their ends. How foreign it is to me.

The people next door are extremely active. I lie in the garden and they act. Yell, talk in madly accelerated tones, with a short choppy rhythm in

which their every change of mood is reflected. Am pounding typewriter in something of the same frenzy. Downstairs the food is cooking. Helen and Reed Whittemore are coming for dinner, and we are going afterward to see *Greed*. Unbearable this dichotomy: what goes on inside, what must be attended to outside. Yet if I had not the outside I should be destroyed more easily than breath.

Just stopped writing. Leaned out of window. A small boy mounted the steps of the house next door, slowly. A man whistled a lilting, repetitious melody in the alley. The small boy leaned over the fence dividing our garden from their path of land (disordered, messy, overrun with packing boxes), leaned over and pitched a piece of broken brick at the head of one of our red tulips.

March 26

I think I know what is wrong with "Pauline." I've been reading too many novels and I'm using a novel technique for a short story. Either that or I can't use the short story as it should be used. There is a novel around her, I'm sure, but whether I am running down this alley right now I don't know.

P herself remains cloudy to me. May change her name. She won't come alive, primarily because I only have seen her in relation to other people, and have cheated on the end. She wouldn't be that tired, or if she were there ought to be one act to reveal all that has affected her.

Lacks punch, cohesiveness of mood or meaning. Altogether a failure. Failure in writing.

Failure too in sculpture. But it may begin to come. Have grasped the basic principle, that the clay is full, a mass which takes various shapes. To make it move you move the relation of one mass to another; nothing to do with outline in the sky, nothing linear. I carry my clay about the workshop like a child. My period began again today. No child for me.

July 21

Zoo yesterday: two deer, male and female, like J and me. Arabesque. Bear walked back and forth in narrow space before one of bars, ignoring rest of roomy cage with nice pool. Head bent, wagging in time with his clumsy feet, which turned slightly inward as they were lifted from ground. Remark while watching: "I guess that's the only exercise he gets." Another mouthful of popcorn.

Badly kept birdcage, enclosed in wide-meshed wire. On top of which were three birds, their heads stuck into the meshes, trying evidently to get into cage, strangled by their efforts. Just ordinary birds both inside and out.

Apropos of animals, caught a fish this morning during my swim. He floated in front of me as I was on my way in: picked him up, looked at him, red-eyed, and he wriggled away, suddenly gone through the water, swirling one large arc and gone. Why did he let me look at him? J says he was probably hooked. But mouth looked all right. Julie said I should have brought him home and put him under my pillow. A prince. Thought of all that, a prince, granting wishes.[4]

Symbolism here, fish always in unconscious water. He knows. Also shape of fish.

Also hills symbolic. Two together, with sloping hollow in between. Also large barn close to edge of water. Green strip of grass in between, smoothly cared for, water blue, barn weathered, too large, hulking, looming, swelling.

August 30

Have not written this for a long time. I find myself divided on question of writing it at all. For surely the mind chooses to remember what it wants,

---

4. At this time Truitt was visiting Julie Pratt, James's first cousin, at her family's summer home on Lake Michigan.

and will exercise a more perspicacious selection than I could hope to. Nevertheless, perhaps detail is lost.

Hence my hunger for sculpture.

October 6

Am reading Gorman's biography of James Joyce.[5] A reaffirmation of all that I once believed, forgot, and now believe again — but, I believe, less blindly. Perhaps this is the transition from the romantic to the classical. In any case, I have less and less sympathy with the former. And more and more preoccupation with what I feel to be reality. The sounds and the stones and the shapes of the leaves and of people's faces. These preoccupy me now for themselves alone, for their own identity, rather than as I did formerly, for their receptiveness to my own perception of agony. I can now vaguely glimpse that laughter of the spheres that the romantic postulates.

Saw the crippled girl from the antique shop going up Thirtieth Street on her husband's arm this evening. Heavenly sky, van Ruisdael.[6] Fall beginning at the tops of the trees, and up the slope, laborious, step by step, the girl, clad in a long brown skirt that swung back and forth, clinging to her husband's arm, bearing down at each step, swinging the right leg out, forward, down, the other forward, then out, forward, down. The pressure and rhythm must be so familiar to the man. Out of people like this comes poetry. Sometimes see her in the grocery store buying a whole quart of milk for lunch.

Joyce stresses stasis, particularly important in sculpture. Also the artist must be conveying something he has totally understood.

---

5. Herbert Gorman, *James Joyce: A Definitive Biography*, 1941.
6. Dutch landscape painter Jacob van Ruisdael.

## Mrs. Fitzgerald, c. 1950

In the current spate of comment on F. Scott Fitzgerald I have been increasingly surprised to find almost no reminiscence of his wife Zelda. Commentators who did not know her tend to dismiss her, well-meaningly enough, I suppose, with the word "mad." Those who did know her dwell more or less affectionately on her charm, her gaiety, her unpredictable behavior, her supposed effect on her husband's work, and, occasionally, with proper delicacy on her illness.

    I knew Mrs. Fitzgerald, as we called her, during the years 1936–1939, while she was in Highland Hospital, Asheville, North Carolina, where she spent her final years. My father was connected with Highland and I remember his coming home one day with the news that Scott Fitzgerald's wife was a new patient. He was saddened by her illness but pleased by her liveliness and charm, and amused by her scorn of the local "beauty parlor." As a morale measure she was taken to town on her arrival to have a permanent; she came back frizzled but undismayed, with the statement, "They did five dollars worth of something to my hair." A girl of fifteen, I was instantly struck by such a gallant dismissal of what I would have gauged a major blow. But it was typical of her. She never caviled what she considered unimportant, and her sense of values, idiosyncratic as it was, was unfailingly delicate and true.

    Mrs. Fitzgerald and my father became cronies within the framework of the institution, sharing the same wry humor to leaven the inordinate stuffiness of its social life. My mother's ideas about life were rather like Mrs. Fitzgerald's, although her conduct was different. I remember one day

---

*Untitled, undated (c. 1950) typewritten pages with handwritten annotations, Estate of Anne Truitt, South Salem, New York.*

particularly when Mrs. Fitzgerald came for lunch. She was wearing a very pretty pale blue dress, her hair was shining in the sun (the permanent had long since grown out and was never, as I recall, replaced), and she and Mother laughed a lot, their chairs pushed slightly back from the luncheon table, enjoying some sort of adult communication which I recognized as the pleasure of two people with a common frame of reference.

That was one of Mrs. Fitzgerald's "good days." She did have bad ones. On those she stalked around, eyes on the ground or fixed on some unimaginable distance; occasionally she was snappish, and once I saw her strike another patient in the hot contest of a volleyball game. But she was never, as I knew her, "mad" within the connotations of the word, never messily violent or wildly disagreeable. Her style, using the word in the same sense as an artist's style, was always implicit in everything she did.

At that time she was in her mid-thirties, my own age now, which renews my intense feeling for the tragedy of her situation. She was a small person, exceedingly well made, with beautifully articulated bones. Too thin, even stringy, she was paradoxically graceful; each of her movements was awkward but her progress had a delicate balance. She moved jerkily, quickly, unpredictably, but always from some very precise source of energy which seemed centered right under her diaphragm. She used all the space at her command. Her arms and legs seemed continually spread-eagled as if she were testing the limits of her freedom and perhaps of her own reality. I believe I have never seen anyone whose body seemed to me more of a unit. Her head, which was small in just proportion to her body, was as vital as her foot. She had a way of ducking her head, then suddenly looking directly into your eyes like a brave child. In fact, her whole ambiance was that of a strong, wild child grown old.

Her glance was almost invariably sad. She rarely laughed freely, her smile was always a little wry. It may have been that she found her situation, a patient in a mental hospital surrounded by sick people of virtually no intellectual or artistic distinction, vaguely unreal, even occasionally embarrassing, after years of circulation among gifted and original explorers of human limitations. She certainly never gave an inch to her environment.

Following an operation in 1938 I was not allowed to return to college to finish off my year. During the following spring my doctor thought

it would be wise for me to take advantage of the physical education facilities of the hospital. So every morning for a period of some months I took part in the regimen of exercises prescribed for the women patients. Mrs. Fitzgerald was very good at these. Offhandedly, she would polish off fifteen push-ups in record time and lie back on her oilcloth (we lay in a clearing surrounded by trees on the top of a hill, each of us on her own two yards of oilcloth; Mrs. Fitzgerald's was a bright calico with a lot of red and blue). During the time she gained she would gaze up at the sun splattering through the leaves, very relaxed and remote. Or she would start up, seize her papers (she usually had a sheaf of large white sheets with her and a pencil, as I remember, around her neck), hastily scribble and then lie back, dissatisfied but assuaged. My curiosity overwhelming my feelings of delicacy, I once maneuvered to glimpse what she had written. About six undecipherable, sprawling units, meant to be words, I suppose, swam helter-skelter about the page. I was disappointed. But this again was typical of Mrs. Fitzgerald; everything *seemed* normal (I was writing poetry myself at the time and given to darting and recording). Then abruptly the context would shift and all communication stop. It was like becoming deaf at one stroke.

The high point of these exercises, and one which occasioned a good deal of jollity among the ladies, was the volleyball game that was the culminating activity. We would trail through the woods, our oilcloths over our arms, down to the volleyball court and divide into our teams. There were two, called (the jollity was institutional) the Pregnant Panthers and the Virgin Termites. I was a Pregnant Panther, Mrs. Fitzgerald a Virgin Termite. She was also the only Virgin Termite during that particular period who could play volleyball at all. Her technique was murderous. Half the time she was off the court, indeed off in her own world entirely, out of which she darted at intervals to record something on her sheets of paper. But when her attention was engaged, sporadically and unpredictably, she would rush into action and bat the ball carelessly and accurately into an unguarded spot on the opposite court. Her serve was virtually unreturnable. As I said, the only time I ever saw her act violently was when she lost patience with a clumsy teammate, and, to tell the truth, I felt she was pretty justified. That also was the only time she showed any interest in

the game. Despite joshing cries of "Look out for Mrs. Fitzgerald" — no one called her Zelda, her presence forbade it — she simply lent herself to a ritual she obviously considered irrelevant.

She did care very much about her painting, and since this was an area in which my father was concerned I grew familiar with her work. At that time I had never seen any painting like it. Her subjects were principally flowers. Under her broadly impressionistic brush they grew monstrous, developing out of their centers great milky spirals (she used white prodigiously) that dissolved into the edges of the canvas. She gave them categorical titles, like *Danger* or *Faith*. I particularly remember one called *Courage*. "Red is the color of courage," she told my father, and very red this canvas was, a scarlet rose-like flower spreading from its heart into swirls of purplish pigment brushed over with her characteristic milky streaks. Her masterpiece was a huge triptych screen of bluish-whitish hollyhock blooms. But I never saw it completed, as I went back to college and rarely saw Mrs. Fitzgerald after that.

I often think of the end of her life in connection with Rilke's feeling that each man must die his own most particular death. Hers was to be burned alive, and in some strange way it seems to me fitting. Red *was* the color that demanded her utmost courage, and I like to think that she recognized and embraced death as vividly and as personally as life.

## Translating *Marcel Proust and Deliverance from Time* in 1953

In 1953 Riqui Hill telephoned me out of the blue and asked me to edit a translation of Germaine Brée's book on Marcel Proust, *Du Temps perdu au temps retrouvé*. Germaine Brée taught French at Bryn Mawr. Riqui was in the middle of the translation, pregnant and not feeling well. I had never read Marcel Proust, but was curious. Sat in front of the fire one cold, dark afternoon and read Germaine Brée's book. Liked it, and decided — brashly, as my French is not more than competent — to help her out. It turned out that Riqui felt worse and worse, I did more and more work on the manuscript, and finally, on her holding the point with Rutgers University Press (the contract for translation was in her name alone), the translation was published with both our names as translators.

I did not read Proust himself until after I had finished the translation — on purpose, as it seemed to me that my understanding of our text would thus be a gauge of its clarity.

I had, obviously, thought a great deal about art, but Proust's formulation of how art came into being, out of an artist's life, set a kind of spine along which my thought has developed ever since. I saw perfectly plainly how an artist's life folded into art, rather as air is folded into egg whites in a soufflé: spirit into the material. It is really for this reason, to clarify this process for myself ever more closely, that I took to writing *Daybook* and *Turn*. I also saw that I had not paid enough attention to my life as I lived it, minute by minute, and began to sharpen my perception and to try consciously to retain those parts of my experience that seemed to me cogent to some kind of mysterious formulation, development, that was taking place in me as I worked along. So 1953 was a turning point for me.

---

*Untitled, undated (c. 1987) typewritten sheet, box 1, folder 17, Anne Truitt Papers, Special Collections Department, Bryn Mawr College Library.*

I majored in psychology at Bryn Mawr. I took two courses in art history as electives — whipped cream is the way I thought of them — pure pleasure. And so I thought of the material I learned so ardently, for years and years. Joseph Sloan taught me, with immense clarity as well as passion: his delicacy of perception, and attention to detail, remains with me. Indeed, it is out of his teaching that I now teach my own students.

I learned at that time how artists influence each other, how the course of art history moved along through artists, was passed along through them; and that, of course, I still pay attention to. But the essential aloneness of an artist's use of life itself I learned from Proust. That, and a method by way of which a life could, with a proper attention, turn to metamorphosis.

## 1963 André Emmerich Exhibition

André decided that I should call myself "Truitt," and be consistent, insistent, in that course. Women artists, he pointed out, were generally thought to be not as serious as men artists; people tended to discount an exhibit by a woman.

    Interesting that I agreed with him — without giving it much thought, though I do remember a very slight thrill (which I deplore) that I had entered an arena more or less exclusively reserved for men — as if that validated me in some way. Gave me status. This does not mean to imply that André was prejudiced against women artists; he has, in fact, always been open to their inclusion in his gallery. My own attitude toward the matter of being female was more or less indifferent until 1976, when I spoke at Yale. Andrew Forge, the chairman of the art department, introduced me as "one of the first of a number of distinguished women artists who are coming to speak to us about their work" — without further introduction. I could have been a housewife in an apron at a sink. I had too little experience, nor had I thought it through enough, to address myself to the matter at that moment. I did think it over overnight, paid my own hotel bill, wrote Andrew Forge, and refused the honorarium. Since then I have taken care to be properly introduced — *not* as a woman — as if women artists were like Samuel Johnson's dog . . .

<div style="text-align:center">• • •</div>

Morris Louis died in October, 1962. André Emmerich was an honorary pallbearer, along with Kenneth Noland, William Rubin, James Truitt. Our house at 1515-30th Street was used as a rallying point on the day of

---

*Typewritten notes accompanying exhibition ephemera, dated July 24, 1987, box 8, folder 3, Anne Truitt Papers, Special Collections Department, Bryn Mawr College Library.*

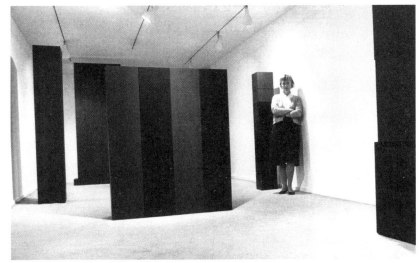

Anne Truitt with sculptures at André Emmerich Gallery, New York, 1963. From left: *Thirtieth*, *Hardcastle*, *Ship-Lap*, *Platte*, *Tribute*, all 1962.

the funeral. When William Rubin arrived, he asked if he could visit my studio. Ken Noland, David Smith, and Clement Greenberg had told him about my work. (Clem was in Europe when Morris died, and I cannot remember his having been at the funeral.) Bill Rubin came and looked at the work. I drove him to Marcella [Louis, née Siegel]'s house at Legation Street, and on the way (as André was then en route to Washington and had also asked if he could see the work) he told me how matters go when an artist has an exhibit. That the artist was responsible for the cost of getting the work to the gallery and back; that the dealer took 40% in commission on sales; that an artist's first NY exhibition usually counted for only very little, the second meant that the artist was "still there," and only with the third exhibit was the artist considered for initial acceptance of some weight.

When André arrived at the house, we proceeded immediately to the studio. He looked around, got out his little black appointment book, and asked if I would have a "one-shot show" in February; set the dates right there. I accepted. Then drove him to Marcella's, went home, changed into a black dress, ate a cracker (the funeral was at 2:00) and then went on to the funeral service.

The service was impressive. Temple full of people, private friends of Morris's and Marcella's, except for the honorary pallbearers as noted above. I remember the rabbi speaking of Morris as a poet. But what remained with me more clearly was the actual burial itself: on a sloping bank in a cemetery way, way out in the country, under a flaming maple tree in the bright sunshine.

I remember the day as such a tight schedule — guests in the house, and driving people here and there — that I did not have time to think. Even to feel much, other than profound sadness about Morris's short life, the loss of him as a presence in Washington (even though I very, very rarely saw him, I knew he was working all the time, a sustaining knowledge), and sadness about Marcella's grief. And Ken Noland's too — the loss of a close friend. And James too was sad, as he and Morris had a mutual compatibility that was, if not whole friendship, akin to it. Also, I was at that time so involved with dovetailing the demands of the household (three young children, guests, etc.) with the demands of my work, which was

like a waterfall rushing down on my head, day and night, that I more or less rode along on the top of events, handling one after another as best I could. André's invitation was an event, like others, it seemed to me at the time. I was pleased, deeply pleased, but remained poised on the fulcrum of my own intent.

Jim Lebron came down from NY to pack the show. I had made measurements of the sculptures for him so that he could bring boxes in which to pack them, but had made some mistakes in the measurements. So he and his men had to remake some of the boxes — in the freezing studio, no water even, very rough conditions; they couldn't finish on schedule, so spent the night in our house. I had to hire a trailer to accommodate three large sculptures, too large for Jim's truck. Ken Noland and I drove that to NY the night before the exhibit was to be installed — drove in a freezing rain, with the trailer wiggling behind my convertible car. We pulled in NY at one in the morning, and there, miraculously, were two parking spaces right in front of André's gallery!

The next day we installed the exhibit — or rather André and Clem and Ken and Bill Rubin installed it and I watched and listened and learned. A tense time as I had never really thought much, if at all, about exhibiting and was virtually wholly ignorant. During all this period, Clem taught me about how to go about it all, and Ken Noland taught me even more — how to be an artist, so to speak — in the public sense of the word. His generosity of spirit guided me over and over.

But in a rock-bottom sense an exhibit is like childbirth, no one can really tell you what it is going to be like. I wore an old suit to the opening, and an old dress to the party afterwards at Charlie and Julie Pratt's. I stood up straight. I tried to be even. But felt like a cork bobbing in a fast stream — light-headed. René Drouin said at one point, "Your work makes me ashamed of ever having liked anything more elaborate," and suggested that the sculptures might do with a very small rise under them — a suggestion I instantly recognized as intelligent, and followed thereafter. That was in a real way the most important thing I learned at the opening. After the dinner at Julie and Charlie's, we went on to Clement and Jenny Greenberg's apartment for a party that they gave for me with Ken Noland. There we stayed up all night, talking; Bill Styron was there, along with

just a few of us at the end. André Emmerich and I have been together ever since. He stood in front of the fireplace at the dinner, and said quietly, "I hope this is the first of many exhibits."

I feel deep gratitude to André, who has remained faithful to me and to my work even though I have never made any money, or almost none — not been in any sense at all a paying proposition. His loyalty has always been an anchor to windward all these years. An artist's independence is always crucial, of course. André has never in any way, shape, or form ever compromised mine. On the contrary, he has sustained it in a way that has been heartening when all else was dark in my life. He has been one of the blessings of my life, a blessing at once psychological and practical.

The day after the opening I bought presents for the children and returned home to Washington and, gratefully, to my studio. I went on working as if nothing had changed, but in fact something had: I had an outlet for the work; the knowledge that I stood on a foundation too.

## Leaving for Japan in 1964

James and I and our three children, then eight, five, and three, left for Japan, where James was to be the *Newsweek* correspondent, in March 1964, and returned in June 1967.

We landed in Japan at Haneda Airport in Tokyo at night. I carried Sam off the plane, asleep in my arms. We were met by Bernard Krisher, who was James's assistant in the *Newsweek* office, and by Ruri Kawashima, the office secretary, who was a faithful friend of our family throughout our stay in Japan, and still is; so is Bernie Krisher, who took James's place when we left Japan. We drove into Tokyo and on the way I saw that every single thing on which my eye lit was strange. Glimpses of low buildings, dimly lit: in a real sense what Japan remained for me, metaphorically speaking. We stayed in the Imperial Hotel — the Frank Lloyd Wright building — so beautiful that it kept me company in the most stabilizing way all the time I was in Tokyo. So totally, categorically right; such a comfort to me. We stayed there three months, during which I found a house for us rather quickly and very luckily, at 76 Wakamatsucho, in a compound owned by the Nishiwaki family, with whom we are still in touch. I studied Japanese for three months at the Naganuma School, learning enough to get along all right, supplemented by household Japanese and what I picked up from the three children, who were soon fluent. I brought my intelligence to bear on Japan, but my heart remained in the United States.

Kusuo Shimizu, the owner of the Minami Gallery, took me immediately under his wing; I exhibited with him, and he was steadfast in his support of my work.

*Untitled typewritten sheet dated July 28, 1987, box 19, folder 5, Anne Truitt Papers, Special Collections Department, Bryn Mawr College Library.*

The Truitt family (from left: Alexandra, Sam, James, Mary, Anne) at Konpira (Kotohira-gu) Shrine, Shikoku, Japan, c. 1964.

## On James Lee Byars

On our way to Japan in March 1964, we stopped in San Francisco for a couple of nights with Hunt and Marion Conrad. Louisa Jenkins drove up from Big Sur in her little Peugeot (with flowers in its two vases, just like the great cars of my childhood). We had lunch down on the beach by the bay, right close to it; sat in her car and munched Greek food. Louisa said that she had written a friend in Japan, Jim Byars in Tokyo, whom she had met while she was studying Zen Buddhism at the Daitoku-ji.

When we arrived at the Imperial Hotel, an envelope awaited me: a large white envelope *filled* with tissue paper, or rather delicate, fragile Japanese paper; way down deep inside it (there was nothing apparent at first except the paper) was a *tiny* gold frog and a tiny slip of paper on which was written (as I remember), "A frog from Kyoto." Or maybe just "A golden frog." The return address was J. Byars. In a couple of days another such missive came, and then they came rather regularly after that. Always a strange message of some sort. He turned out to be my only real friend in Japan.

When James and I went down to Kyoto, we looked him up. Wound our way through narrow alleys to an old wooden building. Jim met us at the entrance, led us up and up to a very small rectangular room, all white, with a large open window. Somehow it managed to look Greek — austere in that way. Nothing in the room at all that I remember. We perched on the floor or on the windowsill. As the light faded, Jim lit a bulb that dangled on a cord from the center of the ceiling. (Most Japanese rooms have these hanging lamps; you rapidly learn to watch them, as there are earthquakes every day or so; if the cord swings back and forth, the earthquake is not a bad one; if it goes up and down, you are in for it.) Jim was dressed all in

---

*Untitled typewritten sheets dated July 28, 1987, box 12, folder 1, Anne Truitt Papers, Special Collections Department, Bryn Mawr College Library.*

James Lee Byars's performance at the Kyoto Independent Exhibition, 1967.

white (he never wore anything that wasn't white, as I remember, even in winter — maybe black now and then). A tall, slender, fidgety young man in his twenties (I think), very intense and *coercive*. He controlled the situation rigidly. Nothing at all familiar. We talked in an uncomfortable way. I felt crisscrossed. James always had an easy way — was always curious and could get along anywhere with anyone. But it was I who grew fond of Jim in time, as I came to know his tender heart and his true dedication to his own strange, unique in honesty, sensitivity. He began to come up to Tokyo, and used to stay with us, with his friend Taki [Sachiko], a beautiful, gentle woman, very affectionate and devoted to Jim. His true companion, and even disciple. It was she who helped him with his events, or whatever one would call them — "Happenings" was a bad word to him. He did not like "art." Raved against it. Never understood why I made *things*. I believe he grew fond of me, as I of him, because for all that we were so different we had in common a kind of atmosphere of mind. He liked James too, accepted him and in a way cherished him even when he was difficult; that meant a lot to me. I never heard him criticize anyone in a mean way. He had no money at all — heaven knows how he lived. Would never sell anything — even his elegant work — circles so perfect that they brought tears to your eyes. He and Taki used to spend a lot of time *choosing* things: morning eggs, for example — the two most perfect shapes. He loved eggs, and used to eat ten when he stayed with us. He used to say, "I am eating like an *ushi* (cow)" and eat more and more — of course he never otherwise got a square meal, I thought, and our cook and I used always to lay in lots and lots of food for him. His nerves were close to the surface of his body — very sensitive to changes of temperature and to atmosphere, physical and psychic. Wonderful to talk with, he had the art of intimacy of that objective sort in which affectation is taken for granted so speech can be direct. A distinguished, strange, even magical man.

There were those who thought him schizophrenic, but I myself thought him idiosyncratic, and liked that in him. But worried about it too, as life was extremely hard for him. He had little touch with what people ordinarily take for reality.

The Japanese way with foreigners is strict, and in some manner I forget it became necessary for Jim to leave the country. I wrote Maurice

Tuchman at the Los Angeles County Museum of Art and to his eternal credit he met him at the airport and took him under his wing. I gradually lost touch with him for all sorts of various reasons — partly because I stubbornly refused to send him lists of my one hundred favorite things or something of that sort — by the time he wanted such lists I was separated from James and struggling along with my children; felt impatient with demands other than those immediately on my own plate, and was absorbed in my own work.

The last time I saw him was in a New York gallery showing Richard Long's work — typical of Jim to have picked him up. Jim walked in while my daughter Mary and I were looking — there he was, tall, in black, black hat, *himself*. We were happy to see one another.

## Japan Interview, 1964

*Let's start with a brief introduction to Mrs. Truitt. She is American and the mother of three children, ages eight, five, and three — the two oldest are girls. She came to Japan with her husband, Mr. James Truitt, who is now Tokyo Bureau Chief of* Newsweek, *the weekly magazine published in the United States. She is not just an ordinary housewife, but also a "mama-san sculptor."*

*What kind of sculpture do you make? Is it very modern?*

Yes. I don't make classical sculpture. My work is modern, but it's not something like the work of the Bauhaus in Germany. That is functional art, and for me function is not an issue — my sculpture is not meant to be functional. For instance, I made this. [*Shows a photo of the work* Tribute, *exhibited at André Emmerich Gallery in New York the prior year.*]

For me, sculpture is a mode of self-expression. I see a thing and feel its beauty or strength. Then I express what I see and feel through the means of materials — shape and color — but the sculpture is not a depiction of the subject matter.

*Isn't sculpting very hard work for a woman?*

Yes, very much so. There's a joke that whenever two sculptors get together, they brag about their appetites. We have to be, first of all, physically strong. As you see, I am slim but quite strong.

*Original version published in* Asahi Shimbun, *March 22, 1964.*

*What are the materials?*

In the beginning I used traditional materials like clay or cement. But more recently I've found aluminum to be a good fit. I have worked with wood, too. Right now it's easier to express what I want in aluminum. Here in Tokyo I have to find an aluminum fabricator and look for materials and welding machines.

Sculpture used to emphasize weight — I mean the sense of weight when you look at the material, not the weight of the material itself — but recent American sculpture emphasizes color, too.

*What does it all mean?*

For instance, one of my sculptures [*Bonne*, 1963] is a large column that is painted with three colors: white on the very top, deep blue on the middle part, and light blue on the bottom part. Of course the combination of each color is very precisely arranged. If you look at the column, you see that the deep blue part in the middle pushes down on the light blue part at the bottom, and the column seems to sink down. The whole form looks very settled. At the same time, the white color at the top seems to be flying up and away from the blue parts. On the whole, the column is quite compelling. The sculpture in the photo I showed you earlier is, of course, colored.

*What's your impression of Japan in terms of color?*

I've been here less than a week, so my impression is limited, but there is one thing I find especially amazing among all the other wonderful colors of Japan, and that is *torii*.[1] Looking at *torii*, I feel that Japanese people have solved one of the central subjects of sculpture. What I mean is the problem of making small things look large. If we want to express all that we feel, we often need a huge building. I am amazed at *torii* because one

---

1. A traditional Japanese gate, often painted red, commonly found at the entrance of or within a Shinto shrine, where it symbolically marks the transition from the mundane to the sacred.

gate made of simple materials, with a simple shape and color, gives an impression of such width and largeness.

Speaking of color, I was told that there had been a big discussion in Japan about whether or not to make the red disk of the *Hinomaru*[2] bigger. I think it's a very interesting problem.

*Your husband is a journalist.*

Yes. He has been with Time-Life, the *Washington Post*, and *Newsweek*, and this is his first position in the Far East. He paints a bit and likes art. He has been writing for *ARTnews* in New York, and he's a trustee of the Washington Gallery of Modern Art. I started making sculpture after I met him. I was majoring in psychology in college. With three children, making sculpture is difficult. I do the domestic work, but at the same time I save three or four hours a day for my sculpture.

*How long are you staying in Japan?*

I have just arrived. We'll stay in Japan at least two years. I would like to see as much as possible. But in the case of my sculpture, it won't become my subject matter. I conceive the form and ideas behind the work within myself. Thus, even if I see a beautiful subject, I won't re-create it. But it may certainly inspire me.

For example, Japanese flower arranging is very compelling, but the flowers themselves have a secondary significance for me, and I'm not interested in using them. The primary significance is my own conception. I want to express this through works made with my own two hands.

Looking at the wooden products you find here, I find that Japanese people really know how to work within the natural lines in wood. In America, we make wooden products by bending the wood into a variety of shapes. This is one of the surprises I've found here. I'm really looking forward to more of these surprises.

---

2. Literally "circle of the sun," in reference to the national flag of Japan.

## Letter to Ralph Truitt, 1965

September 29, 1965

Dearest Dad,

I am sorry not to have written for some time now, but I have been very busy getting the children established in school and putting the house in order for the winter. We are having the most superb weather, by the way; the typhoons are marvelous because they clear the air. I now have a table — a proper one that you can sit down to — in the hall toward the dining room so we can have our meals there overlooking the garden now that the heat is over. The *jinja* flower season is here, a lovely white lily-like flower that smells heavenly, and the whole house seems festive with them.

    I am happy to report that everything is fine. The children are very happy in school. Alexandra, particularly, has expanded and is as gay as she can be. She laughs all the time, is beginning to have real friends, and likes her teacher — everything is infinitely better. Apparently the combination of my staying at home this summer and cooking and reading, etc., with them, plus A's tutor, who is an inspired teacher, changed her course from depression to happiness in a real developmental turn. Mary continues to be her competent self. And Sam is beginning to like school better than he did at the start; he is now used to his glasses, and wears them almost all the time. He has had a little cold, is otherwise in splendid shape.

    As for myself, I feel happy for the first time in years and years. I'm not sure what's happened, nothing outside, as the conditions of my life are

---

*Typewritten draft, Estate of Anne Truitt, South Salem, New York. Truitt's father-in-law, Ralph P. Truitt, MD, was a clinical psychiatrist and leader in the modern mental hygiene movement.*

the same as ever; but I just feel stronger and more able to withstand and cope with the pressures. My work is better too. In fact I am satisfied with what I am doing for the first time since 1962–3. I think I had to sweat out a bad period of years in all sorts of ways, and for a while there I thought I might not ever get over all that hurt. But now it feels as if I might simply have outlived it. Or not exactly outlived, but simply survived. I am doing some volunteer work, by the way, with a medical unit from Tokyo University; just one afternoon a month, I think, but enough to make some contribution to this strange city and not feel so cut off.

Do write again soon. Our love to you, and to Uncle Reg and Aunt Mary. Do let us know your plans.

<div style="text-align:right">Anne</div>

## Letter to Clement Greenberg, 1965

November 8

Dear Clem,

I read Barney Newman's article in *ARTnews* on the catalogue for the Los Angeles show of the New York School; I suppose things do get mixed up awfully quickly.[1]

James is in Korea, and I am free to revolve my experience round and round, and feel like writing some of it down. I write to you because it may fit well into chinks of your own experience. Someday it may be useful. Anyway, gossip between friends is fun.

The first time that I met Ken [Noland] was at the Institute of Contemporary Art in Washington in 1948. He had just come back from Paris, where he had been studying with [Ossip] Zadkine, and was a teacher of painting with Robin Bond — who ended up, I think, in Mexico. He worked on the fourth floor. I studied sculpture with Alexander Giampietro on the third. The first time I saw him he came moseying in to one of the dreadful meetings they used to have irregularly in the sculpture workshop,

---

*Dated and numbered sheets, both handwritten and typewritten, with subsequent edits in the artist's hand, box 1, folder 20, Anne Truitt Papers, Special Collections Department, Bryn Mawr College Library. Although clearly written in the form of a letter, there is no evidence that the text was ever shared with Greenberg.*

1. Barnett Newman, "The New York School Question," *ARTnews*, September 1965, 38–41, 55, 56. In this interview with Neil A. Levine, Newman discusses his objections to the survey exhibition organized by the Los Angeles County Museum of Art, July 16–August 1, 1965, "New York School, First Generation: Paintings of the 1940s and 1950s." Newman's contention that the "New York School" label is an artificial and largely misleading construct finds its parallel in Truitt's sometimes outspoken reservations about the existence of a so-called "Washington Color School."

admirable but ill-fated attempts that were supposed to meld us into an articulate student body — something no one wanted at all. Or maybe someone did, but not me. Anyway, I remember the meetings as embarrassing failures, feeble attempts to "explore" and "expand" — you can imagine. Ken ambled over after the first meeting, talked a bit, and then used to come down now and then, partly for company and partly to work on a head of Bill Taylor, one of the sculpture students. A good expressive head, by the way, made of clay, solid and then cut in half and hollowed out. I don't know what happened to it. He was just starting to be interested in [Theodor] Reik, and I remember he lent me a book about him that I never got a chance to read because we moved to Texas.

We stayed in Texas for one year, and returned to Washington in 1951. I found a studio in an alley in Georgetown; I shared it with Mary Orwen (she had the top floor), then with Mary Meyer, and then gave my half to V. V. Rankine when we left for San Francisco in 1957. At that time I was working in clay and casting in cement, and wanted to do some drawing. Investigating possibilities, I called Catholic University and found that Ken was teaching there. He came to my studio, we talked, and I decided to take his life drawing class. It was a splendid decision; he was a first rate teacher — patient, adept, flexible, articulate, and challenging.

He then drove me to his studio and showed me what he was doing. The studio was a small room with one window on top of an old clapboard garage off K Street. There was one light bulb hanging from the ceiling. The whole room was crammed with large canvases in brilliant colors, Abstract Expressionist in style. But that is only what I know now. At that time I had never seen anything like them, and simply knew that they were beautiful and that Ken was the only artist whom I had met whose work I felt was absolute. From that moment I never doubted his power. But I haven't described it right. It was partly driving into a narrow, littered alley I had never known was there, having only seen the head he had made of Bill Taylor, none of his painting, and then finding myself dazzled in a tiny, cramped space by a teeming multitude of canvases much bigger than those I was accustomed to, in a free, highly textured, immensely varied, tremendously active style in which colors leapt and vaulted and intertwined. I was stunned — as I remember — into silence.

During the time when I took his course in drawing, a period of about three months in the spring of 1953, Ken and I became friends. He moved into another studio, in an alley again, between N and O Streets, just south of that final Washington studio in Twining Court — the one that I ended up with. This again was a room on top of a garage, but a much better space with a double door giving onto the alley from the hayloft and two windows, facing north. By this time Ken was married, had one child, and Bill was born during that spring of 1953. He and Cornelia [Noland, née Langer] had an apartment on M Street, a couple of floors up. One of the doors had a series of charming drawings (the only "charming" drawings I ever saw of Ken's) tacked on it, plus a large photograph of Modigliani looking very stormy. Ken had made the drawings for Cornelia before they were married — in letters, as I remember. They were of children, single figures, perhaps street scenes, altogether delightful.

But to go back to the studio. Ken was teaching, working on his own, worried about his family, worried about himself. He only coalesced, so to speak, when he was in the actual act of painting. One canvas I remember was a diamond-shaped one, very beautiful, very empty, only a few areas of clear color, leaving unpainted canvas: altogether open, and very strange and provocative to my eye. It must have been stained. Could it have been? Anyway, I remember it that way, the color soaked into the canvas. That painting, and a number of others, were destroyed by some vandalistic children who broke into the studio and ran rampant.

It was about this time that Ken began to speak of you and David Smith. It is my feeling, looking back, that Ken stood at some sort of turning point then. He was surprised by the responsibilities of his family. But Ken has always been a sticker, adaptable to responsibility. At that time he began to be weighty, to put it in a very personal metaphor: he felt his own power and began to explore it. He began to conceive of the fact that he might in truth be an important artist (the hardest fact that any artist has to face) and to conduct his life according to this hypothesis. The effort that this cost him you know, knowing Asheville. Or rather, knowing what it is to grow up simply being oneself, nothing special.

I used to think of Ken in those days very much in the context of Asheville, North Carolina, where he had grown up and where I had

lived between the ages of fifteen and eighteen when I left for college. A most mysterious place. Full of turns and twists, with streets that turned up or down and reappeared in the most unexpected places. I loved it physically, hated it from every other point of view. Ken's family had a funeral home, a white frame house on the top of a triangular rise which stood out sharply rather like his own triangles, the rise being abrupt and above a valley. In the front, on a sloping lawn, stood a sign in gray and white letters: "Noland Funeral Home." Behind it, on the same rise, was another funeral home, the one from which my mother and father were buried.

All this is parenthetical, but it partially explains a sort of reverberation that our friendship always had. In a way, it shouldn't be parenthetical, and I should continue with it once started. Ken's mother ran a nightclub on the top of Beaucatcher Mountain, a rather rowdy place with good jazz and food, called the Old Heidelberg. It was a great upstanding building, stark, like some dream of an Austrian castle. I remember that they specialized in steaks and gigantic baked potatoes. I had my first drink of scotch there, and found the whole atmosphere rather shady. But all of Asheville was that. The whole town was open and strange, unexpected not only topographically but psychologically, full of some very romantic Southern feeling tempered by shrewd calculation. It remains for me a mystery. But the air was magical, delicious, full of possibility, clear and tingling — perhaps like the air of all adolescent hometowns, but perhaps also with something slightly different because of the mountains that were so much there. You always felt the swell of the ground under you.

When Ken talks of having wanted to be a jazz player, I know what he means not only abstractly but because I too remember that curious bulk of his mother's restaurant, stark against the bigger bulk of the mountain, and electric with all those mysterious comings and goings in the parking lot below, with music above, and all the hope and promise that our lives really truly were.

Ken once told me that he wrote his name in cement on Clinton Street near the funeral home.

November 10

I have just reread the foregoing and find it mighty chatty; anyway I am enjoying myself — and I know you like to chat, too!

I cannot resist pursuing Asheville a bit more. Ken once told me that he knew the whole town, its outlines and ins and outs. I never knew it as well, not having spent my earliest childhood there, but I knew it well enough to feel its contours. It is a city with a definite center, in the center of which is an obelisk; this is Pack Square, and from it radiates all the main streets. The buses always return there to start again, leaving downhill and climbing back up again. The city is surrounded by mountains that lie at some distance out so you can see them and feel them to be around you. And the whole is made magical by an umbilical cord of a train track that winds down the mountain plateau on which it stands, winds and winds so you see the same valley over and over again from a slightly different point of view each time.

The train (the principal one to the north) left at 5:00 p.m. and arrived at 8:00 a.m., so the shadows and colors were always clear and delicate on the mountains. The whole topography, the placement of the city, remains in my mind as quite perfect in conception, symmetrical in form, intricately complicated visually and plastically because of the infinite gradations in height: your feet always at an angle.

I could wander around it endlessly in my memory (and indeed I often do, with much pleasure), but will return to 1953–57. During this time Ken changed his studio again — to the last one, that mews building in Twining Court. His third child was born two months after Alexandra. He and Cornelia also moved from M Street to Quesada Street, and he continued to teach at Catholic University. So there he was, supporting his family with difficulty, working very, very hard all the time, and beginning to feel his power in relation to the context of New York. We used to meet about once a month or so and talk and talk. About you, and your concepts of art, which enabled us to talk, so to speak. Ken talked mostly, and I listened and absorbed. When I say that your concepts of art "enabled us to talk," I mean that words could be put to ideas that had hitherto remained unspecific, uncreated in the sense that they had been so inarticulate that

they were useless except as expressed directly and unconsciously in work. Ken explored in the course of these long, slow conversations (we rarely talked about people, gossiped — we knew no one in common — it was all art) the context of thought that you implied by your attitudes, actions, opinions, and the context of David's life in the same way. And the attitude and artists he encountered in New York, Pollock and others he met at the Cedar Bar. He would go up, visit, absorb, and then come home and turn it all over in his mind — not only the art he saw but the implications of the way artists lived, how their conversations went, what they paid attention to, what they "chose," what they found necessary for their art and for themselves. Pollock and Helen Frankenthaler were the only two that I remember his dwelling on at length, but I'm sure there were others. And it was the ambience that fascinated (I use the word advisedly) him. It was an astonishment to both of us, in fact, that there actually existed a lot of people who were working out a way of living in which art could be their lives. At least that's the way it seemed to me, and I believe at that time for Ken too, since I got all my concepts about it from absorbing what he told me, intuitively (not to say avidly) as well as in terms of straight information.

In a way, looking back and knowing now the clear curve of Ken's work in all its brilliance (for I am convinced that it was Ken who made the most important, single, splendid vault of "our" generation) it seems sort of touching. We used to sit shivering in our coats over that little old pot-bellied stove which smelled dreadfully of kerosene, I in "the" chair and Ken on some old stool or other, lighting cigarettes with our freezing fingers and talking, talking, talking.

I wish I could convey something of the quality of our conversation — which, as I said, was all Ken's; my contribution was my feeling, which was, god knows, all there. To begin with, there was a curious sort of innocence. You know Ken's mind is, or was, unfurnished. He had no preconceived ideas. Whatever happened to him he examined specifically, and what he chose to examine (and he chose with sure instinct) he examined with obsessive thoroughness. It was all revelation. We were always surprised. That's the feeling that I remember — surprise and a serious delight, held in the context of a really fierce determination.

You know the paintings of this time, so there isn't much to add. I do remember being awfully glad when he had fought his way through the silver paint stage; it always looked cheesy to me, no matter how it was used. We used to argue about it; Ken doted on it for what seemed to me ages! When I moved to Japan in 1964, and we had to vacate that studio, we went through all his old paintings, which I had stacked up around the place, and decided (Ken decided, I advised and dissuaded in certain cases, saying I thought you should see them first) which should be destroyed. He slashed them with a knife, and then had to go back to Vermont. I finished destroying them (some I had seen painted years ago), slashing them further and smashing the frames, and then had them taken to the Washington dump. All very carefully done, remembering Morris's experience. Morris Louis put discarded paintings in the trash, and they were stolen — sold too I think.

That studio really deserves a word. We paid ten dollars a month, and Ken got it by some stroke of sheer genius: a splendid place to work. When he moved in, it was crammed with old iron bed frames — I mean crammed, every room full to the ceiling. He cleared the big loft (how I yearned for that space in Japan!) and the room he painted in, and put a cardboard sign saying "Painter's Room" on the door, with a strong lock, a reminiscence of the vandalism in the old studio. I kept up the double lock, though by the time I left it I had cleared all the rooms and stuffed them with sculpture, as you remember. I used to have trouble with pigeons coming in; they would roost on the tops of my things and make messes. And there were whole families of rats in that big garage downstairs which I never managed to wrest from the landlord; when I left it was full of broken-down cars and jeweler's display cases, all standing in water and used as a camping ground for the rats.

I first remember Ken mentioning Morris early on, I guess about 1953. I remember that I was looking at a tube of plastic paint, and we had just finished talking about it and what it meant, and Ken said he was going to try it.

I had never heard of Morris, but heard lots from then on, all about his work, not so much specifically but in terms of admiration and challenge. Morris really pushed Ken, again not personally (it's interesting to me now

how little personal talk there ever was; I never even took in the fact that Morris was married until you and Jenny [Greenberg, née Van Horne] came to visit in 1960), but his work and his attitude toward it, the way he lived in relation to it, his single-mindedness, his ruthlessness — the whole scale of his ambition and achievement presented itself with insistent immediacy.

Sometimes it made Ken good and mad. It was a stormy competition, no quarter given or desired. I know there were periods of bitterness — I should imagine on both sides — but I never knew Ken to falter even to the slightest degree in his admiration and respect for Morris, both as a man and an artist. He was growing himself, as Morris was, and, as it appeared to me, he grew in the light of Morris's work in the beginning of their friendship as Morris was to grow in the light of his toward the end of his life.

November 23, 6:30 a.m.

I never felt any life coming out of Morris. I felt that, to use David's words, he "stood." God knows he was inarticulate! There he was, all his eloquence poured into his work as far as I ever knew him, which was never at all well. Better really at the very end of his life. I used to telephone every ten days or so and we would talk a little. I never understood why none of his friends came to see him before he died. Morris was very proud.

But it was Ken who swam back and forth energetically — even frantically (we were so *anxious* in those days, everything was immediate) — between New York and DC, fertilizing everything in his path. He was the one who really galvanized a whole number of people; I say number because "group" is too formal. Anyway, I don't know much about it from that angle, as I never knew Gene Davis, Tom Downing, Howard Mehring, Ed Kelley, et al., except briefly and through Ken. He not only galvanized but created a sort of powerful force magnetizing the free-floating talent around New York, with all that New York meant in those days, the 1950s. He made people conscious of a world of concepts and standards which, glory of glories, actually existed right up there just a few miles away. It was passionately exhilarating and blew away the miasmic vapors of provincialism, which have never really

come back. All those painters he left behind him are still putt-putting along in the direction toward which they were wrenched, lured, persuaded — and in which they were finally confirmed by Morris's and Ken's success.

Morris's work was — it seems to me, looking back and from a very limited point of view (I don't see how historians ever *can* make statements) — even more important than Ken's in the 1950s. He was watched and emulated by his students — and by Ken's, because Ken told them to.

So the way it seems to me to have been was that Morris's work held the seeds (lots of fertilization going on here!) that Ken's instincts recognized. Stimulated and challenged, Ken's work veered into the context implied by Morris's, and at the same time, almost equally stimulated and challenged by you and by David, into the context of New York. He then, being altogether enthusiastic, open, and trusting, shared his excitement as he found his footing. These dialogues and his work combined with Morris's increasingly powerful painting to form the core of the influence in Washington.

December 2, 5:00 a.m. (Alexandra's 10th Birthday)

I miss David terribly. Very much more than is logical, given the nature of our friendship, which was intimate but extensive neither in time nor in the area of our lives shared.

David used to come down from Bolton for weekends with [his daughters] Becca and Dida. He would arrive — always unexpectedly, which was nice — on Saturday, pick them up and take them to a hotel. On Sunday he would bring them for lunch with our three. We would then go to the zoo or some such jaunt and then drive his children home. David usually came back for supper (I associate him with cold turkey and lamb sandwiches and salad), and we would see him off for the airport. David was easy to be with because he was so large and bulky, and I always knew that he was like me and would want to be alone again soon.

He had enormous pride in his children (I know this is no news to you, Clem; I am assembling my feelings) and yearned for their understanding. I never felt that he got it — How could he have? — and we used to be rather quiet driving back after leaving them with their mother on

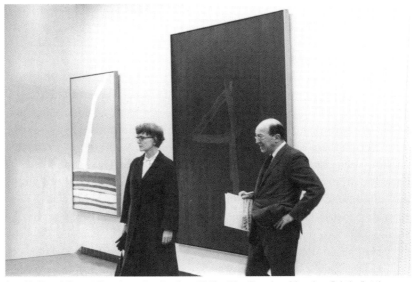

Anne Truitt and Clement Greenberg attending the exhibition "Two Decades of American Painting" at the National Museum of Modern Art, Tokyo, October 1966. From left: Robert Motherwell, *Untitled* and *In Black and Pink, with the Number Four*, both 1966.

Sunday nights. He would always call out some last piece of advice, some minor admonition, gruffly, in the dark evening, as they disappeared (did they feel relief?) into their lighted house. This is the way I most clearly remember David: saying goodbye always with "work good" or some such phrase. He was always saying goodbye.

I think he lived constantly with mortality. He never forgot that his time was short. I have never known anyone (except myself) who worried so about time. Ken seems to *know* about this, and so does Helen. That David was pushed and harried and maddened by it made a bond between him and me.

He was always leaving his name. He once signed a scrub brush in my studio at 1506 Thirtieth Street. It was he who made me conscious of "name" as such, and for about a year I signed things (at his suggestion) as he did on the scrub brush: a brush mark of color, then scratched into it my name in full, then the exact date — not quite the minute and second! David's point was that some day someone would have to catalogue his work (an exhilarating and intoxicating thought to me at that time, 1961 to early '62). He was certainly right, as I found when Mary's sister and I tried to make a reasonable sequence of Mary's work after her death.[2] I still put the day date on my things, but now because of respect, as the dates bring the piece into focus for me and quite often relate to conception rather than completion. But that was David's "take" on my work, and I believe on any work; it was a high depth of seriousness — much higher than any I would have dared openly to conceive for myself. It was this high seriousness to which Ken must have reacted back in the 1950s. David simply took it for granted that if you undertook to make art, your peers, companions, rivals, and challengers were Uccello, Piero, et al. To have David in your studio changed the context of your work: he focused it in the history of art. It was inexpressively glorious, a grand feeling of possibility.

David used words with precision, and his words were useful for that reason. I felt *sure* that he was *careful* about what he said; that can

---

2. Truitt is referring here to her friend the painter Mary Pinchot Meyer, who was murdered on October 12 of the previous year.

be essential when you are moving ahead uncertainly. Later, when we got to be better friends, he told me he tried never to say bad things about work, and that he sometimes — often — just plain lied about it. He felt the artist's friendship was more important than his opinion.

He was very generous with technical advice. His professional competence was absolute. That is one of the specific reasons I miss him so much. When I am faced with a difficult decision or a technical challenge, I tend to sound out David in my mind before I move. And when I am actually working, on my hands and knees or up on my ladder, tired and on the way to being just plain exhausted, I miss him the most. I miss knowing that he is working too, and is as weary, and determined, as I. He was a great source of strength to me, a tender challenge that was not to the slightest degree less a challenge for being tender.

I wonder sometimes if the most real bond between artists isn't physical: the knowledge of that terrible work binds us all — "good" and "bad" — together. I went with J. and B. Lieberman to a dreadful art exhibit last week: a huge, gaunt room crammed with life-sized statues of naked people, standing in rows roughly six inches from each other, presenting thirty bottoms on one side, then a potted plant and thirty more bottoms. Their reaction was one of horror at the art. Mine was one of pain at the terrible work, the hundreds and hundreds of artists who had worked and worked to make what they loved and felt important. The knowledge of work, the feeling of it in your body, the actual physical price of art: this whole realm of endeavor strained and saturated David's experience. He *knew* it so well, and he survived it. He was a comfort.

December 3, 5:20 a.m.

David was very selfish. Loving, as I feel it, but selfish; he cherished his time, his energy, his physical habits. He loved, and took very good care of, what belonged to him and what nourished him and what served him. He loved his car because the engine was good and would start for him on cold mornings. He loved his land because he could put his work on it and into its context, and because he learned from it and because he could go home to it. I have

scarcely known anyone to whom a home place was more important; once at Bolton, David never seemed comfortable elsewhere, only uneasily perched.

The only thing I ever heard him complain about his wife (except money, alas, but again work before people: better to spend the $10, $100, $10,000 on work than perishable coats and dresses) was when he said once that she never understood that he was *already* working when he went out the door in the morning!

And he deeply loved his friends. Helen and Bob [Motherwell] and Ken. And I'm sure others, but them particularly: his voice would change when he spoke of them.

He loved his cigars, his brandy, his good welder's shoes (he worried about his feet failing him, and, of course, about steel falling on them); he loved his books. He loved his arrangements for his work, all of them — and for excellent reason, as they were original, sensible, prudent, economical, and inspiring. Inspiring because he let things lie about the place on purpose, to see what would happen to them in his mind. He loved the knowledge that he was building an empire for his children to inherit. He loved the knowledge that what left his hands (unusually delicate in form for hands so big, unusually hard in texture) went out clean into the world forever.

David never said anything mean about artists. All the rest of us would occasionally be downright bitchy. Ken used to say that David never forgot he was a Great Artist: it was a standard he had set for himself. He set it for us, too. All artists were great from one point of view. He used to say they were all "trying to make the best god-damned art that's ever been made."

David was very masculine. I always felt very comfortable mending the children's clothes while he and J. talked. Now, who would think of mending clothes with Frank Stella? David made me feel, in the most old-fashioned sense, womanly. Pies in the oven and the men-folk in from the fields.

But he could be perfectly horrid about women — really frighteningly mean. Mary Meyer made him feel that way. She challenged him sexually one night when she came to dinner with him (just us four). David was so cruel to her, sexually cruel, that I felt paralyzed with shock.

David once made a pastiche for some guest or other, at one of our sunshiny lunches, all the children munching away. He said making a sculpture was like a man driving his family home at the end of the day after a

picnic. His wife was yakking at him in the front seat. The children in the back seat were eating ice cream cones that were dripping on the upholstery (David hated a mess) and squawking and breathing on his neck and liable to climb out the windows. The sun was going down, it was much later than he had calculated. He was stuck over and over in traffic jams. He got into wrong lanes because he didn't know the way. But he had to keep on driving the god-damned car because he had to get home!

December 10, 5:00 a.m.

In the fall of 1961, when my last child was one year old, I began making a different kind of sculpture, based on the fences, barns, farmhouses, and meadows of my childhood. These led me further and further into sizes that would no longer fit into my studio at 1506 Thirtieth Street, and I asked Ken if I could rent from him his old studio in Twining Court. At this time he was living at the Chelsea, and used the old studio only for storage. For a period of a year I had two studios, then gave up 1506 Thirtieth Street, as my things began to cost more and more and I couldn't afford it. As I said earlier, I paid ten dollars a month for Ken's mews.

From February 1962 to February 1964 I worked there, gradually filling up the rooms with pieces. Ken's things were stored there, and Morris's paints, etc., after his death. And during this whole developmental period I was given all the help, support, encouragement, and — most important of all — information I needed by a group of people. Given it freely, generously, gladly, and in such a way that I could absorb it as eagerly and quickly as I wanted. I feel a great gratitude to these people, and I can now see it is to honor this gratitude that I have been writing to you.

The first and by far the most important was Ken. He came to see my new work in February of 1962, and from that moment never failed me in any way whatsoever. Consistently, patiently, quietly, without conceit, fanfare, or pretension, he affectionately and shrewdly and wisely conveyed to me a whole matrix of hard-earned experience. As I once said to Mary Meyer, "Every time he opens his mouth he says something I *need* to know." It was experience I would not have been able to learn

for myself without years of living: it was what he had learned from 1957 to 1961. And, indeed, I probably never would have learned some of it, as my sensitivity is not acute for people, situations, and events, whereas Ken's is super-acute.

In addition to this private dialogue, Ken told you and David, André [Emmerich] and Bill Rubin, about the work. He introduced me to Helen and Bob. And to Ray Parker, Frank Stella, Barbara Rose, Tony Caro; he welcomed me warmly into his world.

He also supported me physically at the time of the first New York show by supervising Jim Lebron's packing, by driving me to New York with the pickup truck, and by setting up the show. He taught me how to "bear down" on that series of complicated factors that are involved in having a show.

And all the while he answered my questions, which were constant. He explained and described and expressed and translated. And I learned and learned, never forgot and never will forget.

At that time it was not Ken's *work* that influenced me, as it would in 1965. It was his self, his experience as an artist, generously shared.

In a way my debt to Bill Rubin is a funny one because of the timing. It was like a Mack Sennett comedy. I first barely had time to learn, a few minutes, and then instantly used what I had learned as if I had — of course — always known it!

I drove Bill to Morris's house to see Marcella [Louis, née Siegel] the day of Morris's funeral. On the way he said André intended to come to the studio to consider my work for showing. I asked questions about my responsibility if he did take me — who-paid-for-what questions, what was the going percentage for dealers, etc. When I got home there was André; we drove straight to the studio. He said he'd give me a "new artist" show, one, and we'd then see. Now, I don't think André would have cared, really, but *I* cared that I was knowledgeable enough to instantly, "professionally" accept all his conditions — all of which I had just heard of a few minutes before!

Bill also helped on my first show, and was a source of encouragement. But, more important, he gave me a parabola once in the course of conversation: first show, you appear; second show, people notice you're still there; third show, people *begin* to take you seriously. The turbulent waters of New York. That parabola has been an anchor to windward.

December 20

It has now become quite clear to me that I have been writing this as a tribute of gratitude, not as an attempt to "record my experience" or "fill in chinks." I feel fairly sure that there is nothing new in it for you, who know the whole context within which my experience has been so personal and limited. But I can feel my life turning in some new big cycle, moving away emotionally in a great swing from the past, which it has been so busy coordinating and tabulating and trying to understand for the past few years. Particularly since the past was cut so sharply — and cruelly as I experienced it — from the present when I came to Japan. My instinct is that I may never again *feel* the past as clearly as I do now. It is inevitable. You will understand.

The big thing of course has been faith. I don't know whether other people have so much trouble as I have with self-confidence; I imagine they do but never mention it, as I don't either!

My last show I felt to be catastrophic, for all sorts of reasons, some professional, some personal. André's unfailing support never failed to hearten me. I learned more than I think he can imagine from the way in which he treated me.

And to you, dear Clem, I owe the unfailing knowledge that your intelligence, sensitivity, courage, intuition, and absolute devotion to art were always generously at my disposal. I am sure that you have often written letters such as the one you wrote me in March of last year after my return to Japan. But you could not ever have written one that meant more. It came at a time when my struggle was with the bare bones of despair. The knowledge of being totally alone was, for the first time, bitter to me. Your affirmation withdrew the bitter thorn. All that I have done since, or will ever do, springs more freely and more joyously because you cared enough to write me.

## On Tony Caro

Tony Caro showed me pictures of his new work, which I saw then for the first time, at Thanksgiving in 1963. This work focused my attention on the fact that a sculpture could go in *any direction* — literally — up and down, left and right in degrees. Up until that time my attention had been absorbed with problems of weight. Tony's work challenged this absorption, and changed the context of the conceptualization of my sculpture, as indeed it seems to me to have changed that context for his whole generation.

---

*Handwritten note dated January 8, 1966, 5:00 a.m., box 1, folder 20, Anne Truitt Papers, Special Collections Department, Bryn Mawr College Library. At that time already a colleague of David Smith and Kenneth Noland, Anthony Caro met Truitt in fall 1959 in San Francisco, when the British artist was on the West Coast leg of his first visit to the United States. The 1963 Thanksgiving dinner Truitt mentions took place at the Truitt home in Washington, DC; in addition to Caro, his wife, and his two sons, Kenneth Noland and Mary Meyer were also in attendance. In 1969 Caro would begin showing with André Emmerich Gallery in New York.*

## Letters to Louisa Jenkins, 1966–67

January 4, 1966

Dearest Louisa,

I too feel very close these days, and the feeling of your presence and thought is very strong, and infinitely comforting to my bewildered brain and hurt heart. I have your green things in a flat Japanese woven basket right beside my bed, so when I wake up at night I smell them and feel "right," as if I were where I were meant to be.

Also your book[1] is going straight into my mind and heart. I do not understand some of the terms with exactitude, and can see there is a whole context of thought that I must master to thoroughly understand all his implications. Would you ask the store (I remember your friend worked there) to send me — with a bill, please — *The Phenomenon of Man*? I am reading slowly, partly because it comforts me so much and partly because it interests me so much that I read and reread as I go. The thing that astonishes me — though not you, I'm sure — is that I find expressed with perfect clarity all of the feelings which I *know* are true, plus some I haven't conceived of before. It's the absolute truth of his knowledge that so penetrates my heart. And if you had sent it a few months ago even, I would not have been ready. You know I spent the summer worrying about

---

*Louisa Meyer Jenkins (1898–1989) was an artist based in Big Sur, known for her large-scale mosaic murals. Although Jenkins was more than twenty years Truitt's senior and worked in a decidedly different milieu, she and Truitt shared an intimate, regular correspondence throughout Truitt's years in Japan. Their complete correspondence is held in box 15, folder 2, Anne Truitt Papers, Special Collections Department, Bryn Mawr College Library.*

1. *The Divine Milieu* by Pierre Teilhard de Chardin, 1957.

Left: Anne Truitt in her studio, Tokyo, 1965. Right: Louisa Jenkins in her studio on Partington Ridge, Big Sur, California, 1959.

evil, what to do with what had happened to me and to people I know and love. My closest contemporary friend was murdered last fall, a rape attempt[2]; and two other close friends have died this past year.[3] This, plus all you know about, plus, I'm sure, my own failures, have brought me low. But I am so heartened to know that you are there, understanding, and that [Pierre Teilhard de] Chardin is there. And *of course* evil is *transformed* by suffering. I just hadn't "got" there. And I fought and fought against the suffering, so hard and all the time. I begin dimly to perceive my way, only dimly, but with hope.

As an example of how everything works together, the doctor who first enabled me, by his sympathy, to reveal my suffering, is Jewish and was harried from Germany to Singapore, to Hong Kong, to Tokyo. And he leads me straight to Dr. Kaemmerer, who is perfect for me when so many, many doctors would not have understood all the implications at all.

And if you will forgive, as I know you will, my going on about myself, I had the feeling when I first got here and things were at their worst that I was being led in the right way. For example, I learned Japanese easily, found a house right away, found excellent servants, etc.

I have been thinking too a lot about you, and about our talk by the bay when you drove up to San Francisco to see me — something that changed my life and, I am sure, strengthened me in a course of action that I would otherwise have doubted in a way that would have crippled my development; you strengthened my own intuition of *right*. You say that you made mistakes, as we all do with our children. I feel it strongly with my own: they are so *close* physically that it's easier perhaps to make mistakes with them. But with me, you led me firmly, with what I can only truly call maternal strength. In a real sense, we are each other's mothers and daughters and fathers and sons. I used to often feel I was my mother's mother; some of our most tender feelings were within that

---

2. Truitt's longtime friend, the painter Mary Pinchot Meyer, was murdered on October 12, 1964, while walking along the Chesapeake & Ohio Canal towpath in Washington, DC.
3. One of whom would have been David Smith, whose unexpected death by car crash affected Truitt deeply. See also the artist's remembrance "On David Smith" on page 88 in this volume.

implication. And I feel the same with my own children. When Mary [Pinchot Meyer], my friend who was murdered, died and the cable came and I telephoned and found it was indeed true, I went outside and waited first for James, but he had to go back to work, and then for Alexandra, my real comforter, who never left me. She even stayed with me when I took a bath, and let me cry and was there in such a way that I was able to bear those first hours of pain. I'm sure none of this is new to you, but I am just beginning to see it all, and to feel the network that you have described and which hitherto I have only felt through your imagination and conviction. But that real turning point for me was that talk by the bay. Without your strength and conviction — and I know the physical effort you made too, driving up, and the flowers in the vase in the car — without that guidance and love, I truly believe I might have moved toward evil instead of toward good — difficult as it has often been for me to see it as good.

I will write again soon, but wanted to say what I am feeling so strongly.

<div style="text-align:right">Love to you,<br>Anne</div>

March 11, 1966

Dearest Louisa,

I am sorry you had bad weather in Hawaii. Perhaps it cleared up before you left. Did you read the article on Buckminster Fuller in *The New Yorker?* I read it with intense interest, really fascination.
    And now I have *The Future of Man*, which I am deep in. The lucidity and purity of his mind and the elasticity of his prose is a delight. I find that his world sets a grid of meaning over mine, and bestows upon it a new kind of reality that reinforces my experience. I am so grateful to you for sending it. I really need him here, where I continue to struggle with my own failures and diminishments, sometimes with a very faint heart.

Perhaps what I came to Japan to learn was total defeat. And what lies beyond defeat, a framework only dimly perceived but infinitely beguiling in its allure.

I just cannot see my way clear in my marriage. It's as if James's actions, to which he has every right, self-oriented as they are, conspire to thrust me down and down again. And do mine, I ask myself, thrust him down? I pray not. But we are so different from one another.

Jim Byars came back to Japan on some money he got from the sale of three pieces in America.[4] He had to get back to Taki [Sachiko], who was sadly bereft without him. Now they hope to be married, and I do hope that they can be. He is coming here to visit for a few days on Monday, and then is off to San Francisco, I think with the intention of getting some kind of job and sending for Taki. Such were his ideas when I saw him in Kyoto a week or so ago.

My shipment of twelve sculptures, this last year's work, goes off on the 17th, should arrive in New York on April 7th. That is a good feeling of completion.

Love, as always.
Anne

April 9, 1966

Dear Louisa,

You sound so happy and vigorous that it made me happy to read your letter!

I can understand how a visit from Bucky Fuller invigorated you. It strikes me that he formulates in an area in which most people only go so far as to intuit. And as we all get more and more interested in clarity and purity of communication his imaginative precision gets more compelling.

---

4. Truitt was introduced to Byars by Louisa Jenkins, who had met him while studying Zen Buddhism in Kyoto.

I agree with Bucky that there is no chaos. All my apperceptions here are in terms of the most blinding simplicity. Living in Japan has placed me in such an alien space, with such alien color, that I have come more and more to depend on just those apperceptions. If I had merely used my eyes here, I would not have survived.

James has been in Baltimore with his father, who was operated on, more or less successfully, for cancer. He is due home tomorrow, and writes that he is homesick. In the meanwhile, I have been moving steadily down my dark tunnel, toward the light, which is now dimly visible. I agree that all serious people have to go through one, or more, of them. The unserious people turn aside and become what I think of as benighted, gently and imperceptibly doomed to a kind of limbo.

How I would love to come and stay with you for a while! And I will if I possibly can. I don't think I will have a show this year, as next year is my schedule — once every two years. So I shall be coming home then, if not sooner. Do you remember which issue of *Art and Architecture* you saw my work in? I am curious, and would like to have a copy of the reference, which I can get the gallery to track down for me if I know the issue. And I will send some slides of the new pieces.

Your new work looks to me exceedingly interesting. I like the simplicity and clarity, and the amount — i.e., the amount of action relative to the total space. The invisible energy is, it seems to me, most clearly apperceived in the simplest forms.

Your questions [about painting hard edges]:

> 1) I use new tape for every line. I buy it twelve rolls at one time, and use it lavishly.

> 2) I have never tried to make curved lines, but several ideas occur to me, as they probably already have to you too. But, just to pool my mind:

> What about writing the 3M Company, who make Scotch tape, and finding out if they make a wide tape? I should imagine so. If so, you could draw your line on the tape, cut it out, and use it in one piece.

There may be other kinds of sticky paper too. Nat Owings or Mark [Mills] would probably know right off.[5]

You could overlap your tape, making larger pieces, and cut the curve out of that.

Could you buy very thin, expendable plastic sheets, and make them into templates, painting over them and then discarding them?

Considering that you have a strong surface with your matte varnish, could you use rubber cement or some similar adhesive? I can't remember quite clearly, but it seems to me that I remember using it in college to make graphs with. It dries slowly, so you might be able to paste a template down with it, paint over it quickly, then pull it up. The rubber cement can be cleaned up perfectly when it is dry, as it rolls up into little rubber balls.

I'm sorry not to be able to help more, though you may well have solved it by now. Will you let me know if anything more pops into mind?

The cherry blossoms are out, though rather briefly this year as we are having rainy, windy weather. This is Easter weekend, so you will be in Big Sur. I think of you there, with love, as always.

<p style="text-align:right">Anne</p>

---

5. American architect Nathaniel Owings was a founding partner of Skidmore, Owings & Merrill, one of the largest architectural firms in world. Owings built a unique A-frame residence in Big Sur in 1958 (the Wild Bird House), and he and his wife Margaret Wentworth Owings were part of Jenkins's social circle. Mark Mills, spouse of Jenkins's daughter Barbara, was a successful California architect known for exploring the possibilities of organic form by pouring concrete into molds.

August 8, 1966

Dearest Louisa,

"Confidence forces the limits of determinism and disciplines chance." As always, de Chardin expressed what is most helpful and hopeful in the clearest way imaginable. Medically speaking, my doctor assures me that I am out of the woods. But my confidence is feeble, and totters weakly. I have no idea whether I shall ever be able to make art again.

The truth that has been borne in upon me is that I have lived unwisely. For one thing, I was a spendthrift of myself — my energies, my tendrils of sensitivity, my heart. For another, I believe now that I have failed James as much as he has failed me, perhaps more, as his need may, innately, be greater than mine. I neglected his desires to pursue my own work. I followed my own desires and ends, and now I am painfully and inextricably (for the time being) bound in a web of my own weaving.

I have at last faced the fact that I have a sick husband whom I love, and that my first duty lies to him. (Oh how I yearn for that blue air of freedom that I breathed when I panted after my own work.) James returned from his month in the states in a pitiful condition.

He spent the whole month visiting various friends, including the Healeys in Big Sur, and drinking every minute of the time.[6] Alan Watts gave him some LSD, he explored all sorts of possibilities of escape, but he returned convinced that he must cure himself — and this is the first time that he has actually determined to do so. That is a great, and painful, step forward for him. He is now in analysis with Dr. Kaemmerer, my doctor, who undertakes him because she is the only analyst here; as you know, it's not considered good practice to analyze both husband and wife. But in our case, I believe it may work out, mostly because Dr. K is herself both gifted and sensible. Surely if there ever was an instance of the hand of fate, it is her presence here in Tokyo — so unlikely to find someone good here. She tells me that James is curable, and I am cautiously hopeful. It is

---

6. Artist Sheila Healey and archeologist Giles Healey.

plain that I also must care for him. I do not think I can come home this year, with this responsibility.

Dear Louisa, one thing in your letter worries me. Are you also going through one of these dark places? If so, my heart goes out to you. Are you working? Are you well? Do please write.

The children are still in the mountains with the maids, while I have been here taking care of James. I go up on Friday and bring them back the same day so as not to be away a night. In the meantime I have been cooking and taking care of the house, and reading *War and Peace* for the fourth time.

Please let me know when your paper gets low and I'll send some more. Also incense, and anything else you need or want.

I think of you and trust that all is well.

<div style="text-align: right;">Love, as always,<br>Anne</div>

September 2, 1966

Dearest Louisa,

I have a slight but unmistakable feeling of uneasiness about you, as if everything were not well, which I trust is part of my own receding crisis in confidence.

And is there any chance of your coming over here, as you once said you had thought of? I hope so. Tokyo is horrid now, hot and humid, but in a month the typhoons will have swept the summer out to sea — do come if you can.

Nat Owings is staying with us, and a great pleasure it is.[7] If I had had children at the usual time he would be about the age of mine, and I find him a delightful companion, cozy, comfortable, and in some way that the

---

7. Son of the noted architect, who would later open a fine art gallery in Santa Fe, New Mexico.

young seem to have for me now, reassuring. He is so brave. I am asking him to bring you some things, and am glad to think that you will have the warm bath robe when the winds start to come in cold over the Pacific.

    Jim Byars is back, invigorated and refreshed, really made well by his trip to America. He was here with Taki while Nat was, and I think Nat was pretty baffled by him. I forget how he must strike someone unused to his very particular way of expressing himself, being now so fond of him myself, and finding him a source of fresh perception. He is now going to make expendable sculptures, to be let loose into the streets of New York. James doesn't understand him either, but it seems to me beautiful to be so unattached to one's own permanence.

    I now see my sickness in a new way: hard-won knowledge, as a disobedience to the laws of nature. I just hadn't realized it. And if I had, would I have changed? I just don't know, but suspect not. My own acts were more important to me than the context in which they took place.

    I now perceive a context of law, painfully, and begin, very, very slowly, to try to put myself in harmony with it. I'm not sure why it's so difficult. It's not that I see the context, I guess, as unloving, as much as that I don't see it as loving. Yet, I know that you do, and that sustains me and comforts me.

    James is now going to the doctor regularly, and is on Antabuse, a drug that will make him sick if he drinks. The doctor sees this as a sort of safety belt until he develops his own controls, as she explains it to us both.

    I trust that it will work. I am cautiously hopeful, in a way as if I had been in a rocking boat for a long time and now dimly perceive that the storm is subsiding.

    During this month I will return to work. There is a group exhibit coming up at the Minami Gallery, where I had a one-man show two years ago, in which I am included with five Japanese artists who do sculpture in a way somewhat like mine, plus Sam Francis, who has been doing some ceramic work. And Bob [Motherwell] and Helen [Frankenthaler] are coming here in October in connection with the Museum of Modern Art show to be held here then. So things are in the air, at least. Perhaps the terrible feeling of isolation may ease. Jim Byars helps enormously, too. He just lent me a book by Buckminster Fuller in which he mentions his

world map. Is it possible to order one? If so, I would be glad to have one, and if you know how to get one I'd be grateful if you'd let me know. I like his realization that we all live on an island in one ocean.

I send you my love, as always, and hope that all is well with you.

<div style="text-align: right;">Anne</div>

November 20, 1966

Dearest Louisa,

The Buckminster Fuller map arrived, and has fitted right into the house and the eyes of its inhabitants. The cook's comment was how small Japan was. Alexandra's was Where is the other arctic continent? James's was that *Life* had published it when he was a boy and he had cut it out and put it together. I am interested in the rhythm of cold to heat and the immense landmasses. I have it near my desk tacked on the wall; it reminds me that nothing is necessarily what it seems to be.

I am glad to know about your nun who almost died twice, and feels that life is a mystery to be lived through. Now that I feel better, it seems to me an infinite privilege to be admitted to the living through. So much seems to be just plain given to us. Everything important, in fact. The other night, when James was in Korea, I had dinner with Clem Greenberg.[8] I was being driven home in a taxi, through the thronged streets of Tokyo, a dark night with smoggy fog, a lot of noise and confused jumbling, when all of a sudden I was flooded with the greatest feeling of pure joy. Right in the middle of this ugly, alien city. It was as if, in some inexpressible way, I belonged on the earth.

---

8. Clement Greenberg would have been in Tokyo to accompany the traveling exhibition "Two Decades of American Painting" (October 15–November 27, 1966), hosted by the National Museum of Modern Art, Tokyo, and organized by the International Program of the Museum of Modern Art in New York (a program that some have suggested was a CIA-funded Cold War initiative).

Buckminster Fuller, *Dymaxion Air-Ocean World Map*, 1952

Clem's visit was like being placed in a field where the needle pointed true north: the range of his knowledge is so informed by his sensitivity that his line of judgment is very pure and sure. And not only in art. He is also sensitive to people, and a companion full of unsuspected pleasures. One of which was the commonplace one of eating and drinking. We had lots of meals together, with delicious things to eat and drink, all made more delicious by our unhurried and easy conversation. It was such a pleasure to range over the field of everything that we knew: people on the level of gossip made interesting by affection, art on all kinds of levels both historical and contemporary, and even plain talk of ways and means. Because James has been so sick I have missed the companionship of a mature man and took even more pleasure in it for that.

But James is definitely getting better. (Sam just appeared with a rubber snake and scared me to death!) The fascinating thing to me is that every time I feel the end has come, definitely, that my feeling has gone or deadened beyond recall, something happens to make it alive again. I have sometimes the feeling that we are being pushed apart and sometimes the feeling that we are being drawn together, and both are equally mysterious. The only factor in our relationship which remains stable is our conviction that we have both made mistakes with each other; we keep on trying to see what they were and how we betrayed each other while at the same time we were trying to sustain each other. It's as if this relationship, an ordinary one between two people, were a sort of microcosm of something fundamental. It has an element of terribleness in its continuity.

Our doctor has decided to stay in Tokyo, which is, as you can imagine, an infinite relief. She will go back to Germany this summer, and for this reason among others I have decided to come home for a few weeks in January, about the 16th as I see it now. What I would like to do, if it's convenient for you, is come to San Francisco, and from there to Carmel for a couple of days with you. Then on to Washington (to see doctors for check-ups and friends) and on to New York; then to Boston to see my sisters. If James is not as well as now, or if something goes wrong with the children, I won't be able to come; but I am hoping that all will be well. Then, on my return, James and I can make some decision about staying here for another year or not. It will depend on what the doctor thinks

too. Now that we know that she will stay in Tokyo, we may well feel that it's best to stay until James is really well, which may take another year.

And so, dear Louisa, I stop to get the evening baths started, the children quieted down for the night. We are having the warmest winter in ten thousand years, they say.

<div style="text-align: right">Love, as always,<br>Anne</div>

March 13, 1967

These days have been complicated by all sorts of children's activities, and by my own boom in the studio — hence the gap!

Thanks so much for your beautiful little note about the announcement. I am enclosing two pictures of the exhibit to give you some idea of what it was like. The geometric work is all 1966, and the new things are along the line of the other slide. Something happened to me on that trip, and when I got back I found myself unable to tape a line, unable to make anything that wasn't freehand — a very surprising change it was to me, thoroughly startling as I have been working strictly within the lines of geometric color and shape since 1961. I am now doing a lot of drawings along this new line, but they are turning more toward strict exploration of hue: one color with very, very slight gradations of hue. They interest me a lot, and have that autonomy of their own which guarantees their own organic progression. You can imagine my joy to have this going on once again inside me after those months and months of sterility.

On color and space, and image and background: As you can see from the slides, the colors are carried out to the very edge of the paper or picture frame. As I feel it, this lets the colors relate not only to the space within the picture frame, but to the space outside it, i.e., to the same space that I and other objects occupy. This may be a very personal reaction, but it means to me that the colors and space can then breathe, or operate, in a context larger, and to me more exciting, more provocative, than that of a made picture. Thus what you wrote of as the background, the space in the picture

unoccupied by an image, has as much *place* in my concept as the image itself. The background, to use your word, is as much image as the color.

I am interested in your concept of positive and negative matter, but I don't think I *experience* it that way. I *feel* the space just as strongly as I feel the object that displaces it, so space and object are mutually determining, they create each other. Perhaps this is what you mean by positive and negative matter expressed in different terms.

I sometimes wish that I had a more abstract mind, but there seems to be a center — about my solar plexus — which is the only part of me that is able to *know* anything!

Do stroke the cat for me. Does she have a name yet?

Love, as always,
Anne

June 8, 1967

Dearest Louisa,

Jim Byars left here on Wednesday to fly directly to Los Angeles. He was in a very bad way, feeling depressed and miserable about leaving Taki, about not having been able to make it here, etc. It was just plain impossible, and he faces the adjustment, difficult for us all but agonizingly so for him, of making a living. He *must* have a job of some sort. He will get in touch with Maurice Tuchman, the curator of modern art at the Los Angeles County Museum, who gave him encouragement, and who cabled him to come when he could. I am confident that Jim has the strength to do whatever presents itself to him there. Anyway, I gave him your address again, and your telephone number in case of emergency — I do hope that was all right. He may need a friend. The real problem is the job. He is now thirty-five, you know, and has lived on the ragged edge for so long that his contact with real life is frayed — you will understand.

October 20, 1967

Dearest Louisa,

At last a moment of leisure. The children are out playing, James is working, and I can sit at my desk looking out onto the beautiful trees and write you. This house is a continual amazement to me. It was the *only* house in Washington when we were looking which was both in good condition and large enough for us, and we bought it without actually being in love with it. But now, after a few months of living here, I can see clearly how blessed we were. It is not only easy to live in — a marvelous kitchen, plenty of space, well arranged — but also the whole area is really heaven. Great trees like Big Sur, and all of them now in blazing color. I feel as if I had left a totally gray environment and come out into the sunshine — as indeed we literally have! We are having the most beautiful weather, with bright blue skies and clear air. You can imagine how happy I am.

To go on for a minute about myself. The studio is now in working order, and it's just as if I'd never left Washington in some sense or other. I feel cued back into myself. By chance two of my old pieces from 1962 and '63 had to be moved back into the studio and I had the opportunity to study what I had done, and see it really clearly for the first time. I also looked at my old drawings from 1963 and found myself in a new way. Now I am having some pillars made which I will paint in a new way I have thought of, or which has come to me, and am making a series of drawings unlike what I have done before — a sort of extension which I don't understand but which I am pursuing happily. Am taping curves, by the way, which you may remember our talking about last year. I do it with small segments of tape about an inch or so long, a tedious process but I like it, and it works. I had been very anxious about working in the house, thinking that the proximity to my "other life" would bother me, but not at all. It's easier in a way. I simply run upstairs and look after the children, who are fairly independent anyway, and then down again and back to work. I guess those years of hard work have set up a sort of system inside me which makes the work pour out regardless of the conditions which I had always thought had to be so rigid. I also decided to spend

almost all my salary at the school on help, and now have — again by "chance" — a very nice and comfortable woman who works for me five hours a day for four days a week. I can afford that, and it just exactly takes the burden off me in terms of ironing and cleaning. I find, to my surprise, that my energy is now equal to what I have to do, and things work out fairly evenly. I think a lot of it comes from living in a place which is so beautiful; it nourishes me. Money is still a problem, but I have applied for a Guggenheim, and am at least hopeful that it will come through. The old uncomfortable ambition seems to have left me, and I honestly believe that if I can find the money I can work quietly for the rest of my life. But, strangely enough, now that I don't care I find that people are interested in what I do. Maybe that's the way it goes.

Thanks for the Politec material. I now have a very large amount of Liquitex which I had ordered in Japan and which I brought back with me. When that shows signs of running out, I'll try Politec, which sounds wonderful. How are you getting on with the smell, and what kind is it? Like alcohol? Can you get greater transparency than with Liquitex?[9]

I thought Taki's letter was heartbreaking. How sad her life is, and how beautiful. She loves so gently and with so much tenderness and understanding. I have a rather uncomfortable feeling about Jim, whom I hear from but haven't seen. He cashed my check, so I'm afraid he may be in straits, and will try to get him a grant here if I can. I see the people on Saturday night and will ask again if I can present him for consideration. Could it be, I ask myself, that he is breaking down again in a bad way? America is so open, the opposite from Japan. Maybe he needed the break he found there with Taki and an environment that simply wouldn't let him lose contact with his own reality. On the other hand, he literally couldn't live there. It's the most difficult problem I've ever encountered. But I *know* there is some place for his delicacy of perception. I worry about him, and about Taki,

---

9. Truitt was an early adopter of the water-based acrylic paints that emerged in the 1950s. Although she experimented briefly with marine paint as a coating for the aluminum sculptures she made while in Japan, she soon switched back to acrylic, which she prized for its solubility, transparency, and quick-drying qualities.

as you do. As for doing something for Taki, I think writing letters, which I haven't been doing in the rush of my life, is the best thing. Do you know that she lives in a *tokonoma* space? Scarcely enough to turn around in. She is so close to the edge of spirit. Maybe a soft wooly wrap, a loving sort of wooly object would be what she would like. In a bright color.

An interim occurred here. Mary came in with a nosebleed, and I had to go down and cook dinner for us all, except James, who is still working. And now the end of the day has come, a time I like better and better as I grow older. Perhaps, as you say, one needs more and more time to be alone. I loved your walking by the side of the sea one Sunday instead of going to church. We spent one weekend on the Eastern Shore of Maryland, and I too was drawn to the edge between the sea and the land. It's there where things begin and end, and where they are most real. On the Eastern Shore, where I grew up, the land comes right down to the sea in a sort of marsh which smells wonderful; in fact, the land melts into the sea, you can actually almost see it happening. It's not like the West Coast, where the ocean is vast and comes in, so to speak. The sea there *is*, and the land *is* too, and they meet equally. But the land gives way, gradually. And the colors are marvelous, in the real sense of the word — something to marvel at. Very delicate, and close in hue and value. As if something very important were expressing itself as something very severe and strict in tone.

My cousin here, my fifth or so cousin (we've never been able to figure it out, our grand or great grands were brother and sister or even more remote a connection) has introduced me to the study of theosophy — I guess it's called. [P. D.] Ouspensky et al. I am interested and think I may pursue it and see how I feel. I'm not sure as yet.

But now life is with me again. Sam is in the tub and wants to tell me about what he wants for his birthday. He is in a stage of passionate friendships and is expanding in all sorts of ways. I must listen to him, and put all the children to bed, have my own bath and stop the day myself. My dearest love to you, as always. This has been a letter all about me, but not because I don't think of your life in the studio and in your house. I trust you continue to flourish. How I wish we met more often!

Anne

Installation view of "Anne Truitt 1967," Minami Gallery, Tokyo, 1967. All works untitled, 1966.

November 22, 1967

Dearest Louisa,

I am returning your books to you, with many thanks. I enjoyed them all three, and learned a lot, particularly from those two wise women, the analysts who wrote at length. Am now embarked on Maurice Nicoll, who fascinates me and who has probably already fascinated you. Am working along with him and the New Testament you sent me, and for the first time, outside of my own interior gropings as they were illuminated for me by Chardin, I am beginning, dimly, to grasp a whole new world. I wonder if perhaps personal therapy is really a prelude to a long study, rather like peeling an onion, more and more layers to shed to get to reality. Not that the world of the senses isn't a world of reality too, but one gets through with it somehow. I do so wish that we lived closer together so we could talk more. Perhaps some day.

    In the meanwhile, I am deeply involved with the children, James, the housework, and all the time-consuming affairs of the world. Not for a few days though. We had planned to take the children to Connecticut to spend Thanksgiving with James's cousin and her family, but Alexandra got flu and I have had to stay home with her while the rest of the family left. She and I are cozied in with our new kitten, Kawa, who is an angel, a real dear who purrs all the time, Siamese. We all three lie in bed while I read *Men of Iron* to Alexandra, and it is splendid — a real period of rest and peace. Alexandra eats soup and crackers and I eat brown bread and cheese and salad, the dishwasher runs only once a day, it's all so easy. It reminds me a little of my visit with you, very quiet and perfectly blissful.

    I have started working again. Have reduced my shapes down to the most stark I can conceive, and the colors the closest. Sometimes so close I can barely discern them myself but this seems somehow important to me.

    I went to New York last week for Ken Noland's opening — a beautiful show — and saw Jim Byars for a few hours while I was there. He says that when he got to Los Angeles he saw a sign, *Rolling Rock Hits LA*, and his mind snapped back into place. Since then, he claims, he has felt fine. He looks blooming physically, a bit pink in the face, as plump

as he ever gets, with very long hair and rather bizarre clothes which suit him all right. He has many projects which present themselves to his mind, and which he is busy doing. One was the presentation of a four-hundred-foot-long man made of paper[10] on the street in front of the Museum of Modern Art, which was closed for the occasion. The paper was dissolvable, and he had sanitation trucks from the City of New York, which cleared the street with hoses minutes after he had laid out the man. There is apparently a whole group of people in New York who are involved with such projects and he is one of them. But — and for me, knowing the purity of his projects in Japan, it's a big but — the edge of his inspiration seems blunted. He sent out announcements of the project of the man with the message of time, etc., written on the penis. Then it turned out that the Museum and the City objected to the inclusion of the penis in his paper man. So he gave in, but had decided when I talked to him to have two girls with the penis stationed on the sidelines who would rush in and place it just before the sanitation trucks flushed the man out of the street. This, he pointed out, would be an act of subversion, but the penis was important enough to his concept of the occasion for him to do it. I wrote him just before I left New York asking him why, and haven't heard what he finally did. It seems to me that his emphasis is misplaced. Very different from a circle of perfect white Japanese paper exposed for ten seconds on the slopes of Mt Fuji. He is anxious to get Taki over here, and I so hope he may be able to manage it. Another thing he did was to have made a circle of black silk; when people appeared at the gallery (Dick Bellamy's) he asked them to take off their clothes and get under the circle. It all had childish undertones of sexuality, which seem to me silly. It worries me. He seems to me to have a mind of great beauty and intensity, and this betrays it. And it's all part and parcel of a whole atmosphere of America, or indeed of life perhaps, which drags back rather than lifting up.

---

10. *The Giant Soluble Man*, staged by Byars on November 16, 1967, in conjunction with the "Made with Paper" exhibition on view at the Museum of Contemporary Crafts, New York.

After Ken's opening we went to a loft party in his honor, and I could see clearly for the first time what the New York art world submerges in. A dark, great loft with a blue light at one end. A cauldron of beans surrounded by bottles of cheap red wine and cheaper white bread. People dressed in short dresses and beads and Indian costumes frantically hopping around to music so penetrating that your bones dissolve. Marijuana being smoked in a corner behind the coat racks. Fragmented encounters. Public communication on the level of sexuality, which is instinctively so private. All this in an area which we were told was unsafe to leave except in groups because of violence in the streets. A fantasy of desperation, redeemed by a certain real gentleness between the people.

My dearest love to you. I think of you night and morning from our different points in space on the earth. The trees are bare here now, and beautiful colors of pale gray and white.

<div style="text-align:right">Anne</div>

*Postscript (Twenty Years Later)*[11]

When you said yesterday in your still-beautiful voice, now thin as a great grandmother's silver spoon, "I would have been eighty-nine in November of this year," I was taken aback. Not by your approaching death, a fact akin to other facts we have companionably examined, but by the age you were when we lived as neighbors in Big Sur, California.

So in 1964 you were my age — sixty-six. You had a Peugeot then, a svelte tan car you had filled with Big Sur flowers from the meadows that we used to walk over, when you drove up to San Francisco that March morning in 1964 to lunch with me when I was on my way to live in Japan. You had planned well; before you picked me up, you had bought Greek sandwiches with several kinds of olives in little containers, and tea. You drove straight to the Bay and parked facing the water. If the Peugeot had

---

11. Journal entry dated October 13, 1987, Estate of Anne Truitt, South Salem, New York.

been a boat we could have launched into the Pacific Ocean from our beach. A sparkling day. We breathed the lovely wind, ate (I was too anxious to eat much, you noticed that but wrapped my remains tactfully), and talked. You talked, I listened. My husband of seventeen years was more unwell than I had realized even a few days before when we had left Washington, but I had made the decision to move with him to Tokyo; my three children and I were committed to that trajectory in his unreliable care. You spoke of your own marriage, of its violent end at your hands. "I ripped it apart," you said. "I made him suffer, and I suffered for years." Your voice was rough with remembrance, and remorse. "Let your marriage unravel." Neither of us pretended it was going to do anything else. We did not look at each other. We watched the blue waves and you began to speak in parable of how our whole self lies like a deep mysterious fish under such waves, how patiently we must hold the thin line to which we are attached to it by the desire to know ourselves. You called forth perspective. I breathed it like the sea wind. Slowly it seemed to me that I could trust that air. For the next dark years I held those two images — the rope unraveling slowly and the fish alive in the depths. When my marriage came to an end five years later, its final moment was as natural as its first, had some of the same innocence.

    You drove back to Big Sur that afternoon. I understand very well now how you worked it all out; rose early, picked the flowers, drove four hours, bought food, met your young friend, and drove four hours home. All in the economy of your energy so that you could place your experience in my service. I recognize that pattern in my own life now. I plan and use myself in the same way. I learned how from you.

    I see you in Big Sur, moving silently over the hills, now lion-brown, now brilliant green studded with lupin and poppies. We lived on Partington Ridge, overlooking Partington Canyon, up which the Pacific fog rolled every night, sometimes so high that both our houses would be engulfed until midmorning. You lived alone; your studio was off your living room as mine is in my garden, handy but not obtrusive. Your daughter visited you; my two daughters (my son was conceived in California but was still unborn) scrambled around my legs. You had distance; your years coiled inside you like strong muscles, held you a little aloof. As mine do me now, a secret labyrinthine fortress.

Your name is my mother's, Louisa. I have kept you in your place on the earth, feeling you there for almost thirty years. When we spoke yesterday our voices spanned the continent, intertwined lines of sound, one body to another. "I am a convinced Roman Catholic," you said. "I don't pretend to know what this is going to be like. I don't need to know." And, "I am glad I leave you behind me, still here alive and prospering." "I will come one day," I said, and we both laughed joyously.

We will not speak again.

## On David Smith

I am rereading obituaries of David Smith.

Yes, he did "stand." And he did "owe no allegiance." And he was "idealistic." All his own descriptions of himself, which match my memory of him.

David's comments on his use of iron echo my feelings about wood; but in my case it is the history of the tree from which this wood grew slowly that makes it right for me.

Kenneth Noland told me that he waited at his house until he got so uneasy about David (they had both come from Bennington College, in two cars) that he drove back along the road. He came to a terrible sharp curve, and David's truck had gone off the road — straight instead of making that curve. Ken found the ambulance there. He got into his car and trailed the ambulance to the hospital, but David died either in the ambulance or shortly after arriving at the hospital. He was hurt in his head; never regained consciousness after the crash. Just before he got into his truck at Bennington, he turned to someone and said, "You'll live longer than I will. Keep the world going." These recollections should be checked with Kenneth Noland.

He suggested that I use mahogany, which I began to do. Five-eighths-inch mahogany plywood — he was absolutely right. And he is right that

---

*Typewritten page dated July 24, 1987, box 16, folder 6, Anne Truitt Papers, Special Collections Department, Bryn Mawr College Library. Truitt's first encounter with David Smith was in 1954, when an early figurative work of hers was included in the "Society of Washington Artists 62nd Annual Exhibition," National Collection of Fine Arts, for which Smith was a juror. Smith awarded third prize to Truitt's sculpture Elvira, made in 1953 and now destroyed. They became better acquainted in subsequent years through their mutual friend Kenneth Noland, and in 1965 both Smith and Truitt would be included in the seminal exhibition "Seven Sculptors" at the Institute of Contemporary Art, Philadelphia.*

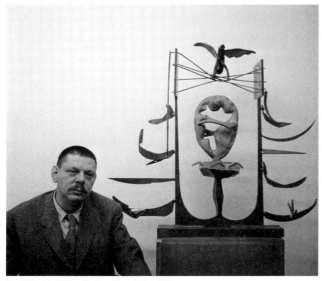
David Smith, 1950, with *Royal Incubator*, 1949.

"techniques are always there." Any strong concept carries with it all the means an artist needs to bring an idea to realization. My impression is that a concept bears a magnetic charge as teleological as that inherent in a developing embryo.

A last word about David. He was an intellectual man. His living room at Bolton was strewn with art books, open higgledy-piggledy on his enormous desk. He had a fine music outfit, listened to fine music. As far as I know, he insisted on everything that he took in being of fine quality — wine, cigars, food. Used to stay at the Plaza in New York on his forays there, even when poor. This insistence on excellence went straight through him. Nothing tawdry. I have heard tell that he was exploitative of women, but I never saw that myself. He liked character wherever he found it. And he respected where respect was earned.

## Letter to André Emmerich, 1966

June 20, 1966

Dear André,

I occurs to me that I have asked you to comment on my work without ever saying what I was trying to do.

When I returned from New York last year I found myself in a bind, and the bind seemed to me to be *space*. If I proceeded in the direction in which I had been working, I had to turn toward larger and larger *objects*. What I conceived, plastically, in terms of directly apperceived volume, loomed outside reasonable dimensions — twenty feet high, thirty feet long; one hundred feet high, eighty feet long. I was really hung up. If I had been smarter, I thought to myself, I would have been an architect. For a while it seemed impossible. Total stoppage. I could just feel those pieces, exactly what they should be and clamored to be. Until they pushed at me so that I turned, shifted, to another dimension of perception: Could it be, I thought, that if I used only what my eyes *saw*, actually saw, *combined* with the lines of force of what I felt plastically, that I could make objects of viable size experienced as objects as forceful as the ones which compelled me?

So I turned to sheets of aluminum, which would define a space for me in terms of force. These fields of force I could then reorganize in terms of visual force, i.e. visual cues, in terms of color and line and value.

In terms of the visual cues I was unlimited.

So far, in the work that I have done for the past year, I see what I feel struggling into being. It moves slowly, and I move along with it hopefully, uncertainly in one sense, certainly in that it moves.

---

*Typewritten sheet with handwritten annotations, box 14, folder 7, Anne Truitt Papers, Special Collections Department, Bryn Mawr College Library.*

## A Conversation with Walter Hopps, 1973

WALTER HOPPS: One thing that I haven't talked to you about at all is other artists. You mentioned that you had seen Georgia O'Keeffe's barn — the painting at the Museum of Modern Art[1] — in the early 1950s; and you commented on Stieglitz's photographs.

ANNE TRUITT: Yes, which I first saw in 1947 at An American Place, because Doris Bry[2] was working there, and I met O'Keeffe there and saw the Stieglitz photographs.

WH: Do you remember what ones you saw?

AT: Oh yes. I saw the Lake George ones, and I saw the ones of barns, and with the juxtaposition of trees and barns with stone underpinnings. And then I saw a whole series of *Equivalents* [1922–35]: the clouds and the trees — mostly poplar trees. I saw some of storms. I saw a whole range of them.

---

*This conversation took place on November 11, 1973, just weeks before the exhibition "Anne Truitt: Sculpture and Drawings, 1961–1973," curated by Walter Hopps, would open at the Whitney Museum of American Art, New York. The transcript, held by the Estate of Anne Truitt, South Salem, New York, has not been previously published.*

1. They are likely referring to O'Keeffe's *White Canadian Barn II*, 1932, which, although part of the collection of the Metropolitan Museum of Art, was on loan to MoMA from 1951 to 1961.
2. Anne Truitt and Doris Bry met in 1944, when they were fellow boarders at a rooming house in the Boston area. Bry would introduce her new friend to James Truitt the following year. She would go on to become a scholar on the work of Alfred Stieglitz, and Georgia O'Keeffe's longtime business agent and confidant. Her papers are held at Yale University.

WH: Tell me about the *Equivalents*, because I felt a certain resonance. I'm not sure many people have understood what Stieglitz was about with those *Equivalents*.

AT: Well, I think I have to start with the fact that I'm sort of a Platonist. It sounds pompous, but it seems to me that the reality we see reflects another reality. And the reason why those caught me was because I felt that he was trying to *catch* what interests me in life, which is when I can see an object that seems to show me a structure behind the object. Also, visually speaking, they deal with little variations in value — not so much structure but little variations in value held within a selected area out of a larger event. You take a whole sky and isolate one little rectangle . . . and that interested me.

WH: Those words describe what he's doing very well — and also much of what you do.

AT: You have to be alert to catch it.

WH: Who do you think the first artist, as such, that you ever thought about was?

AT: Giotto. Or no, Renoir! That painting that I saw on my way out to the water at Mrs. Arensberg's house.[3] I was on my way out the door and on my left I saw this beautiful little painting. Beautiful, *beautiful* little painting. I'd never seen a painting before. In my parents' house they had paintings, but they were nineteenth-century and they weren't . . . they just weren't beautiful. And I was just completely struck! I was very young and very shy, but I plucked up my courage and asked who did it.

WH: How old would you have been then?

---

3. Compton, a historic residence in Trappe, Talbot County, Maryland, was the summer home of the Arensberg family, who would occasionally invite the Dean family over to swim on especially hot days.

AT: I was about thirteen.

WH: And this was at the Arensberg home?

AT: I think.

WH: Where?

AT: On the Eastern Shore.

WH: What was the town?

AT: Easton. But this was out in the country. And we had just come to swim.

WH: Then you said Giotto.

AT: Well, then I went to Bryn Mawr, and at Bryn Mawr in my junior year I had a free elective credit, and I was just hot for psychology then — I took all the psychology and all the biology courses. I was hovering between medicine and psychology, and I took a history of art survey course just for pleasure. And it really was a pleasure. I just got terribly interested in Giotto, because of the feeling. For the first time it occurred to me that I could . . . that it would be possible to *make* an emotion visually. The bulk of the figures and the heaviness of the color was sort of a mordant quality. And the fact that he actually used color to make *weight*; it wasn't the drawing that struck me, it was the color. He used the color to make the weight. It wasn't in the expressions on the faces, which were very clumsy, but in the *color* that he conveyed. For example, in the Pietá [*Lamentation*, c. 1305], the color made me . . . just gave me this feeling of anguish. That was a revelation to me. Masaccio, it's the same thing. And then when I hit Piero della Francesca I realized with joy that you could wed these two things together: you could use form *and* color, and that the structure — let's see if I can get it into words — the structure itself had meaning and power and emotion, and that the color could not be applied to it but show forth the meaning of the structure. That was what I learned from Piero — and I dearly loved him ever since.

WH: Those are extraordinarily important things to realize then.

AT: So happy it made me!

WH: Did you take any studio art classes, as such, at that time?

AT: Never.

WH: What a blessing.

AT: I never, never, never did anything with my hands . . . except knit. I was good at writing. I've always written. And I wanted to save the world in psychology. So simpleminded.

WH: When did you start using your hands — other than to knit?

AT: Well, let me . . . Can I just continue with college first? Cause we were finishing off. Then the next year, with equal pleasure, I took the second part of the survey course, which began with the Impressionists, and that was just absolute heaven too. I didn't learn as much as I learned from Giotto and Masaccio and Piero. Masaccio too I was very fond of, because of the fact that he reduced action to silence: the fact that he froze the action, and the fact that I could *see* and feel the action frozen. Timeless — it became timeless. Then the color and the Impressionists. But that was easier for me. I feel that was just easy; it seemed more fluffy to me, didn't quite go as deep.

To answer your question about the hands. When I was working at Massachusetts General Hospital during the war, I think about 1944, I took a night course at the Cambridge Art Education Center in sculpture — just by chance because Doris Bry wanted to do it, and somebody else, a friend of ours named Paul Johnson. So we three went and they gave us a big hunk of plastilina — whatever that horrible-smelling gray stuff is — and then he showed us a few little simple facts, like the fact that the thighs are triangles, and the triangle of the ribcage and the reverse triangle of the hips, and this and that. And then we were to do little figures. Well, god, I was the speed of light! I just made little figures. It was nothing, but

I just instantly sort of seemed to understand it. The instructor was a man named Franz Denghausen. He said the little figure looked like Miró, and I thought, to tell you the truth, it *did* look a little like him. It had solidity, but I never paid any more attention to it. I just did that, sort of, without thinking, and went right on writing and right on working at the hospital.

WH: How long did you take that class?

AT: It must have been about ten lessons, maybe eight. But my hands had no trouble; they seemed to know what they were doing. It was just easy.

WH: You hadn't done any drawings?

AT: Never. No. I had a governess, and the governess didn't like arithmetic any more than I did, so she never really taught me much arithmetic. But she loved geography and she loved making relief maps, and we used to make relief maps of the Andes and things like that out of flour and water and salt. I remember pushing the flower and water and salt around, making little peaks. I always had the impression that my hands would be very clumsy.

WH: And they turned out to, indeed, not be at all.

AT: Yes. The whole emphasis in my family was on writing and reading.

WH: And after this night class in Boston?

AT: Then I went on writing. I wrote stories and poems and studied Joyce and Virginia Woolf and everybody I could lay my hands on. And the more I wrote short stories, the more I realized that I wasn't interested in the sequence of events in time — that it bored me. I didn't feel comfortable with it, and I wasn't really interested in it. And you can't actually write unless you're interested in the sequence of events in time — at least, I thought you couldn't. And then . . . I don't know exactly what happened, Walter. Something coalesced in me and I just thought: well, I'll do something timeless. So I went down to the Institute of Contemporary Art and enrolled

WH: Here in Washington, DC?

AT: Uh-huh. That's when Ken [Noland] was a student. And I studied with Alexander Giampietro, who was a *very* good teacher.

WH: What did you study with him?

AT: Sculpture, plaster casting, clay work — everything in sculpture. Well, those two things mainly. And we worked from a model in clay, which I loved.

WH: So it was rather classical training?

AT: Yes. But very firm classical training.

WH: Who do you remember as being there with you when you first enrolled?

AT: Bill Taylor. He and I [*laughs*], we appropriated two corners of the studio and we just settled ourselves in. We both concentrated, and we worked very hard and very steadily. And around us circulated all these interesting people. Ken would come down . . .

WH: What was he doing up there?

AT: Ken was a painting student. The first time I paid attention to Ken, other than just to see this person wandering around, was when he made a head of Bill Taylor. He just came down to the sculpture studio, made the head — and by god, it was a good head! I was absolutely astonished, and from then on I watched him. He was the only student there that struck me as having any talent.

WH: This was the first time you ever met him?

AT: We both grew up in Asheville, North Carolina.

WH: And had never met?

AT: No.

WH: But you did meet right away and developed a friendship with him at the school?

AT: Yes. We used to talk now and then, but sort of casually; and then in 1953, when I had a studio in Georgetown, I wanted to do life drawings, which I'd never done, so I called Ken up and he was teaching at Catholic University, and he came over to the studio. Then I studied life drawing with him at Catholic University. From then on we used to meet I guess about every two or three weeks, or every month or something like that, and talk. And then we became good friends.

WH: Let's go back. It was around 1949 that you were at the Institute of Contemporary Art?

AT: Yes. It was, let's see, September of '48, and I stayed until December of '49, and then we moved to Dallas, Texas. Then I studied with Octavio Medellín, who was a Mexican sculptor. He was teaching at the Museum School.

WH: In Dallas?

AT: Yes. And I finished there a marble mother and child, which is now gone, and a stone head; and he taught me to make big clay figures by pinch methods that the Mexicans use. In three months I learned everything I could learn. So then I stopped that and set up my own studio.

WH: There in Dallas?

AT: Uh-huh.

WH: What sort of things did you make in that studio?

AT: I made endless clay sculptures, which I cast in cement and in plaster.

WH: What was the image?

AT: People. Mostly women. Mostly heads in the beginning.

WH: More or less to life scale? Larger?

AT: Life scale. And some little figures . . . little clay figures. I just worked steadily. Very bad work. And I did a lot of carving in stone for pleasure.

WH: While you were there in Dallas were there other artists' work you were beginning to look at or think about?

AT: No.

WH: You focused that much on your own?

AT: Completely. I could go and look to see if there was anybody, but I didn't see anybody so I just worked on my own. I've never paid any attention, really, to what was going on around me, unless I saw something that I liked — like the head that Ken did. Anytime I saw anybody that had anything that I liked . . . but I just never saw it.

WH: A lot was going on in New York and San Francisco, especially in the new American art between about 1947 and 1953. You say you were there in Dallas in '53?

AT: No, '50. The whole year of 1950. We went to New York in, I think it was January 1951, and we lived there for nine months. During that time I thought that my drawings . . . in fact I knew that my drawing was very weak, so I went to the . . . Do you know Sculpture Associates where I used to get my tools on St. Mark's Place? There on the bulletin board was a little advertisement, saying Peter Lipman-Wulf will teach art or something. So I simply called up Peter Lipman-Wulf. Seems a remarkably unintelligent way to proceed, but that's what I did. And without knowing anything about him, I went and looked at him and I liked him and I could see that

I could learn from him. So for seventy-five dollars a month I went there every morning or something — three mornings a week, I've forgotten — and studied drawing.

WH: What sort of drawing did he do?

AT: German expressionist drawing. But he had a very strong academic training. And the poor soul tried to teach me to draw, which is difficult. I was very clumsy; I don't have any facility. Although my hands were very good with that little woman, I didn't — I never had any real facility, Walter. Everything I've learned has been against the grain. It's always been difficult for me, I think, except that one woman. Maybe if I'd stuck with naturalistic sculpture, it would have come easy. But the ideas I had were never really completely naturalistic and I always had to struggle. [Marino] Marini, for example. I thought a lot about Marini in Dallas. He was the one I was following then. And Giacometti, to some extent. Not contemporary American art. I never really thought about it, and I was isolated. I think *ARTnews* came in, but I never really honed in on it until some time later — 1953, I guess. Even then I didn't hone in much. Every time I wanted to learn something I just went and learned it where I wanted, where I could find it. I loved life drawing, and I felt that was important to me, so I studied that with Peter Lipman-Wulf at American University, and V. V. Rankine was giving a night class and I went to that, which was really sort of friends of hers. And then I learned welding from a man named Jack at the Hawk Welding Company — he just taught me the technique.

WH: Where is the Hawk Welding Company?

AT: It's here in Washington, DC, down on Wisconsin, just below M Street.

WH: What prompted you to go there to learn welding?

AT: Well, I just saw the sign: HAWK WELDING COMPANY, so I went and knocked on the door and asked if they'd teach me. Jack said he would teach me. He was wonderful.

WH: Just to add that particular skill to the others?

AT: I wanted to cantilever, and in clay. At that time I was building big clay women and casting them in cement, sort of like *Elvira* [1953],[4] but some of them were bigger. I would take them out to Maryland where they had a big kiln, about the size of this house it seemed to me. It took two weeks to heat up and two weeks to burn off, I think. They would make a platform and put these big clay things on the platform and fire them for me. They had flying buttresses inside — I worked that out. Medellín hadn't taught me that. I reinforced them in the middle — you know, clay bridges.

WH: You mentioned that you wanted to learn to cantilever some forms.

AT: Yes. I should say one thing here apropos flying buttresses, because when I said that nothing artistic happened in my childhood . . . I think the biggest, really the biggest thing that happened to me before seeing the little painting, was my mother took me to Westminster Abbey. My mother had been to Radcliffe and she was a very intelligent woman, very intellectual, but all of her intellect went into reading. She was what they refer to as . . . I think they call it "cultivated." She just . . . liked to read. But she never talked about art. We went to Westminster Abbey, and we walked up through the main nave — you know how dark it is? Oh, it was fascinating — all that space! And then we went out into the cloisters, and my mother showed me the flying buttresses! How the structure — how the buttresses — were holding up the space! My god, it was a revelation to me. I can still feel the stones under my feet. I thought to myself, by god, everything's like that: everything has an inside and an outside and it's all whole. After that, I never again looked at a building — or anything, including a person — without feeling the inside and the outside and how it was one, and what held it together. Why is the man standing like that? Because his bones were a certain way, you see; he's standing on his bones. So that was tremendous.

---

4. Work destroyed in 1962.

WH: When was this you went to England?

AT: I was ten. And I was writing then. I never can remember a time, Walter, when I wasn't collecting. You know, I was always looking at everything and collecting.

WH: What sort of cantilevering did you have in mind?

AT: Well, I was going to make things like the flying buttresses, but they weren't going to be triangular. They were going to be things like that piece we destroyed[5] — you know, the square things. I was working in wire, soldered wire, but of course the solder wouldn't hold it up and the wire wasn't strong enough. So then I thought I'd make them of steel and expand the scale. But it never worked for me because I was so terrified of the welding machine!

WH: At this point, had you heard of David Smith's work?

AT: Vaguely.

WH: But hadn't met him?

AT: No.

WH: Well, it must have been an absolute, overwhelming joy when you finally did meet him and see his work. Or was it? What was it like?

AT: It wasn't his work so much. It was David. I don't think it's really been work so much for me as it has been *people*. I'll tell you what was an overwhelming joy for me, was when I went to Bolton Landing. I remember weeping, and I let everybody else go ahead so they wouldn't see me. I thought it was just *incredible* how beautiful it was. Incredible! The

---

5. *Painted Wire Construction*, 1952.

juxtaposition of the pieces of sculpture with the land — that was what got me. The fact that he had been able, again like Piero della Francesca, to take reality and make it into a sculpture. He'd been able to freeze it.

WH: I couldn't believe it when I first went there. I was not prepared for the kind of visual poetics of that union between a man's work and the land that already existed, on which he's chosen to live his live.

AT: Yes, it was wonderful, wasn't it?

WH: When did you first meet him?

AT: I first met him in 1960 at Mary Meyer's house. I was pregnant with Sam, and I remember lying on a sort of couch, and they talked the entire evening. Didn't say a word during dinner. It was Ken [Noland] and Mary and James [Truitt] and me.

WH: Ken was still living in Washington then?

AT: Yes. And about three-quarters of the way through the evening David turned to me and said, "You're awfully silent." [*laughs*] I remember that vividly. That was the first time I met him.

WH: I think you mentioned before that then through the 1960s, prior to your visit and stay in Japan, you had occasion to see him here in Washington.

AT: He was divorced then, and the children were living with Jean [Smith, née Freas]. And he use to come down for weekends, and all our children were more or less the same age — the ages meshed — so he would come down on Friday, spend Saturday with them, and then Sunday he'd bring them for Sunday dinner and we'd all have dinner in the sunshine in the dining room and talk. Then we'd take the children to the zoo or something, and then drive them home. And then he'd come back for Sunday supper, and then he'd go off to the airport. I can see him now going out the front door. He was a wonderful man. Very vivid. So bulky, wasn't he? And very intelligent.

WH: Did you have a chance to talk with him some about work?

AT: No, I used to keep *very* silent when I listened to him. I remember when he came back from Voltri [Italy], his showing the pictures of all the sculptures he'd done at Voltri, and his pleasure. No, I just kept quiet and listened to him. By that time I was making the things that . . . the work I began in '61, and he used to come to the studio — I guess he came maybe twice — and would sort of check on me. Come in and just say, "Keep going." He used to say, "It has a delicate strength." I think that was what he said. And he watched it.

WH: Just, "Keep going"?

AT: Yeah. But mostly he talked about himself, and I was happy to listen. I really didn't have anything to say, Walter. I was working. Besides, he was interesting. I don't think David's work ever influenced me . . .

WH: I don't either.

AT: . . . specifically. But what influenced me tremendously — just as it was in Ken's work — what influenced me was David's character. The way in which he lived. And that's what Ken and I used to talk about in the days when we used to meet in the early '50s when Ken would be going to New York and then coming back and bringing news, so to speak, to the provinces. He would bring news to Morris Louis and to me, and news to Tom Downing and that group of people over there: Gene [Davis] and [Howard] Mehring, whom I never knew at all. But he would come back, and the things that interested us were the things that had to do with the way in which an artist *made* his life so that he could make art. What . . . how did he live so that he could make art? So he'd be able to stay on that knife-edge? What did he pay attention to in art, and what did he pay attention to in life, and how did he organize himself so he could produce? And that . . . I learned tremendously from David. So did Ken. I think both of us just patterned ourselves.

WH: Well, it works out in concrete terms; it works out very differently in different individuals — how they organize their lives to be able to do it.

There is not the least resemblance as to how you live your life compared with how Ken Noland lives his, and yet the general issues I'm sure you really probed and discussed.

AT: I don't think they're alike on the outside. It's a question of where you put the weight of your life. I think the thing that interested us — I'd better say the thing that interested me, of course, although we talked it back and forth, and I think it interested Ken just as much because he was the one who started me on it. I don't think I would have thought of it on my own. The fact that you had to balance off. He had to balance off his children and his wife and his family; and I had to balance off my family. And yet, at the same time, live so that your work came first — even though it didn't look as if it did.

WH: I know exactly what you mean.

AT: Yes, I'm sure you do.

WH: But so many aspects of that are often so very hard for people to understand. And, of course, not achieving that balance is probably the most usual tragic loss of someone with skill — not being able to do that.

AT: It's very difficult. It's a difficult balance. And you have to pay attention to it. I never really paid attention to it until those conversations. It was Ken who put me on to it.

WH: Ken left for New York when? Around '63?

AT: No, it was 1962, because I took his studio. It was in February '62 as I remember. I asked him if I could sublet or pay the rent — the ten dollars a month — on the place, the mews place, Twining Court, that he had in the alley off between O and P and 21st, 22nd. And he said yes, so I began to pay ten dollars a month. Then I pushed all of the . . . well, the place was full of old bedsteads and pigeons' nests, and I had all the bedsteads carted away and painted some of the other rooms — had them whitewashed. Then I would make my sculpture in the big room that he had cleared — the big

loft room and then another room that he had cleared, and we just pushed his paintings into one room, or two rooms I guess it was. Then I cleared another room, and I would make the sculptures and put them in two other rooms on the second floor, and then finally the room in the basement. It was a dirty old place! It had no water and awful rats. I used to stamp my feet when I went in. Very dirty. Then in 1964 when I went to Japan, we went to [the owner] to see if we could keep it and use it as a storage space; and he said no, he was going to tear it down. He had his feet on the desk, sort of a businessman with his feet on the desk. He just laughed at us. And so we went away. And then we went through Ken's paintings and destroyed — slashed! — we slashed with a razor a lot of paintings. Anything that either of us had any doubt about, we saved, and the rest I had destroyed. He went back to New York. And then we put some of it in storage.

WH: Did you miss him when he went away?

AT: No. Yes, I missed him. No, not really. Not really. Because he was in New York, and I sort of saw him now and then. And I went on working, and he went on working. No, we didn't see each other that much. I never stopped being absolutely devoted to him, but I wouldn't say that I actually *missed* him. It was . . . I was always learning from him. In the early '60s, every time Ken opened his mouth I learned something because he was just that further along on the trail, you see. He taught me about dealers; he taught me about, oh, what you wrote to a gallery; how to always keep a certain distance with the dealer. All sorts of things about where I was going, he taught me. Practical things.

WH: Did you meet André [Emmerich] through Ken?

AT: Yes. Morris Louis died in September of '62, and Bill Rubin came down, Ken came down, not Clem[6] — Clem was in France, as I remember — and

---

6. Truitt met Clement Greenberg during the late 1950s while living in San Francisco, as part of a social circle that included Anthony Caro, Richard Diebenkorn, and Louisa Jenkins.

André came down. Those three and James were all pallbearers at the funeral. And on the day of the funeral, Bill Rubin came over at ten — and he taught me a lot too; right there he taught me about what André would expect from me, would expect me to agree to if André took me. I really knew nothing. And then André came over about twelve and he said, "I'll give you one exhibit and we'll see how it goes." So I said fine, and then we all went over to the funeral. It just happened on that one day. So, yes, Ken told André. The first time Ken saw the work I was making in '61 or early '62, he said, "I'll help you," and then he told Clem, who came down, and David and André. And I just slid into the gallery. I never had any trouble. I really didn't have to do anything.

WH: When we talked before, you mentioned what a quiet man Morris Louis was.

AT: Very.

WH: It's very interesting that apparently with some people he was extraordinarily quiet. I'd never had the occasion to meet him. At other times, I've heard it described that he did an enormous amount of passionate talking with his students, when he did teach. The other thing that always seemed a great pity, but it's turned out otherwise because the paintings are so beautiful to look at, is that so few of them were seen during his lifetime here in Washington. Can you tell me what you thought about when you saw them? I don't mean in relation to your own work at all, but just what the work means to you.

AT: Just for interest, James and I went to an exhibit that he had at the Washington Workshop [Center for the Arts].

WH: Yes, when it was on Twenty-First Street, or . . .

AT: It was in a building on the corner of New Hampshire and Twenty-First, I think. New Hampshire comes in at an angle?

WH: Right.

AT: Sort of an old, red brick building, is what I remember. And the paintings were in the basement. They were enormous. And I thought they looked like the sort of paintings you'd see aboard ship in a saloon — you know, one of those big rooms. That's what it reminded me of. They were very flashy and they had a *lot* of silver and gold. And I did not like them very much.

WH: Those are the paintings that he destroyed almost all he could of them.

AT: Well, I think he was right. That's what I think.

WH: In the [Vincent] Melzac Collection is one that Kenneth Sawyer, the art critic in the Baltimore area, had acquired somehow or other, earlier. And then Melzac and Louis did not get it back to destroy it so it had somehow slipped through.

AT: They were very expressionistic. They were handsome, Walter. That's what they were, and I don't particularly like handsome art. They were too handsome. They were *very* decorative.

WH: This would have been when?

AT: That would have been around 1954. '53 is when Ken first said to me, "There is a good painter in Washington named Morris Louis." I remember he had a tube of Magna paint and he said he was going to experiment now with acrylic paint and that Morris Louis and he were going to work together in it. And I think he said Morris Louis lived in Silver Spring, but shortly thereafter he moved in to Legation Street. Now that was the first time I saw Morris's work, and I had not met him then. I didn't meet him until — again, I was pregnant with Sam — it was the summer of 1960, and Clem and Jenny [Greenberg, née Van Horne] were spending a weekend with us and Morris came after dinner one night. And I just thought he was a very silent, dignified man whose presence I liked. His presence was sort of a lavender color if that isn't too . . . But lavender and pale blue, combined

with very, very rich, dark blue and very dark red; it had a lot of variety in it. But the overall feeling was one of great delicacy of perception and strength. On the other hand, he didn't say much. That was just his person.

WH: Well, that puts him into the room here with us.

AT: Yes. Oh, he was beautiful. You would have loved him immediately. You could just feel him — yes, really. I always loved his presence. It's just that he never spoke. And then the next time I saw his work was in . . . I guess it was that weekend. In fact, it *was* that weekend. We went to Legation Street and there were the *Unfurled* paintings. I remember Marcella [Louis, née Siegel] going around giving us things to eat. I felt so sick. The house smelled something awful because of the chemicals that Morris used. Jenny felt very sick too. We went out on the porch part of the time. But the unfurls were put out on the living room floor, which was a room about this size, maybe a little bit bigger. Stretched out on the floor, and Clem and Morris were giving them names. As I remember, Clem was giving the names: *Omega* and *Alpha* and this and that. And I remember saying the next morning at breakfast to Clem that I didn't particularly like the paintings. And Clem just looked at me and he said, "Wait. Wait and see. Think about them and see what you think in a few months." But Morris, again, was very silent. He'd get the painting out, look at it. He had a way of sort of ducking his head. Held his head down and a little bit to one side sort of like that. And lean over the paintings. And then maybe a few little words exchanged, and then that one will be called *Alpha-something-or-other*. It would be rolled up. Quite a lot of silence. Rolled up. And then another one would be unrolled. And we'd all walk around it, look at it, name it, and then roll it up. We spent the whole afternoon there.

WH: It's been about eleven years now.

AT: Those were the only two times I saw him. Oh, I think they're beautiful. I just couldn't see them. I couldn't connect the left side with the right side. I couldn't get it together, as they say now. Maybe partly because of the

floor, but also I think because it was just a very new painting. I couldn't see it as a unity.

WH: It was extraordinarily new.

AT: Yes. Very.

WH: What are your favorite paintings of his?

AT: I think my favorite ones are the ones in which he has a great sort of a drenching rain of color, and then at the top you see the . . .

WH: Those are my favorite. The *Veil*s.

AT: Love those. The *Veil*s. I just love those. Little delicate tops, and then that drenching rain. I just *love* that. When Morris died Marcella gave us a straight striped painting.

WH: Yes, I remember. It was in the Tilden Street house.

AT: Yes. But at that time nobody knew that Morris was going to be famous. Everybody thought, you see, that Morris . . . No, nobody. At that time he had a contract with the Rubins, and Bill Rubin was there sometime after the funeral picking out the paintings that he wanted. And, at that time, there was a little boy up on a stepladder — at least he looked to me like a little boy — up on a stepladder taking pictures. And, again, the paintings would be laid out on the floor of the living room, and this little boy up on a stepladder would lean over and take a picture; and then the painting would be turned over and Marcella would sign it to authenticate it. Clem was there and Bill Rubin, Larry [Rubin] was in Paris. Clem and Bill and James and me and Jenny. Ken? I don't think Ken was there. He may have been.

WH: This was after Morris had died?

AT: Yes.

WH: Just going through these extraordinary rolls one after another.

AT: Yes. Also, it was most extraordinary because we all tripped down to the basement, and there in the basement were these paintings rolled up on the floor! Great canvases up to about here on me. It was like a river or something. These were very long rolls. And then Clem said: "Come on upstairs," and we went upstairs, and there in the guest room — a little extra room — was another great floor of these things, up, again, to about here. Just rolled up and lying there. Marcella had never seen them. Nobody'd ever seen them, as far as I know, and that's the reason for the atmosphere. It was electric! Bill Rubin was . . . [*laughs*] because, of course, he got to pick ten, as I remember. He gave Morris . . . This is what I remember and I'm not sure. But what I remember is he gave Morris ten thousand dollars a year and he got ten paintings. Same arrangement he had with Ken the following year. But that ten thousand dollars was guaranteed. And Marcella at the Rockville . . . She was a principal at the Rockville Elementary School and she worked like a dog. Every morning he drove her to the bus terminal: she went out to Rockville, he went home and worked all day, then he picked her up at five.

WH: When you went down to the basement that time, do you remember seeing any of the armatures he made? The wooden armatures?

AT: No. I remember seeing some wooden things back in the studio, but they were sort of big horses, as I remember.

WH: Like sawhorses?

AT: Yes. And we're talking about varied . . . One sawhorse was quite tall. One sawhorse was about this big, as I remember.

WH: About four feet off the floor then?

AT: Yes. And then it was quite wide, about three-quarters as long as this rug. And then, as I remember, there was another low one . . .

WH: Perhaps two feet off the floor then?

AT: Yes.

WH: How far apart were they?

AT: About maybe six feet.

WH: Six feet apart.

AT: Something like that. They obviously weren't meant to bear weight. They were like armatures. And then there were the big green cans of his solvent. You see, he died of cancer of the lungs, and nobody knew whether it was because he smoked all day long and drank coffee and didn't eat, or whether it was this solvent. And no one knew that Marcella was going to be very . . . well, she wouldn't have been poor because she had her job, but nobody thought Morris's work was going to take off at all. So what Ken did was, with really extraordinary generosity, he bought all of Morris's canvas and he forced the money on Marcella. He bought *all* of his canvas and all of those awful green cans of solvent.

WH: He bought all the raw materials?

AT: Yes. At a time when he could little afford it. And then all that stuff was moved into my studio. I remember looking at it with great fear because I really . . . it was almost as if the cancer could come jumping out of the green cans at me.

WH: Did you notice the vacuum cleaners? The Electrolux?

AT: No. I just looked in quickly because I didn't want to peer. So what you're really getting is the photograph that I took in my mind quickly that day, and I don't remember the vacuum cleaners. It was a very small room.

WH: It's amazing he was able to do that in such a small space.

AT: I don't see how he did it.

WH: What was the largest dimension of the room perhaps? It wasn't even thirty feet, was it?

AT: Looked about as big as this room.

WH: About twenty-six feet by maybe eighteen or so?

AT: Yes. And just about this size — I mean this shape. Those dimensions.

WH: Well now, he worked all day and he worked at night, too; he worked at any and all times, I guess.

AT: I think he did. He must have. I remember Clem saying he left five hundred paintings.

WH: That's a lot. When I first saw Morris's work it was one of the occasions when I absolutely did not know what to think.

AT: Which one did you see?

WH: Well, I saw some that were unstretched. I saw one that had been arbitrarily stretched by Patrick Lannan — this curious man, J. Patrick Lannan, had acquired from Martha Jackson. Now, somehow or other, I guess Clement and Morris knew one another in some way I failed to understand. This was well before Clem was able to direct the gallery French & Co., the original, extraordinary gallery that existed there in the mid-1950s — mid-to-later 1950s. Somehow, prior to that, Martha Jackson had bought a set of amazing canvases. Now, she never exhibited Morris Louis. She bought them and then, I guess . . . I don't know how he came into contact with her, but, somehow, he did, and he needed money. She bought some, and then she sold them all. She didn't really like them — she didn't think anything of them apparently. She sold them all to a collector who was buying a lot of work from her, named Lannan.

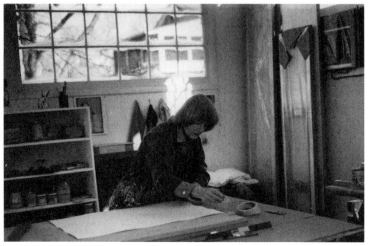
Anne Truitt in her studio, Washington, DC, 1978.

AT: She must feel rather foolish today. Probably that came about because Ken went up and was with Tibor de Nagy.

WH: That's right. And somehow, just around New York . . .

AT: He used to push Morris to exhibit.

WH: Well, you see, earlier . . . It was at the time of French & Co. that I met Lannan in New York. I hadn't seen the Louis show there. I saw the Newman show and I saw the David Smith show — just those two — on trips east. In any event, prior to coming to New York, Patrick Lannan arrived out in California — and to make a long story short for our purposes here, he was interested in buying very large abstract paintings. The word went out that here's a man who doesn't want to buy one that'll fit over the couch; he wants them as big as they come. And you know the size of some of those Sam Francis works. So, holy smoke, it was just an absolute joy to know that there was a man who said: "Bring on the big ones." All right. In the course of this, he was an amazing man and we used to describe him as Daddy Warbucks with hair — steel-gray hair — and he looked like he was about seven feet tall and seventy years old with four-foot-wide shoulders. I mean, this was the impression made on the younger men. All right. So he said: "Look me up in New York sometime, I may have work for you." Well, that seemed a strange thing to say, but the work didn't bother me. It turned out the work was advising him how to stretch up a big painting of Sam Francis's that he tried to . . . and I had the first fight I ever had with Lannan — we've had a few — because it didn't fit his dining room in the apartment on Park Avenue. Floor to ceiling, and it still was six inches too long. He said: "Well now, Walter, which do you think? Will it be the top or the bottom that we fold under?" I said neither, and we had words exchanged then. Anyway, I knew that this man was determined to fold it under and he owned the painting. And Nicholas Krushenick was there hired as a workman, too, of all people; I didn't even know him as an artist, he just was a picture-stretcher, for all I knew. And I excused myself and left. And I've never respected Krushenick to this day because he was a party to that, making up bars so Sam's painting would be folded up.

115   A CONVERSATION WITH WALTER HOPPS, 1973

AT: Yes. Very wrong thing to do.

WH: In any event, a visit prior to getting down to this dubious work, two days earlier, I saw this painting and I'd never seen anything like it hanging in the foyer: bare canvas, big, and just some vertical stripes out in the middle. And: Who? What is that? He explained. Never heard of him. Finally, it rang a little bell. I'd heard from the French critic Michel Tapié about one of the painters he was interested in, and that was a little insight, but I had no sense of what this man painted, where he lived, what went on.

AT: Interesting.

WH: In any event . . .

AT: So private.

WH: . . . it just threw me off. I was trying to deal with all of what seemed to be perfectly empty space, and I was no sooner getting to that, when Lannan said, "Oh, I have a bunch more. I have a whole batch of those from Martha Jackson," and he opens up a closet or storeroom and pulls some out unstretched. "Well, now," I said, "who stretched this painting up?" He said, "Oh, I had it stretched up." Well, I was convinced, Anne, that he stretched it up all wrong. If I hadn't seen that . . . I knew that this man was so insensitive ultimately that he must have made the wrong size stretcher bars. I resent this about Lannan because it threw me off at least a couple years, thinking about Morris's work, because I figured: here he just bought some unstretched canvases from Martha Jackson, who was not the peak of sensitivity herself in certain ways . . . ambitious and vigorous woman but never quite fully in tune with what she had around her. She loved the work; in a way, I think she loved the *activity* but not the work. In any event, here they were, and I just . . . you know how you would? It's funny what you said about the unfurls, because it's just like he had . . . he wanted them big and he had all this spare canvas put on there.

AT: Yeah, he gave you a feeling of being lost in space, which of course is one of the things he wanted. Also, it is a question of amount. That's another thing that Ken and I used to spend time talking about: amount. How much you put in. How much paint you put on. For how much canvas, how much paint? The amount of paint you put on it, and the amount of canvas. I guess Ken must have picked that up. I thought he picked it up from Clyfford Still, but it may have been he picked it up too from Morris.

WH: Oh, I'm sure. I've come to feel that Ken Noland had curiosity to spare, and shared all the fruits of his curiosity with an awful lot of you.

AT: He most certainly did! In fact, I think he, single-handed, did the whole sort of fertilization of Washington. Morris . . . of course I didn't know Morris. See, I only saw him those two times. Three times — once we had dinner together, all of us. Ken was the one . . .

WH: When I say curiosity, I mean kind of the world out there.

AT: That's right. He was passionately interested in it. See, Ken was very ambitious, and he had no furniture in his brain. He had never heard of Plato, for example, or Socrates. He didn't know anything. Or Heraclitus, or James Joyce. He never read. He knew almost nothing. So his brain was like a great, marvelous empty building all full of light. And whatever you told Ken . . . I remember telling him about Plato. Whatever you told Ken you could almost see him placing it; you could see him taking this piece of information and just putting it some place in this big empty space. And then you could see him prowling around and around and around it and thinking about it, so that every bit of information that went in there was used — anything that he felt he could use. I used to just marvel at the fact that he never read anything. But he had this terrific curiosity and great ambition. He would go to New York and spend two or three days and then come back. You see, Cornelia [Noland, née Langer] had been the roommate of Jean Smith, David Smith's wife, so that was the connection there. And he would go to New York and see David, I guess. I never asked exactly what he did up there, except that he would come back with this

information. He'd go to the Cedar Bar, and I think he saw Clem, too. By that time he'd met Clem. Yes, he was the one that . . . he was teaching at Catholic University. Poor as a church mouse. And he had as his students Mehring and Downing, and Gene Davis he taught too.

WH: Although, as we mentioned the other day, Gene is loathe . . . Gene Davis just will not admit that he was a student.

AT: I don't understand why he isn't glad, but then that's just his character. I guess he would prefer to think he sprang full-blown like Pallas Athena. And Ken . . . In those days, you see, Walter, I think Ken got terribly hurt because people didn't give him credit. He would come back and share all this information in a most generous way. He would come back excited, you see. It was exciting: here we were in this little, tiny town and nothing was going on. So he'd come back and bring all the information with great excitement, and with great intelligence; because of his having all that space, you see, in his mind, all this new information would come in and it would be extra exciting because it didn't meet any opposition inside.

WH: So true.

AT: So all of his experiences were fresh to him, and that freshness was conveyed to the people around him. I know he talked to Tom Downing and all those people the same way. And he also, of course, for Morris he conveyed the information too. Like Mercury, he kept going back and forth bringing messages from the world. Clyfford Still he met . . . I remember his putting me on to Clyfford Still. The concept of painting on the edge of things. The concept of the cutting edge of art. That was what Ken brought back from New York. The fact that there was a cutting edge of art. That was a brand new idea to me. I had never really thought about it before. The fact that — which he obviously, I guess, got from Clem — the fact that there was sort of like a glacier that was moving forward, or a stream that was moving forward and that there were certain people who were at the forefront, who were pushing out into unknown territory; and that the ambitious artist — to use Clem's phrase — focused on that edge and only on that edge.

WH: It was strange — in a conversation some years go with Herbert Marcuse, of all people, we were talking about the various kinds of resources that allowed art to happen, and we got onto something that was just . . . stupefyingly obvious: that the static visual arts are just the most awkward of all, and inevitably — even the moving visual arts, as a matter of fact, require extraordinary combinations of people, although the eye and mind and decision is as solitary as in any art ultimately — for it to actually physically happen it's totally unlike writing.

AT: Yes, it's a situation.

WH: Right, and the matter hasn't changed in several thousand years of Eastern and Western culture — that very little visual art comes into being without very crucial combinations of people. So, as simplistic as it seems, yes, Morris was able to do this and Marcella worked to support him. But, you see, it's even something more than that, I suspect.

AT: It's more than that in Marcella and Morris's case, I think, because he never showed her his work. So I think that on her part it was the most delicate love. I just love that. I just love it! It was the most delicate love that she had for him in that she protected him and had such faith in him that even though she didn't see the paintings she still upheld, supported, and affirmed the man. She didn't know anything about them.

WH: She saw his earlier work, like the little beach scenes hanging in the house — all sorts of work that would be simple and familiar to us. But then it was as though he went off on some kind of journey. I mean, he left her with the beach scene and a few other things . . .

AT: *Trellis* [1953] he had on the wall.

WH: *Trellis*, yes. And then he went off on his own.

AT: That's right. And she never failed to be loving and supportive. I just think it's a remarkable thing. It's truly great. So unselfish, and it's truly

what love is — to affirm the other person no matter what they're doing. It's very rare. And, of course, Marcella would never tell anybody. It's one reason why I always say it; whenever I get a chance I say it so it won't get lost. He never enjoyed his money. Ken use to say, "The only thing he ever got out of it was the white Thunderbird that was parked on the street when he died." He didn't know how to have a good time. He didn't know what they call "having a good time." And, of course, he'd only sold two or three paintings when he died. Bill Rubin gets a lot of criticism, but the truth of the matter is that he really underwrote both Ken and Morris at a time when they were sinking, and he deserves a lot of credit for it.

WH: For that he does.

AT: Well, whatever else he's done. Yea or nay, he still deserves credit for that. I've always found him very generous. I remember when the word of Morris's operation came. We were all sitting around a table: Larry Rubin was there with his bride from Paris. And we were sitting around a table eating lobster or something or other. And Larry telephoned Marcella about something or other. And Ken got up and said: "Morris has just been operated on for cancer of the lungs." Absolute dead silence as we all took it in, sitting around a circular table, we all took in the information that he probably was going to die. And then David Smith pulled back his chair and said: "Well, he's a man who's used his life well. He's done what he wanted to do with it." And then we all began to talk a little bit about . . . But that moment of absolutely stunned silence — we were just stopped by it. Ken didn't know that he was going to die so quickly; no one knew he was going to die so quickly. And I remember feeling terribly hurt because nobody came down to see him. Ken and I talked about it. Ken didn't know he would die, as I say, so quickly or he would have come down. But no one came to see him. That sort of hurt me.

WH: Yeah. I remember being quite stunned when I heard that he did die, because by that time I had become enormously interested in what he was doing.

AT: He just read the newspaper one morning and died, sitting on the sofa.

WH: It was what — about a year later when you had your first show with André in New York, wasn't it?

AT: In February of '63. It was just a few months later: September, October, November, December, and January: four months.

WH: The other night you showed me those guest pages that were sent down. Now that's in the material box, is it not?

AT: Yes.

WH: Good. That was fascinating. I wonder how much of the work by people who came to see yours had you seen at that time? Much at all?

AT: Almost none. I went to New York in November of '61 when Sam was just one year old, and I felt for the first time, you see, set free, because when the baby's born they're not really born until they're a year old is my feeling; they still have to be kept very close to you. Or, you know, they want to be very close to you. But then when they're a year old I always feel they seem to me to be finished and it's almost as if they want to begin to move on their own. And Mary Meyer and I went to New York. That was the first time I'd seen any art. I think that was the first time I paid attention to art outside of myself and my own little interior labyrinthine explorations. Went to the Guggenheim. That was really what did it. I don't know what the exhibit was that was on, but I saw my first Newman[7] and I had the same feeling I had with Giotto and Piero della Francesca. I thought: Wow! Somebody who really understands space and how simple it is! How really simple everything is! That all you really *need* is space and just a little bit of structure and the color. That's all you need. You

---

7. *Onement VI*, 1953, included in the Guggenheim exhibition "American Abstract Expressionists and Imagists," 1961, curated by art historian H. H. Arnason.

don't need anything more. I just was overcome. I'm choking up, thinking of it. I'll never forget it.

WH: For the color . . . ?

AT: The color was fantastic! Yes, of course. It was dark blue and it had a pale blue stripe in the middle of it. And that's *all* there was. It was in that little semicircular room — you know the Guggenheim. Then I also saw a number of different ways of doing things. I saw that people were taking — I don't remember the name of the artist, but there was just a wooden . . . a piece of wood, rectangular, about maybe twenty-four by twelve inches, something like that. And, as I remember, the man had just taken another piece of wood and put it on top of it, and then he had painted something on it. But it was just very simple. He'd used nothing but wood and paint and a line, in effect.[8] And what else? I saw my first [Ad] Reinhardt[9] — I had never seen one before. In fact I couldn't see it. I said, "Oh! It's all black" And Mary Meyer said — Mary was wonderful — she said, "No," she said, "Look!" And I looked and, by god, I could see that there was blue and black together, and I thought, Wow! That's where it really is! It's in those little places just like the earth and the water meeting in my childhood on the Eastern Shore of Maryland. The *meeting* of those two colors. It was just magical to me. I just thought it was a revelation too! Couldn't get over it. And then I went home, and I was staying with Mary Meyer's mother — Mary and I were — and I sat up. Mary went out with Ken, and I sat up in the middle of the bed in the guest room, in the middle of the bed like a bullfrog or something, and I just thought all night. I took three baths. I couldn't go to sleep. I literally couldn't go to sleep — I was all wound up. And I kept taking baths, thinking that I'd be able to go to sleep. But fortunately I didn't go to sleep. And that night, I thought: well, I'll just do exactly what I please now. Then I remembered all the things out of my childhood. Then

---

8. Nassos Daphnis, *No. 32-61 M*, 1961.
9. *Abstract Painting–1961*, 1959–61.

*Three*, 1962. Acrylic on wood, 54 9/16 × 17 13/16 × 7 in. (138.6 × 45.2 × 17.8 cm).

123   A CONVERSATION WITH WALTER HOPPS, 1973

I remembered where the water met the land and I remembered all the trees and all the houses and all the proportions, and I thought: I'll make fences and barns and houses and trees and all the things that *I* love. And when I woke up in the morning and came back home, I immediately got some shelf paper and I drew. Logically, because I didn't know anything about scale drawing, I just drew out three pointed pieces of picket fence and I varied automatically, without really thinking anything about it. I just varied the peak and then I drew two crossbars and a thing to put it all on the bottom just to hold it together. And then I went to Galliher's and ordered the lumber and got myself some white house paint and some clamps and some glue, and I trotted back to the studio and put the fence together. And then I looked at it and I thought: my, it's a fence! I was pleased with it. I painted it white and I was even more pleased with it. I thought, it just feels just like me. I like it! And then I thought, I'll make more. So I drew some more on my white sheets of paper and with this great roll of white paper I went to Galliher's, and I had Mary in a little blue snowsuit. Mary was about two or three, I guess — two and a half? And I went — it was snowing — and I went in and said to the man: "Can you make this?" And the man patiently looked at these long sheets of white paper — you know, so awkward — and he said, "Well, you can take this across to the mill and they'll make it." And I got terribly excited. It sounds sort of silly. I grabbed Mary off the counter and I grabbed the paper and I ran outside. I said, "Thank you very much," and I ran outside. And then I just knelt down in the snow — it was certainly something — and I hugged Mary and I said: "Now I can make *exactly* what I want." I was all excited. And then I went back to the studio and drew. I kept on drawing on this big paper until I went to Bill Lawrence at the mill, then he said, "You know, you can make scale drawings." And then I went down to Muth's[10] and got a scale ruler, and an architecture student taught me in two seconds how to use it. And then I began to make scale drawings, and I would take them to Bill Lawrence. Then Ken came to look, and he said, "Are these permanent pigments?" I'd never heard of permanent

---

10. The George F. Muth Company, seller of art supplies and wallpaper.

pigments! I was using house paint. I said, "Oh? I don't know." So I called up the man — the Liquitex man in Cincinnati — and talked to him, the vice president of the company, because I didn't know who else to go to, and I asked him. I told him what I wanted to do, and he told me how to paint them. Then I just ordered the Liquitex straight from him. And then I began. I took Ken's studio, and then the more I made these plain fences — plain fence-like structures just painted white — the more I realized that it wasn't the fence and the barn and the tree and the house and the boards and the this and the that. It was the proportion and the color. And I realized that I could counterpoint; I could get two frames of reference, which harked back to Giotto and Piero. I could use the color for the meaning, and the form for the meaning, and marry them so that they would be one more complex meaning than either one separately. But that was a surprise to me. That came to me, you see, as I was working.

WH: It came very quickly.

AT: It came quickly because, of course, once I could make anything I wanted to then, you see, I could make things big. And I didn't . . . You see, I had three children, and James was Phil Graham's assistant and vice president of the *Washington Post*. There was all this stuff that had to be done. And I had car pools and, speaking of things that make art possible, I had a very good live-in maid who'd been with me since San Francisco, who came from the West Coast with me. And I used my mother's money. I also took my mother's money — I couldn't have done it without that. I inherited money from my mother. And what I did . . . I'd never used it before except to buy houses with, and what I did was I just simply spent the capital. I just would call up the man who handles it for me, this modest little sum, and I'd say, "Please send me $5,000." And I spent the money like *water*. I mean I just didn't *ever* think about it. I just spent it. And if I took ten thousand a year to make the sculptures, I just *took* it. You see, I had James too. I mean, I was being supported. But I just used my mother's money. It's one reason why I'm so poor. I had used *all* that money to make whatever I wanted to.

WH: It's good you did.

AT: Yeah. It may be now. But for a long time it didn't look like that. It looked rash. I mean, the man who ran the money, when I separated from James, he said, "Well, if you hadn't used all that money . . . !"

WH: It was rash, but it was exactly the right thing to do.

AT: I just didn't think about it. I didn't think one way or the other. I just *did* it. And I just thanked God that I had the wherewithal to do it. I'm very grateful to my mother for not tying up the money, just leaving it to me straight out.

WH: I understand more and more the heartbreak of moving to Japan.

AT: I had to make a choice between my marriage and my work. So I chose my marriage. I'd do it again, too. It was difficult because I knew what I was doing. But I was right.

WH: There was a good piece of luck then too, Anne. You were away from this country. Let's speak of something good about it: you were away from this country during years — good heavens, I'm in show business and I can speak of the vulgarity of show business — but you were away from this country during one of the most vulgar periods of exploitation of work. You wouldn't say this, but I will because I was a part of that — of the kinds of work that could anyway be related to what you would concern yourself with and develop in such an extraordinary, beautiful way.

AT: You mean the large prices and everybody getting overexcited?

WH: No, no, I don't mean that at all. I mean, among other things, that . . . well, I guess there's nothing wrong with the term "primary structure" except it just doesn't sound . . . it offends my ear. If I think about it, I can work out what it means. But when I first heard the term "primary structure" — and perhaps it isn't just the term, the words have a certain innocence — but all of the rhetorical bilge that went into it, as though there were some kind of mechanical system now that was going to generate all of this new,

important, three-dimensional work. Well, *I* had the sensation that one had to get out of the way because a primary structure was going to fall on you . . .

AT: Mow you down!

WH: . . . among other things. So, it was a blessing in many ways that you were out of the country at a time when a lot of that particular onrush of promotion and exploitation and great critical uproar went on.

AT: Probably it was. Yeah, it isolated me. Probably, too, I had to go through all that . . . I had to go down that side path that I went down in Japan in order to come full circle again. Probably. Anyway, that's the way it happened.

WH: Right. Whether one *had* to or not, it worked out that way. And that was a benefit of it. Certainly nothing that was deep and essential and important to your work was lost. Quite the contrary. Not a thing was lost.

AT: I don't think it was, Walter. I think . . .

WH: I know not. I can see that.

AT: I think, too, the fact that my eyes were absolutely saturated with close values for all those years — very close hues and very close values.

WH: In Japan?

AT: Yes. The fact that that was all I saw. I mean, granted that I used to be so homesick I shut my eyes . . . still, after a while, my eyes, I think, literally changed. So I can see . . . sometimes I can see things that, you know, just see very subtle little variations, I think, that I didn't see when I left. Particularly in value. I don't seem to use it much, but it's there if I need it. Also, it's very good to get shaken up.

WH: Barnett Newman said, "For an artist there has to be a certain sanctity of place." It really brought home the meaning of the understanding of your own light that you could work within and just *know*. How does one ever know the real importance of that until it's denied or it's changed?

AT: Yes. This longitude and latitude suit me. I was born here. Born in Baltimore and grew up on the Eastern Shore. And this particular longitude and latitude just suit me. I think that's very important. You have to find out where *you* are. What's like . . . the inside? It's like a kind of an analogy of the inside. You have to find out where you are in the inside, and you have to find out where you are on the outside in order to place yourself correctly.

WH: This period while you were away . . . there was so much writing that in no way touched upon any sense of . . . What I'm talking about is the kind of human touch and feeling as content in the artwork. A kind of monstrous virtue was made that these were blunt, unfeeling productions . . .

AT: And a lot of bombast, wasn't there?

WH: Yes.

AT: I used to read it in Japan. And a lot of theories. I've never understood all the theories. What are they talking about?

WH: Yes. Exactly. It was a great . . .

AT: And a lot of mathematics and stuff. When it's really just feeling, I think. Again, it's the reflection, isn't it? It's the reflection of structure behind a structure you see. It has to do with math. I guess you can express it mathematically. I remember coming back from Japan in '65 for an exhibit, and I wanted to go and see Robert Morris. I think I told you about that. Did I tell you? I went down . . .

WH: '65, yes.

AT: We moved to Japan in '64, and I came back for an exhibit in January of '65. A disastrous exhibit. Disastrous!

WH: This was the show at André of the work done in Japan?

AT: Yes. And what happened was there was a dock strike. So first we used the work that I had done in '63, and that exhibit looked all right. That had *Keep* [1963] in it, for example. Then, because in Japan there was never any reverberation, I felt as if I were in a sound-proof room because whatever I did never got any reverberation back from it, you see. It was just as if I were in a vacuum. So what I did was, pigheadedly, when the dock strike broke, I took that exhibit out and put in the new work, you see; so there were really two exhibits during that one exhibit.

WH: That's interesting. That I had never known. Cause the only installation photographs I've seen were of the Japanese work.

AT: Yeah. Well, the good part of the exhibit was the first part which Clem and I installed together, and Ken too as I remember. And that was an all right exhibit: it had *Sandcastle* [1963] and *Keep* and the '63 work and early '64 work. But I was so pigheaded that I never even consulted . . . I mean, I didn't pay any attention to Clem at all. I just simply went right ahead, swapped the old work out, moved in the new work, installed it myself. The installation was okay. But the quality of the work had dropped, and it was immediately visible that it had dropped. I went back to Japan in despair. Because I could see with my own eyes it had dropped! And the color, that had looked okay in Japan, looked *simply awful*. In Japan I had used aluminum, which I continued to use. I didn't realize then that aluminum was wrong for me, and I used it because of the ease of shipping. And I used Japanese marine paint, and I used a whole complicated way of painting it with Japanese marine paint, which I got from the Nippon Paint Company. When I went back to Japan after the exhibit I switched back to Liquitex. I wrote the vice president again and had him ship me Liquitex to Japan. And then I went back to that color . . . but it was the light, and also myself. My eye was off. I was off my center and I just couldn't do it.

So that combination, even though I used the Liquitex, still didn't work. That was a sick feeling. And then in Japan I always knew the work was poor; I just had to keep on making it. And some of those pieces, Walter, I remade three or four times. I used to take the paint off. God, it was ghastly!

WH: Who fabricated all that aluminum?

AT: What happened when I went to Japan was I went to the biggest aluminum company and I started off with the vice president or something. There I was in my little cotton dress . . . One thing about Japan was I had to be so horribly pushy. [*sighs*] As I think I told you, I felt like Alice in Wonderland with my arm up the chimney and my leg out the window. I was so *big*. And everything I wanted to do was something they had never heard of, and they obviously thought I was crazy but they didn't want to be too impolite about it. But I could *feel* it. So it was just like moving ahead against this huge, impossibly black, impenetrable resistance. Anyway, I went to the vice president — this very polite gentleman — and we sat down at the inevitable little table and drank green tea, and then he handed me on to an engineer. And this company made three pieces, and then they passed me down to a little company called Almit, and I ended up with this little, teeny-tiny company in Shinjuku, and then I worked with a man there and he and I made the pieces together. I made scale drawings. And then our driver would come in with me because my Japanese wasn't up to doing all sorts of technical talk, and he would interpret for me. Then they made my pieces all the way straight through Japan.

WH: Back in this country, it wasn't in '63, it was some later time you decided to seek out Bob Morris.

AT: In '65. I went to see him, and I thought I would find someone like myself. I guess I was lonely. I *was* lonely. I thought I would find somebody whose mind *must* be like mine a little bit because he was making the same kinds of things.

WH: You'd seen them in the magazines or wherever?

*Knight's Heritage*, 1963. Acrylic on wood, 60⅜ × 60⅜ × 12 in. (153.4 × 153.4 × 30.5 cm).

131   A CONVERSATION WITH WALTER HOPPS, 1973

AT: In magazines. He was making gray — plain gray wooden boxes and shapes. And I thought: oh joy, somebody is doing something that has the same kind of mind that I did! [*laughs*] So I went, trotted down. I called him up and he said, yes, come on down. It was simply awful! Oh, I was so unhappy. Mary Meyer had just been killed, for one thing. And I was really very unhappy anyway. And the minute I got back to America everybody of course wanted to tell me how they . . . you know, that they'd experienced . . . Anyway, I went down. And Barbara Rose was there, and I just felt . . . How did I feel? Well, it was worse than being Alice in Wonderland.

WH: This was at his studio?

AT: Uh-huh. I felt totally rejected, which was . . . I don't blame them at all, but they sort of laughed at me and picked my brain at the same time they laughed at me. It was very uncomfortable. I don't think it was anything mean or anything, but it was just uncomfortable. Because I was disappointed. When I got there I saw that he hadn't — he didn't love his things. He didn't *love* his gray boxes . . . I saw immediately that his content was very different. What he was interested in was different. And then he'd done some sort of Pop things with penises and organs of the body made out of some sort of plastic-metal stuff, which I thought were just repellent. I felt as if I'd been slapped in the face with a wet washcloth. I was so disappointed. Then we went out and had a drink, and I tried to talk about the fact that I was trying to get the light on the object so the light and the object were married together; and they didn't understand what I was talking about. But there was no malice in it.

## Artist Talk, Baltimore Museum of Art, 1975

To endure is not — alas — always to prevail.

A mystery confounds the problem of work in art, which is that it is simply not enough. High art is not *necessarily* the reward of hard work. But we have to *act* as if it were, just as we have to act today as if we were going to be alive tomorrow.

How does work work? What does it do for us? One element that seems clear is that the capacity to work feeds on itself in a developmental way — that is, it has its own line of growth, and this line can be depended on. From 1948 to 1961, I worked out of obsession, but an obsession often served by guilt. I felt uneasy if I missed a day in the studio, as if I hadn't done my duty. In 1961, when I was fortunate enough to see my way clear before me in a range of work which I recognized as categorically my own, the guilt dropped away, to my total astonishment. In its place came a perfectly peaceful conviction of competence. I imagine it's what a doctor must feel when he is awakened in the middle of the night by a patient. He is *there*, a doctor, his knowledge at his command. I can only assume that this sudden assurance was a kind of coalescence, a catalytic distillation of the years during which I dragged my feet to the studio every day whether I wanted to or not.

Most artists work hard, it seems to me. But I sometimes notice a sort of more or less conscious cut-off point. (An artist can be badly weakened by this kind of unconscious reservation.) It can be a point in time — "I'll work at this until I am twenty-one, twenty-five, thirty, forty..." — or in effort — "I'll work three hours a day or five hours a

---

*Presented at the Baltimore Museum of Art, February 2, 1975, on the occasion of Truitt's exhibition "White Paintings." Transcript from undated, untitled typewritten sheets with handwritten annotations, box 9, folder 1, Anne Truitt Papers, Special Collections Department, Bryn Mawr College Library.*

day or ten hours" — or a point in pleasure — "I'll work unless . . ." And here the "enemies of promise" really move in.

These are personal decisions, more or less at individual will. They hang on the artist's scale of values, and on his character. It has always seemed to me that so-called talent is relatively ordinary. But the capacity to fail and persevere for ten or so years is rather rare.

And no matter how the artist holds his own line of purpose, his result is in jeopardy. He may have a crippling accident, or may suddenly have to support circumstances that drain his vital force, or may find himself caught in a situation which wipes out a cultural context on which he depends. Even the most fortunate have to adjust the demands of daily life with the demands of personal obsession.

This adjustment is tricky, and I thought I would say a few words about my own experience with it. When I began working in art in 1948, I was married and had to fit my hours into a schedule of shopping, cooking, housecleaning, entertaining, and — very often — moving from city to city. In 1955 I had my first child, followed by two more, in 1958 and 1960. By 1961, when my work suddenly became clear before me, and totally preemptory, I had a large and complicated setup within which I had to operate.

My husband was a very active journalist, which means a lot of time-consuming entertaining and being entertained; plus the fact that he was a hospitable person and we had houseguests rather continually. I was expected to enter into his life with a commitment to his career, and felt I should do so, in the context of marriage. Having been traditionally brought up, it didn't occur to me to fight the situation. I simply took it for granted that I had to fit what I wanted to do into it.

My children were at this time six, three, and one. Their care came first. Doctors' appointments, reading to them, rocking the baby to sleep, car pools — all that had to be done, and done well, before I could turn to myself.

What I did was to raise the ante on myself. I got up very early and used every single second of the day, trying not to rush and not stopping. I would do things like cooking the dinner at 6:00 a.m. before the house was overrun with people. And whatever time I had, I spent in the studio. If it

was fifteen minutes, then it was fifteen minutes. If it was three hours — and it almost never was — it was three hours.

It helped me that I understood my own rather rigidly conscientious nature well enough to organize my priorities so that I wouldn't feel that I was neglecting my primary duties, which seemed to me to be to my husband and children. I did what I had to do for them first, and then felt free to pursue my own ends.

The reason for all this finagling and effort is that an artist has to produce enough work to see who he is. It seems to me that he only has this way to find out. His work will teach him, if he can bring himself to do his work.

The paintings now on display upstairs in the museum are parts of a series I call *Arundel*. In them I have set forth — as directly as possible, allowing them to command their own space — certain relationships that I have noticed. In them, I have used the freedom that two-dimensional painting allows. The relationships open into space, as you may have noticed, in a way impossible for an object, which is always limited by its very objectness. I regard them as inflections of my sculpture.

A final word about the pursuit of art. First, it is a *pursuit*, a voyage of discovery. Secondly, it can also be such a voyage for the observer. The artist places his life in the service of his fellow men. He distills its essence as best he can, and takes the *responsibility* for this risky business. Self-oriented as this pursuit necessarily is, he can, if he is successful, illuminate for others as well as for himself. This is, very basically, his hope — and perhaps his occasional reward.

# Interview with Howard Fox, 1975

HOWARD FOX: I'd like to start by asking you several questions about your background. Do you have any formal training in the visual arts?

ANNE TRUITT: I have very little formal training. I went to the Institute of Contemporary Art in Washington from September of 1948 until December of 1949, and then we moved to Dallas, Texas. There I studied for three months under a man who was with the Dallas Museum of Fine Arts School, but all I learned from him was a little bit more about carving stone. And that was the end of my formal training.

HF: So you started out carving stone?

AT: Yes. Well, no. I started out studying with Alexander Giampietro, and he taught a regular, straight studio course in sculpture, and we learned how to work in clay and to cast plaster and to cast in cement. It was a more or less academic course. It was extremely well taught — Alexander Giampietro is a wonderful teacher — and I learned a tremendous amount. I learned all the technical things I really needed. And from then — after I had been in Dallas for three months — I left the museum school because I wasn't really learning anything in particular; then I set up my own studio, where I worked from then on. And whatever I wanted to, I learned; when I wanted to learn welding, I went out and studied welding. When I wanted to do life drawing, I went out and took courses in it and just drew from life.

*This interview took place in October 1975 at Anne Truitt's studio in Washington, DC. A version of it was originally published in* Sun & Moon: A Quarterly of Literature & Art, *no. 1 (Winter 1976): 37–60.*

HF: Your education is rather eclectic, and you are predominantly self-taught.

AT: Exactly. I just followed my nose, so to speak.

HF: What was your earliest work like?

AT: I worked in clay. I did bodies, human bodies, in clay. I worked in cement and did quite a lot of cement casting. Carving wood. I also did some welding. I did quite a lot of work in wire. In fact, I did just about every technique that you'd want to know or could use in sculpture. I experimented with it.

HF: Your early subjects were predominantly nudes and representational then.

AT: No, it was never really representational; it was just semiabstract. I did one stone head that's still intact because it was sold, and I did a mother and child — I think it's in the basement in a box. I'm not sure, I can't quite remember. I did some other stones, and I did some torsos. But they were abstract.

HF: And what size were these?

AT: Life size.

HF: Well, life size is really quite big when you come right down to it.

AT: Yes it is. They were big sculptures. But they're gone now, except for a few. One I gave to my children, and one I gave to a friend, and those are extant. The rest I destroyed because I didn't like them.

HF: That's probably the best reason of all. But do you — in your early work or subsequently — acknowledge any particular influences?

AT: I think Alexander Giampietro was all right because of his technical interest, certainly. And he also had an influence on how I work in the studio — my rhythm in the studio. He had a very plain, common-sense point of view of art. No folderol, no fuss. Just absolutely straight working habits, which I already had for myself from other disciplines.

HF: This idea of discipline is central. Your work radiates a sense of discipline. And I see in your studio as well a most careful attention to details.

AT: Well, attention has a great deal to do with art, doesn't it? If you don't pay attention in art, then you're going to miss it. And to me — I guess that you could say that attention is what you bring to bear as a kind of discipline. I think it's in my nature. I've always been like that. I was born like that. And then I had a very disciplined upbringing. And then I went to Bryn Mawr, which is a very disciplined college. But I think the really major influences on my life have been just as much literary as they have been artistic — perhaps even more so: Proust, Agee, Walker Evans, Joyce, Woolf, Dante, Virgil . . .

HF: Thomas Wolfe?

AT: . . . Homer. No! Virginia. Well, Thomas too. Dante, Homer, Virgil . . . the Greek poets, the Greek dramatists — all the people I lived with. My father had these in his library.

HF: I can understand Proust or Joyce. I quite imagine your interest in them. But what about Dante, Homer, or Virgil?

AT: Because their scale is tremendous. Their detail is distinct and cogent. And their aim is about as high as you can get. It's universal.

HF: Would you say that your work is in any way a probing or an impulse toward that universal?

AT: My work is heuristic. That is, I make my work in the process of discovery.

HF: Yes. I wanted to find out about your working methods. You mentioned discipline already. How do you begin a work when you decide to begin? Do you decide? What prompts you to start a piece and what kind of piece might it be? That is, a drawing or a sculpture. [*laughs*]

AT: [*laughs*] I know you're having trouble getting that into words because it's just about impossible to get into words. I don't think I can actually talk about individual pieces because I live with my work. I actually see my work before I begin it. That is, it comes into me. I see it perfectly well, perfectly, and then I set out to make it.

HF: And this emerges intuitively? Or do you work by sketches?

AT: No. I don't work at all by sketches. I never do sketches. Never. I make drawings, but the drawings are absolute, so to speak. Very, very rarely do I make any sort of sketch. Although I do sometimes when I'm working on color, which can be a very long process for me. Sometimes it's very long and sometimes it's very short. I occasionally make color "splotches," and these I fit into a kind of rough sketch. A rough — I hate the word "sketch" — a rough sort of facsimile of what I have in mind, simply for the purpose of experimenting with the counterpointed proportion of color areas. It may take me a long time to get my colors right because I can see what I see in my head very clearly, but I can't make it. So what I do is come as close as I can. And then I have to give up.

HF: Is this working with the color?

AT: Yes.

HF: Then you're also talking about mixing and blending the paints?

AT: Yes.

HF: When you do these "splotches" does it have any particular value for you? Do you save that work?

AT: I save it only because my dealer in New York, André Emmerich, told me to save it. So I just stick it in a drawer.

HF: Do these represent art objects to you? Or are these just strictly working diagrams?

AT: No. These are just working drawings.

HF: And they're nothing that you would consider as an end in itself?

AT: Not a bit. No. Whatever value someone else might put on them — whatever use they have to me is in the process.

HF: So really, you are taking about process, procedure, as a rather integral part of your work.

AT: What else is art?

HF: Well, there are some people who consider it objects, just finished objects. Still others aren't even interested in starting the object, much less finishing it.

AT: You see, I'm just not that kind of artist. I *never* do finished objects. I always have to stop short. It's not *possible* to finish an object, and what I do is just come as close as I can. I make an approximation, and then I stop.

HF: When you say that you can never make what you want to make, are you referring to each time, each instance that you set out to create an object? Or are you saying that in a larger sense?

AT: Both. Because the ratio between the number of works that I could have made and the number of works that I have made or have the prospect of making leaves the weight on those that are unmade by about, say, seventy-five per cent.

HF: How many works might you do in a year?

AT: I think in 1962 I made thirty. It depends very much on what my circumstances are. There are many periods when I haven't been able to work. I have three children, and I was married for twenty-one years, and there have been *many* times in my life when I wasn't working. And also it's been a question of money. It costs a great deal of money.

HF: How, typically, might you go about making one of your sculptures? Do you call it sculpture, incidentally?

AT: Yes, I call it sculpture.

HF: How do you feel about people calling it painting?

AT: I don't mind what they call it. They can call it whatever they please.

HF: But would you call it painting?

AT: You mean my painted sculptures? [*laughs*] I think I'll just call them sculptures. And I make both paintings and sculptures, as you know. So they differentiate in my mind from paintings.

HF: Do you make your own wooden forms? Do you have a carpentry shop?

AT: No, I don't. I have a whole system. I make scale drawings, and then I have a contractor to do it. A competent, imaginative man. An honorable man. I give him my scale drawings, and then he works, with an equally honorable character, and they're meticulously made. The structures are made out of three-quarter-inch marine mahogany plywood, splined and mitered in a very special way — it's very difficult. They are sprayed on the inside to protect them from moisture. It's important to do this construction carefully because the wood must be free to expand and contract to a small extent due to the inside/outside temperature difference. There are also ventilation holes so they can breathe.

HF: These scale drawings — are they made on a drafting table? Do you work with drafting equipment?

AT: No, I just work with a scale ruler and a T-square. And I just make perfectly plain the scale of the sculptures. You see, when I see a sculpture, it appears to me in the air already made. I simply take that form and put it down in a scale drawing. Then I get a structure (from the cabinetmaker) that is comparable to a painting stretcher — a structure for paint. It is delivered to my studio in perfect condition. Perfect. If it's not perfect I return it. I then proceed to put on between twenty to forty coats of paint, sanding between them. I sand manually, plus I use two sanders, a heavy sander and a light sander. So they're *very* meticulously finished. I apply the paint with very special brushes: nylon, one to three inches wide, depending on the size of the area of color. You see, I do it all by eye. It isn't mathematically controlled. It's done by instinct. And I take off all the paint and do it again if it's wrong. If it's a sixteenth of an inch off it's wrong.

HF: To look closely at your work, one sees really a lot of texture in the painting.

AT: You see it on purpose, because I put it there. I put it there by varying the brush stroke. I put a vertical brush stroke and then a horizontal.

HF: Yes, there's almost a crosshatching. You can see it very clearly in certain lights. Why does this appeal to you?

AT: I am aiming to get film color. I am aiming to get color that will take the form. I want the color to stand alone.

HF: Do you think that the evidence of brush stroke makes it stand alone?

AT: It makes it present. Some color looks like japanned lacquer. Its hard surface calls attention to itself as a surface separate from what it is applied to. It repels the eye. My brushstroke breaks up this surface and allows the eye to absorb form and color simultaneously as a single experience — I

hope! Color that is thus set free to stand by itself and to define its own form is not *applied* color. That is the reason I use paint as I do. And that's the reason I feel strongly about texture. I want color that stands alone.

HF: So in a real sense then you're also very much interested in painting as a process.

AT: I love it. Every artist has to have his kicks. Mine come in putting on the paint.

HF: And again that goes back to discipline. Being careful to the attention of details.

AT: And joy. Yes.

HF: You speak of painting in a sense that almost makes you sound, surprisingly enough, like an Abstract Expressionist or an action painter.

AT: I am. I am an action painter. That is the action of my arms. But it is in the service of the piece that comes out, not in my own service. The action of painting — let me pause over that for a second. I'm interested in what you might call *Ding an sich*. I am interested in the thing-in-itself. I am interested in what comes into being. I am not interested in what cannot be. I am interested in how the paint moves under the brush. I myself am not interested in myself. I'm interested in being as clear and noninterfering as I can — being as cleared and channeled as I can to what is being revealed. I am not thinking about action. I'm not really thinking at all. I simply *am*, so to speak.

HF: Which is a marked contrast to somebody like Franz Kline or Jackson Pollock.

AT: That's why I was pausing over the term "action painting," because it's a misnomer as applied to what I do. Action painting is not just making an action, not running up and down ladders and doing a brushstroke ten

feet long and moving up the ladder and then coming down the ladder and doing another stroke, which is what I do. That's action, but it's not action painting, in the sense of the usual gestural painting. It is a gesture and it is action, but it is not in the context of Abstract Expressionist painting.

HF: You say you are interested in the thing in itself: and you are not necessarily interested in expressing yourself as you paint these objects . . .

AT: I realize it happens . . .

HF: Oh, yes. Regardless of how minimal one wants to be, it's going to express something of its maker. But —

AT: Let's not use the word "minimal." I deplore the word "minimal" because it implies a fading out. It implies a meagerness, and I don't feel that. I feel a fullness. When I'm putting on the paint I feel that it's full. For me, sculpture is full, it's not minimal at all. I've been pushed into that bracket just by historical happenstance.

HF: I presume you are talking about Clement Greenberg, among others. Greenberg said that you were really the forerunner of minimal artists.

AT: Well, if I'm a forerunner, then I'm a forerunner without intending to be. The interest in the minimal by people like Donald Judd, the interest in serialism, the interest in certain polemical ideas in which I am not interested now at all, the interest in certain theories — they took off in different directions. My direction has been personal, extremely personal. I am not interested in theories. I worked completely instinctively and completely — "instinctively" is not the quite right word. I did my own work. I do my own work. And then in 1963 or '62 when I looked backwards I could see that what I had done was to take the painting off the wall. But I didn't set out to do it. I can't imagine "setting out," because that would imply a complete mental set. And that is not at all what I do. I work as I work. And then, post hoc, I can articulate a hypothesis in accordance with which I apparently would have been working. But only post hoc.

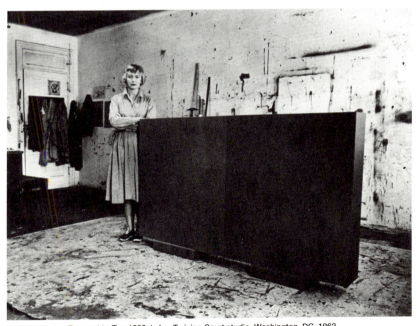

Anne Truitt standing next to *Tor*, 1962, in her Twining Court studio, Washington, DC, 1962.

145 INTERVIEW WITH HOWARD FOX, 1975

HF: You were not preoccupied with any particular problems that have been raised by the history of modern painting. Would you deny hypotheses that maybe other people have applied to your work?

AT: What other people do with my work I don't much care. That's not my business.

HF: I fully appreciate that you are not engaged in any operatic gesture of selfhood, nor are you interested in what cannot be. Would you describe your work as being revelatory of something beyond yourself?

AT: I wouldn't describe it any way, to tell you the truth. I don't mean that at all aggressively. [*pause*] *I* would not describe it; other people can describe it if they wish. For me it's constantly revelatory, from where I stand. I can't describe what is revealed to me. It would not be possible to describe it other than in my work itself. I've already described it. And after I've made the thing, then I look at it to see what it has to teach me. And then I learn from each piece. For me it's always an onward exploration. And to use a word like "revelatory" makes me feel slightly nervous, because it makes it heavy. It makes it portentous, or even pretentious. It's a weighted word; it makes it sound fancy. You see, my work is completely ordinary to me to the degree that it is my life, and so I don't regard it as revelatory. I can't help making my work, it's simply the way I am, simpler to make it work. It's just the way I breathe. It's natural to me. And it doesn't have any weighty philosophical rationale. I don't know how better to express it.

HF: Earlier you mentioned aiming at the universal. I think there are many artists who could care less about universal values in their work. They are interested strictly in the object, and the object reveals nothing. Some, like Sol LeWitt or Tony Smith — two superior artists, in my opinion — don't even touch their works. But yours is different from this. Now, is the reason that your art is different the same reason that Homer, Virgil, and Dante wouldn't call to mind LeWitt or Donald Judd?

AT: I see what you're getting at, yes. Anyway, that's the world in which I live. I mean as a modest companion to them — Homer, Virgil, etc. It's just where my mind happens to be. I think if we return to process it might be a little clearer. You see, the structures that I see in my mind I regard as the base of my work in somewhat the same way that a painter regards the canvas as a base. It's a support. A three-dimensional support. The structure I regard as a form. Then, you see, the piece clothes itself, advances toward me, comes into being intrinsically with the form — but *after* it, so that the actual formation of the sculpture is in two steps, the first being the structure, and the second being the essence of its actual form, which is the color.

HF: Yes, you've described yourself as being in the service of the object, to its coming into being. To use Emerson's idea of the transparent eyeball might be overstating, but —

AT: The concept rather than the object. I'm in the service of the concept. To me that feels more accurate.

HF: Why do you prefer wood? You have worked with aluminum for this kind of work, but you destroyed the aluminum pieces.

AT: Good question. I worked with aluminum in Japan because it would be lighter to carry on the ship.

HF: So it was pretty much an economical consideration.

AT: It was economical and it was also . . . it was primarily economical. I moved back to wood because I found that I did not love aluminum. In Japan I had three and a half years of being off my sensitivity. Whether it was cultural shock or whatever, it was a whole complex. But when I returned to America in July of 1967 I moved back to wood, and from then on I stayed with wood.

HF: Why didn't you like the aluminum?

AT: I just don't like it — the way I don't like steel. Once you get beyond wood I'm uncomfortable. It's like wearing linoleum, or wearing vinyl. I would *never* wear vinyl. I have to wear cotton. I'm not comfortable with rayon, for example. I'm not comfortable with anything unless it's cotton or wool. It has to be real. It has to be related too to my body. The relationship between aluminum and my body is too disparate. I'm not comfortable with it. I don't like it. And then because the paint works with it is also a reason why I like wood. You see, the paint — the color — has to marry the wood. The color has to melt into it, become intrinsic to it, and it doesn't do that with aluminum; with aluminum it just lies on the surface. An aluminum sculpture is automatically a painted sculpture. The paint lies on the surface, and there's no way to get beyond it. It won't go in. I just never was able to feel satisfied with painted aluminum. [*pause*] In Japan, I used my head a lot.

HF: Is the composition of your paint also natural, or do you use synthetic paints?

AT: I use acrylics. I've been using Liquitex since 1961, and it's so much a part of me that I understand it perfectly. Perfectly. I can do anything with it that I want to. So it feels native to me. And it helped from the beginning. For one thing, it's soluble with water, and I love water. From the moment I began to use Liquitex, I felt comfortable.

HF: Some critics have talked about the rather looming, columnar aspect of your sculpture, while others have mentioned the quiet, intimate, unassuming and almost subdued way in which they declare their presence. These descriptions sound rather at odds with each other. Does it impress you that way? What determines your choice of scale?

AT: I intend the piece to be what it needs to be. I intend to make it as purely as possible. And what other people see is beyond me. What I see and what anybody else sees is entirely different. And one of the things I've had to get used to is that essentially the pursuit of art is a selfish pursuit. Essentially it's a necessity, and it's self-centered because I make

my work for my own eyes, for my own self, and no one actually sees what I see. Now what other people see is determined by who they are, by the rods and cones in their eyes, by their physical structure, by their health, by their mood, by a whole myriad of circumstances, and it's not my business. My business or my *concern* is to make what is real for me . . . as *real* as I can make it. And then leave it. And I've had to train myself to leave it. That's a good discipline. Of all the disciplines that's the most difficult.

HF: You probably have a whole gamut of emotional responses to individual pieces that you do. Perhaps each piece has its particular mood. Do you have that emotional spectator reaction to your work? Or don't you see it as a spectator?

AT: No. I recognize them, the way I recognized my children when they were born, or friends or places. It's a feeling of recognition. And each one is different.

HF: How do they differ? How might they be different for a spectator? Or for you as a spectator?

AT: Those questions are in areas where I would to run with the hare and hunt with the hounds. Do you understand what I mean?

HF: Maybe I can reword it this way. Do you not title the pieces yourself?

AT: Yes, I do.

HF: I've noticed that in the piece — I think it's *Summer Sentinel* [1972] — now in the show at NCFA,[1] you even changed the title.

---

1. "Sculpture: American Directions, 1945–1975," National Collection of Fine Arts, Smithsonian Institution, 1975.

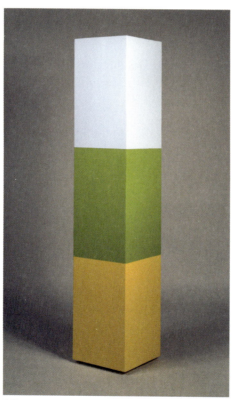

*A Wall for Apricots*, 1968. Acrylic on wood, 72⅝ × 14 × 14 in. (184.5 × 35.6 × 35.6 cm).

AT: No, I changed the color. That was a structure that I made in 1963, and I changed the color. The original color was different; that was called *Finian*, and I wasn't satisfied with the color. Also, I had very little money to make a new structure, but I wanted to make another color form. You see, every piece that I make is a *sample* when you get right down to it. For any specific sculpture I could use different colors. I would like, if I had an infinite amount of money and time, to make thirty like that. Then I would be able to play, just as you play with spray in a water fountain, say, with various colors that would inform that structure.

HF: Are there certain colors that are absolutely inappropriate for certain structures?

AT: Well. I wouldn't be able to tell. I've never been able to do that. It might be that I could make them in all the various ranges of colors and saturations. But I really don't know. All I know is that certain colors come in with certain forms, so to speak.

HF: If you had taken the same batch of paint that you used on *Finian* or *Summer Sentinel* or another piece and used it on another structure, would that have changed the title of the work?

AT: Yes, it would.

HF: What do these titles represent to you? Why do you choose so deliberately what the titles are?

AT: When you get into the area of titles, you're moving into an area of great privacy and great intimacy, and I always notice that when titles come up I feel uncomfortable because it's too close to my bone. And I really would prefer not to talk about it, except to say that they are very, very, very important to me. They refer back to, usually, a whole complex experience. And they often have three or four different meanings — private meanings, which if analyzed would be like picking the wings off a dragonfly. I just plain don't want to do it. I just don't want to put my conscious mind

into fiddling around in that. I don't mean to stress the privacy too much. Poetic, it's something poetic, more in that vein, you see.

HF: If the pieces evoke feelings and moods — and they do — why bother to title them? Why not just reserve the title for your own use instead of "publishing" them?

AT: Titling them exorcises them for me.

HF: The spectator mustn't be privy to such information?

AT: The only thing that concerns me with the spectator is the point I was just mentioning, the fact that he doesn't see what I see. That worried me for a long time. And then I came to terms with the fact.

HF: I don't mean you can impute too terribly much to titles; that would be like playing bingo. The pieces certainly speak for themselves. Franz Kline chose his titles very arbitrarily. He named things after completing them. He sometimes invented titles with groups of friends. They would sit down and say, "What's a good title?" For example, *New Year's Wall Night* [1960]. Well, I read one analysis that said what the title stands for is rebirth and rejuvenation, and yet there's a wall preventing —

AT: Oh dear, oh dear.

HF: And, of course, the only reason that he named it that was because he was working on it around New Year's and it happened to be a wall-sized piece. It *was* a wall.

AT: But for him . . . I mean, I might have called something *New Year's Wall Night* too. God only knows what it meant.

HF: But for you, calling a piece *New Year's Wall Night* would mean something very specific, or . . .

AT: *Very.* I would know what it was, but I would have put it into as clear terms as I could in making a sculpture. [*pause*] The quality of art is a mysterious thing. I can feel it, and it's as unmistakable as anything, much more unmistakable than this chair.

I respect other people wherever they are, and I respect all of them. I really respect the work of all artists who are serious, no matter what it is they do. If it looks sensational or if it looks as if it's merely appealing to the senses, I still respect it. I honor their attempt to make what is real to them real for me, just as I try to do. I honor their intent. Not so much in the sense of praising their work as in the sense of honoring or respecting it. And I would only articulate on its quality if asked. If asked, then I speak. But otherwise I keep quiet.

HF: Is there any particular object or artist that you would like me to ask you to comment on?

AT: No.

HF: Is there any artist that you particularly admire, who perhaps inspired you or influenced you, or who you just think is a very fine artist? Any contemporaries?

AT: Well, Barnett Newman is dead, isn't he. Morris Louis. Kenneth Noland. David Smith. Helen Frankenthaler — I think her painting is very good. It's the color understructure. And the beauty, the nakedness of the gesture. Beautiful. Beautiful. Fragile. Beautiful. Clear. She has authority, she has the authority of courage. That's really very rare. It's extremely rare. That's what I find too in Anthony Caro. Just a few people.

HF: You mentioned Kenneth Noland. You worked in the same studio with him, didn't you?

AT: Kenneth Noland and I have been friends since 1948. We met when we were both students at the Institute of Contemporary Art here in Washington. And in 1962, when he moved to New York, I knew that he

wouldn't be using his studio, so I asked him about renting it, and I just took over paying the rent. Well, it was a very ramshackle studio. There were rats, and no water and no heat. I used to stamp my feet when I went in so the rats would be warned. I got sort of fond of the rats though, in a sense. Pitiful, they were. But Kenneth Noland and I never actually worked there together. I just shared it with him in the sense that I paid the rent and he used it for storage. And then after Morris Louis's death, Ken brought over all of Morris's paints and they were stored there. When I went to Japan in 1964, we had to move all our stuff and store it elsewhere, as the landlord decided to tear the building down. That space is now a parking lot.

HF: Do you feel a kinship with the so-called Washington Color School?

AT: In a sense, that was an invention. Again, it's post hoc. It really was a phrase invented by Gerald Nordland. It first came up when I was in Japan. In the formative years of the Washington Color School, as it's called — I *think* Nordland was the first to use the phrase — I was here. But I never saw any of the artists except Kenneth Noland, and Morris Louis I didn't meet until 1960.

HF: Are you satisfied that critics have seen and understood your work properly? Or is that again one of those things that doesn't matter to you?

AT: I wouldn't say it doesn't matter to me. I think everybody wants to be understood. I mean, I would be lying if I said it doesn't matter. It does matter. It's very, very nice to be understood, to feel that somebody has grasped what you're trying to do and is *simpatico* with it, fits in with it. You put your works out in the world as presents. And the world is a terrible place, full of pain. And if it hadn't been for other artists . . . I don't reckon I would have survived. They keep you company; I put my work out to keep other people company.

HF: Is it simply a balm for the harder times?

AT: It's not a balm. It's bread! Bread is a necessity. I think it's more substantive. [*pause*] Well, I'm a Platonist, I guess you'd have to start there. So being a Platonist, that's where I am. And I'll live on that level, and I make from it. And I think most people do live on that level, with varying degrees of consciousness.

As for the critics, the adverse criticism I think all artists have to come to terms with. And everybody comes to terms with it in different ways. I think to say that it doesn't hurt would be untrue. It does hurt. It always hurts to not be understood. Occasionally it hurts quite a lot, but most of the times it hurts a little. And sometimes it just doesn't hurt at all. I don't think you actually get used to it. In the beginning when I first started exhibiting I thought, well, in a few years I'll get used to having my feet off the grass, so to speak; I don't think I actually did. To deny it would just be untrue. As for being influenced by it, I would say I was influenced almost not at all. Virtually not at all. However, in every single exhibit I have ever had there has always been at least one person who spoke to me or wrote about what the work meant to them — and that has been crucial.

HF: Donald Judd, in a review of your 1963 show at Emmerich, called your work "thoughtless."

AT: I don't think I saw the review.

HF: He says, "The work looks serious without being so. The partitioning of the color on the boxes is merely that, and the arrangement of the boxes is as thoughtless as the tombstones which they resemble."[2]

AT: Yes. I remember. That's the famous Judd review. I don't mind what he says. That review has always interested me, because very shortly thereafter he began to make work rather similar. It's rather mystifying. That's the reason why, you see, when Clement Greenberg says that I was

---

2. Donald Judd, "New York Exhibitions: In the Galleries," *Arts Magazine*, April 1963, 61.

a "forerunner," I have never really understood myself whether I was a "forerunner" or — well, I really don't know what to think. It's not my part to even think of that. Again, it's a matter of running with the hare and hunting with the hounds. It's the critic's business to take care of all that. I don't really know about that. But I do know that that review has always interested me because I think it's odd.

HF: Have you met Donald Judd, or spoken to him?

AT: I met him once at a party, in 1968, and we just said hello to each other and then veered off. Not exactly a meeting of the minds. I don't think we'd be too compatible — although we might be; he's a *very* intelligent man.

HF: And an interesting theorist. Lawrence Campbell said of your Emmerich show in 1965 that "one may perhaps be reminded of progressive playground equipment, or, distantly, of the sculptures of Don Judd."[3] I think the comparison is —

AT: Wrong.

HF: What separates his work from yours?

AT: I think his work *is* what you call minimalist. He really is interested in series, and he is interested in the module. No, his work is very different. I think he really is interested in, as I say, the concept and the concept alone. He's interested in the object showing forth the concept. We just said that mine did too, so we're caught up in that sort of linguistic or semantic bog. Let's say his concepts are different, and he's not as I am — his things don't come through in two stages. I think the fact that there are two stages is crucial for my work, in that the form precedes the actual realization of the piece. For Judd, the form is the piece. He stops there, and my major concern begins afterwards. So I'm in another area. I think my mind is

---

3. Lawrence Campbell, "Reviews and Previews," *ARTnews*, April 1965, 14.

just different from his mind, and I have to use my mind to understand his mind. Usually, with art of any quality, whether I use my mind or not, my consciousness just rises when I look at it. I *recognize* it.

HF: Jeremy Gilbert-Rolfe said of your work, and in a way that is probably pejorative, that it was overly consistent, static.[4] And I'd like to know, do you believe this? Or, stated another way, do you feel compelled to disbelieve it?

AT: That's very well stated. I don't really feel compelled to do anything about it at all, because again, that's his business. I think it's interesting to think about the element of time, because if you take a plant growing, and you make a timelapse film of it, you can see that the plant is very busy growing, but you don't usually see the growth. But if you simply switch to the microscopic examination, you can see it is teeming with life. I think a lot of that has to do with focus. I think that's one of the elements of art. It's a question of where you focus your sensitivity vis-à-vis the work. So it can either look static and rigid, or it can look full of growth. It is a matter of focus.

And then, I think too that when critics look at work they obviously look out of themselves. Some people have a taste for rapid change, and some people have a taste for a more slow change. I can see how that criticism of my work could be made logically by people who feel that work should change and move very quickly, as indeed many artists do change in this era. This is a very rapidly changing era. It may be that my own sensitivity is a slower-changing sensitivity, and out of key with the speed of these times. Of course, though, I'm not dead!

Most people do not see my work. I'm very much underground, and very content to be there. I like it underground. I prefer it. Certain things grow better in the dark. You see, there's no more I can gain from what they refer to as fame. There's nothing that can be given to me. Fame can't

---

4. Jeremy Gilbert-Rolfe, "Anne Truitt, The Whitney Museum," *Artforum*, March 1974, 70–71.

add anything to me. I don't seek it or want it . . . though I could have more financial security.

HF: Would it disturb you to become more noted than you are?

AT: Yes, it would *disturb* me. Because it would disturb me literally. It would take up my time. On the other hand, it would serve me because I would then have more money to put into my work and bring up my children on. So it would serve me. It would enable me to make more sculpture, more work, and to bring up my children with a greater ease of mind.

HF: I would like to ask this last question about the white-on-white paintings. Color is so important to you; you described it as the essence of the actual form. When and why did you begin to work with white-on-white? First, do you use different shades of white, or is it all through the brush stroke?

AT: The brush stroke. I use titanium white. I use a Chinese brush that someone brought me from China — a beautiful brush! And it's only the brush stroke. Why I did it, it just seemed an interesting thing to do. I felt it. I've been making a lot more, too.

HF: Did you feel when you started it that it was a departure from the kind of thing you had been doing? Or a continuation, perhaps an amplification?

AT: I never depart from myself. What I do is just like a river flowing out. It just flows into another pool. But the main stream is always the same, which is just me, my own sensitivity. Just as if you were to put out your hand — it's you putting out your hand. So it's just flowing in another way. I can't say exactly why. I didn't have any intellectual reason. The white paintings started from a series of white drawings I did in Arizona in 1973. On the plane going out to Tucson I just all of a sudden began to think why don't I just do that, just as though you might think, well, I'll have an apple. I mean as plainly as that.

I'd just done a large amount of work in color, and perhaps — I think there was an element of wanting to pare it down further, to make

it a little clearer, a little further down to the bone. I wanted to get down to the place where the thing is coming into existence. And I can move it down further — I can move down further *with* it if I eliminate color. Then I'm down to the structure. And the structure stands forth more plainly to me. So that, I think — well, it was a complex set of things. I don't mean to be simplistic about it. I think probably my major impulse was to move into an area in which the structure was set free a little bit more. You see, color is very beguiling. Color is a decorative element. Because of the nature of our culture it tends to be looked upon as decorative, so it tends to throw people. The color diverts attention, and the color also elicits an emotional response.

I wanted to, as much as I could, *eliminate* the emotional response, so I could peel another layer off my eyes, and peel another layer from what I was doing, to see down, to see up, to see what would be in back of the thing. To see for myself.

## Artist Talk, The Madeira School, 1975

When I sat down at my desk last week to address what I would be saying to you today, my eye fell on my calendar. To accompany the week of September 28, the Metropolitan Museum of Art calendar presents a painting by Eastman Johnson depicting the Hatch Family, Park Avenue, New York.

We are looking into a drawing room, richly hung with dark crimson curtains, carpeted with a sumptuous oriental rug. On the left, a handsome elderly couple, obviously the grandparents, are peacefully ensconced, the lady knitting, the gentleman tilting his newspaper to catch the light falling through a window behind him. A respectable, vigorous father sits at a desk on the right, leaning back to overlook his family who spread around him — nine children ranging in age from around seventeen to a baby in arms. His wife leans pensively on the mantel. The atmosphere is one of security and opulence, a repletion of well-founded human reproduction. The concept of The Family is here an apotheosis. It is essentially a picture of sexual richness and personal achievement. Whatever yearnings these people may have are subsumed by their roles in society. Men are satisfied to work at desks and to read newspapers, women to knit and to bear babies. The mother is literally guarding the hearth.

Essentially, shorn of accoutrements, this richly ornamented family is operating just as the family operated when human beings lived in caves. Their biological roles interlock to serve society, and their own biological fulfillment extrapolates into a matching social achievement — male in

---

*Presented at a panel discussion on the topic "Women in the Arts," part of a daylong symposium titled "A Celebration of International Women's Year" at the Madeira School, McLean, Virginia, on October 10, 1975. Truitt taught art at Madeira, an all-girl boarding school, from 1967 to 1972. Undated, untitled typewritten notes with handwritten annotations, box 49, folder 10, Anne Truitt Papers, Special Collections Department, Bryn Mawr College Library.*

Eastman Johnson, *The Hatch Family*, 1870–71. Oil on canvas, 48 × 73⅜ in. (121.9 × 186.4 cm).

the world, female in the home, which acts to form the warp and woof of a stable social structure.

In 1976, the context of the Hatch situation is virtually reversed. An intelligent contribution to the contemporary social structure now requires that a consideration of the limitations of biological function coincide with the increasing limitations of resources available on this planet. This change has undercut the traditional role of women so drastically and so quickly that we are really involved in a revolution. Men can continue to function more or less as they have always done, i.e., primarily to run the world's affairs, but women find themselves called into question. They are quite literally denied the hearth if they wish to contribute to a society that no longer needs, and indeed can no longer sustain, large numbers of new human beings.

Let's spend a minute with Mrs. Hatch. She has one pair of twins, but even counting them as one pregnancy and birth — if we space births two years apart, giving her fifteen unpregnant months between babies, and marry her at twenty-two — she reproduces at twenty-four, twenty-six, twenty-eight, thirty, thirty-two, thirty-four, thirty-six, and thirty-eight. With these activities, plus the demands of an opulent household containing a set of grandparents, heaven knows what other members of the family, and probably many servants, plus social activities, parties, etc., we may safely assume her to be tired, if not fulfilled.

I have gone into this background because the Hatch Family Syndrome, if I may call it such, operates, I think, as a kind of mythical ideal that is now doing women a disservice. It hangs as a theatrical backdrop, hallowed by tradition, and when we move realistically and intelligently in terms of today's demands and ecological constrictions, we find ourselves, willy-nilly, in a position of revolt against this tradition that tends to make us alternately sad — we are no longer cherished wives and exalted mothers, protected by social sanctification — and angry — we wonder that we never before saw that we were allowing ourselves to be used as vessels to produce members of a society that we had very little part in actually forming. Closely considered, to be so passive is to be very stupid indeed.

I do believe that neither nostalgia nor anger will serve us well at this juncture. We will do better, I think, if we let the Hatch family fade into

fairytale irrelevance, and address ourselves to the excitement of finding out who we are.

For those of us in the arts, this confrontation with self-exploration, and preoccupation with it in distinction from the more politically oriented objects of this revolution, is perhaps more clear-cut than it is in other professions. An artist in her studio is isolated with herself no more and no less than a man in his studio. Gender is irrelevant. The terms of the struggle are the same for both men and women, equally demanding and equally complex. Art is made within its own context, and stands or falls in accordance with standards of quality that are categorical within that context. For this reason, I have always refused to allow my work to be shown in exhibits limited to the art of women. One might just as well set up exhibits of work done by people born in 1920 or living on the banks of the Mississippi.

It is current coin in the art world that the art of women is, ipso facto, different in content from that of men. This theory reminds me of Freud's obsession with the interpretation of sexual symbols in dreams, an obsession that falls into the ridiculous if embraced too dogmatically, since every object is either longer in one axis than the other, or round. This is not to say that women may not deliberately choose to explore that part of human experience which belongs biologically or culturally to women, and to make this exploration the content of their art. Judy Chicago, an artist who has chosen to do so, has just published a book on her experience as a woman artist deeply involved in the political struggle to gain recognition, and I recommend that you read it if you wish to know how painful this struggle sometimes is.[1]

My own experience has been very different, partly because of my temperament, partly because of my privileged circumstances, and partly because of my historical context. I was in my fifties when "women's lib" swept the country, and already pretty well liberated.

The only specific problems that have faced me due to being a woman who is also an artist have been practical ones, and those I have solved,

---

1. Judy Chicago, *Through the Flower* (New York: Doubleday, 1975).

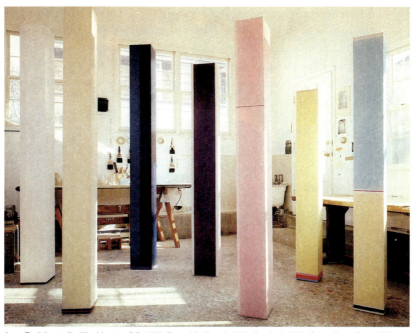

Anne Truitt's studio, Washington, DC, 1979. From left: *Portal*, 1978; *Sentinel*, 1978; *Come Unto These Yellow Sands*, 1979; *Pilgrim*, 1979; *Nicea*, 1977; *Sand Child*, 1979; *Amica*, 1979.

without thinking much about it one way or another, in the most sensible ways I could devise. Essentially, it is a matter of priorities. I have to juggle the demands of my household, and occasionally physical limitations, with the demands of my work. An analogy might well be that of a male artist who had to support his family while pursuing his art. It has never seemed to me that I was put upon specifically because I was a woman. No individual pursuit is ever easy. There are always problems of time and energy, and my own solution is simplicity itself: without, I hope, being priggish about it, I just get up early and work hard.

Occasionally, I find that I run up against what appears to be prejudice. The basic structures of my sculptures have to be made by a cabinetmaker in accordance with my scale drawings, as their facture involves complicated factory techniques. At one point I thought that I would bypass the contractor who had been working with me in this process. I went to see various cabinetmakers and found that their bids on the work were higher than those given by the contractor, even though his included his own work. Obviously, the cabinetmakers were charging me more than they were charging him. This gave me a start, but I didn't waste time on being surprised or angry, and simply reverted to my original system as more practical and intelligent.

Not being by nature either polemical or politically minded, I have always made decisions that would enable me to make my work in the most expeditious way possible. When I lived in Japan, I found it was sometimes embarrassing to be doing something women weren't supposed to do at all in that society. I felt horsey and pushy, but I just had to accept the fact of feeling ashamed and move ahead. In short, my attitude toward whatever prejudice I have met has been pragmatic.

As for the problem of recognition, I do not believe that reaction to my work has been premised on my gender. In any sophisticated appraisal of art, quality, and quality alone, determines judgment.

So I have worked out for myself a reasonably feasible life in which I can combine some of Mrs. Hatch's pleasures and achievements with a more individual endeavor. This is an attempt that has little to do with my gender. For me, I simply try to live with all *human* freedoms and accept responsibility as best I can for all my *human* potentialities.

## Artist Statement, 1976

When I was in the seventh grade, I wrote a report on how perfume was made in France. Fields and fields of flowers — and there were pictures, in vivid, improbable colors, of wagons heaped with mountains of blossoms — were, by a lengthy and precisely demanding process, distilled into single drops of fluid which smelled of them all, in a proportion at once true to themselves and to a human concept of beauty. So it seems to me that art is made. The artist's life distills into an objectivity which can, given certain circumstances, reveal the just proportion of an individual life to human life in general, and may point beyond to a universality with which human life is itself in just proportion. Heaps of experiences, in themselves specific, detailed, and vivid, yield their unity in forms that, if the artist is granted grace, can reveal the essence of an individual life. Each work holds that essence, and the whole work of a lifetime traces the single distillations that mark its progress in time.

A person stands on the earth, subject to the events of being human. These events demand to be understood and, occasionally, to be withstood. My sculptures withstand, to hold within themselves parts of my experience for my own learning. Thus fixed for my contemplation, my experience is in the service of my understanding as it develops in time. My work clears the way behind me, so to speak, so I can advance in the light of its being, and this is a being which, despite my best efforts, evades my comprehension. In my work, I move from the unknown to the unknown, but with the sustenance of its company, its intimate nature strengthening my intent to hold to that most intimate nerve of myself, out of which the work has arisen, mysteriously.

*Published in the catalogue* Anne Truitt: Sculpture and Paintings *(Charlottesville: Bayly Art Museum, University of Virginia, 1976), 5–6.*

In the early 1960s, the urgency of my passion to hold my life in stillnesses was so intense that the work stood fast, stubbornly repelling the rush of time. As time took me further, I loosened enough to flow with time itself, and found its implications appearing in the work. I found a fascination with the ever-receding subtleties of color and the lightness of brushstrokes which themselves objectify the time it took to make them. In *Spring Snow* [1974], for example, the icy green falls from the top of the sculpture through the tender air of early spring onto the warming earth below, which flattens itself to receive it. In my paintings, I mark the encounters — the meetings, the partings, the cataclysms, the tender touches — which are the essential points of our lives. It does not, in my experience, take much to mark these points. A glance will do, a scarcely perceptible turning of the body toward or against. Apprehension of a real event, crucial in its effects, can be as light as the echo of a single flower caught in a scent that holds it replete in a new context.

The context of art is, for me, the context of human life itself. I catch its fleeting points as best I can. I fail, and expect to continue to fail. In hot pursuit, I can, paradoxically, only watch from my own still center, learning from what I make.

## Artist Talk, Yale University, 1976

I would like to begin by addressing myself to the matter of placement. These sculptures, as you see, are facing east-west-north-south on coordinates of latitude and longitude all their own. So are you, and so am I. We each occupy a unique place, categorically our own. From this position we look out, so to speak, at the world. Although obviously painted wooden structures, these sculptures also stand in a space belonging entirely to each, and to each alone. In the slide you are seeing they are placed in the Whitney Museum. Now they are scattered around the country, but each continues to command its own space, and will do so for the length of its existence — as we will.

In 1961, when I began making sculptures like these, which asserted their presence in such a way that they addressed themselves to human beings as preempting space in the same way in which human beings do themselves, I was challenged as having disrupted sculptural tradition. Visitors to the André Emmerich Gallery exhibitions in New York in 1963 and in 1965 would come in and, after looking around, would ask, "But where are the sculptures? What are all these bases for?"

---

*Presented as part of the Yale School of Art's guest artist lecture series on January 23, 1976. Untitled, undated typewritten lecture notes with handwritten annotations, box 8, folder 27, Anne Truitt Papers, Special Collections Department, Bryn Mawr College Library.*
    *When invited by the Office of the Dean to participate as a guest artist, Truitt was advised that graduate and faculty women at the School had expressed interest in having more women included in the lecture series, and was asked whether she wished to be presented "strictly as an artist" or if she "would be interested in addressing the particular subject of women in relation to the arts." Truitt wrote in response: "Since I am an artist who is also a woman who is weaving making work into the process of bringing up three children, I find that questions in this area always come up, and I am always happy to address them, as they interest me myself. But I would prefer to come 'strictly as an artist.'" Despite this, on the day of the lecture Truitt was introduced as a "woman artist," leading her to subsequently write to the dean and refuse the honorarium for her visit.*

All images this page: Installation views of "Anne Truitt: Sculpture and Drawings, 1961–1973," Whitney Museum of American Art, New York, 1973.

From left: *Summer Child*, 1973; *Morning Child*, 1973; *Hardcastle*, 1962; *Gloucester*, 1963; *Carson*, 1963.

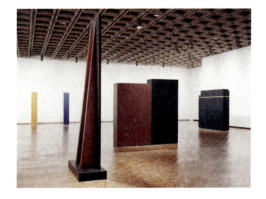

From left: *Three*, 1962; *Mary's Light*, 1962; *Odeskalki*, 1963; *One*, 1962; *White: Five*, 1962.

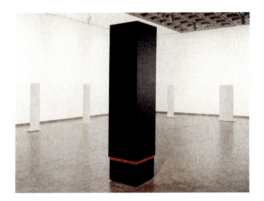

From left: *A Wall for Apricots*, 1968; *Carson*, 1963.

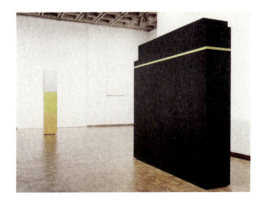

Most of them left in a state of high dudgeon, angry. Even in 1974, at the Corcoran Gallery exhibit in Washington, someone was so upset by this controversy of what he thought art should be that he pushed one piece over on the floor.

Yet the essence of the work lies partly in this assertion of a right to exist in the same way we exist, rising from the earth as we do. Historically speaking, this assertion was in no way so startling as it apparently seemed to some people. Barnett Newman, Morris Louis, Kenneth Noland and others had claimed the same spatial relationship between the human body and their paintings, which were so wide, so preemptory in their breadth and height, as to challenge the observer's own space. It was within this context that it became possible for me to move conceptual space off the wall and out onto the floor where it could stand upright, side by side with the viewer instead of hanging in confrontation.

This sculpture is called *Goldsborough*. I made it in 1974. It stands about eight feet tall by fifty-nine inches by eight inches. This work connotes for me a geographic location as well as commanding its own place, as it embodies for me a whole ambience of my childhood on the Eastern Shore of Maryland.

Place is affected by time, and this sculpture, *Morning Child*, six by one by one feet, made in 1973, included this coordinate, i.e., the light and feeling of morning. And of a child's morning, a whole energy level.

The morning of my life was spent on the Eastern Shore of Maryland, and in 1961 I decided to home in on what were for me the realities of this experience, out of which all the rest of my life has developed. This is the first work of this period, called *First*. I ordered the wood cut to my full-scale drawing on shelf paper, glued the boards together myself, and then painted it with house paint.

The new work was at first more or less literal. This piece, about four and a half feet high by three feet wide and eight inches deep, quite obviously refers to a "fence."

I almost immediately began to extrapolate from my initial concept. This piece, from early in 1962, *Green: Five*, stands five feet high by fifteen inches wide by seven inches deep, moving toward a human scale in itself.

Color is still rather literal. The dark green of fences.

Right: *Goldsborough*, 1974. Acrylic on wood, 101½ × 39 × 8 in. (257.8 × 99.1 × 20.3 cm). Far right: *Morning Child*, 1973. Acrylic on wood, 72½ × 12 × 12 in. (184.2 × 30.5 × 30.5 cm).

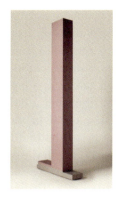 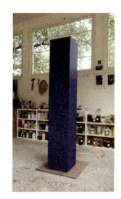

*First*, 1961. Acrylic on wood, 44¼ × 17¾ × 7 in. (112.4 × 45.1 × 17.8 cm).

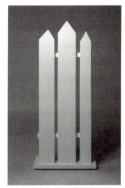 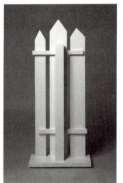

*Green: Five*, 1962. Acrylic on wood, 59⅞ × 15 × 7 in. (152.1 × 38.1 × 17.8 cm).

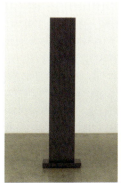 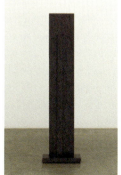

In this piece, I began to understand that color was beginning to operate in a mysterious relationship to form that made a metaphorical meaning clear to me. I made this for a friend of mine, a Marine in the Second World War whose identical twin brother was killed at Iwo Jima. Entitled *Two*, this stands almost four feet tall, is forty inches wide and seven inches deep.

*Mary's Light*, about four and a half feet tall by fifteen inches by seven inches, was the first sculpture in which I moved into this new area. Here, the color, off-center by an almost infinitesimal amount, works independently but in collaboration with the actual structure.

Now the work began to grow, not only in height — this piece, *Hardcastle*, still early in 1962, stands over nine feet tall by forty-two inches wide by sixteen inches deep — but also to display more formal variation.

*Lea*, the Old English word for "meadow," stands almost six feet by thirteen by eight inches.

It is one of the earliest sculptures in which I used the columnar form essentially as an armature for color. That is, the structural form supports the planes of color in the same way that a metal form is used technically in sculpture to support volumes of clay or plaster.

It was about this time that I became conscious of the fact that what I was doing was making three-dimensional paintings. To say it another way, I was carrying forward the familiar historical context of two-dimensional paintings into the three dimensions of physical volume and wedding the two together.

I was surprised to find that this was true.

Here, in my own life, was a clear affirmation of the old truth that art teaches the artist. As I moved ahead from piece to piece, with trust and confidence in the work, the work instructed me in what I was doing. It is for this reason, among others, that the artist must work for many years with faith in himself, so that he produces out of a hard-won range of experience a body of work individual enough to reveal to him who he is. He earns this knowledge with his patience, his perseverance, and his courage in venturing to step boldly from insight to insight. This is the real excitement of being an artist.

I notice in myself an inner "radar" that continually scans my experience for those facets of it that are useful to my work. Maybe this is

*Two*, 1962. Acrylic on wood, 47⅜ × 40 × 6⅞ in. (120.3 × 101.6 × 17.5 cm).

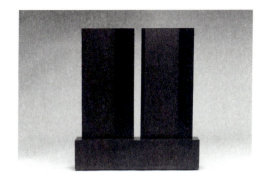

Right: *Mary's Light*, 1962. Acrylic on wood, 53½ × 15 × 7 in. (135.9 × 38.1 × 17.8 cm). Far right: *Lea*, 1962. Acrylic on wood, 63¾ × 12⅞ × 7⅞ in. (161.9 × 32.7 × 20 cm).

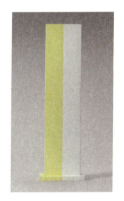 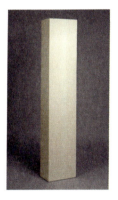

*Catawba*, 1962. Acrylic on wood, 42½ × 60 × 11 in. (106.6 × 152.4 × 27.9 cm).

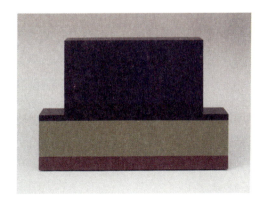

173  ARTIST TALK, YALE UNIVERSITY, 1976

why artists often appear odd. They're always picking up signals. This is *Watauga*.

And this is *Catawba*.

Those two pieces have names that sound alike because they originated in the Indian language used around Asheville, North Carolina, where I spent some time when I was growing up. Both were included in the 1963 exhibit at the André Emmerich Gallery in New York. In the previous year Mr. Emmerich came to my studio in Washington for the first time. There, after only a short while, to my amazement, he offered me my first formal exhibition.

By this time in my life my three children were eight, five, and two in age, and demanding their full share of my time. The work I did in the studio had to be fitted into the usual schedule of car pools, cooperative nursery school teaching, household chores, plus the obligations of the wife of a very active journalist.

Under the duress of these demands I learned, of necessity, to take full advantage of every single fifteen minutes in the day. Trying not to rush, but never stopping, I simply went ahead as best I could. Had I not, over the previous thirteen years, forced myself to daily concentration in the studio just as a matter of habit, I don't think I would have been able to sustain a clear line of progress in the midst of these multiple mundane obligations.

These two pieces, *Shrove*, sixty inches tall, and *Primrose*, fifty-one inches tall, both ten by ten inches, are parts of a series of three sculptures made late in 1962, in which I used a modular structure of superimposed blocks sharply counterpointed by color.

Early in 1963, the structures began to divide into proportions. These three are shown in an installation shot at the Corcoran Gallery of Art in Washington in 1974. They are all about seven feet by eighteen inches by eighteen inches.

The 1963 work continued to proliferate, ringing changes as the year went on.

Here you see *Sandcastle, Carson,* and *Dawn City*, another 1963 piece, on the right, in an installation shot taken at the Corcoran Gallery of Art in 1974.

Installation view of "Anne Truitt: Sculpture and Drawings," Corcoran Gallery of Art, Washington, DC, 1974. From left: *Summer Sentinel*, *Bonne*, and *Odeskalki*, all 1963.

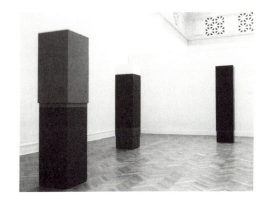

Right: *Shrove*, 1962. Acrylic on wood, 60½ × 10 × 10 in. (153.7 × 25.4 × 25.4 cm). Far right: *Gloucester*, 1963. Acrylic on wood, 74 × 71¾ × 13 in. (188 × 182.3 × 33 cm).

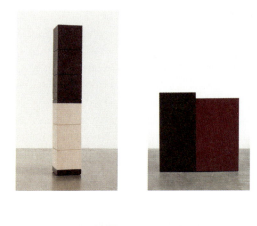

Right: *Bloomsday*, 1963. Acrylic on wood, 68¾ × 60 × 18 in. (174.6 × 152.4 × 45.7 cm). Far right: *Dawn City*, 1963. Acrylic on wood, 74⅝ × 42 × 10 in. (189.5 × 106.7 × 25.4 cm).

 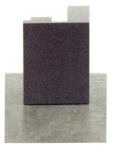

175  ARTIST TALK, YALE UNIVERSITY, 1976

In March of 1964 I moved with my family to Tokyo, where I lived for three years.

There I discovered my own personal dependence on placement. Thrust by circumstances into a totally alien environment, in which I myself was not only to my usual degree abstracted from my surroundings but also literally alien, I lost touch with myself. Deprived of my own inner certainty, I was forced to use my head to make my work. That is, I no longer enjoyed the effortless flow of intuitive insights which had sustained me from 1961 to 1964. Almost immediately, the spirit of the art faltered and dropped. There were all sorts of factors, both personal and objective, which contributed to this failure. One was my use of aluminum for structure, in order to reduce shipping costs. Paint will not "marry" well with metal. It lies on the top of it, will not meld into it to create a new "being," so to speak. The structure remained inert to my feeling, indeed seemed to resist it. Another factor was the light in Japan, which was very different from that to which I was accustomed. Not only did I myself have difficulty in seeing color in Japan, but also, when I shipped the work to New York, I saw — to my horror — that in the American light the color was off my sensitivity. Also, in desperation, I varied the elements of structure in ways that deviated from that sensitivity. I fell into what was at that time a pitfall for me — a neo-constructivist way of thinking. Some years later, when preparing for a retrospective exhibit at the Corcoran Gallery of Art, I decided to destroy all the works made during my three-year stay in Japan.

In July 1967 I returned home.

With *Morning Choice*, 1968, six feet by fourteen by fourteen inches, I came back to myself. I returned to the rigor of the columnar structure, and to wood, and changed my modus operandi. Not only did I begin sanding every single coat of paint before adding another, using increasingly fine sandpapers, but I also began putting on many more layers of paint. These came to have the meaning of skins to me, delicate membranes of color. I slowly came to more and more complex relationships of hue, based on many superimposed coats, sometimes as many as forty, and almost always fifteen or so. In some pieces from this period, the lines of demarcation between one area of color and another are painterly. That is to say, I allowed the action of my brush to show. In this increasing

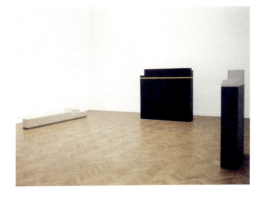

Installation view of "Anne Truitt: Sculpture and Drawings," Corcoran Gallery of Art, Washington, DC, 1974. From left: *Sandcastle*, *Carson*, and *Dawn City*, all 1963.

*Down*, 1964. Acrylic on aluminum, 19¼ × 70½ × 14 in. (49 × 179 × 36 cm).

*Morning Choice*, 1968. Acrylic on wood, 72 × 14 × 14 in. (182.9 × 35.6 × 35.6 cm).

interest in the act of painting itself, my works on paper and canvas have paralleled my sculpture.

One work began to follow another in intuitive sequence as they had before I went to Japan. *Summer Treat* stands nine by two by two feet.

I would like to say a word here about the referential quality of my work. Obviously, the content of an artist's work varies considerably from individual to individual. In my own case, the content of each work is specific to a particular area of my own experience. These share the characteristic of being highly emotionally charged for me, but I am sometimes surprised by what presents itself to me as a sculpture. The inner "radar" that scans my experience, about which I spoke earlier, seems to operate more or less independently of conscious choice. What distills into my mind as a whole work, instinct with a life of its own, preemptory and undeniable, may spring from years and years of a certain kind of experience or may equally frequently spring from an apparently incidental event — something glimpsed from a car, say, or a certain mixture of grasses in a meadow.

In any installation, such as this show of works from 1968 to 1972 at the Corcoran Gallery of Art, the artist learns what his experience has been. This is the advantage of exhibiting. The artist can "take off" from past work into future work with the ground cleared, so to speak, behind him.

In 1970 I built a studio in my backyard in Washington, and I have worked there ever since. Here I have space and light, and am able to make larger works than before.

In the interest of clarity, I have used the pronoun "I" in speaking to you and have strung my work on the thread of my life. Occasionally, I am asked where my work "comes from." I truly do not know. I watch to learn.

Thank you.

Students viewing *Summer Treat*, 1968. Acrylic on wood, 110 × 24³⁄₁₆ × 24³⁄₁₆ in. (279.4 × 61.5 × 61.5 cm). University of Arizona Museum of Art, Tucson, Arizona, 1978.

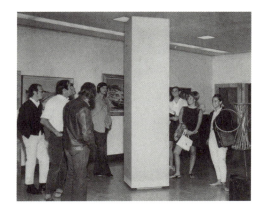

Installation view of "Anne Truitt: Sculpture and Drawings," Corcoran Gallery of Art, Washington, DC, 1974. From left: *Catawba*, *Ship-Lap*, *Lea*, and *Essex*, all 1962.

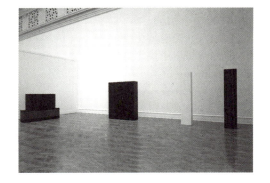

Anne Truitt's studio, Washington, DC, 1986. From left: *Twilight Fold*, 1971; *Winter Dryad*, 1973; *King's Heritage*, 1973; *Foxleigh I*, 1975; *Knot*, 1983; *Damask*, 1980; *Come Unto These Yellow Sands*, 1979. Painting in background: *Hyphasis*, 1986.

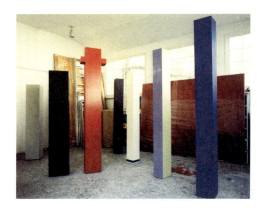

## Letter to E. A. Carmean, 1976

September 28, 1976

Dear E. A.,

It is rare for a critic to grant an artist the grace of making comments on what he has written,[1] and thank you for the opportunity. I am writing this early in the morning, and will deliver it to you on my way to the university so that you can turn it over quietly in your mind before we talk late this afternoon.

Your words have given me a mixed feeling, not at all uncommon with me, or indeed perhaps with most artists, of being, on the one hand, very well understood and, on the other, buried politely with cockle shells and a few tattered flowers to mark my place. Which is not, I feel strongly, in the so-called Washington Color School. I know you have just moved to Washington recently, and moreover haven't heretofore, if even now, paid much attention to the history here. I have been here off and on since 1947 and have watched, at first with surprise, and then consternation, the slow but inexorable growth of a myth. As it grew, it gathered unto itself ambitions that have ridden on Noland and Louis in a way that sickens me. Please do not place me in that group, by implication riding the same wave, I beg of you.

And I beg it the more passionately as I truly feel independent. I have been working in sculpture since 1948. In 1961 my work "broke through."

---

*Typewritten letter draft with handwritten annotations, box 9, folder 1, Anne Truitt Papers, Special Collections Department, Bryn Mawr College Library.*

1. Carmean, curator of twentieth-century art at the National Gallery of Art, had written a catalogue essay for Truitt's 1976 exhibition "Anne Truitt: Sculpture and Drawings" at the Bayly Art Museum, University of Virginia, Charlottesville.

I have been interested in rereading Michael Fried's analysis of Louis's breakthrough in 1954, to note that my own more modest eruption seems to me to have the same four characteristics: 1. It occurred after I was forty; 2. The work following it bore virtually no relation to the work preceding it; 3. I *found* my indentity, i.e. discovered, as if my eyes had been peeled, where I actually was in myself; and, 4. In the removal of the color situation from the wall to a freestanding structure it seems to me that "art itself" made the step, i.e. demanded the step. I myself never realized the last point until the winter of 1974–75, when I read what Pollock had said about it being time to take the painting off the wall, but not yet. Well, I agree with him, but have taken it off anyway — in a way clumsy, inept, and experimental, but doggedly. And not, let me make clear, at all "on purpose." It was not until 1963 that I realized that I had been trying to do just that, and not until 1974 that I realized any connection with Pollock. I really think that my antecedents, from a formalist point of view, are Pollock, whose literalness prepared the way for the color to stand free; Newman, whose work, in November 1961, showed me with lightning revelation the possibility of *enough* color; and Reinhardt, who, the same afternoon of 1961, put me on to the subtle variations of hue which matched one range of my own sensitivity to life in general.

This is not to deny in any way my debt to Ken Noland, in a friendship dating from 1948, nor my profound respect for his work and that of Morris Louis. But in 1961, when I began to make my work in a real sense (I destroyed all my work from 1948–61), I had seen very few Louis paintings (essentially a 1950s exhibit at the Washington Workshop Center and some *Unfurleds* stretched on the floor of Morris's living room in 1960) and very few of Ken's breakthrough circles. (This because I had been in San Francisco from 1957–60, and isolated by childbirth until the fall of 1961 when my last child was one year old.) (I have not seen Howard Mehring, Tom Downing, or Gene Davis more than a few casual times in my life, and have never seriously talked to any of them. Morris Louis I knew equally casually — if any relation of Morris's could be called casual. He was a profoundly serious man.) So I was, in a direct sense, operating within the same context as they, but independently pursuing my own ends. And these ends were sculptural. I thought and felt in three dimensions,

and it was in three dimensions that my work emerged to try to set the color free into our own space.

In discussing *Bonne* [1963], the implication (really a syntactical implication, I think) is that I adjust the sculptural shape to the color. This is not the way it goes. I conceive the sculptural form in space, as if the color itself came into being as form. I do not actually "make art," or rather when I have, consciously that is, by making formal choices, it has been to the disservice of quality. It was for this reason, because my work fell into formal "art making" during the years 1964–67, that I destroyed all of that sculpture. For this reason also, "polychromed planes" makes me nervous, as color and form feel one to me.

The *Arundel* paintings[2] are, to my eye, far more violent than anyone has noticed. The encounters are at once scarcely perceptible and cataclysmic — to my sensitivity. The center penetrated by the opposing forces of color is burst open into the same space from which the forces emerged to meet. The lines in the later paintings confront one another to defy and to acclaim the space that defines them. They do so mainly by the act of coming-into-being. True encounters are always, for me, surprises.

If it would be possible, for your sensitivity, to call the bottom member of *Albemarle* [1975] a "field" instead of a "platform," I would be happier. I feel it that way. I don't quite understand "set-back based platform" anyway.

Anne

---

2. Truitt worked on this numbered series of graphite and white acrylic paintings from 1973 to 1999. "I use only pencil and a very little white paint against a field of action I render at once active and inert by making it entirely white. In these paintings I set forth, to see for myself how they appear, what might be called the tips of my conceptual icebergs in that I put down so little of all that they refer to." Anne Truitt, *Daybook: The Journal of an Artist* (New York: Pantheon, 1982), 97–98.

# Artist Talk, George Washington University, 1977

Metaphor: Meta + Pherein (to bear): Figure of speech in which a word or phrase literally denoting one kind of object or idea is used in place of another for analogy: "A ship plows the sea."

1. To look at it as if you had never seen anything before. To look at it with childlike eyes, fresh, without preconception. Not as art, but as something come upon, somewhere. Important to walk around it, away from it, back toward it, out of the corner of an eye.

2. To try to feel its existence, its being inside itself. In what space is it existing? If it were breathing, what air would suit it best? What would it look like with the passage of time? At sunset? At sunrise? At noon?

3. To try to feel what it is saying, putting out as a feeling. What emotions in your own life does it evoke? Stern? Gay? Gentle?

4. Given all this, how is it conveyed? What is the relation of its height and depth, its dimensions, to what it is conveying? A piece shorter than one's self, for example, evokes quite different feelings from that evoked by a piece which towers over you.

---

*These are notes from a talk Truitt gave to Marcella Brenner's class at George Washington University in Washington, DC (typewritten notes with handwritten annotations, titled "Marcella Brenner's Class August 1977," Estate of Anne Truitt, South Salem, New York). Truitt became friends with Brenner and her then-husband, Morris Louis, in the early 1950s. Brenner later founded the graduate program in museum education at GWU in 1974.*

Given dimensions, how is the color acting to evoke meaning? How is the meaning conveyed by the interior relationships, the proportions of color? By their interactions in terms of hue? Saturation? Value?

Art depends for understanding on an attitude of mind in the viewer. It requires attention of a certain, particular sort — a kind of willing suspension of criticism (preconception). We are accustomed to using our eyes to identify; identification is irrelevant to the apprehension of the essence of a work of art.

A chair, for example, is usually apprehended on this level — as a chair. In another dimension of thought, it is a structural arrangement of verticals and horizontals, full of movement, stress, thrust and counter-thrust. Cf. Cézanne. People in Flatland cannot conceive of a circle, cannot see it. A work of art can, on first sight, be thought of as a Flatlander looking at a circle; it looks scary because the laws accordance to which it exists are not apparent immediately. When they are comprehended, a whole new dimension of experience is evoked.

Art cannot be understood if it is approached in the ordinary way in which we take in our experience. You don't read a fairy tale, or a poem, the same way you read a recipe for lasagna. You don't pick out a cabbage the same way you would choose a painting. There has to be a willingness to be taught by the work of art.

This requires a kind of submission. It can be frightening and make people feel angry, threatened. It can scare people that there are things that they don't understand.

The crucial point of context between a person and a work of art is intensely personal. People can be encouraged to know and believe this, and to trust their own reactions, their visceral responses. Certain kinds of art appeal to some people more than to others. This is fine and just as it should be. Looking at art is essentially a learning experience, but the content of that experience is an increase in knowledge about one's self in the last analysis.

When you hit upon an artist whom you don't understand, and feel threatened, it can be an indication that some latent part of yourself is being touched in some new — hence threatening — way.

The touchstone of art is joy. People can be encouraged to trust their own joy.

Beyond the immediate emotional response to a work of art, if the attraction is strong enough, lies work — the work of learning the how of its making. This is fascinating if it happens naturally.

For the general public, it seems to me that the most important thing is to convey to them that they can have faith in their own reactions.

## Keynote Address, University of Maryland, 1978

*One hears endlessly repeated that reproach by the powers-that-be toward the less fortunate artists who ask their favor: "There are too many artists!" Doubtless, there are too many of those without talent, on the whole too much bad work; but if the recompenses and benefits were distributed with impartiality and judgment and especially with regard to spiritual needs . . . there would not be too many artists. It is not the abundance of the artists which causes the misfortune . . . it is the too-small number of enlightened amateurs and true connoisseurs who would consecrate a part of their wealth to the encouragement of the arts and artists, rather than speculating on the needs of one who is so miserable as to have to accept the prices offered for his works.*

— Pierre-Nolasque Bergeret, *Lettres d'un artiste sur l'état des arts en France*, Paris, 1848.

This wail of complaint falls all too familiarly on the ears of those of us concerned with the state of the arts. It could have been written in 1978. It was, in fact, written by Pierre-Nolasque Bergeret in his book *Letters of an Artist on the State of the Arts in France*, published in 1848, 130 years ago. It is the voice of an artist confronted by a world that has failed to offer an institutional system within which art can be absorbed justly and intelligently. Before addressing myself to the problem about which he complains, I would like to consider the complaint itself. Specifically, the tone of the complaint.

*Presented at the Maryland-National Capital Park and Planning Commission Symposium held at the University of Maryland, College Park, on September 23, 1978. Originally published in Anne Truitt,* Threshold *(New York: Matthew Marks Gallery, 2013), 124–27.*

To my ear, it has a whine incompatible with the nobility implicit in the pursuit of the artist. This pursuit is, ipso facto, an individual pursuit, undertaken in a singular sense. Singular not only in that it is undertaken by a single person within the inner chambers of his or her being, but also singular in that it is, in the highest meaning, the acceptance of grace. The artist does not actually choose art; art chooses the artist. A person can decide to become, say, a lawyer, train diligently, work intelligently and have a reasonable hope of success. Bringing into being art of any quality remains a mystery. As Jack Tworkov, an artist whose work is undoubtedly familiar to most of you, once expressed it: "I work on a painting, I finish it, and then I stand back and look at it, and sometimes it looks all right. And that's a little touch of grace."

In this context, the artist necessarily stands in jeopardy. The central fact of this jeopardy is, of course, that no amount of hard work in the studio will guarantee that the work will be of quality. Whenever we speak of art, it seems to me that we must remember that the artist lives with this fact. Like Prometheus, the human who stole fire from the gods and was punished by being chained on a mountaintop, immobile under the attack of a vulture who ate out his liver and was able to do so each day because the liver grew whole again each night, the artist beckons the wrath of the gods when he challenges their power to create. I say that we should remember this fact of jeopardy when we speak of art and artists, but I also say that the artist has the responsibility of thinking clearly about the situation. There is nothing that gives him or her the right to be understood, to be welcomed, to be nourished, to be cherished by society. There is nothing that bestows upon the artist the right to wail about whatever results accrue to the work he or she produces. The real rewards must be recognized as belonging strictly within the four walls of the studio. They must arise out of the joy of making the work itself.

So today, as we address ourselves to the business aspects of art, to those problems that lie outside the studio and have to do with what happens to art in the world, I believe we would be wise to maintain clearly in the backs of our minds the plain fact that the artist works alone in the studio. In the last analysis, success or failure in the worldly sense are irrelevant to this entirely individual passion. No matter what the world

has to say about the work produced, the artist is always essentially alone in an ideal pursuit. This is a privilege. The price is high. But the rewards are incomparable. Rauschenberg once remarked that he was a depraved person, that he had tried all of the ways of sensuous pleasure and that art was the greatest "high" of all.

It is precisely for this reason — because the artist presents to public view his or her highest self at the apogee of its height — that the feelings of artists are so vulnerable to criticism. Behind the whine of Bergeret's complaint is a genuine wail of pain. It just plain hurts to present one's self turned inside out to the public gaze and to find it scorned. Or misunderstood. Or — and here we approach the topic of our discussion today — turned to the uses of merchants. Merchants who may themselves in turn suffer in a way not unlike the way artists suffer. A New York dealer, André Emmerich, recently remarked that he often found himself the butt of hostility. "We, the art dealers, are the moneychangers in the temple," he said. Art objects indeed are in some sense icons, objects imbued with meaning akin to spiritual value. It smacks of blasphemy to thrust them into the hurly-burly of buying and selling. Yet there has to be some way to interface the artist and the public, lest the artist fall into solipsism and the public be deprived of the aspiration art can evoke.

Our present institutions for handling this interface have historical precedents that I would like briefly to consider. At the beginning of the seventeenth century in France, the medieval guilds controlled the apprentice system by means of which artists were educated; they also controlled the quality of the materials used by artists, held the exclusive rights to sell art and even to limit the number of practicing artists allowed to do so within their areas of jurisdiction. These rights were challenged by an increasing exchange during the seventeenth century of art and artists between France and Italy, most specifically by a rapidly developing tradition that artists be trained in Rome, thus widening their horizons and placing them beyond provincial control. Gradually opposition crystallized until in 1648 dissident artists were able to obtain from the royal government the right to set up a school of drawing, to establish what came to be called the Royal Academy. As this new monopoly slowly replaced the guild system, the artist's social status was redefined. No longer an artisan who hawked his

own wares, the artist, learned and traveled, was elevated to the position of arbiter of beauty and taste. The precepts of the Royal Academy were strict, and its power grew rapidly, centered in Paris, much as the power of the contemporary art world centers in New York. Since members of the Academy were forbidden to engage in commerce, middlemen sprang up to handle the exchange of art; these middlemen were the precursors of our contemporary dealers. Art criticism, at first unsigned, began to be published during the 1740s. The conception of art as a learned profession placed it within the realm of those subjects on which intellectual men of letters could write. And so during the eighteenth century there developed in France the system which we now enjoy, if that is the word: the alliance of critics and dealers as interface between the artist and the public. (For a fascinating account of how this process occurred in France, I recommend to you a book titled *Canvases and Careers* by Harrison and Cynthia White.)

I have gone into this brief history in order to lead up to my own observation that we seem now to be in the process of breaking up the monopoly of this alliance. Artists are returning to the guild practice of selling their own works out of their studios, of forming cooperatives for selling work, of exploring alternative spaces for exhibition. We see increasing numbers of artists acting as curators. This is on the one hand a sort of groundswell heralding an increasing independence of stance on the part of artists, and on the other a phenomenon harking back to the Renaissance prince-patrons: the direct patronage of the government. Artists now have a vocabulary of letters — NEA, GSA — government agencies that concern themselves with the choice and promulgation of art in the interest of public consumption. At this moment the situation could be compared to Dr. Doolittle's Push-Me-Pull-You. If artists are not to find themselves in the awkward and unbecoming position of darting frantically from one end of this beast to the other, patting the head of the government as they nose out possibilities of patronage and rushing to stroke their peers who are seeking new directions, they have to think very clearly about how they wish to place their work. They have to articulate the values they hold dear and then to adhere to them in the face of inevitable economic and psychological pressures.

I now turn to address myself directly to the practical considerations about which I have been asked to speak to you today. In my own experience of working and exhibiting, I have found it useful to make a distinction between the studio and the world and to maintain that distinction not only in my mind but also in my actions. For example, I do not allow, as a general rule, visitors to my studio. That area remains private to me alone. I do not think of results in the studio. When a work is finished, I take my hand off it and, metaphorically speaking, move it into a separate part of my mind. There I consider it in relation to the whole complex context of my experience of exhibiting. I bring to bear what might be called ordinary intelligence in contradistinction to intuitive intelligence, the kind of intelligence one might use to pick out an apple to eat rather than the kind one would use to study an apple painted by Cézanne. In a practical sense, the knowledge an artist needs to handle his or her work in the world is folk knowledge; it is passed from one artist to another, from one generation of artists to another. There are all sorts of details — the recording of work, the photographing of it with the resultant marking and storage of slides, transportation, storage, insurance, paper transactions of various sorts. Files have to be kept. Supplies have to be bought. Letters have to be written. Logistical decisions have to be made. Essentially the artist has to be a good quartermaster. The mounting of a large exhibit is a systems analysis operation, requiring endless patience with details, a cool head for the inevitable crises, and a moral fortitude that endures until the exhibit finally stands completed as visualized by the artist.

If you know a person well, if you respect him and wish other people to become acquainted with him, you consider him in the context of your knowledge of the other people around you and make decisions based on compatibility. This, it seems to me, is a kind of guideline in approaching the introduction of your work to the public. An artist can seek this kind of recognition with dignity and circumspection, without venality, without the overanxiety that usually betrays insecurity and has, almost invariably, the effect of repelling the kind of serious attention you wish. People can smell overanxiety as animals are said to be able to smell fear; they intuitively recognize that the artist is not sure about his work and they react with rejection, concluding that if the artist is uneasy there must be something

to be uneasy about. It is best to remain in apprenticeship to yourself until you are sure of your work and can present it to the public with the unmistakable dignity of integrity. When this time arrives — or indeed if it arrives, as sometimes one is mistaken about one's own talent — the artist can look around and study the available options with a cool eye. One thing is certain, and that is that work of quality eventually makes its way on its own merits. Art of high quality attracts events unto itself.

When I used the word *consider* in speaking of the finished work, I used it in a context I would like to explain further. When an artist considers his or her work, it is not unlike considering a person. It is important to remember that the final decision in any personal transaction about his or her art belongs in the artist's hands. Let me repeat that. The final decision in any personal transaction about his or her art belongs in the artist's hands. The people who deal in art in the world may initiate a transaction and may birth it, so to speak, but the artist has the power to choose whether it is right or wrong to let a particular transaction come to completion. I think this fact is often forgotten. From artists one hears weak complaints about dealers and museum personnel as if they held this power, and the truth is that they do not. The artist is always accountable to his or her art.

Consideration for the work extends by extrapolation into a general consideration for the people who deal in art, for their problems, and even for collectors who may need a very special kind of understanding. It is not easy to be a collector if one is a sensitive person; one can recognize, and many collectors do so realize, that it is a delicate matter to buy a work of art, to *buy* a part of the artist's spirit.

What I am trying to present to you clearly is a situation in which the artist behaves appropriately. It is not as if he or she were in a line of battle — under attack by the world. There's no need for an aggressive stance. Once the work of art is completed, it automatically moves into the realm of an object and has to be handled in accordance with the ordinary procedures of worldly transactions. In some way the artist has to come to terms with intelligence to make the transactions appropriate to what he or she visualizes as good for the work, according to individual experience and values.

I should like to close by saying that in the last analysis the artist's work is underwritten by character: by character that has been formed in a lifelong process of growing self-knowledge, informed by widening experience. One of the exciting aspects of being an artist is precisely this kind of development. The artist takes risks and makes mistakes and then lives with the results, learns from them and moves on. If the artist is thoughtful and maintains a sturdy independence, if he or she makes an honest attempt continually to refine values in the light of experience, it is possible to live in the world productively without in any way compromising the integrity that underwrites all art.

## Artist Talk, Australia, 1981

In the opening chapter of Patrick White's novel *Voss*, the German protagonist, who has come to Australia to explore a way across this mysterious, then-unknown continent, remarks to Laura Trevelyan (whom he comes to love) in remonstrating against her reluctance to venture far from her residence: "A pity that you huddle . . . Your country is of great subtlety."

    I would like this afternoon to juxtapose this point of view about your immense land with a statement made in 1943 by two well-known New York painters, Mark Rothko and Adolph Gottlieb: "There is no such thing as good painting about nothing. We assert that the subject is crucial and only that subject matter is valid which is tragic and timeless."[1]

    I suggest that artists are explorers, but distinguished from ordinary explorers by the fact that they are driven to invent a world into which they then venture for a lifetime of learning. This adventure becomes for them an obsession, an obsession I believe motivated by an unusually acute feeling of alienness in an alien world. By the word "alienness" I do not mean to imply the social disjunction commonly called "alienation," but a more universal insight into "the human condition." When this insight is felt sharply — and all human beings do, I believe, feel it so from time to time — alienness is felt as a tragic state.

---

*Truitt was invited by the Australia Council for the Arts to give a series of eight lectures in Sydney, Newcastle, Canberra, and Melbourne from June 2–27, 1981. The above talk was presented on June 4 at the Sydney College of the Arts. Handwritten notes on legal paper, box 49, folder 9, Anne Truitt Papers, Special Collections Department, Bryn Mawr College Library.*

1. From a letter to the editor by Adolph Gottlieb and Mark Rothko, sent to Edward Jewel, art editor of the *New York Times*, June 7, 1943. Reprinted in Miguel López-Remiro, ed., *Mark Rothko: Writings on Art* (New Haven: Yale University Press, 2006), 35–36.

And so it follows that art of quality penetrates into this area of tragic subject matter, in itself timeless, as the essential loneliness of the human being is timeless.

Artists, like Voss, refuse to "huddle," and move forward as best they can into a "country of great subtlety" — in art the country of self.

Thus art has become for me a heuristic pursuit.

# Willa Cather Lecture, Lincoln City Library, 1985

I grew up on the Eastern Shore of Maryland, the peninsula that juts down from the mainland of our continent and is isolated by the Chesapeake Bay to the west and by the Atlantic Ocean to the east. I have not yet seen Red Cloud, but Easton, the small town in which I lived the first thirteen years of my life, looks much like pictures of it: board houses and fences. The sky and the earth meet there, as they do on the prairie, as equals: land stretching free to a straight horizon. In my native country, water inflects the land, but at a distance they are virtually indiscernible from one another.

Like Red Cloud, Easton was connected to the world only by railroad tracks that ran from the mainland down the peninsula. When I was a child, I used to be waked up by the sound of a train whistle in the night. A sound as vocal as breath: a long note that began as a pant, built to a wail and then, very slowly and seductively, tailed off into silent air. I used to turn over in my warm covers, safe under my family roof in a place of my own, enlivened by my images of the distances from which the train came and into which it went.

This experience instantly connected me to Willa Cather when my father one day spoke to me of a book called *A Lost Lady*, about a lovely lady, he said, who lived in the center of the American continent and had a husband who ran railroads. He himself had been born in St. Louis and had lived in the far west as a young man. He described it to me, particularly the lines of railroad track running in empty, earth-colored space. I saw these cutting across the American continent, and because I loved the hum of the telephone wires strung up on poles around Easton, just as I

---

*Presented in the Jane Pope Geske Heritage Room of Nebraska Authors at the Bennett Martin Public Library, Lincoln, Nebraska, on October 9, 1985. Typed transcript, box 55, folder 7, Anne Truitt Papers, Special Collections Department, Bryn Mawr College Library.*

loved the sound of the train whistle, I connected them together on a map of America I made up for myself: stretches of land as alive as water, but stilled, crossed by lines along which human beings moved and spoke to one another — human beings as important to themselves as I was important to myself, but incidental, even irrelevant, to the immense scale around them.

This complex image was the first in which as a child I placed myself as an American, inheritor of this continent, and I owe it to Willa Cather. So when I was invited to come here to Lincoln, and to speak of her, I was glad because it gave me a chance, even at this remove, to thank her. In essence, her powerful validation of America as an entirely satisfactory source of art tacitly underlay my confidence when, in 1961, I began to make sculpture that owed nothing to Europe and stood on its own American feet at an American scale.

I read all of Willa Cather's novels when I was growing up, have reread most of them once, and some even more than once. I noticed on my most recent rereading during the last four months that I return ever more gratefully to her work now in my maturity because she so clearly and so compassionately sees, as I do increasingly as I age, how one human life contains all human lives, setting a scale for the history of humankind rather in the way that a mark can set scale in a work of visual art. Bernice Slote remarks in her introduction to *April Twilights* that Cather's "divide," where "the grass was the country as the water is the sea" and "the red of the grass made all the great prairie the color of wine-stains" evokes Homer's "wine-dark sea." Cather's pioneers are each Odysseus. They are heroes of the myths their lives told as they lived them out in a land without history. This is, in very essence, the American heritage: we are the descendants of people whose high blood called them to isolate themselves from their traditions, who dared the unknown land, who *chose* to take the chance that they would be able to make out of their own bone marrow a context within which they would be able to live.

Not all could. Mr. Shimerda kills himself. But Mr. Rosicky does not. Mr. Shimerda is proud. Mr. Rosicky is not. The turning point in his life is finding the humility that allows him to innocently beg money from his fellow countrymen in order to replace his kind landlady's Christmas goose, which he has eaten in the desperation of hunger; it is one of these

fellow countrymen who gives him passage to America, setting his course for Nebraska. So he comes to the end of his life in the fullness of his own understanding of his own life, and has the comfort of knowing that in death "he would never have to go farther than the edge of his own hayfield." The earth is a metaphor for the endurance he has brought to bear on the creation of his own life.

The land remains. People belong to it. Ántonia, and, even more, Alexandra Bergson, who engages it on its own terms and makes a place for herself *on* it because she understands her identity *with* it.

> Alexandra drew her shawl closer about her and stood leaning against the frame of the mill, looking at the stars which glittered so keenly through the frosty autumn air. She always loved to watch them, to think of their vastness and distance, and of their ordered march. It fortified her to reflect upon the great operations of nature, and when she thought of the law that lay behind them, she felt a sense of personal security. That night she had a new consciousness of the country, felt almost a new relation to it. Even her talk with the boys had not taken away the feeling that had overwhelmed her when she drove back to the Divide that afternoon. She had never known before how much the country meant to her. The chirping of the insects down in the long grass had been like the sweetest music. She had felt as if her heart were hiding down there, somewhere, with the quail and the plover and all the little wild things that crooned or buzzed in the sun. Under the long shaggy ridges, she felt the future stirring.

*O Pioneers!* is, to my eye, a painting more than it is a novel. Willa Cather is a poet of the eye. I see *O Pioneers!* as a great canvas, somber and grand as a Courbet painting is somber and grand: earth-greens and umbers under a sky keyed to gray. On this canvas, Cather brushes color very sparingly. Marie Tovesky's "coaxing little red mouth" and her "red cashmere frock" when she is introduced as a child in the first chapter are echoed in "the red coral pendants" of her earrings when she is a young woman, and in her

red blood slowly draining out of her body to stain the white mulberries on the orchard grass when she "bled quietly to death" on her dead lover's shoulder. "The hand she held was covered with dark stains, where she had kissed it." And the dark stains return us to the key of the book: the dark brooding earth and sky that frame her body as they have framed her life.

But Willa Cather is too wise to paint always in dark colors. Marie's pink geraniums light her tidy, warm, sweet-smelling kitchen; her "delicate little rolls, stuffed with stewed apricots," her "coffee-cake with nuts and poppy seeds" are so delectably real that they seem in themselves guarantees of human survival. Mr. Rosicky declares a family picnic in a killing drought. "No crop this year, he says. That's why we're havin' a picnic. We might as well enjoy what we got." So he and his sons swim in the horse tank in the burning heat, and the family feasts. For in the long run a high heart can carry the day when everything else has failed.

Willa Cather's high heart is the core of her legacy to her fellow countrymen and, most particularly, to her fellow artists. Be where you are, she says. Trust in what you learn, in the authenticity of your own experience. Speak clearly. Bear testimony to your own faith in the gift of your own life.

## Commencement Address, Kansas City Art Institute, 1987

The sculptor David Smith once remarked to me that "artists are the only true aristocracy," and I am happy to welcome you into that honorable company. Smith was born in South Bend, Indiana, so he too rose up in strength out of the middle of this great continent of ours, and set out, as you are doing, on the adventure of his life.

Artists' lives are indeed adventures, and into territory as uncharted as that of Daniel Boone, who once was asked whether he had ever been lost in the woods, and replied, "No — but I once was bewildered for two weeks!" You also are likely to be bewildered now and again, for an artist's life is predicated on a subtle attunement to an unknown self. Original work in art is a matter of listening attentively to yourself, even if what that self is saying seems utterly outlandish. It is a fascinating way to live, because if you listen carefully and follow courageously a particular kind of inner voice that you can learn to trust more and more, you will find yourselves surprising yourselves as long as you live. I myself started out as a psychologist, worked in that field for some years, then turned to writing, and only finally to sculpture. I tell you this in order to illuminate for you the unexpected turns your lives may take, to alert you to the value of keeping yourselves light on your feet so that your lives are ever-expanding explorations.

The kind of art that engages you now (painting, sculpture, fiber, ceramics, photography, printmaking, video, design) may have — probably will have in the future — a very different, perhaps even entirely different look from the work that currently engages you. The artists who disappoint themselves are those who build fences around their expectations, who preconceive their work too narrowly. For if you preconceive who

*Delivered on May 9, 1987. Typed transcript, box 49, folder 18, Anne Truitt Papers, Special Collections Department, Bryn Mawr College Library.*

you are, you only make work that rises out of a self you already accept as "correct." This not only limits the possibility of brand new concepts erupting into your work, but also deprives you of the value of learning how to be tough on yourselves, to endure, and to rise above your failed aspirations, which usually turn out to be steps toward an unguessable goal. I urge you to preconceive as little as possible. Accept yourselves as strangers to yourselves, and let those strangers teach you who you are in the process of *becoming* as you move from one work to the next. Have faith in what your work is teaching you, and stand fast in that faith no matter what storms of criticism *or* praise rage around.

If you do this, you may find yourselves out in left field, obsessed by concepts that seem to bear little or no relation to what people in general think that art is, *should* be, or *could* be. But method *always* follows a spontaneous, new concept, which seems to arise equipped with all it needs to become actual. This is a law I have observed over and over again. Partly, I think, because artists diligently train their hands to obey their minds and hearts, and partly because the creative process is so ordained.

The second salient fact about powerful concepts is that they result in work that is magnetic within the pertinent field of art. Work of authentic originality and value attracts attention all by itself. One of my seminar students recently returned to visit the class. She told us that during the last seven or so years out in the world, she had supported her work by odd jobs, had moved from cheap studio to cheap studio, had shown in a modest way, had managed to work steadily one way or another even though she often got discouraged. The other day she had been startled by the approach of a dealer who had seen her work and who *invited* her to exhibit in his gallery.

You need not pay more than intelligent attention to the work in art that you find around you as you move out into that arena. Kiefer, Schnabel, Lüpertz, Cucci, Salle, Fischl, Tawney, Borofsky, Longo, Rothenberg, Haring, Scharf, Sherman, Clemente — they are already the past; *you* are the future. Study the lives of artists. Philip Guston, for example, toward the end of his life entirely changed the kind of painting for which he was famous, moving with exemplary honesty into work that brought down upon his head a storm of criticism — but may be the work for which the future will principally honor him. Fashion in

art is always leavened by the taste of the majority, and the taste of the majority is always conditioned by a potpourri of excitements at least partially generated by artificial forces that bear little or no relation to the powerful current of ever-expanding conceptualizations of truth, the current in which genuine artists move and to which they contribute. Place yourselves squarely in this current and learn to swim there, for it is in the company of other artists of your generation that you will find challenge. And comfort too, for artists keep one another company in what is quintessentially a lonely endeavor. Art is not for the faint of heart. Loneliness comes with the territory, and you will devise ways to fortify yourselves while you learn to live there.

Because authentic and original work magnetizes events to itself, you need not fuss yourselves by *worrying* about ways and means to get your work known. Established artists keep a radar turning day and night, seeking out younger artists; they are watching generously for new members of their company. And the world of employment, of dealers, museums, and collectors, which looks formidable from a distance, dissolves when familiar into individuals who are attached to art as artists are — people with whom you will have common bond. There are, of course, as there are in any field of life, meretricious, unserious people who feed off art, but young artists can develop their own radars that pick them out so that they can be avoided. This takes a confidence that can only come out of experience, out of a period during which you "pay your dues," so to speak, work steadily, and look around and judge what you see. It takes patience, too, and a determination not to let your work be compromised by fashion. Sheer luck comes in somewhere in how your work fares, but to a degree luck can be made. Robert Longo and Cindy Sherman, for example, became friends while studying at New York State University in Buffalo, where they began to show their work in a makeshift space they made for themselves so that it attracted attention. But it was exciting work, and that was the decisive factor. It can be critical to place yourselves in situations rich with alternatives. If two cars collide on an empty road, the results are limited; if they collide on a Los Angeles freeway at 5:00 p.m. on a workday, a great deal happens. There is a freemasonry of artists in any one generation. It s good to join it. But you will not need more than sturdy common sense,

and fidelity to what you yourselves value — to be responsible for, and to, your work in the art world.

It is wise, I have found, to keep two facts in mind while dealing there. The first is that the price of a work of art bears no relation to its quality; price is entirely a matter of current valuation, and current valuation is determined in the marketplace by standards that may have nothing to do with the quality of the art. History will have taught you this, but an artist's work is so dear to the heart that it is difficult to remember this fact in the hurly-burly of the art world.

The second fact is even more fundamental: there *is* no mete response to art. That is, there is no response that takes into account the cost of the work to the artist. The world can make no payment that equates with a lifetime of effort.

The truth is that the reward of art is secret. No one shares it with you and few can imagine it. The rewards of art are intimate. And, above all, exhilarating. As Rauschenberg once remarked, "There is no high like art."

It is in aspiration that the artist's life is noble. Whether it is distilled into paintings like the *Mona Lisa*, or into works of art that are apparently only mysterious actions like those of Joseph Beuys, ephemeral in their very nature, or in knots of twine like those of Lenore Tawney, or in Cy Twombly's marks of paint that look to many people like nothing but scratches, it shines a beacon. For art has a profound influence in the history of humankind. Its advances are less obvious than, say, the direct effects of evolving legal concepts on our lives, or the spectacular technological discoveries of medicine, of physics, the exploration of space, the use of computer science, but they are no less universal. For art embodies the highest aspiration of every generation.

I close with a quotation from Pericles, who spoke these words in the fifth century B.C.:

> For the whole earth is the sepulcher of famous men and their story is not graven only on stone over their native earth but lives on far away without visible symbol woven into the stuff of other men's lives.

So I wish you all, with all my heart, noble lives.

# Journal Excerpts, 1987–89

September 7, 1987
Yaddo

I am feeling as if I were rising smoothly into an air that supports me perfectly. My sixty-six years carry me as if essentially they had all along been the withes of the intangible basket now lifting me above my life. It flattens below me: a landscape only I will ever know. I wonder at its order. My eye alights here and there. On people, places.

December 1
Washington, DC

The sky is dark thick blue. Against it the naked trees twist on themselves, just rubbing. Orion stalks the southern quadrant, bared by the wind. It is his reliability, compared to which his shine is irrelevant, that stays me. Tolstoy was right that it is a mistake to think that beauty is always truth. Only truth is truth. Orion is vested by a lifetime of watch: on my way, in night, he maintains the patterns of himself. For three years no wind has stripped me bare: I have sought out and crouched in the lowlands, the soft, rounded hummocks and deceptive green hills of humanness. I have anesthetized myself with daily-ness.

There are two paintings drying behind my back on the four-foot-by-eight-foot plywood spanning the two wooden horses I banged together in

---

Truitt *kept this journal from September 7, 1987, to March 16, 1993. Her book* Prospect, *published in 1996, is based on her journal entries from spring 1991 to spring 1992.*

the 1970s. I wear my flannel nightgown. Inside it, my flesh has dropped. The amount is the same, but gravity has pulled it away from my skeleton in a slump toward the rectangular so that my shape is recognizable only to memory: the body over which I wore loose cotton dresses as a child of eight. But then my eyes were nearer to my feet, my pivot closer to the ground. This new rectangularity throws me out of proportion. I have been feeling unfamiliar to myself and terribly *heavy*: gravity is having its way with me against my will. My spirit has followed my flesh down. Lying low seemed a natural adjustment. Even graceful, a virtue, a humble posture easing toward the final humility with which the body lies down in the earth.

Yes, that is right for some but not for me. Over my nightgown I put, as soon as I opened my eyes this morning, a quilted wrapper, pink, but it doesn't show because over it I wear my down jacket and, over that, my warm blue denim work shirt that still carries on its back specks of the Day-Glo-cherry-colored paint with which in 1970 the young artists of the Corcoran Gallery Workshop on Calvert Street stamped "Fat City." Rectangular I may be inside all these layers, but, like Orion, my pattern asserts itself, as if my skeleton had just "decided" to carry my peculiarly distributed flesh straight up without cavil.

Dawn has colored the sky apricot, not the color I need for these two paintings nor for the next to which I shall link them. Crimson — a color that forbids ease. A trumpet voluntary.

December 2

A Samurai warrior swung from his hips, legs out, one and then the other, stamping himself on the ground. I used to practice that walk in Japan, just to see what it felt like to act that powerful. Useful now, as yesterday I found that if I lower my center of movement to a point midway between my hip joints, I can carry my rectangular torso easily. My joints complain a bit but I expect them to adjust. No quarter given. I have also begun to stretch my backbone: down to touch the floor, up as far as I can reach. I have called a halt to the thick stoop of age.

The surface of my face is unmistakably lined. Slump there too. But also offset by the pattern of the eight-year-old I remember: a plain face, open, with a too-high forehead and wide-set blue eyes bordered by light hair, white now instead of yellow but the same waywardly fine texture.

December 3

Age's rearrangement of my inherited physical elements is getting to be more and more comfortable. I have the impression that I won't have to pay this much attention to it again and will simply ride out the rest of my days in this new posture. And even if changes do take place, the principle of adjusting my psychic proportions to them should hold true.

Now I am wondering about the sculptures I intend to make in 1988, the first new sculptures since 1984. As yet I see them only in intimation, but as they pulsate in and out of view in my inner eye they look as if they might be in an unhabitual proportion.

> And now there came both mist and snow
> And it grew wondrous cold:
> and ice, mast-high, came floating by,
> as green as emerald.
> — Samuel T. Coleridge, *The Rime of the Ancient Mariner*, 1798

Green ice is pure, without the milky white bubbles of trapped air characteristic of most berg ice. No one knows exactly where it comes from, but in Antarctica it is thought to be exposed by the shear of mountain glaciers.[1] Somehow it survives intact within the complex ice fabric of a berg and rides it out into the southern ocean. Coleridge's "emerald" is a flash straight out of the heart of the continent. My self sometimes sends out this kind of imperative message.

---

[1] Stephen J. Pyne, *The Ice: A Journey to Antarctica* (Iowa City: University of Iowa Press, 1986), 9.

January 1, 1988

Yesterday the International Earth Orientation Center (now based in Sevres, France, instead of Greenwich, England) stopped the Universal Time Clock in order to allow the earth to rotate for the one uncounted second necessary for it to catch up with the clock. A breath caught out of time, the earth spinning free of the human definition implicit in the control of human record. A definition based on an element itself part of the earth's body: cesium, atoms oscillating at precisely 9,192,631,770 cycles per second. Atomic clocks tick off exactly forty-eight hours, but their very regularity throws them out of synchronization with the rotation of the earth, which takes a bit more than twenty-four hours to complete one turn. Even this slowdown is irregular. Principally because some momentum is lost as friction, but also because the shape of the earth is constantly changing, either fairly evenly in the bulging sea tides that swell its surface or less evenly in changes of mass: tectonic shifts as one crustal plate plunges under another, and movements of magma, the very stuff of the planet, which varies in density and surges about according to its own nature.

I like to think of the scale and idiosyncrasy of the earth. Even though we evolve from certain of its lawful elements the formulations with which we order our lives, the earth remains intransigent save to its own laws. A paradigm of independence, the grace of allegiance to inherent nature.

January 30

A stunning life, O'Keeffe's. Literally, her obduracy stuns me. I can think of no other person so circumscribed by herself alone. She gave no hostages to fate. She made certain choices and adhered to them so faithfully that her life evolved as an example of decision itself. Decision as excluding as if she had turned herself into a camera so that she had the advantage of looking through a lens and the disadvantage of seeing only what she framed. Her eye is as precise, as sensitive to variations in value, as a lens, but her hand feels to me nervous, as if she were in some way fundamentally uncertain about technique.

Perhaps Alfred Stieglitz's definition of her as an artist came too soon. She jumped from her rather tentative early instincts for the abstract into full-scale painting, and under the influence of Stieglitz and his fellow photographers grasped the camera as a pole by way of which she could instantly vault over technical uncertainties and give herself an original point of view. She framed herself as an artist by excluding from her life all that might have challenged her definition of herself. She even colored herself black and white — she wore only black and white clothes for the last I don't know how many odd number of years of her life. She even colored herself black and white so that she stood out against the glow of her Abiquiu Desert, distinguishing herself by separation. A theatrical device. She *appeared* to be defining herself, but I wonder if she did not rather live out Stieglitz's definition.

Berthe Morisot too came under the defining influence of other, male, artists when she married Manet's brother. Before she was married, Morisot's painting had an extraordinary innocence, delicacy, and authority. Married, she abandoned her perfect key and color and settled into the practice of art — except for a harsh self-portrait so trenchant in its self-revelation that I could see that she understood what she had paid for her adjustment to her world.

O'Keeffe seems to me to have gone too far in elevating herself above the risky checks and balances of ordinary life. She committed herself only to herself. She fashioned a cell out in her desert as decisively as a zealot.

But the lives of these two women, as always with artists, fall back into a history tangential to their achievement. Their radiant work remains.

Note for myself.

Actually, what the two women lost — what the two women forgot or failed to pay sufficient attention to was touch. In some way they began to use their minds to make their work, and they forgot that what you touch you enliven and that you only can enliven by touch. You cannot enliven something by an idea. So consequently their fingers, their hands, their beings began not to have the capacity to convey life. Morisot's early work is unbelievably beautiful in its innocence. And O'Keeffe's very early drawings have a kind of direct trenchant touch quality which none of her later work has at all. So actually it's the quality of touch that they both

lost. In O'Keeffe's case she tried to struggle to have it, but her hand had not been trained enough for her to have it in traditional art and she just never figured out how to get it into abstract art. Perfectly possible to get it in there — she just didn't figure out how to do it.

January 31

"An awesome present" is what one of my grandsons says if I give him something that impresses him. Current expressive adjective, exaggerated for effect, but *not* exaggerated for the wrapped-up idea my mind presented me with this dark morning.

For suddenly, forcefully, it occurred to me that the hard, cut-and-dried fact of age is that the spirit does not age at all. The strength of my body is increasingly incommensurate to the strength of my mind: the curve of my physical stamina runs *down* and the curve of my mind runs *up*, and they are definitely parting company. I have been adjusting to this fact for some time now, but while doing so I have continued to harbor the illusion that these adjustments were in some way temporary expedients. That if I used my intelligence cleverly, I would climb to a plateau on which I could manage an economy of energy in a way that would enable me to work as unremittingly as I have all my life. I'm shocked to realize that this is a mistake. "My wretched body" is the phrase I have been using to whip it along, even while I have been thinking of myself as handling its declining energy tactfully.

I do not, for example, "count" much of what I do: loving exchange with my family, housework, shopping for food, this writing, letters, visits with friends, seeing exhibits, studying what interests me. Even teaching. I have been relegating these activities to the background of my "real" work: the studio. So that I've had the impression of running without moving forward except inch by inch.

I am angry. Always a sign of malalignment. The inertia of my body maddens me because it eludes my control. I am appalled to observe that a large, ever enlarging, part of myself would welcome pleasurable ease. A friend exactly my age, a composer who has worked hard all his life

and is by nature more forthright and realistic than I, remarked last night, "I could just enjoy myself now, read novels and eat nice things and see people I like and have a fine time!" A pause. "But I write better music than I used to. And I play the piano better too." Another pause. "*Odd situation.*" Yes, it is. Strange to both of us, and unwelcome. The idea of being lotus-eaters is unfamiliar to us both. The difference between us is that he is honest about the tendency and I have been practicing the wily art of denial.

And, in practicing it, driving myself into the ground. Two days of teaching this week wore me out — and I have years of teaching ahead of me because of financial necessity. If I abandon denial, how can I maneuver? Gurdjieff's concept of many I's, the idea that in the course of our lives we develop different I's to meet different situations, offers a feasible way out of anger. Instead of calling my body "wretched" and implicitly lashing it along, I could alert my "mother I" (the one who for years tended my children and now, as I visualize her, sits placidly in a garden warm with the sun of an eternal spring afternoon). She could rise to her feet and come to attention. My mother I is tender, un-angry, and understands weakness. Placed in her experienced care, my body would be respected. A fine solution for day to day, but my "artist I" is daunted by the prospect of acknowledging her harness with a weak partner. Well, she will just have to get used to it. Today I will put one coat of paint all around on each of my new sculptures. Such a come down: *one* coat.

One coat remains, however. One coat. An advance in line with the effort of my whole life. Even as I write I feel the ease of adjustment. No denial, no anger — both block energy. Acceptance of myself leads my way once again.

I suppose that ultimately the diverging curves of spirit and body will entirely part company in death. In the meanwhile, I will tend to balance from fresh perspective. It's still a shock though. The artist in me will perhaps just come to death in midstream, snatched against her inclination out of her preoccupation with her work. Does she tire also? No sign of it. She is not given to submission, having had her own way for so long.

February 1

More coats than one, after all. My heart lightened in some mysterious way; I was able to bring one sculpture to within a day's work of completion. I feel its company as I write: its existence in itself lightens my heart.

February 2

Seventy degrees yesterday. Dulcet winds this morning at dawn. I sat on my front porch and watched the sun begin to touch the trees, first the topmost twigs, then the slender highest branches. Finally, a decisive edge of gold materialized on the thick black bare branches.

Perhaps because this brief glory reminded me of the burnished Tuscan air in Italian Renaissance art, I suddenly seem, for a second, to be living in a painting. A sentience alive to an ever-becoming-into-being of which I was a breath.

February 5

One of the fascinations of aging — and there are many, it is certainly the most interesting period of my life — is the emergence of pattern: three periods of conscious change that seem to me as difficult and perilous as the original labor by way of which we were delivered into the world. They roughly coincide with the decades of the twenties, the forties, and the sixties. The first and last of these passages are closely tied to an inevitable course of physical events. In our inexperienced twenties we come into our strength and undertake our responsibilities. In our experienced sixties we have largely met these responsibilities, one way or another, and confront our mortality.

The middle passage is the most critical because the change is primarily psychological, spiritual. Sometimes called *metanoia* — from the Greek, "change of mind" — it is not inevitable, hence lacks the safeguards of natural teleology. Actually, this change, which is particularly startling

because when it comes to us it slants into the full, apparently rather stable stream of our lives, seems to me a kind of divine gift. We all have occasional moments when we unexpectedly see ourselves stripped of our ideas about ourselves, as if a bolt of lightning illuminated in an awful flash the landscape of a self we had thought familiar, safe, about which we had even entertained a certain comfortable complacency. Sometimes — if we are pricked by shock to be quick and brave — we decide to remember these revelatory flashes, encourage them to proliferate, to connect, and to lengthen into a steady light that allows us to examine ourselves with an eye toward realignment with a new point of view.

This extremely unsettling process began to overtake me in Japan in 1964 to '66 when I was forty-three to forty-five. I became so profoundly uncomfortable that I was forced to turn my experience over and over, exposing it to an examination that very gradually evolved into an entirely new attitude. In essence, the self-determination I had worked so hard to develop and which I had cherished as my independence of mind and action was revealed as having emerged out of ideas I had come to in my twenties and embraced in my thirties to such a degree that they had hardened into a carapace. This embossed and elaborated crust had first to be cracked — pained at that — and then discarded piecemeal. A scary matter, for who would be underneath? Peeled, naked, I found myself a kind of small, translucent sea creature. Wholly vulnerable. But wholly sentient. Tentatively I began to explore that raw sentience, its odd wisdom.

February 7

The line of tanned winter fields lies lovely along the waters of the Eastern Shore of Maryland. In the distance, a delicate meeting as intimate and strong as bone to flesh. Closer, perfectly articulated reeds bend to the wind they render visible in high sweet song. I find I *can* go home again to this land of my childhood, now: I want nothing from it. Poised, intact, I regard with the wondering eye of childhood, enriched and ever renewed. A glade in the long vista of my lifetime.

February 15

Cold seems to stiffen trees in winter. Their bare branches look brittle, though already dotted with the just-perceptible knots of buds. My myopic eyes are best at this season: naturally attuned to abstraction, they revel in the delicate mist of color put forth by these rich pointillist buds.

February 21

I have finished work on *Portal*. Two other sculptures are coming along, slowly. I come to terms with time reluctantly. Months go by between the conception of a work and its completion, but I do see them completed — unlike the lives around me. A few nights ago I went to a party of my contemporaries, and observed once again the plight of our confrontation with time: eyes unmistakably young looked out at me from nests of wrinkles.

March 13

Not even the faintest shine of moon in a sullen sky this morning. Gibbous these last few days while I have been sitting on a panel at the National Endowment for the Arts, it must by now have waned to a sliver up beyond the purple gray clouds from which rain is softly falling onto snowdrops, crocuses, and jonquils newly sprung from our sweet-smelling earth. The quiet is welcome to my ear, for the Endowment is housed in the old US Post Office building, which accommodates every day many hundreds of the citizens it serves: who pour into its courtyard, where various food is offered. A lively, noisy fairground into which we panel members were released at intervals from our intense discourse. A reminder to us that the public for whom we are making artistic decisions is vehemently unwieldy and various.

Our panel was not unwieldy, but was as various, a proper reflection of our increasingly diverse culture. Every time that I return to work for the Endowment, I am impressed by the intelligent way in which our

government gropes toward a sensitive and flexible support for our arts. The principle of equal opportunity for every citizen in this nation informed our every decision. Furthermore, encouragement to take advantage of this opportunity, determination that art not be defined as elite, patterns officially stamped with an approval that might act to stultify aspiration. It takes particular attention to maintain this aim, for the members of the panel did constitute a group elite by virtue of their achievements, and no one of us wished in any even subtle way to do other than to place our knowledge in the service of our common principles. An exhausting process, a course of panel meetings. We all felt the strain, countered it with humor and comradeship, and disbanded in good fettle.

March 14

Ten hours of sleep have restored me to myself. The voices of the NEA panel members, a just luminal Greek chorus in my head since Friday, are fading.

March 31

I'm like a pelican these days. So weighted by a pouched beak into which I have stuffed undigested thoughts and feelings that I am reduced from flying to wobbling.

I have been reading Aniela Jaffé's essay on Carl Jung's last years. She became his secretary in 1955, the year he turned eighty.

"Don't interfere!" was one of his guiding axioms, which he observed so long as a waiting-and-watching attitude could be adopted without danger. Situations in which interference was obviously required were decided exceptions. [Events] happened and he let them happen, not turning his back on them but following their development with keen attention, waiting expectantly to see what would result. Jung never ruled out the possibility that life knew better than the correcting mind, and his attention was directed not so much to the things themselves as to that unknowable agent which organizes the event beyond the will and knowledge of man. His aim

was to understand the hidden intentions of the organizer, and, to penetrate its secrets, no matter was too trivial and no moment too short-lived.[2]

This is a precise description of the attitude that I glimpsed first in 1948, when I realized, with dismay, that writing fiction was not for me because I was not as deeply interested in *what* happened, narrative, as in *how* things happened. I came to understand in some dim preemptory way that time was a device of some sort, that what happened along the tick tock of its artificial linearity was to me, temperamentally, less fascinating than my halting, difficult attempts to catch fleeting hold of the laws in accordance with which it was happening. My intuitive step was into sculpture, into literal three-dimensionality standing outside of time, intact unto itself. Subject to time but not of it, released from it by objectness. Perfectly naturally, I stopped writing and began to study how to try to bring forth — out of myself — what would withstand time.

Years later, in 1984, I spent nine months as acting executive director of Yaddo, five hundred acres of woods in Saratoga Springs, New York. "Interference was obviously required" by my role there, but because it was, I had to act particularly carefully and thoughtfully, and I began to notice how very small a part I played in the course of events. I began to find it wise to act as little as possible, within reason. How often action placed me at an arbitrary angle to a natural flow. I took to solitary walks in the woods, balancing on my own pivot of gravity, like one of my sculptures, and found a new joy (I don't like that word, but still), that of not touching anything at all. I moved what would obstruct free passage of the paths through the woods but nothing else. No matter how alluring the party-colored pebble, the delicately articulated acorn, the odd leaf at my feet, I refrained from picking them up. And as soon as I accepted this new reluctance to interfere as a developing attitude, I began to generalize it, to allow it to saturate my point of view. And so, without preconception, with surprise, I underwent a profound change that set me free into a tentative but potentially overwhelming apprehension of a unity within which even the operation of the laws governing it became irrelevant.

---

2. Aniela Jaffé, *Jung's Last Years*, translated by R. F. C. Hull (Dallas: Spring, 1984), 102–3.

April 14

The Second World War is not mentioned much in conversation anymore. Reduced to WWII, its details have evaporated into two national stains — the American use of the atomic bomb and the German Holocaust. Neither can be absorbed by either nation. Like the most intensely shameful experiences of a personal life, they lie like black oil slicks on sea, forever refracting, repelling excuse, revelations of human character.

The war erupted into my life at Bryn Mawr. I was a sophomore, twenty; grief for my mother, who had died in October 1941, had begun slowly to subside into the context of the life I was circumscribing for myself by intense study of my mother's ideal legacy of integrity and my own developing clarity of purpose. December 7 was a Sunday. I was working away as usual in the Quiet Smoking Room of Rhodes Hall when someone burst into it crying out that the Japanese had attacked Pearl Harbor. I jumped up, scattering my books and papers on the table, and ran up three flights to a friend's room so that she would hear the news from me because both her father, a captain, and her fiancé, an ensign, were stationed aboard the USS *California* at Pearl Harbor. Even as I told her, conscious of delivering a shock, some detached part of myself noted what a face looked like when it "turned white."

That detached part of myself, an observer, had been my familiar all of my life — I cannot remember ever not having it as a sort of refuge that felt to me more stable than any other aspect of myself, from earliest memory. My mother's slow death of a brain tumor had reamed it wider, deeper. I had begun to trust its levelheaded capacity to sort and absorb any and all experience. I turned into it more and more, not knowing its purpose but always with a stubborn conviction that if I were faithful to all I observed on all levels of apprehension, it would evolve out of this core and lead me. So it has. A magnetic center around which my life has drawn a shaping line such that, twenty years after that mockingly sunny December 7 afternoon, my work began to form in a sort of distillation that rendered my experience visible to me.

Vincent Sheean spoke to us in a lecture the following evening. "In thirty-six hours we have lost more ships to the Japanese than England has

lost during the entire war," he said. The Hawaiian attack is "the greatest reverse of its kind in the history of the world." From Sheean's tone as much as from his information, we students took in the fact of peril to our nation even before the fact of peril to our lives as we were going to have to live them from then on.

I do not mean to blow my own experience of the war out of proportion, but rather to place it there, in the general proportion of American women in my generation. We were in no physical danger ourselves. No planes strafed us into ditches. No bombs fell on the ground we walked. It was our imagination, the most vulnerable of all human qualities, which was excoriated by unremitting fear for other people, those whom we knew, loved personally, and those to whom we were joined only by common humanity. When the war finally ended, I remember thinking, "No one is killing anyone else," measuring a degree of agony by a degree of relief.

We "grew up" as fast as we could, my generation. Men "went off to war." Women "kept the home fires burning." Men brutalized themselves to kill or be killed. Women felt the responsibility implicit in being protected — a weakening emotion, all but demeaning, degrading — and tried to make it as worthwhile as possible for men to protect us. We powdered our noses and pushed up our breasts and wore soft clothes and smiled and smiled and smiled. We tried to be appropriate awards, trophies of war, decorations. We were, so to speak, after the fact: incidental. We bore as many babies as we could. We could do that: make men facing mortality immortal. Looking back, it seems to me that we — men and women — did all this rather bravely. But perhaps we women deserve more credit than we have been given or have given ourselves. The sheer horror of the war, the life-and-death scale of the immediate horror that engulfed the men, reduced the cost of our adjustment to civility: a polite return for protection. I wonder how much this gratitude of ours has tinctured the lives of my generation of women. We are so habitually diffident. Age is changing us now. I noticed that we are beginning occasionally to surprise one another when, old friends, we meet and take advantage of the enlarging concept of communication to speak out. But by and large we are going to our graves a silent, polite generation.

There is a certain reticence in age that has beauty. None of us can share one another's lives to a degree that will do other than mitigate

what we have all lived through. Because we were brought up not to be melodramatic about ourselves, we do not think of ourselves as survivors. We think of ourselves as having outlived other people in our generation because we have. We are as polite to one another as we are to the world at large. We spend as much time in our gardens as we can. We wear more and more comfortable clothes as our bodies lump up here and thin out there. Perhaps we are the last remnant of Edwardian elegance. Our mother's embroidered clothes have a dim refraction in our loose Liberty cottons. But our silence is that of choice, not of weakness.

April 24

Just as death may be, in my friend Aleksis Rannit's phrase, "the final tenderness," so honest observation of oneself may lead to such final disillusionment that finality is itself welcome. I wonder if perhaps this personhood is a garment I may in time be honestly glad to drop. For some weeks I have been fraying the edges of my natural energy because I incurred responsibilities months ago that I must now meet with an economy depleted by these very responsibilities. Unpredictable situation — or was I imprudent? In any case, underlying faults in my character are appearing like cracks from which topsoil has been shaken. I am appalled.

I see how thin the layer of my self-discipline is after years of effort and how much my self-confidence has relied on this discipline. I have gone too far, so overrun my own strength that my fundament quakes. The other evening I backed my new car into a post and dented it. I speak when I should be silent. Tears rise to my eyes without reason. But — there is always a but — I am humbled, and humility is the starting gate of wisdom.

I spent yesterday in the garden returning to source. It was a comfort to fall asleep hearing rain and knowing that it fell softly on my tomato and pepper plants, on pansies, petunias, zinnias, candy tuft, marigolds, and lobelia as blue as a Greek adjective. The crab apple tree is glorious even though misshapen by the ice that broke it in half two winters ago. The young Norwegian maple is putting out tiny bronze leaves along branches that the seventeen-year cicadas branded last spring. Both trees survived. I

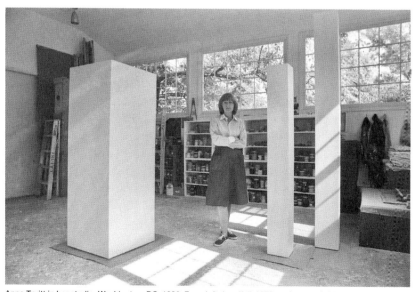
Anne Truitt in her studio, Washington, DC, 1986. From left: *Landfall*, 1970, and two unfinished sculptures.

will survive. The earth goes as stubbornly on its way as the fundament of my character; I notice that where I have touched it, it is wild.

April 26

Elephants tend to grow larger every year they live. Our society would be different if human beings did too. Or would people above a certain size be automatically consigned to death?

My garden is settling happily. Seven white tulips blow gracefully on their tall stalks under a windy purple lilac tree. Today I go out for tea. My life is settling too. Normality is a true and faithful pleasure.

April 28

Last night I had dinner with a friend. For almost forty years our lives have touched, once closely, but for the last twenty-four years at a distance. I felt a certain trepidation about our meeting, and I think that he did too. But when we saw one another a spontaneous friendliness bloomed between us. "You haven't changed!" "You haven't changed!" We have, of course. We have not grown larger like elephants, but each of us takes up more psychic space so that we spoke to one another as if from the exactly maintained centers of two delineated circles within which we have each carefully articulated our experience. It turned out as we talked that we have made similar decisions about the course of our lives, thoughtful decisions that arose out of a common referral to temperament. By adhering faithfully to values that are natural to us, we have avoided certain temptations as well as evaluations of ourselves other than our own. Having arrived at individual perspectives, we found ourselves laughing together and shook hands with mutual respect and departed on our separate ways with contentment. Personal contentment, but we agreed sadly that our earth and air has become, as we used in our twenties and thirties to fear it would, increasingly impure — perhaps irreversibly so. An impurity matched by an apotheosis of the mediocre in art keyed to the taste of an ever-enlarging audience for which it has become

an entertainment as undemanding as the other entertainments industries relentlessly churn out for their diversion. The formal devices of art have been picked up as useful in contexts that reduce them to semiotic signals as easily read as signs denoting the location of restrooms. Communication is all, as if it were in itself a value regardless of content. In the cacophony of a drum so relentlessly beaten, it is difficult for people to be reflective enough to reach thoughtful conclusions about what life actually is, my friend pointed out. Numbed, they hurry from sensation to sensation; they are either reluctant or unable to stop the action long enough to think about it clearly enough to distill what would give their lives personal and reliable meaning. Artists eager for acceptance succeed by offering ever-more-startling *images* rather than demanding originality of spirit. So art tends to become more understandable in general, but at the cost of keying itself to a popular denomination that tends to deprive it of serious contribution to human history. The upshot of the matter is that although people in general are less isolated from art in general, serious artists are themselves more isolated than ever.

May 8

When I am with men my own age, I sometimes notice how rarely they ask me questions about my life. What they see before them is apparently enough. Or their own definition of what they see before them is enough? Or are they indifferent? Or are they reluctant to address me as a peer? The facts of my life are obvious. At my table, they eat food earned by me as if I had made it as effortlessly as the milk with which I once fed my babies.

This is a serious matter. We — for we women collaborate with the arrangement in ways both subtle and conniving — deprive ourselves of one another's profound companionship. When women ask for comradeship, they are demeaned by the fact of having to ask, placing themselves in the position of suppliants. And vice versa. Lord and lady: a convention by way of which serious intercourse between the sexes is at once stiffened and lightened into a gavotte. I eschew the dance.

May 10

The university term ended yesterday. My grant has begun; I do not teach until January 1989, so I left my office in particularly meticulous order and closed the door behind me with a decisive click. But there is a difference between closing my own door and having one closed on me; as my last student said goodbye and turned away from me, I saw relief on his face, spring in his elastic step. Humility is a lesson teachers learn over and over. Inexorable time and mutual efforts render our students independent, and us irrelevant to them.

May 12

When I arrived home from New York last night I was so tired that I simply dropped my clothes as I walked around, undressing piecemeal in my empty, twilit house. A very hot bath; soup, crackers, yogurt; sleep. Today is a whole day to delight in the pleasures of solitude before I depart tomorrow for St. Mary's College on the Western Shore of Maryland.

May 23

Age has restored me to the sweet summers of my childhood. I feel this warm morning the same languor I remember with deep pleasure, a promise of repletion as thrilling as translucent green leaves lifted and turned against a blue sky by a light wind. In my middle years, I lost this innocent acquiescence to sensuality. I think I even feared it a little, intent as I was to act: to meet demands responsibly and to impose my will on events.

Counting backward the annular cycles of my work, a record like the circular growth rings in a tree trunk, last summer was lost: spent on preparing my papers to go into the archive at Bryn Mawr College and on living restlessly in a house being repaired and painted. In 1986, I wrote *Turn* — aligned out of my notebooks. 1985 was a summer such as this one bids fair to be: I painted steadily, day after day, absorbed, alone. But

without the odd familiar acquiescence to summer itself, which I feel this morning. A cellular feeling. If I were really a growing tree, my leaves would now be all green, my roots pushing easily into rich leaf mold.

May 24, 12:25 a.m.

The indissoluble guilt of every life is the lie we invent in living it. We postulate original sin because we are haunted by a vague feeling of being in the wrong. We are. No matter how honestly we articulate ourselves, we speak from a point of view that changes unpredictably, subject not only to information automatically mediated by the clinical neurotransmitters in our nervous systems but also by our own rationalizations. What we see as manifestly true one day we can recognize as mistaken the next day, even the next hour, or thirty years later. So we write the scripts of our lives as we live along, perpetually acting and reacting as best we can. Some lives are desperate improvisations, others more consistent. But every thought is an action that hardens in the act, accumulating like coral cells in a madrepore — just beneath the visible waters of our lives. Our characters are formed in this way, accreted minute by minute, day by day, month by month, year by year.

We are diligent. We never stop "thinking," even in sleep. We have virtually no control over anything that happens around us except by way of this interpretation. Our whole situation is too complex: forces on one side of the earth inevitably affect people on the other. The chain reactions of cause and effect are as ceaseless as our minds. "The mills of the gods" grind not only slowly but also relentlessly and in continuity, generation to generation.

It is interesting that under these conditions we feel so responsible for our lives. My own feeling of responsibility is grounded in the fact that sooner or later my experiences consistently — and often to my surprise — reveal themselves as logical, calibrated to the very smallest turns of my decisions. Any turn deflects a line. I have the impression that although the precession of events in my life, like the interlocked physiological process in my body, is determined without my collaboration, its psychological tenor — moral key — is my own.

6:30 a.m.

I took my coffee out to the wicker armchair on my front porch to watch the sun rise and to think over this matter. But when I felt the breeze on my cheeks, caught its little rays through the leaves of the trees and watched the sky's lovely changes, I lost my taste for explanation. I leaned my head back and gave in to the nameless pleasure of being human in a beneficent universe.

May 25

I feel happy — effortlessly. Usually I arrive at happiness by way of adjustment. I examine all round whatever situation I am in and continue to do so as patiently as I can until I see my way clear. Sometimes quite suddenly, and always with the particular release that hallmarks the liberation of what is natural to me. This process involves enticing my ugly dragons out of their caves, sometimes even the courage to go in after them. If I can get them out into the sun, they stretch, their scales get warm, and fear gives way to interest. Then to an objectivity so lively that its energy is itself a source of happiness. A feeling of being in proper proportion with the world around me.

But the kind of happiness I feel this morning is like a breeze; heaven knows where it comes from.

May 27

Yesterday I finished working on a little sculpture, *Breeze*, sixty inches by five and a half inches by four inches. A slender column bearing colors as if to reveal their range beyond the eye's reach on all four sides. *Still Memory* came into focus yesterday around dawn; now I am slowly but very surely moving along on its undercoats. A yellow-blue pearly sky heralds a good clear day for mixing color.

If consciousness is conceived of as a kind of light, and that light as coextensive with all life forms, our earth is wreathed with filigreed overlays

of light, intricate layer on intricate layer, from the depths of the seas to the heights of the skies. Each consciousness experienced as individual; each layer of consciousness taking into account as real only its own plane.

May 30, Memorial Day

The sadness for those who have died young in wars is immeasurable. Tinged by nostalgia, elegiac of all that we remember of our own youth: ideals of honor and achievement that felt as much promises as aims; bodies supple as willow wands, eager as arrows. Homer, who understood, and gives us to understand, the delicate balance and pride and tenderness that marks heroic character, says of dying warriors: "Death unstrung their limbs."

May 31

For the past two days I have been more curator than artist. Now inventoried and packaged, the work that had accumulated in the studio is ready to go into storage this morning: hundreds of working drawings dating back to 1960; works on paper, framed or carefully wrapped in layers of chemically inert paper; small sculptures in the series called *Parva*; paintings on canvas. Toward the end of yesterday afternoon, I began to feel in some odd way embarrassed by this mass of work, as if I had done something that would make a Japanese *hazukashi* — ashamed. As if I had taken a course of action that called an attention to myself so disproportionate to a single life as to be impolite.

June 8

Cuts — amounts — inflections of color — pressures: space against space, hue against hue, value against value, all swinging and singing in a luminous place above my eyes. A drama. My hands seem to act on their own.

They move from here to there on rough thick pure paper. A line, a shape to which this line becomes both underline and content — a color — another that stretches beneath just so far. These are, it seems, to be my new paintings. As innocent of intent as the "fences" I made in 1961 and 1962.

The solstice.

Today we who ride on this side of the earth pivot away from the sun and into the long deliberate orbit toward the short dark days of December. Usually, the solstices give me a glorious feeling of security and immensity. I enjoy being part of a grand sweep. Today is different. I have not been well, and pain is demoralizing. I do not seem to learn as much from it as I used to. Acceptance and patience answer to it quite without flourish. But I seem — heaven knows how, given the evidence in my life — to have retained the idea that at a certain age I would be "finished" as a porcelain bowl is finished: shaped by use and glazed by experience. I hoped it would be comely. When I was a child of eight, say, I looked confidently forward to being ten; at sixteen to twenty; and so on until thirty five, an age at which I envisioned myself finally as "all grown up": in a black dress with pearls looped gracefully over a white collar, hair burnished by the nightly one hundred strokes. Stilled, forever after competent and clear-headed — indeed the envy of my wild self who wore paint-spotted blue jeans, hole-y blue sneakers and for "good" some standard garments which I bought as "suitable." What turned out was that at thirty-five I was immersed in my husband, our baby, my sculpture (at that time I was making life-size figures in black concrete laced with scarlet), in our house and our friends, in reading (Spanish history that year) — just simply in the *process* of living. The black-and-white pearls image was the last in which I put faith. I realized that *I* was going to change and change, but I have kept on hoping (a little) that the circumstances of my life would deliver me onto a plateau, a level plane on which I would live rather easily.

I certainly miscalculated. My temperament keeps evolving anew and automatically keeps my environment in taxing flux.

It is thoroughly illogical that I am surprised by being so intricately knitted into other lives. I myself hooked every single loop and tied every single knot.

It has taken me a long time to realize that the history of women is a history of oppression. Whether conscious or unconscious is irrelevant to the fact. The "need for justice" remains imperative. Women do not, certainly, live under the threat of imminent physical extermination, but we are familiar with what Primo Levi pinpoints as the hallmark of victims: the "consciousness of having been diminished."[3]

A minor theme only intermittently audible over and under the rich major chords of my privileged, engaged life, a vagrant acquiescence to forces beyond my choice and control has always hummed subtly in my ear.

I have experienced this as a weakening acceptance of my placement in my society as a given: a temptation to substitute the grace of womanhood for achievement. In return for protection, to be content with patronage — even grateful for it. I remember with a kind of relief noticing that when I was pregnant people were always kind to me, granted me privilege, immunity. I was earning protection by making a contribution universally acknowledged as useful to society at large. I was in my *place*. But when I came, in my work in art, to step out onto the stage lit and managed by historical male power — the arena in which each generation plays out its drama of achievement — I found the graceful draperies of femininity not only encumbering but irrelevant to my aspiration.

They shredded, leaving me bare to what Gerard Manley Hopkins calls "sharp and sided hail." Because I was naive, I expected to be taken on a par with my peers, whether male or female. I expected justice. I found instead an arrangement of values. The work of men was automatically defined as more serious than the work of women. Not invariably — objective judgment exists — but tacitly — insidiously. A silent resistance depressing to enterprise as if a claim to equality, to acknowledgement, were brash, unbecoming.

Levi follows his "I demand justice" with "but I am not able, personally, to trade punches or return blows."[4] Nor I. My nature failed to provide me with weapons. I was as powerless as Levi in his *Lager*. And over the

---

3. Primo Levi, *The Drowned and the Saved* (New York: Summit, 1988), 75.
4. Levi, 137.

years I have come to his position. I too prefer to suspend judgment, with pity and rigor. I am grateful to him for thinking and feeling his way to this position, which is in itself just. For revealing to me by way of clear articulation a kind of moral cowardice I recognize in myself. The adjective "aesthetic" hits home; I have tended to refrain from protecting the little ways in which I have felt myself automatically, as a female, diminished, because to do so I would have had to act in an ugly way. "Complicity" also hits home; by remaining silent I have aided and abetted injustice. Because I have not insisted on the truth — and it is certainly a truth that there is no intrinsic disparity between men and women — I have rendered service to the "negators of truth." "Precious" service too: a real prerequisite to the preservation of a very large, pervasive lie.

July 8

I have finished the six-by-six-foot painting on which I have been working for some time. More patiently than I used to, doggedly tracking the concept that was presenting itself deliberately to my inner eye. I had to work it out in a series of paintings on paper that behaved rather like a film developing, image dissolving into image in fascinating evolution. When I stood back to look at the painting after the final stroke, I saw that I had made exactly what I had intended to and that its name was *Quest*. But I saw too that even though I had been living so intimately with it I did not *know* it.

July 9

On July 7, Sotheby's sponsored an auction in Moscow in a joint venture with the Soviet Ministry of Culture. Twenty-nine Russian artists were included. This is the first time that these young and unknown artists have had the opportunity "to be sold" on an international level. This event rose out of the Soviet cultural reforms initiated in 1985 under the aegis of perestroika, the restructuring of Russian society under Gorbachev in a new more open policy; now Soviet art can be exported, brought out into

the world market. I gather that Sotheby's European dealer, Simon de Pury, chose the work included in the sale. As a representative of a mercantile house, he bypassed the person-to-person artist-dealer relationship that developed in Europe in the seventeenth century when the medieval guild system finally broke down and that has ever since been the method by way of which art was mediated. So a mercantile house first selected art and then presented its selections for sale as a straightforward commodity just the way a department store offers dry goods. "One criterion used was how good we felt the artists are and how much potential they have," said Simon de Pury, "but whether the works have a market in the West was also taken into account."[5]

It is unquestionably an advantage that work of Russian artists can now be exposed to the world at large. But I feel trepidation. The materiality of art has always put value at risk — it stands to fall to kitsch, to a level of objects the aesthetic excellence of which is defined entirely by popular taste. Because art deals with ideas, arises out of an artist's serious effort to concede meaning, its very nature is that usually its meaning is not immediately accessible — even, or most particularly, to artists themselves. If intellectual, sensitive judgment of art is subverted by mercantile considerations, by a need to cater to the fickle taste of the marketplace, its force is blunted. Presented to the world in the same way as an ordinary commodity, art is devalued, reduced by common denomination. Under these circumstances, artists might earn their livelihoods more easily but they would pay a high cost for food in their mouths if they even by implication forfeit integrity of vision.

Hermeneutics, the art or science of interpretation, is largely obviated when art moves straight out of the studio into the immediate utility of sale. No need to wonder about a useful object. A frying pan is a frying pan no matter what color, shape, or material. Just so, art objects could be cut as well as judged on the pattern of usefulness to a public aesthetic.

But some interpretation is integral to any process of selection. Sotheby's venture simply makes forthright marketability a major factor

---

5. Gary Lee, "Sotheby's Goes to Moscow," *Washington Post*, July 7, 1988.

in the evaluation of art, thus in one stroke largely defining what is "good art" as what is saleable art. If what is good is what is saleable, a mercantile house could first define the good and then promote its interpretation to the public — and make money. There is nothing intrinsically dishonest in this process. Nor is it even different from that devised by meretricious art dealers, and there have always been such dealers as well as idealistic ones. Sotheby's has only stripped it bare: selection for sale, then sale.

The Sotheby's auction was brilliantly successful. The house flew in eighty collectors from London and New York. A total of 120 artworks sold for a total of $3.6 million. Five paintings by one young Russian went for a total of $767,636. So Russia now has, instantly, the same kind of art market that prevails in other Western countries. A coup of merchandising.

Ironically, this is precisely the situation projected by Karl Marx in *The Communist Manifesto* of 1848. Frederick Engels writes in his introduction to this document "that in every historical epoch, the prevailing mode of economic production and exchange, and the social organization necessarily following from it, form the basis upon which it is build up, and from which alone can be explained, the political and intellectual history of that epoch."[6] Based as it is on the economics of money, our society's intellectual history is to a degree constrained by what Marx calls "bourgeois" values. Artists have traditionally tended to separate themselves out of society in order to evade this constraint. This attitude may be coming to an end. Karl Marx writes in the *Manifesto*: "The bourgeoisie has stripped of its halo every occupation hitherto honored and looked up to with reverent awe. It has converted the physician, the lawyer, the priest, the poet, the man of science, into its paid wage laborers."[7]

Artists do not, it seems to me, want halos. But converted into wage laborers, they stand to betray their vision. And they deprive the world of the value of that vision, the value of stubborn individuality actualized.

---

6. Friedrich Engels, "Preface," in Karl Marx, *Manifesto of the Communist Party* (Chicago: Charles H. Kerr, 1906), 8.
7. Engels, 16.

July 10

The other side of the convex-concave line along which art is devaluated by the marketplace is its overvaluation there. Contemporary mercantile manipulation has ballooned prices. So works of art are on the one hand reduced to objects of common commerce and on the other elevated to be financially dear. A sinister hypocrisy.

My own instinctive feeling has been to avoid thinking much about this social issue at large by hewing steadfastly to my privacy. But Primo Levi has taught me the implicit self-indulgence of solipsism. Refusal to think clearly in gray areas of this sort can indeed be "a moral disease or an aesthetic affectation or a sinister sign of complicity."[8] If I do put my mind on the matter, I may start inside my privacy in my studio, but must define my attitude toward the objects I make and then define my attitude toward the world into which these objects go.

Solipsism: "A theory holding that the self can know nothing but its own modifications and that the self is the only existent thing." It's Latin, *solus*, alone, plus *ispe*, self.

July 13

I was deadheading the flowers bordering my flagstone terrace the other day when I noticed that a large gray-violet-green fluffy tangle had alighted there. When I examined it, delighting in its subtle matrix of delicate tendrils, I saw that it had flown from a neighbor's smoke tree across and up the street a way. It had traveled aloft quite a distance. If it had fallen on fertile soil, this collaboration of wind and seed would have started another smoke tree. I thought of the shining tracery left by the tracks of slugs on my front steps, and all of a sudden the plants and animals living around me entered my imagination as a whole alive context replete with secret purpose.

---

8. Levi, *Drowned and the Saved*, 48–49.

A building on the route to my dentist is faced with mirror, and yesterday I caught a glimpse of my reflection there while waiting in a group of people to cross the intersection catty-corner to its facade. I am like the tuft of smoke tree, I thought, wafted by chance, as incidental in a vast dance of forces. I thought of families too, how we scatter from a birthplace, like colonies of spores borne on a wind.

July 14

I circle back to the matter of art in the marketplace. As Primo Levi could say, "I was not a murderer," I can say, "I am not a meretricious artist." It is not a statement on the scale of his, but one of similar factuality, a point of reference in a moral context. For it is obviously wrong to place the mysterious gifts of the spirit in the service of any ulterior motive whatsoever — renown or remuneration. I do not suffer from "a moral disease" — literally a moral dis-ease. On the contrary, I am at unique moral ease in my studio; I feel that I am where I should be, doing what I should be doing. I do not discern the use of my work, but it feels to me a good as well as an imperative. I have intrinsic faith in it even as I make what I do not entirely understand. The closest I can get to use is its role in my life as a fascinating teacher.

And I honestly do not find in myself "aesthetic affectation."

"Complicity" is a more tangled involvement. For my work does enter the marketplace and is inevitably subject there to its forces. I feel these forces too: the temptation to wish for sales, the temptation to feel bitter about the worldly success of other artists, their fame and riches. I try to withstand both. I am reasonably able to do so — no more, no less. I do not congratulate myself. I have been fortunate: born with energy into a privileged family, I have been less than most people at the risk of financial need and of envy. In addition, my complicity with the forces that would devalue the art I value as a good in society is largely mitigated by my obscurity as well as by the honor of the dealers I have chosen to handle my work. I am watchful, also. To withdraw from all traffic that comprises the world of art would be to deprive myself of objective checks

and balances. Isolation is not a solution; nor is it brave. I must, it seems to me, continue to hew to my privacy — essentially hew to my temperament. The vulnerability intrinsic to that temperament leaves me open to being hurt, but the longer I live keeping that nerve open to the world the more clearly I perceive its usefulness as a guardian of integrity. For hurt is felt by my ego in the largest sense, by my vanity in the smallest. I treasure neither in the complex, intricate, radiant whole I occasionally — but ever more persistently — know intuitively to be the true context in which I am living. So I will continue to use common sense in my dealings with the art world and retain my own pivot in it. From this stance, I can evenly observe its whirling from the perspective of pragmatic objectivity.

## July 15

Summer has deepened, day after day of temperatures in the high nineties and low hundreds. We human beings have not only allowed chemical poisons to penetrate the friable earth but also have polluted the air with our doings so that the ozone layer around our planet is thinning dangerously. If unchecked, this depletion will apparently turn our environment into a "greenhouse" nurturing death instead of life. Not quite yet though, as even in this noxious air my tomato plants and flowers are stubbornly flourishing here in the garden where I write. I protect my little rectangle of the earth as tenderly as possible, but more and more as if it were an enclave under threat. A society is not healthy if an individual is so reduced to privacy.

## July 23

Spiritual teachings are couched in the polyglot of differing languages but universally warn against five pitfalls: lust, anger, greed, attachment, and vanity. These are the particular sources of suffering that blot out intimacy with what Pierre Teilhard de Chardin calls the "divine milieu," divine beneficence. They intertwine like Chinese ivory carvings of intricately writhing animals in which the back leg of one is seen on inspection to

be the foreleg of another. Thwarted lust and greed, intrinsically insatiable, inflame anger that can become the engine that powers a personality, attaching it to the schema of a world that adamantly refuses to bend its trajectories to an individual's will. When in the protean grip of these emotions, we are as hapless as Jason's bride Creusa in the fiery wedding garment woven for her by the jealous sorceress Medea — the gown that she could not pull off herself even as it consumed her flesh.

I worked out two ways to spare myself this ravage. First, I try to catch these feelings just as they step over the threshold of my consciousness, while they are still only visitors at the door and not in residence. I do not deny them, for that would be dishonest, but I do not make them welcome. I then make a second effort: to substitute them with their counterparts — continence for lust, forgiveness for anger, contentment for greed, detachment for attachment, humility for vanity. This litany — continence, forgiveness, contentment, detachment, and humility — evokes in me a perspective like that of a glade in a thicketed forest. I stand clear in that calm space. I breathe by choice my own breath, drawing in air so alive that in it I seem to have my original being.

August 4

I am working on my third large painting of this summer and am quietly wondering if I am once again changing behind my own back. I have been attached to sculpture partly because of its independence: it stands free in its own space, in the passage of light and time, as we human beings do. I am noticing that this advantage is undercut by two intractable factors. The first is the intransigence of its three-dimensional physicality. My sculptures are particularly difficult because they are so large and so heavy and their multilayered, delicately glazed surfaces are so vulnerable. The second factor is related to my own development: I more and more experience myself as *not* independent because I have come more and more to recognize a unity that renders the independence I have so cherished a misunderstanding. The tuft of smoke tree I found on my terrace can only be thought of as having been independent in a romantic anthropomorphism, by attributing

to it singular and conscious motivation. Actually, it wafted in accordance with laws to which it was subject, and I have come to know that my own apparent independence is virtually as subject. What is experienced as motivation arises out of a complex of unknown, ultimately unknowable, psychological and physical forces. I am independent only in the narrow sense of being intact. So a part of my identification with my sculptures has come into question. The fact remains, however, that if I had the money, I would make them most joyfully!

But even with this fact in mind, I am finding that the fascination of making paintings grows and grows. I have long known how to set space free in them — depth, breadth, and height by implication within a context I make as I paint; that has been a consistent delight for years. But this summer's work has moved me closer to the intimate nerve of my sculpture: weight in closest proximity to escape from the law of gravity. At the tail end of my work today, just before I succumbed to utter fatigue, I put paint on paper more simply than ever before and saw as I stepped away to look that gravity had been contravened. A reality I almost do not know had come just barely visible. A hole that refracted back to my earliest perception bloomed out of my memory, as if in a fast-running film, into form.

August 9

I finished the third large (six-by-six-foot) painting yesterday. An image that I have been catching since 1960 on the edge of its turns floats free in these works, poised on a tilt of color which at once rivets attention because it is gravitative and at the same time resists stasis because its hue pulls the eye back into receding space. There is really no place to catch and hold on to safely. I seem to have cut loose from weight organized within the vertical and horizontal, which I first caught a glimpse of at Westminster Abbey with my mother when I was ten.

This morning I stepped out onto my upstairs porch to look at the stars, lured by the first crisp edge of autumn in the air. A little north of brilliant Venus, I saw the faint alluring sparkle of the Pleiades. For some reason beyond logic, the sight of these stars — six quite visible

to the naked eye, a seventh just barely visible, more invisible except by telescope — always fills me with a rush of pure joy. As if I were recognizing home in the distance. And indeed, the Pleiades are at a distance: 220 light years from Earth, these stars fill a space 1,200,000 times that between our sun and earth; each is many times brighter than our sun. They shine from within a nebula, a mass of cloud-like matter from which they refract a soft luminosity. I gazed, transfixed, and suddenly became conscious of my feet planted on the earth, on a ball of material not only turning more rapidly than I can even imagine but also wobbling on this axis of rotation from millisecond to millisecond according to fluctuations in the pressure of invisible air.

October 22

During my flight north[9] we cruised above New York in air so clear that the city lay bare beneath us in a miniaturization of itself. It was only by denying the evidence of my eyes that I could call up its actuality, its scale from ground level. Returning yesterday, we flew through a layer of clouds so deceptively refracting the sun above us that looking down I could have been looking up, or could have been in a shallow boat floating on a misty lake. Such experiences detach me from reliance on my senses. Ever more "realistically," I perceive my self essentially independent from them even as I move confidently in their context, and work out of it too. I hover over unmoored structure in the paintings I am making, as if to make my own unmooring from my senses visible — but it stands, intransigent, as if stayed in law.

    A friend drove me to the airport yesterday by way of Smith College, which I wish to see because my mother's mother was one of the nine women in its first graduating class. By sifting out the older buildings, I was able to envision what the college may have looked like when she

---

[9] On October 3 Truitt gave a visiting artist lecture at the School of the Museum of Fine Arts in Boston, the text of which is included in this volume. See pp. 242–53.

was there and to draw closer to her. I remember her as a woman of my own age now: an indomitable figure, impressive even in her bed to which rheumatoid arthritis anchored her for the last years of her life. Child that I was, I recognized the quality of *choice* in her, as if she disdained her circumstances to pursue purposes all her own. That memory has strengthened me. Anna Palmer, her name was, when she set out from Boston to Northampton. She must have descended at the very train station I saw as we passed by. A brave young woman with her life ahead of her, with intentions ineluctably telescoping toward the end of her life when she was the old woman her granddaughter now welcomes as kin.

The business of going out to speak is odd because it has no apparent outcome. For a discrete period, I enter an entirely new terrain, meet people I will likely never see again, with whom I establish relationships, even rather intense ones, only to part immediately. A metaphorical microcosm of an entire life.

October 24

Rain is shearing the leaves off trees this morning. I stand at my garden door and watch the grass receive them, each on a slope of wind.

*Chrysalis* is finished; a new painting is started. Later this week, I will wash and starch my white curtains. Then I will be ready for whatever comes — clean curtains being for a house what clean hair is for a body, a signifier of alert care, one that might even forefend disaster.

October 25

At the very core of my life, I know in a way unspeakable the distinct presence of the divine. A force that narrows to a point toward which I myself am at pains to narrow until a kind of touch is established. This touch is so *real* that my being is stayed in its actuality. The reality of the divine is reinforced by my perception of it in the same way that the existence of the sun is reinforced by its rise every morning. I can reach this point at

will if I am quiet, and there is my comfort. Much more than comfort, for I find there a perspective to which my individuality is incidental, although it has a decided place there.

November 13

The painting I am working on has no name. It is slowly emerging out of layers of blues finally glazed late yesterday afternoon. Today I aim to circumscribe its center, unattached to any point other than to that center around which I feel it pivoting as previous paintings have pivoted on the vertical and horizontal lines of gravity. I am once again brought face to face with the independence of the artist in me. She continues steady as she goes, absorbing and transmuting. Her course holds my life true. All dovetails into that alignment and perspective, develops naturally out of its stability. Continuity also, for the artist learns no matter what happens.

November 15

Yesterday was a difficult day. I began it after a night of torn sleep out of which I slid into consciousness as if out upon steep waves on which I felt myself windblown spume.

"Temperament" is a word that has kept recurring to me. This morning I looked it up in the dictionary: "Constitution of a substance, body, or organism with respect to the mixture or balance of its elements, qualities, or parts."

My final psychology paper at Bryn Mawr dealt with the matter of ego strength: What in psychic development leads to an individual's capacity to adjust? I still see that question as central. And essentially mysterious, for although we struggle all our lives to maintain a balance within the range of our temperaments, we do not quite know how, or with what, we do so. In any case, I have leveled off, and this time I feel as if I will remain so.

I have "closed" the studio, covered my work safely and put it mentally into a holding pattern. The knowledge that my paintings are there,

waiting, is profoundly satisfactory: they cannot change behind my back or come at me from a damaging angle because they are material objects, inert until they come once again under my hand.

December 15

The earth is fast moving on its orbit toward the winter solstice. Each morning I wait for the sun to rise later, later and later, and each evening I watch light drop earlier and earlier into darkness. I feel this waning light in my body as inertia, as if gravity were waxing. For years I have planned my annual cycle of work to accommodate this feeling that is not entirely dependent on light — which I have known since 1981 when, in Australia, I went through the solstice in June and felt it scarcely at all.

January 1, 1989

Snow is dropping in big flakes so distinct that in the light of the city lamp that illuminates my garden I can follow their deliberate fall from the black sky to the black earth. I watch from my kitchen door, and remember just such a snow in 1984 at Yaddo. There I had watched land, on which I had lived attentively for nine months, receive and absorb, day and night, in and out, all that fell to its lot. Speculation stilled by this impartial osmosis, I felt myself slowly come to receive and absorb in the same way, to reach the edges of a unity within which each element of experience, subjective and objective, fit seamlessly into a whole that includes me as integer because I remain whole, in no way diminished except in scale. As if my individuality were comparable in amount to that of a mitochondrion, one of the minuscule bodies held to be the centers of cellular respiration. But even "respiration" is too heavy, too structured. There is simply no word for this feeling of being at once permeated and permeating. In this state of mind I feel most irreducibly myself, most truthfully *a self*, with all that being a self may imply.

January 19

The painting I finished yesterday, *Promise*, is poised almost imperceptibly on a pivot of gravity.

The mitochondrion stays in my mind. Surely, in the purlieu of the cell, it can know neither up nor down.

It is dark as I write, predawn. I have already been in the studio adding a coat to the painting — still unnamed — that I hope to finish today. It will pivot on a slender sphere of scarlet. I am curious to see how it will look and how its space will feel. All this up-down ambiguity is new to me. A change in my habitual concept of space, always so soundly grounded, exemplified in sculpture, that most grounded of arts, is evolving beyond my ken, is becoming visible to me in my work.

January 20

When George Bush took the oath of office as president of the United States today, I was listening to a lecture on the pastoral landscape at the Center for Renaissance and Baroque Studies at the University of Maryland. In the congenial company of scholars, intently examining Poussin's painting of Polyphemus, I heard a learned discourse on how Poussin epitomized in this painting of the solitary giant, his back scarcely distinguishable from the rugged mountain perch from which he faces out toward the sea on which his beloved Galatea disports, the boundaries between a pastoral world inhabited by nymphs, satyrs, and human beings tending the earth and the idyllic world of art. Galatea's sea is visible only in a remote distance; she is invisible; only the pipe with which Polyphemus serenades her authenticates her existence. But she "holds" the painting: saving her presence, we would be confronted by a more or less ordinary world enhanced by a vivid pastoral imagination but without mystery. For Poussin states (to my eye) that the world accessible to imagination reaches only to the edge of a meaning toward which we — rough-hewn and primitive as Polyphemus in our passions — yearn, a meaning we court with the reed pipe of art. "I

am where I belong," I thought as the lecturer connected Polyphemus and Galatea with Theocritus's *Idylls*, with Roman wall paintings, with Horace's *Odes*, with Ovid's *Metamorphoses*. Historical changes, the turn and turn about of political power symbolized by the transition from President Reagan to President Bush, take place in this rich context of human thought that reaches out toward the frontier between the human and the divine.

January 22

I signed *Promise* and *Cleave* yesterday. It is as if I were making a world in which I were being forced to acknowledge boundless vulnerability.

January 29

I open my eyes into a sunrise of extraordinary splendor. Broad translucent bends of gold, scarlet, and apricot yellow held in tension by streaks of opaque blue gray stretch across the eastern sky. A symbolic guarantee of a promise implicit in nature sufficient to lift my personal heart, but as I gazed deep into its brilliance I remembered the drive with friends yesterday afternoon through a derelict section of Washington I prudently avoid when I am alone. The pitted streets through which we drove were strewn with rubble, tracks through ruins scarcely less wasted than those in the wake of a catastrophic earthquake. Gigantic cement pipes had been heaved up out of the earth and lay tumbled end on end in the interstices of bleak buildings either windowless or clumsily boarded against ingress. Litter — shards of glass, crumpled paper, splintered shafts of wood up-slanting, various bars of steel, matted garbage — made ugly every open area to which the eye might look for relief. People, mostly groups of sullen men, loitered about. An old man drank from a beer can. A child in a blue parka hung listlessly over a stair railing. Over the cellar of a boarded building, a faded sign: Beauty Salon. Inside, deep back in a room so dark that only shadows were dimly outlined against a distant bulb, arms moved — the only purposeful

gesture visible for blocks and blocks — over an oval shadow that must have been a head of hair.

Only brutal indifference filters down to these citizens from the radiant marble dome of the Capitol, around which last week luxurious limousines, elongated as sharks, cruised in the effrontery of inaugural ceremonies costing millions of dollars.

February 16

Art is redemptive. If it is lucidly received, it acts as a liberating force returning the viewer's spirit to a state of innocence within which verisimilitude catalytically extends the reach of understanding. It is for this reason that the artist's life, otherwise as anecdotal as any other, has to be lived with a special attention. For verisimilitude, truth to life, is acceptable only if it is vital, so utterly faithful to the reach of individual experience that it evokes that of all individuals.

My life draws an ever more overlaid line on the earth under my feet. A pattern, a connective crisscrossed cat's cradle.

A sunburst of conception in my mother's womb one July night in a clapboard house set on a lawn spreading clear under maple trees on a quiet street in a small American town. Slow darkness out of which I slipped in the early morning of March 16, 1921.

## Visiting Artist Lecture, Boston, 1988

Artists are adventurers. They set out alone into the strange realm of their own spirits, equipped only with courage and what they carry with them. What they carry with them is their personal experience. In order to carry it with them, they have to examine it in a particularly attentive way, so that as they go along it becomes as intrinsic as dye in cloth, coloring everything to which they put their hand. They then render their individuality visible, thus making it useful to other people. Essentially, artists struggle to understand themselves so that they can give themselves away.

In this sense artists lead solipsistic lives. Solipsism is the theory that only the self exists, or can be proved to exist. The colloquial analogue of the word "solipsistic" is "selfish," and for this reason, before I realized I was to give myself away, I resisted for some years the idea that I was somehow caught in the center of a web I wove for myself as I lived — a myth I invented as I went along to make sense of my life. I now see that my interpretation of my life is fallacious only to the extent that it is determined by the nature of intrinsic limitations, no more and no less a lie than that to which every human being is subject by the very fact of having been born into an idiosyncratic sensory vehicle by way of which experience is automatically mediated.

We all have this limitation in common. We all come into this world unknown to ourselves, and we all have the responsibility to learn who we are. It is important to state that this process is universal, because ever since the Renaissance concept of the artist as a special, esoteric person began to prevail in Western thought, the differences between artists and other people have been increasingly exaggerated. This artificial gulf has tended to

---

*Presented on October 3, 1988, at the School of the Museum of Fine Arts. "Boston," typewritten notes with handwritten annotations, box 49, folder 21, Anne Truitt Papers, Special Collections Department, Bryn Mawr College Library.*

set art apart from society in general, to the detriment of those who might learn from it. A lame acquiescence to this divisiveness has also tended to color artists' feelings about themselves, to bloat them with vanity, with the assumption that they are entitled to special consideration. It is never wise to allow oneself to be defined by others. In this case, such passivity does particular harm because it tends to substitute a social definition for the exceedingly difficult and perilous individual definition of self that lies at the heart of the artist's adventure.

I use the words "difficult" and "perilous" because I think that there is a real difference between the depth to which people in general are called upon to explore themselves and that to which artists undertake to plunge. For artists are their own resource. They *are* what their work is *about* by the very fact that they make it, regardless of whether they represent the world around them or evolve a formal iconography into which their experience distills. In either case, so much of human experience is universal that a lucid individual view serves to illuminate it for all of us. I am convinced that when personal experience is honestly examined, and honestly expressed, it adds an authentic thread to the warp and woof of human thought.

Granted the generally universal nature of human experience, there is a gulf that is not artificial between one person and another. I have chosen to stand straight on my own territory, and to define myself for myself in my work. I will try to do so for you this evening. I will use declarative sentences, but I assure you that the development of my work has not always been as clear to me as I may make it sound. But then, it would not have interested me so much if it had been. Perplexity is fascinating, and determination conquers all.

I choose not to be defined. With that cleared out from under our feet, I would like to put my foot on my own particular adventure — not because it is in any way extraordinary but because it is an example of how one artist developed. I am smoothing my way for you, but I can assure you that it has not been smooth. I recently got my papers together to deposit in the archives of Bryn Mawr College, and I was startled to see my own tracks through thickets of confused passion.

My first distinct memory of myself as an entity is from infancy — and that tends to be characteristic of artists: they have long, distinct, and

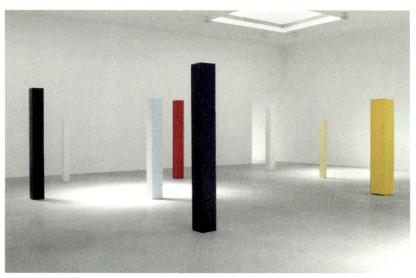

Installation view of "Anne Truitt: Sculpture 1962–2004," Matthew Marks Gallery, New York, 2010. From left: *Twining Court II*, 2002; *Prescience*, 1978; *Harvest Shade*, 1996; *Return*, 2004; *The Sea, The Sea*, 2003; *Threshold*, 1997; *First Spring*, 1981; *Sun Flower*, 1971.

luminous memories that they hold on to and use. What I remember is lying on a table at night. I am in a pulpy body that is wet and cold. Someone is leaning over me. She is taking the wet and cold away and is making me comfortable. I am *surprised* to find myself in this odd situation. I look up at the ceiling. A ray of light crosses it deliberately, thrown up from the street below.

This is paradigmatic of all my experiences. I am inside my body. I look out from it. In my second memory, I move independently for the first time: I walk on uneven bricks from my father's knees toward a window from which I am being called.

In both these memories I feel confident, attentive, interested. I was fortunate in having been born to parents who rather let me alone. I seemed to feel from them a kind of confidence in me that set me free into my own space, to set a pace for myself. They expected from me a kind of attentiveness that would keep me reasonably safe in my independence from them. These two memories have set my course ever since: I *look out* and I *move*.

None of this is particularly unusual, but I have come to understand in the course of a long life that what *was* unusual was the energy and purpose with which I set to exploring what was around me and to collect from it and to save out of it — as if from the very start I began to set in motion a radar beam of attention that has swept round and round over my head ever since. It passes over almost everything, but when it focuses, it focuses with immediacy and intensity, and nothing on which it focuses is ever lost to me. It is out of this treasure trove of selected experience that my work in art has sprung.

It may be that a common characteristic of artists is a particularly acute sensory apparatus — a nervous system that picks up information in the raw, without insulation; and also picks it up in detail, vividly, such that it accumulates experience with a special immediacy, with the force that makes fire hot and ice cold. This can make artists' lives difficult, but it is a stock in trade, though unsought and unearned. It is a gift and a responsibility, and artists who are wise take care of their bodies. They eat well and guard their health and energy so that they can tax it when they choose to use their bodies up in their work. For all artists do that. They use themselves profligately. That is one of the particular joys of art: the

feeling of using oneself without let or hindrance, underwriting in one's own person a course of action without visible end.

I have dwelt at some length on how this process developed because I would like to make certain that it is properly aligned: founded in my body, informed by my mind, and lit by a spark that is life itself, which I do not understand in a linear, logical sense but which is so intimate to me as to be my innate consciousness. A consciousness with which I entered this world with the distinctive knowledge that I was somehow informed already. I have the impression that when I depart I will take it with me. Or it will take me with it.

I think of it in myself — and it is in all of us — as an alive nerve. I know when my work is quickened by it. I destroy my work when it is not quickened by it. It is a mystery.

The circumstances of birth are as much a given as one's sensory apparatus. I am fortunate to have been born to parents who not only implicitly encouraged independence but also had money — not so much as to loom but enough to give me its privileges. I was born in 1921, and grew up in a small country town on the Eastern Shore of Maryland, at a time when horses still brought ice and milk to our door, and when the only noises were animals and birds and wind and rain, and human voices did not have to be raised to be heard. When I set out to explore, first by walking and then later on my bicycle, I could safely encompass the whole territory of the town and land around me, so that it was imbued with the intensity of personal discovery. I am nearsighted, but this fact was not discovered until I was about ten years old, so my first impressions of the world were blurred. I made my way by concentrating on details close to me, on the one hand, and on the other by using my kinesthetic senses, particularly by intuition of weight and mass. And by developing antennae for emotional atmosphere: I couldn't see people's expressions so I had to guess what they were feeling by reaching out into the air around them.

This sensory development that I have traced for you, combined with my intense reliance on independence, coalesced in the work I began to make in 1961: large, plain sculptures deriving their proportions and carpentry from the seventeenth- and early eighteenth-century brick and clapboard houses of the town I grew up in. They stand on their own feet, clear in their own space, clad in an atmosphere of color.

But let me go back and draw the line along which I came to this work. After moving about a bit — including a year's stay on my aunt's farm in Virginia, during which I learned for the first time to use my hands, to make dresses, to separate cream from milk, to can peaches — I went to Bryn Mawr College.

At Bryn Mawr, I learned the art of formulation — how to express experience in precise form and to develop it in systematic ways, along with a range of information which set in place a structural context, an armature, for my thinking. This ability to formulate was crucial to my development as an artist. Ever since Picasso and Braque shattered the appearance of the natural world by inventing Cubism in the first decade of the twentieth century, artists have had to invent their own iconography. They formulate a reality intimate to themselves and develop this reality rather systematically in a large number of works, thus establishing their own iconography as a territory to which they lay claim. At least they have had to do this if they wished to push the limits of formal art. I do not denigrate artists who are loyal to appearance, but the bent of my mind is toward abstraction, toward the formulation of experience into abstract visibility. At Bryn Mawr, I was not as much interested in visibility as in serving people — I majored in psychology — but I caught on to the principle of abstraction. And to another principle: that of never allowing any one theory to harden into conviction; never losing touch with my own experience no matter how it might contradict anyone else's experience. I got the habit of sticking stubbornly to independence of thought, just as I had stuck to independence of movement when I was a young child. It is partly for this reason that I have consistently resisted the tag of Minimalist.

After graduating from Bryn Mawr in 1943, I worked for the remaining years of World War II at Massachusetts General Hospital, as a psychologist during the day and as a Red Cross nurse's aide at night. This meant being exposed to pain, either mental or physical, for virtually all my waking hours. Everything in my life seemed to have prepared inside me a large place into which this pain could be absorbed. It was particularly in the wards of the hospital at night, when I had my hands on patients in all sorts of ways (so that I learned with my body), that I began to glimpse the existence of what Federico García Lorca calls *duende*. I felt it as something

inside the patients first, then as a well of feeling in myself which matched their pain, and which we, the patients and I, filled together. Lorca wrote that "the *duende* surges up from the soles of the feet." He called it a "mysterious power that everyone feels but no philosopher can explain," a force that "has to be roused in the very cells of the blood." The *duende* "wounds, and in the healing of this wound, which never closes, is the prodigious, the original in man's work." It is "drawn to where forms fuse themselves in a longing greater than their visible expressions." The feeling that welled up in me began to emerge in the form of poems — endless scribbled sheets of paper now deposited at Bryn Mawr. Bad, mad, wild poems which, in the 1950s, by which time I had married and was living in Washington, DC, and had a studio in an alley there, transmuted into life-size figures in black cement slashed with scarlet.

Just as the patients had taught me through my touch on their bodies, marriage and the birth of my three children taught me through my own body "from the soles of my feet." And once I had come to the art of sculpture, I adhered to its practice through thick and thin. David Smith used to say that it takes about fifteen years to make an artist. I began sculpting in 1949. Twelve years later, in 1961, at the age of forty, I slipped, by what seemed to be a sort of miracle, into work that not only rose up right out of my own well but also rose into my trained hands and out into reality. Twelve years of apprenticeship to myself. I went to art school for one year and was lucky enough to have an Italian teacher who taught me during that year all the methods of traditional sculpture. The atmosphere was altogether wholesome. By "wholesome," I mean that we learned without ulterior motive. Unplagued by hidden agenda, we avoided the moral error of what logicians call "linked causation" — that is, we made work for its own sake and not for any purpose to which it might be put. Of course, we knew that artists exhibited their work, and that we might ourselves, but our discussion was more likely to be about the scale of Ashanti gold weights than about exhibition. The situation in art schools today is far more sophisticated, and I think that that is good, because the more variables operating at any one time the more likely it is that some combination of them may alchemize into an entirely original form of expression. But good only if in a context of normal proportion,

one which distinguishes clearly between the intrinsic value of making a work of art and the extrinsic value of its use in the world. This intrinsic value is essentially heuristic. It abides in what the artist learns in an honest and passionate exploration of resource within self rather than in objects produced. I speak, of course, from an artist's point of view. From the point of view of the world, a great work of art renders the artist virtually expendable. And so the artist should be left to be: private life is private. Motives are matters of interpretation, and interpretation is, of all human activities, perhaps the most subject to error.

A life is anecdotal, that is, it moves along in linear fashion from event to event. These events differ remarkably little from person to person. They constitute the subject matter from which the content, the meaning, of a life is derived. I have been speaking of what can be learned, but the essence of this content, which is the essence of art, cannot be learned. It has to be caught in some mysterious way, apprehended just beyond the senses by a reach of intuition.

The distillation that took place in my work in November 1961 is a mystery to me. It came upon me suddenly, during one night following a day of looking at art in New York. This day of looking was, I think, its precipitating cause. I had been living in California for some years and had been having children. I was out of touch with the variety of ways in which art had developed. Three aspects of this art struck me: the space in Barnett Newman's huge paintings; the close values of Ad Reinhardt's color; and the use of carpentry in a little wooden sculpture I saw at the Guggenheim Museum. These specific visual facts collided in my mind, without merging, and it was as if they instantaneously solidified into three tools for my hand. I grasped too, for the first time, the fact that art sprung out of concept and not out of process. I had been isolated in my apprenticeship to myself and had doggedly continued to pursue what was real for me by trying to wring it out of matter: out of clay, cement, welded steel, wood, stone. In one great clap of insight, my entire understanding of how art came into being turned upside down. And instantly lined up with my nature — my innate classicism, my intense attachment to proportion, to form, to color.

This insight was the precipitating cause of the sudden change in my work, but the predisposing cause was my entire life. For what I saw in my

inner eye as I sat up in the middle of my bed all that night in New York was the landscape of my childhood: the wooden fences, the flat reaches of pale rivers, the clapboard houses, the subtle colors of the tidal Eastern Shore of Maryland. I saw how I could use the three new tools put into my hands to bring this deeply intimate and highly charged vision into rebirth. I got up early the next morning, took a train home, bought some shelf paper, drew on it, ordered boards cut to match my drawing, glued them together and made *First*.

I would like to make clear the fact that I was at this point distilling the totality of my experience, and that I was not thinking of art while I did it. If I thought at all — aside from technical problems that I had to solve — I thought of love. I am sorry that "love" has become so devalued a word as to no longer express profound depth of feeling. As these sculptures poured out of me, it seems to me, that although I was making visual objects I was actually speaking the unspeakable, of how life had penetrated me and taken form in three children, brought forth in pain and blood that reverberated in my memory of the patients I had tended in my twenties; of conflicts so thicketed that I had had to abandon hopes long cherished in the face of helplessness; of dawns and dusks and rain and sun and ice and fire; of the courage with which human beings get out of bed every single morning without knowing from whence they came or where they are going.

*First* is literally a fence. As the work moved forward, literalness was slowly left behind; proportion and color took over.

•••

I would like to change my key here and to speak a little about how I have evolved ways to handle my work in the world without undue damage. For this work went out into the world almost instantly, with no effort on my part at all, simply because other artists saw it and recommended it to André Emmerich, who immediately offered me a "one-shot exhibition" in February 1963. At the end of that opening, he turned to me and said, "I hope this is the beginning of many exhibitions," and we have been together ever since. Now that can be called pure luck, and indeed luck plays a part in life, but I hold it as a pragmatic fact because I have seen its

proof over and over that work of quality comes, sooner or later, into the light of appreciation. It may not happen in an artist's lifetime. That is a sad fact. Not because serious artists necessarily crave praise, but because art is a lonely pursuit. We need a *comitatus*, a band of companions. For we are ourselves a *comitatus* within the larger fabric of society, set to a degree apart from it because we contribute to it at an angle, tangentially, and are not essential to its everyday functions.

I have found it useful to make an arbitrary distinction between my work in the studio and my role as an exhibiting artist. I use the word "role" on purpose, for no matter how pure the artist's conduct, exhibiting has an element of drama. When I foray out of my studio for an exhibition, I consciously maintain my current work in my inner eye, and stay my mind on it. Actually, I often have lost intense interest in the work that is being exhibited; I have moved on. So the reception of an exhibit refers to past work, which dulls its impact for me.

Not that I am not hurt. I am often hurt. I have seen my work sat on because it was mistaken for a seat of some sort, and I have seen it pushed over because it irritated people — some resent large objects that stand up to them. I have had some exhibitions in which everything sold and some in which nothing sold. But I have never had an exhibition during the course of which I have not received at least one profoundly touching note of appreciation. There has always been one person who saw, felt. The only real danger of exhibiting is taking it too seriously. When all is said and done, artists return to their work; they go home to it.

Although they can be wonderfully sensitive, even instructive, critics are essentially irrelevant to artists. As Barnett Newman once remarked, "Critics are to artists what ornithologists are to birds." I once asked a friend of mine who is a critic what Joseph Beuys's presence felt like during an Action; he told me how the Action had gone; I asked again what it felt like; in fact, I asked three times and then gave up — he simply had not felt Beuys's *presence* at all.

Let me make an analogy for you. The earth spins in space. We observe it. We measure it in various ways. We order observations and measurements to form a semiotic byway of which we arrive at what we call knowledge of it. The earth continues to spin. Just so, the artist continues to work.

I would like to say a few words about the particular position of the artist who is a woman. I am sorry to have to do so. For a long while I denied the existence of discrimination on the basis of gender. Until in 1975 I gave a lecture at a university and was introduced as "a woman artist." I was taken aback, and because I had not thought the matter through I lamely went ahead and spoke without addressing the implication that artists who were women had anatomically to be set apart so that the wind might condescendingly be tempered to the shorn lamb. I thought it over on my way home, wrote a stinging letter to the man who had introduced me, and refused the honorarium.

In his last book, *The Drowned and the Saved*, Primo Levi addresses the subtle collaboration between the oppressors and the oppressed at Auschwitz. Trained as a chemist, he was appointed a "privileged person" and found himself in what he calls "a gray zone, poorly defined, where the two camps of masters and servants both diverge and converge." Although this analogy is out of proportion, men and women do find themselves in such a "gray zone" in which social history has railroaded them into it even as prisoners were railroaded into Auschwitz.

Levi pinpoints complicity as the moral issue within the zone. His emphasis is on the complicity of the oppressed with the oppressors, but in the case of men and women the complicity goes both ways: we are all equally at moral jeopardy and must protect each other as well as ourselves. I find it most useful to refrain from anger and to handle any instance of discrimination immediately, with an even hand, without compromise.

I would also like to speak briefly of another historical phenomenon: the way in which art history autocratically picks up an artist's work and places it in a context not of its own articulation. I have thought long and hard about this matter, because when I began to exhibit in New York in the 1960s, I found my work named: Minimalist. On the one hand I was praised for having initiated what I had not had any intention of initiating, because my work was so personal to me; and on the other I was denigrated because that work did not fit properly into the developing canons of Minimal art. I found myself placed in the uncomfortable position of being defined by a cacophony of voices within which mine was drowned. My reaction was to listen, to bring

to bear on what I heard as much sense of proportion as I could, and to keep on working steadily.

I wish that I could say that I have found in the intervening years a wiser position, but I have not. The saw that "if you don't like the heat you should stay out of the kitchen" is as true as most maxims. If artists exhibit, they step into an arena in which they are fair game.

In closing, I would like to say that on balance I do not know of a more fascinating way of life than that of an artist. *Homo sum; humani nihil a me alienum puto.* I am human; nothing human do I hold alien to me. Artists take all in, and in the crucible of their spirits they alchemize and ennoble all that they touch.

## "Painted Lady of Paris": Review of *Utrillo's Mother*, 1989

Interpretation is always perilous, offering at best revelation, at worst impertinence. It is perhaps riskiest in a fictionalized biography. Sarah Baylis runs along this knife edge in her narrative of Suzanne Valadon's life, *Utrillo's Mother*, and maintains her footing principally because of her enthusiastic and imaginative empathy with her heroine. Maurice Utrillo became during his mother's lifetime a more famous painter than his mother — his version of Paris as a white city under a gray sky has become almost banal — and the title of the book is ironic: in the politics of art a woman who was a more original artist than her son has been neglected in his favor. Baylis sets out to right this wrong by revivifying Suzanne Valadon. She certainly succeeds in making someone come alive, though so much of what she writes is invented and her emphasis is so personal that the actual significance of Valadon's life as an artist is to a regrettable degree obscured.

The facts of Valadon's life are well recorded, if not well known. Born in 1865, the illegitimate daughter of a provincial French laundress who took her to Paris, to Montmartre, when she was five years old, Marie Clémentine Valadon supported herself from the age of nine in a series of jobs culminating in that of circus acrobat. She was forced to abandon this budding career when she fell and hurt herself when she was sixteen, but in the little world of Montmartre she had already made her mark as a beauty and a spitfire and soon found herself in demand as a model. The artists for whom she modeled — notably Puvis de Chavannes, Renoir, Toulouse-Lautrec — became her friends as well as her lovers, and when they discovered her ambition to be a painter, and noted her talent, they took her under their wing.

---

Utrillo's Mother *by Sarah Baylis (New Brunswick: Rutgers University Press, 1989), reviewed by Truitt in the* Washington Post, *April 30, 1989.*

Suzanne Valadon, *Marie Coca with Arbi*, 1927. Oil on canvas, 25⅝ × 36⅜ in. (65.3 × 92.5 cm).

They even changed her name. Puvis de Chavannes remarked that because she posed nude for old men, she should call herself Suzanne, after the biblical Susannah and the elders; she began signing her work "Suzanne Valadon" in 1883. She had drawn even as a child, but now, while she modeled she learned. Renoir encouraged her: "You too," he said when he came by chance upon some of her sinuous, tender drawings, and welcomed her immediately into the company of artists. Toulouse-Lautrec was equally impressed and showed her work to his fellow artists, one of whom introduced Valadon to Degas; she soon began to study with him. With the encouragement of her mentors, she started exhibiting in 1894 and enjoyed a limited degree of critical and commercial success. Finally, her reputation was eclipsed by that of her son, Maurice Utrillo, who was born illegitimately in 1893 and was an alcoholic almost from childhood. Valadon married a banker in 1896 but divorced him to live with a friend of her son's, André Utter, whom she married in 1914. After this marriage ended twelve years later, she lived alone until her death in 1938.

These are the bare facts over which Sarah Baylis weaves her narrative. Her protagonist, Valadon, speaks in the first person. She is an old woman looking back on her life, and with her first words, "I've always been a liar," she insists that the reader accept her version of the events in her life. Within a few pages the old woman records the loss of her last tooth and indulges in the memory of a sexual molestation she experienced at the age of five: "Even then I had a predilection for bad things," she remarks, rather complacently. Shortly thereafter, a gypsy tells her fortune with Tarot cards but by this time the reader has adjusted to a rattling good yarn rather than a biography.

Sarah Baylis's own life ran somewhat parallel with Valadon's — she also worked in a variety of jobs and was an artist's model — until her tragic accidental death in 1987, at the age of thirty-one. Her understanding of what it is to be a woman on her own, shorn of defenses, is profoundly moving. In one scene, for example, a friend of Valadon's is raped by a coarse man who may have been Maurice Utrillo's father; Baylis records this outrage in heart-stopping detail, opening an abyss into which the reader peers with sudden and complete understanding of what it means to be so helplessly invaded. Outrage is the key of this book: the feeling of

women that they must continually bring to bear their own indomitability if they are not to be mortally victimized.

Baylis may indeed have grasped the key to Suzanne Valadon's life. A friend who visited the artist just before her death found her an embittered old woman. Stunned, he tried awkwardly to recall her to her artistic achievement, and quoted her as replying: "My life work? My life work is ended, and my only satisfaction is that I never betrayed or abandoned any of my convictions. Perhaps some day you will see that someone will bother to do me justice." Sarah Baylis bothered, and in her vigorous and imaginative portrait has succeeded in bringing the woman to life. As for the artist, Suzanne Valadon has done herself justice: her work remains and speaks for her.

## Canada Journal, 1989

*The last time I felt the subtle forces of destiny was in the spring of 1989. The influences that would lead me, in January 1990, to change my life by initiating the Emmerich retrospective were building up, but anonymously, in the form of inanition, as if the air I breathed were becoming less and less oxygenated. I became obsessed by a yearning to draw a line in my own person on the earth, due north and then due west across the American continent, ocean to ocean. I panted to run free on that line as I had used to run along the shores of the tidewater rivers near Easton. I longed for limitlessness. I hoped for revelation.*

*And then fortune presented me with opportunity. I met John Dolan, a friend of Samuel's, a photographer. When in the course of conversation I mentioned my idea, his eyes lit up. Within seconds, we decided to drive together across Canada. He wanted to photograph. I wanted to see what would happen.*

*We met only twice before we set out. We took a chance on each other, began as disinterested companions, and ended as friends.*

—Anne Truitt, *Prospect: The Journal of an Artist* (New York: Scribner, 1996), 65–66.

---

*In late June to mid-July of 1989, Anne Truitt and John Dolan drove from Cambridge, Massachusetts, to Vancouver, British Columbia, primarily along the Trans-Canada Highway and through the prairies and Canadian Rockies. Truitt was in her sixties, and Dolan, a photographer and friend of Sam Truitt, was in his twenties. This is an excerpt from the journal Truitt kept during this trip. Spiral-bound notebook, box 1, folder 21, Anne Truitt Papers, Special Collections Department, Bryn Mawr College Library.*

June 7

Washington, DC – Chestertown, MD – Washington, DC (167 Miles)

*Celestial navigation*
Form depends on time (and space)? That which is with time is with form? Timelessness = no form — form made *in* time and space.
The coordinates for form are time and space.
    Calculation of a precise position on the surface of the earth depends first on an assumed position: you know roughly where you are. Just so, your view of your life in the context of its history depends on a continuity of consciousness that permits a reasonable assumption that you are who you are, where you are.
    Navigation depends on two grand conceptual planes rising up from the planet like two Haring wings: the Celestial Meridian and the Celestial Equator. The Celestial Meridian is a vertical extension of the Greenwich Meridian, a conceptual line running from North Pole to South Pole thru Greenwich, England. The earth rotates 360° in one day. 360° divided by 24 hours equals 15° per hour.

June 12

Home – National Cathedral – Home

*Those who die young in war*
A dreary day. All morning and all afternoon I pushed myself along like a balky donkey, and toward evening walked out. The act of putting one foot in front of another slowly took over. I found myself on the familiar path up the hill to the cathedral, past Walter Lippmann's house, which always throws my mind back to the time when we used to go to parties there; he is dead now, along with most of the people I knew then, and all of a sudden I was swept by an overwhelming feeling of unreality. How could it be that they were simply gone? Removed, like pieces lifted off a chessboard.

The bronze-leafed fountain in the cathedral courtyard flung glistening water up into the sultry air. A man sat on a bench, watching its rise and fall. I stood in an arch only a second, not wanting to disturb his quietude; the tennis ball that a theological student threw up carelessly years ago is still stuck under the elbow of one of the saints, high in his niche on the cathedral wall.

Winding through the cloister on the polished stone floor, I entered the Bethlehem Chapel and sat down next to the plaque commemorating Lt. Col. A. Peter Dewey "1916–1945" Croix de Guerre.[1]

I felt myself coming home to him.

For he had asked me to marry him, and my life would have been very different had I accepted. His life was as embedded in tradition as his commemorative plaque in the stones of the cathedral, integral to the history of his nature — in contrast to mine, always on an edge.

We met only once — in 1941, when I spent my spring vacation of my third year at Bryn Mawr with Aunt Nancy on her hill in Virginia. She invited him to a dinner, they having found mutual pleasure in their love of France, where Peter had been fighting with French troops when France fell to Germany; he had rented a house near hers, retreated there to write a novel. A formal dinner: I wore a long silk skirt, thin stripes of scarlet, green, and peacock blue, which I wound around me when, after dinner, Peter settled me into the front seat of his black, low-slung, long-bonneted Sunbeam-Talbot — the first foreign sports car I ever saw, as Peter was the first sophisticated man I ever met. Dark, brilliant, quick, and vivid: his voice still lilts in my ear, rather high-pitched, darting up and down as he moved rapidly from subject to subject, dazzling in his density and range. I was transfixed, enchanted.

He drove very fast, changing gears in a surge of speed. The red mud of Albemarle County under our wheels was illuminated by the immense circular headlights of his car, and by an orange moon, full, hanging, it

---

1. US Army lieutenant colonel Albert Peter Dewey, Office of Strategic Services, was mistaken for a French officer and shot and killed by the Viet Minh at a roadblock outside of Saigon on September 26, 1945. His death is said to be the first American fatality of the Vietnam War.

seemed, just above the trees arching over our heads as we penetrated deeper and deeper into the ever-narrowing country roads. The mild air was soft and smelled of early spring, new grass.

When we reached his home, Peter lit candles. We drank champagne. We talked: he talked, I listened. He showed me his manuscript — a scroll of thick French paper, inscribed in a large hand, cursively rolling on and on. Even in my inexperience, for I was as innocent as the spring grass, I knew that this was not the way a writer wrote a book; a cool voice in the back of my dazzled mind noted style, not the harsh drive of substance. Perhaps his courtship failed precisely in that recognition, even as I succumbed to his tenderness, a lover perceptive, delicate, vigorous and, finally, restrained by his own feeling for the appropriate.

What did he see in me that urged him to propose marriage a month or so later? Perhaps a grace note at the end of his life. He knew that he would return to the war, lost in his beloved France but, waiting in the wings, an ineluctable fate. For by the time he was killed in Indochina, four years later, having lived only twenty-nine years, he had married and fathered a child.

In what does the meaning of such a life consist? I asked myself as I left the chapel and walked in the Bishop's Garden, needing its earth. Courage, sheer bravery of the heart. Hard-won. Peter had stammered, he told me, all his life until he found himself crouching in a ditch under the strafing bullets of low-flying German planes: he never stammered again. The line of his life ran short: I think of a star rising up into a warm spring night, a spark against deep sky, brilliant — gone.

Peter Dewey *loved* me — perhaps — must have: a serious man.

Never acknowledged until now.

June 25

Day 1: Cambridge – Tonawanda, New York

The names of businesses along highways proclaim the stubbornness of romantic hope. The one into which we pitched at twilight yesterday after a straight run west across Massachusetts and New York is called the

Anne Truitt and John Dolan, Canada, 1989.

Boulevard Gardens Court Motel. The freeway, on which traffic ceaselessly zooms within ear fall, shares with the concept of the French *boulevard* only breadth and landscaping: four striped lanes separated by a cement strip of no-man's-land and lined with buildings perhaps tacked together at haphazard intervals atop patches of cement so thin that their edges show on the pale dry dirt beneath. The "gardens" of our motel are pots of drooping geraniums, but that may be because "mother is indisposed," as the proprietor remarked shyly when he ushered us into the cubicles we now occupy. He is a looming hulk of a man with broad, used-looking shoulders and a cockatoo of bristling pepper-and-salt hair above a crackled face; given fewer pounds and more money, he might cut a determined figure. Perhaps it was he, a *boulevardier* by nature, who named this motel. It does have a "court" — concrete atriums marked off in parking slots smartly slanting toward our doors. There seem to be only three guests. The third is a slat-thin man whose shampoo bottle had spilled into his plastic carryall.

Traveling with John is like moving with wind personified. He bloweth where he listeth. When it came time to find a place to sleep, his green eyes got greener, his attention focused on what looked to my weary eyes like a uniformity so impenetrable that it offered not even the possibility of intelligent choice, and, suddenly, by a kind of agreeable osmosis, he had decided to stay here in this pastel-shingled dream court. He is fleet of eye and foot. His photography does not seem to rob a person or a place, but rather to take image and leave benison, as if an intelligent breeze touched down here and there.

June 26

Day 2: Tobermory, Ontario
*Buffalo: 40° latitude, 80° longitude; moved 10° longitude, 0° latitude from Boston*

First we saw a cloud rearing up out of the urban landscape in front of us, effervescing and dissolving into a pearlescent early morning sky. Then a noise seeped into our consciousness and, as we clearly approached Niagara

Falls, evolved into full cry. The whole — waters and the sounds of them — redefined direction for me. An absolute geography allowed no escape, an absolute speed no leeway. And only air could have moved faster than those waters, which ran at the very edge of water's potentiality for movement. The earth held its own. When I looked straight down from the center of a bridge over the torrent, I saw, through the combs of foam, plain rock. And along the brink, over which the waters dropped, the sun pierced them in such a way as to make a translucent emerald border through which ran a distinct, particular black line of cliff.

We lost our way twice today because we were talking.

June 27

Day 3: Arrived at Batchawana Bay and the Chippewa River, thirty miles north of Sault Ste. Marie
*47° latitude, 85° longitude*
Exactly due north of Traverse City, Michigan

June 28

Day 4: Batchawana Bay, Lake Superior

Yesterday we almost lost the 7:00 a.m. ferry across Lake Huron from Tobermory to Manitoulin Island because I overslept.

John is named for his great-uncle, Jack Dolan, who was lost at sea in a tempest off Galway, Ireland. He took down with him the thick woolen sweater into which his wife had knitted the pattern symbolic of their particular family. My forebears were also seagoing. Their clipper ships went out from Boston, mostly on the China route. In the nineteenth century one was wrecked off the Arabian-African coast; Robert Williams was the only man who could swim, and he alone survived. He made his way to the shore and to an oasis where he found a frog and ate it raw. Picked up by a nomadic tribe, he was held as a slave by the Arabs for seven years. He

learned their language and must have endeared himself as well as made himself useful, for the Arabs set him free. He wrote from Calcutta in elegant Spencerian script with a steady hand — "My dear wife" — without ado noting that he was on his way back to her in Boston.

Way higher up on the prow of the ferry, John and I told one another these stories. Strangers to each other (we had met only briefly, and only twice before we set out), we are both working to thread a loom, a warp and woof, into which we can weave the little personal history of this trip that we are making together.

The smell of painted iron on the *Chi-Cheemaun* ferry, its high sills, its list under my feet, invigorated me. I leaned alone against its railing and watched how the prow furled the water in fern-like tendrils, vanishing evenly into a pattern of evanescent foam. A seagull tilted to the wind, riding in place. In the blade of its white wing, alternately a line and a plane against the fog, I recognized the precise, alive equivalent of the image that has been for twenty-nine years a mark of my work.

The *Chi-Cheemaun* docked on Manitoulin Island, and we drove out from her belly into a sunny realm under the reign of early spring. Palest green leaves animated the slender, straight white stems of birch trees beyond a foreground of wide, providing meadows lavishly strewn with wildflowers yellow, pink, and purple laced with brilliant orange: a living Monet landscape. A land seemingly exempt from all harshness, yet in actuality one recently reprieved from bitterest winter. We stopped to dip our hands into a freshwater lake and found on the shore fossilized rocks imprinted millennia ago with intaglios of shells. An Eden we could have been reborn into: so delicate a lacery of land and water beneath our feet and a sky so immeasurably broad above our heads that we seemed to my intoxicated senses entirely penetrated by divine beneficence. We asked one another if we could live here. John shook his black head doubtfully. And I too am beyond the reach of utter innocence. But I had no intuition of bitter exile: it is enough that the earth can shine in such perfect harmony. And John thought that the caterpillars we saw on the fossilized rocks along the shore were gypsy moths: end product of a genetic experiment that in some way escaped from a scientific laboratory to proliferate and to destroy foliage. *Et in Arcadia ego.* There is no heaven but heaven.

June 30

Day 6: Whispering Pines, Batchawana Bay

We have had two and a half days of rest here in a cabin on Lake Superior at the mouth of the Chippewa River. Late yesterday afternoon we paddled a canoe up to the falls by way of which the Chippewa drops to the level of Batchawana Bay. Lazy, we let our canoe turn in these lively ripples as they come back into the easy breadth between rich forested banks. In one cut, of distinctly colored earth, geological time could be as easily read as in a primer.

Tree-toppled roots, foremost into the shallows, showed how this secret land engaged the water, spilling into it that which had grown on it. We caught the scent of wild rose; a couple of lazy paddle strokes brought us alongside a luxurious sway of blossoms. I took one delicately into my hand and buried my nose in it, and as I did so felt the tug of meaning. Only by the most subtle linkage of cause to effect could my person have been drawn so far to this particular shore.

July 1

Day 7: English River Motel, Manitoba

Clock time has little relevance as far north as this. Light is continuous for seventeen of twenty-four hours. We drive the Trans-Canadian Highway, sometimes for miles on end, a ruler-straight line cut through ochre-red rock. An endearing road because it is well engineered: carefully graded and tactfully divided into intervals allowing central passing zones impartially to drivers headed east or west. Its direction rarely derivates even slightly north or south. Its verges of loose gravel are just wide enough for common sense. It is laid down flat and thin on the earth like a surveyor's tape. Sometimes it gives out. Yesterday evening we drove for some time on deep umber ground, bare to the edges of pine forests on either side. The firs are short and sparse, stunted by cold. We are running along the edge of the Arctic watershed: on our left the water runs south, on our right,

north. The Arctic Circle circumscribes the North Pole at approximately 23°, seventeen feet from the Pole, 2° away from us on the curving earth. But we have touched the circumference of the outermost reach of the water, moving toward becoming the frozen Arctic plains.

We found a reach of a different sort at Agawa Rock, where for the first time this journey began to draw from me.

July 2

Day 8: Carberry, Manitoba

Yesterday was the "off" day inevitable on any journey. There are forty years between John and me. We talk of all manner of things. We interest each other and are trusting of each other by instinct and faith, but the bedrock of our lives is as thinly covered by what we can so far share as the rock over which we drove for ten hours is covered by a skin of land. Hard as rock, the fact is that his life is largely before him, mine largely behind. There is a kind of generosity that age owes to youth; essentially, perhaps, forbearance to disclose the naked truth into which experience distills only in years and years of time. The other side of this curve is the generosity of the young to the old: it is John's strength of character and body that is underwriting the physical effort of this trans-continental trip. He does almost all the driving, steady and prudent at the wheel. I am carried. The balance of our relative strengths tilts on the fulcrum of endurance.

July 3

Day 9: Maple Creek, Saskatchewan

In the dream from which I awoke smiling this morning, an open, orange melon, perfectly fresh and ripe, washed into the little cove on which I sat, cross-legged and naked in my young smooth body, half covered by the

tide flowing gently in from a blue horizon. My first thought was to return the fruit to its origin, and I wafted its halves back into the little waves, but it came into my mind that it was meant for me to eat, so I put them aside, behind me on the crescent beach, and shut my eyes as if to see more light. For one of the bedrock facts that experience has taught me is that the phenomena of the world are in essence mysterious equivalents of what can be apprehended by opening a vista inside myself.

The blade of the seagull's wing against the fog on Lake Huron, the utter feeling of perfect placement on the face of the earth that suddenly overwhelmed me as I sat on the ledge of Agawa Rock: these are equivalents, reminders of some vast reach of law only intermittently, unexpectedly, accessible. The essential effort of my life, its purpose, is to align myself with the force I feel animating this reach. I name this force divine but know it has no name, as sound has no name.

Yesterday I *saw* it in the movement of the marvelous grasses of the Saskatchewan prairie: beneath a cerulean zenith reflected now and then by shallow pools of deepest blue water, wind lifted and tossed, flattened, twisted, smoothed waves of wondrously multihued grasses. The horizon ran perfectly around the whole circumference of the prairie: land met sky and sky met land, touching but not touching as both were infinite to the eye. Uplifted and sustained I drove for five hours straight in a state of exhilaration while John slept in the back seat. No thought of self marred my delight. No more relevant to this grand reality than a single waving grass, my person fell into due proportion as if fulfilled by nonentity.

This profound satisfaction rose also, in the way of the world, out of a practical decision John and I had taken at breakfast: we will part company in the late afternoon. We are both accustomed to hours of solitude and silence. He works mostly in the evening and at night; I in the very early morning. Our psychic metabolism has been set awry by our contiguity. We decided not to aim for adjustment, but rather to accommodate one another. "Neighbors," John said, smiling.

Late yesterday afternoon we turned south off the Trans-Canadian Highway into the Cypress Hills Provincial Park, and settled ourselves in our motel monastic cells. I so enjoyed my evening alone and feel sure that I will hear when we meet that he did also. Neighbors, and companions of

the road, leaving aside the shared physical effort of traveling (to which I seem to be rising ever more steadfastly), we take mutual security from one another's experience. So I walked out into the sunshine (we have changed time zones once again), ate a fine dinner while reading and then walked happily around this small prairie town. A railroad edges it on the north. Trains are like blood vessels in this vast land; two grain depositories rear up high into the air — "prairie cathedrals," as they call them in Nebraska. Otherwise, the town is like a miniaturized city: one of every useful facility, low-lying buildings under a multitude of towering cottonwood trees. I stopped under one to gaze up into its flickering heart-shaped leaves, which are long-stemmed so they flutter in every whim of wind, refracting a mesmerizing variety of light. I saw why they are called "cottonwood," for a kind of cotton ball hung on one branch; touched, a soft loose bag clogged with tiny seeds.

A tranquil-faced man and woman sat rocking on their wooden porch. We said "Good evening," and fell into easy conversation. They have "six going on eight" grandchildren. We spoke of families. The woman said that incest now worried her most. She'd not considered it related to her own life until recently.

Her opinion — he was silent and looked a little shame-faced, as if discomforted that the guilty implication of incest fell more on men than women — was that it had always been common but children had not been believed and adults had, of course, been silent. I was startled because my complicated goddaughter, whom I had visited in Cambridge, Massachusetts, before setting out on this trip, had also brought up this matter with me, also as a recent topic of discourse.

We are like the seeds in the cottonwood tree ball, fixed in a close communicative network.

• • •

When Pierre Teilhard de Chardin's mother cut off his baby curls for the first time, she did so seated with him on her lap in front of the immense vaulted fireplace of the family chateau. She had put a cloth around her son's shoulders to catch the curls, and when she finished cutting she removed this cloth and shook it out over the fire. Teilhard de Chardin

saw his hair flame to ash and burst into tears because, as he later wrote, he perceived instantly that if his hair could be consumed by fire so could his whole body. This insight set the curve of his life: he became a Jesuit priest on the side of immortality, and on the side of mortality, a paleontologist who tracked the prehistoric bones of humankind. He evolved a theory of human development in which he conceived of God as a kind of magnetic point, an apex toward which human beings were inevitably attracted. Everything that rises in this silence "must converge." De Chardin envisioned ever-closer communication among the peoples of the world, a mental evolution toward a shared world mind that would eventually itself evolve toward union with God.

His theory is apt.

July 4

Day 10: Drumheller, Alberta

All day yesterday we drove through the vast prairie, winding in and out on the narrow dirt roads that make a utilitarian connective network for the few inhabitants of these tracts of wheat and grazing land. Houses and their outbuildings are often painted bright red; this color must be heartening in the deep winter snows, and even in brilliant sunshine declares the intention of indomitability. For it must take a store of courage to live on land that so categorically does not need the human hand. Deserted homesteads, abandoned to sky and wind, are skeletons of failure. Hour by hour, day after day after day, the men and women who choose to survive here must wrestle with the implicitly cruel fact that even their best effort can ultimately have only the most fleeting effect on the remorseless nil of these spaces. Only by falling in love with beauty could a person submit to such blatant irrelevance; the same kind of love that sailors feel for the sea. But there are no white whales here. All must be submission and endurance, above all endurance, denied the illusion with which the pursuit of an individual grail endows human effort with romantic energy.

We stopped to listen to the prairie wind, hypnotic, sweet sounds borne on the bending grasses. Grasses of many, many different kinds, varied in color — purple, mustard-yellow, greens akin to viridian — and in length and similarity, as particular in vibration as if together to form a stringed musical instrument. "Would we," I asked John as we stood knee-deep, "have been moved to art if we had been born here in this place?" His head tilted. "That's a question." Unanswerable. But we are ourselves as intact within our lives as each of these grasses, and John photographed as easily as he breathed, and I absorbed as if I were a tuning fork.

Animals fit here. Cattle roam in herds, ushering their young. Antlered antelope stood alone on a looming hill, alert.

We drove for four hours before coming to; the car needed gas, and we needed food. Manyberries was named by the Indians. Saskatoons, a kind of blueberry, are abundant on this particular patch of land. We were accosted by the owner of the one restaurant as we parked. Betty — only first names needed, we could have been Indians ourselves, one tribe because human — told us that the jagged range of mountains under the distant wing of which we had been driving were the Sweet Grass Hills, ceremonial peaks to which the Indians had ritual recourse.

We are still on the prairie here at Drumheller, but the earth — over which the prairie grasses stretch like an alive skin reflexive to every swell of an opulent body — has been gouged out by extensive strip mining. Bored into, its layers lie exposed in the corridors of a mechanical canyon revealing a perfect record of geological time. This is a bleak town. John may feel differently and we may linger, but I myself wish to put behind me the marks of rapacious human greed. Today we must go to Calgary in any case, as late yesterday afternoon our windshield was struck and now must be replaced. Fortunately, the star of shatter is on the passenger's side of the car. I felt the violence in the center of my heart, and my first thought was that we had been shot at. I was not even certain for a second that I had not been killed. John, who was driving and who held the car straight on the road after the impact, thinks a rock flew off a passing truck.

July 5

Day 11: Mount Engadine Lodge, Canmore, Alberta

We fled Drumheller. Moved by a common imperative, we fled straight for the Canadian Rockies. John, by the time we met for breakfast, had already independently found this lodge in a book of accommodations. We made reservations; we are tired of improvisation.

D. H. Lawrence once wrote that when you hunt a fox, "the fox has to know that he is going to be caught." A projection of intent tends to organize experience as it unfolds, to magnetize a goal into reality. We are in this sense "making" this journey as we go along. We are now attuned by long silence as much, or more, as by conversation. The role of information in artist's lives is quixotic. One of our tacit bonds is decisiveness on the specificity of what we individually pay attention to. Drumheller is a trove of scientific information: neither of us needed it.

(Drummond) Drum: "a long narrow hill or ridge."

Esker: "a mound of sand, gravel, and boulders deposited by a stream flowing on, within, or beneath a stagnant glacier."

If our lives unfurl rather as fern fronds open in characteristic vital patterns, there must logically be entities of physical reality that await our interaction with them in the course of time. A solipsistic point of view would claim that we dream our lives into reality, that because only the self exists, the self can only know what it invents. But the salient quality of the physical world is its unimaginableness.

A charm of travel is this magic. Spirit and place sometimes meet and match.

We have come to such a place: a valley running north-south between two ranges of grand mountain peaks. Scarps of bare gray rock streaked with snow surge toward the sky as if to declare a terrestrial indomitability that practically reinforces my heart. The lower slopes of these mountains are striated by fir forest, variegated crisp dark green verticals articulated as fine-tipped brush marks. The valley is a bushy bog through which a swiftly running creek widens and narrows in a spacious meander endowing it with grace.

And with a restful scale that is reflected in the solid comfort of Mount Engadine Lodge. Peeled tree trunks fit tightly into wooden beams, which in turn support a harmonious structure backed snugly into the eastern mountainside. My room overlooks the valley to the west. Wind pours into my window like fresh water. We are the only resident guests. Guests in Europe, for the Canadian Rockies could be the Austrian Alps, and this lodge was built and is owned by an Austrian mountaineer. Rudi — came in 1971, lodge built and opened January 1987. German is spoken. A European taste envelops us. Every element is intelligent, from the wholesome meals we are served to the light warmth of our down feather beds. I woke up in the middle of last night just to feel myself at ease in this place.

July 6

Day 12

At ease enough to loosen up feelings I have been tamping down for months and months: not the layers of intuitive experience I habitually lay down one on another with enough air in between them to let them fertilize into compost; rather a pit into which I have hastily shoveled all that I have been neither able to understand properly nor to absorb: an explosive deposit. Time bedevils a life when psychic gravity somehow loses its resilient magnetic power.

Yesterday afternoon I walked up the steep shoulder of the valley's western slope and turned south on a grassy logging trail. Alone in this vast space, it came to me suddenly that I could *tell* the mountains towering over me in the sky. I spoke, the mountains stood fast. And as I heard the sound of my voice, its echo stirred a chord I have not heard in myself since I first realized that I had been ejected into the world, alone, and somehow hurt. The brick path, uneven under my sensitive soles, the smell of my father's boxwood: the garden into which my parents exiled me when my younger sisters, twins, were born. I was eighteen months old. From whence do we get the idea that protection is a birthright? I can only remember

having that conviction, and feeling utterly bereaved, as if I had lost some precious beneficence.

My parents failed me, as I in turn fail my children, and as they may fail theirs. A pattern, generation to generation, perhaps not so much personal as intrinsic to human limitation. I spoke this to the mountains. It is as if all my life I have sought a place where I could put the primal pain of intentional human betrayal without hurting anyone, to deposit it securely and leave it. Leave it here in this mountain fortress, dissolved into the air above the earth — which will in time also receive my body.

And my children's bodies, and their children's bodies, and their children's children's bodies . . . I stood still, my blue sneakered feet rooted next to a bursting circle of vigorous yellow dandelions. The truth of all our inevitable deaths reverberated in all the cells of my body. I spoke the litany of our names to the mountains. It felt, as examples of humanity, received.

July 7

Day 13

Two moose, a male and a female, have just walked across the valley under the open veranda on which I write. They will remain here, and I felt for a moment a wish that I were one of them. But I am precluded because I am human, heir to that responsibility. To personal responsibilities also. Today I must go down from the mountain and telephone my family, and tomorrow we go north.

July 8

Day 14

By the time I reached the Canadian Ranger post, which has the nearest telephone, I realized that the car did not contain enough gas to return to

the lodge and then make it down to Canmore today. So I wound down to the town across bridges and beside aquamarine lakes, bought gas, and returned up here. I hold the hypothesis that everything that happens has meaning. In some cat's cradle of fate I must have had to meet and speak with the nine people I encountered. And the fact of having driven these mountains, down and up, seems to have left me a little less unwilling to leave them this morning. For I earned by that effort their indelible measure.

My psychic metabolism has for years absorbed experience in order to transform it.

Slanting rain effortlessly transformed the stark and jagged ridges into a radiance that overwhelmed me even as it lifted me into a realm of truth, beauty itself set free.

I leave with a whole new comprehension of what it is to be physical. I am understanding with my body in a new way, as if it were more permeable than a few weeks ago. Like a piece of wood, stiff — now pliable, soft, as edges open to penetration.

Also a new understanding of beauty, a new feeling of scale: range, height, massiveness, weight.

I kept looking back at the peaks above the Mount Engadine Lodge valley as we wound down out of their range.

July 9

Day 15: Valemount, British Columbia

Today we turn southwest to Vancouver.

We have been on the road for two weeks today. We reached our furthest point north, Mount Robson, at 54° latitude, 119° longitude, yesterday. Mount Robson is on approximately the same latitude at which the Attawapiskat River flows into James Bay, which opens north into Hudson Bay. It is as close as I shall get to Hudson Bay, which I had hoped to see on this trip. Age is imposing geographical limits on me. Yesterday I could not make it to the top of the rocky path that led steeply up and out onto the Athabasca Glacier.

I conceived of the line I started out to draw on the continent as extending out and back across the North American continent. But like my goal of reaching Hudson Bay, that concept may also be proving to be romantic.

Perhaps the romantic energy of my nature is being called in, so to speak, from my personal life — just as galactic material is inevitably magnetized into a black hole in space. I think not, however. For my limitation is physical, not psychic, and this journey may simply be revealing to me that the reach of my energy will now more freely extend into my work than into my action.

Athabasca was a point of turn. One not having so much to do with literal age as with the history of my own body. A personal, not an abstract, limit: a line I never foresaw in my thinking about this trip. A line drawn *for* me instead of *by* me. We drove away from the glacier toward Jasper yesterday between magnificent mountains on the faceted slopes of which snowfields were raked by winds that drove snow and mist in veils across the mighty peaks. We could only see what this wind revealed to us. Perhaps that fact had something to do with my tentative contentment in acknowledging, without let or hindrance, of willfulness, my having come to a barrier. The force that over millennia uncountable formed these mountains, grain by grain, pressed into mass and then exploded them up out of the earth into the air, is on a scale that so enlivens the spirit as to make the bare fact of existence itself a happiness.

Valemount is a hamlet surrounded by these snow-streaked mountains. It straggles along the arms of a road across the highway, each corner a gas station. Adjacent, four motels. One restaurant, one laundromat, one pizza parlor. After supper last night I strolled about the muddy roads. The license of outright curiosity is one of the privileges of travel, and I peered at people's houses — mostly mobile homes anchored to plots of ground — and wondered what it would be like to live here. Perhaps not unlike any town this size within reach of television. A daily slice of information may vary little from Valemount to Toronto; we share what is essentially the gossip of a global village. But I wonder what it is like to take all things equal, as they come, without the perspective of history, which provides an intellectual scale comparable to the physical scale of the mountains. But the spiritual is a more important scale than either.

Within the context of its values growth proceeds without dependence on the human contrivances named civilization. Wisdom is (because it is wise) virtually invisible.

I was introduced to Plato at the age of eighteen. It immediately felt "right" to me that Plato held the phenomenological world to be a reflection of an ideal world, in itself a reflection of a still higher plane of reality. I had always in some unnerving way felt that the physical world was like a stage set within which I moved with pragmatic confidence but of which I could not feel all that was real, defined. So it was because of personal misgivings that I eagerly embraced the concepts of a hierarchy rising on a continuum of planes: physical to mental to spiritual. The physical enabled the mental to function effectively, and only consecutive intellectual developments could open the way to spiritual growth. When a few years ago I read *On the Line* by [Gilles] Deleuze and [Félix] Guattari, contemporary French philosophers, I understood immediately that this hierarchy on which I had based so many of my conceptualizations was thrown into question. Deleuze and Guattari offer the rhizome as a model of reality.

July 11

Day 17

Decision to leave Friday. Like all decisions, out of context of factors balanced, taken unconsciously as well as why: organic.

The difference between spirit and body is ever more clear to me. Teilhard de Chardin worried about burning, but the spirit is entirely independent of the body, so that I do not. Spirit seems lighter and lighter as body grows drowsy.

My pilgrim soul would get on any ship. Into any car, space ship, train, aircraft and go anywhere, flying before as if a figurehead on a clipper ship.

Vancouver is a great seaport. Boston also. Port to port cross-continent.

I feel as if I have come to the end of the line. As if that line continued westward out into the Pacific Ocean as far as I can see — and on and on beyond — bearing a part of my spirit out into the air over those waters.

The line I had thought of myself as inscribing was all the while spinning itself just one footstep's length before me.

Distinction between physical line and spiritual line.

Actually I suppose I have resisted the physical line in my body — have only intermittently taken that fact seriously. That line *will stop*. No more foot on earth, hand on earth. No more touch of tree, rain, other human hand. End of touch — that will be for me the deprivation death will impose.

The other line — of spirit — I am not drawing myself. Actually, have drawn a line of imagination and found that it has led me from imagination into a dimension beyond its reach.

July 14

Day 20
United 56   1:00 Seattle   8:39 Dulles

Remember the *pattern* of experience, like a blueprint, whole: as Mozart said that he heard a piece of music as a whole, entire, before he wrote a note. My feeling is that our experience *exists* before we live it. Time is nonexistent.

This morning I woke to the harsh call of a seagull. A clear sky of that particular pale blue only seen in sea air fills the heavens, pellucid above the western horizon, toward which a ship flies steadily: delicate rose-pink clouds float above the mountains to the northeast, forming and evaporating like little warm breaths.

I fly back home today: turn my back to the Pacific Ocean and my face east. My possessions are carefully divided into what I will take with me and what John will drive home in the car.

My psychological edges will have to solidify now and draw a line around me within which I will remain intact, once more a solitary unit in the world. John's presence, either side by side as we drove or reliably somewhere about, has kept company some lonely part of myself. We have both been borne along on an exhilarating spontaneity. I was right to feel him the wind personified. My own feet are always feeling the ground,

but I sensibly abandoned stance for faith and had the pleasure of moving bonelessly, on air.

July 15

Day 21: Washington, DC

Air bore me east over the American continent. I gazed down on it — snowy mountains, prairie, and finally green fields — with total respect. I now know what it is to measure that distance one wheel revolution at a time. My trip to Europe in 1984 taught me the authenticity of historical time; this journey is that of spatial time.

We debarked at Dulles Airport in darkness, and as our mobile transport lumbered away from our aircraft I looked at it looming over us, a great empty ship lined with lit windows. Then, off toward the distant Saarinen Terminal, a catenary curve of wing stayed by the erect control tower, I felt as I never had before the delight of living in an age that had conquered the air. As if I had within a few weeks traced the line from pioneer travel to space travel.

July 16

Autumn is implicit in the cool rain falling in the early dawn this morning. The days at Yaddo, when I lived there during the fall of 1984, rise in my memory: the rich, deep color of the earth poured forth in splendor at the apex of its rhythm toward still winter. I recognize my imperative drive to go far north this summer, toward the sun over the Arctic Circle, as symbolic. I wished to place myself in that light as if it could permeate my body, endow it with physical immortality. I am glad I went. I could only have grasped so clearly the fact of my limits by testing them; I moved stubbornly out to their circumference, and came to that edge beyond which I cannot underwrite with physical strength the leap of my imagination.

I am returned to my house and studio with satisfaction. For the first time, I see my way clear into old age. I am curious. Having drawn a line I had conceived of as continuing out, I see that I have instead drawn one of containment around a territory within which I can explore for the rest of my life to my heart's content.

July 20

When my children were very young, we spent a summer in a white clapboard cottage on a remote lake in Michigan. We slept on screened porches, and mine had a broad roof peaked toward a lathe that ran lengthwise to shut out rain. One night I was awakened by a soft rush in the air and realized that a bat was swooping over my head. I turned on the light and watched its broad black blade in flight. Then, quite deliberately, it folded its supple, hinged wings into a flat envelope, turned its thin side toward the edge of the lathe and slipped silently under it, out into the night.

This elegance and economy has remained with me as an ideal way to act. But the last four weeks — I left home one month ago today — has forced upon me a new realism. I have cherished idealism in the guise of imagination. Imagination put to the test of action has been forced to give way to actuality. I am a prisoner of the law of cause and effect, as if intricately woven into a web of intractable tensile strength.

July 26

Ocean to ocean: continental trip.

NOVA TV: Oceanographic research: infrared film of the currents in Atlantic: Gulf Stream: runs from Caribbean along coast of Florida to Newfoundland. Divides East Atlantic to British Isles — Southeast to Azores and then in a gyre back to the Bahamas. In infrared — red deepest current — currents look like writhing scarlet serpent, a Chinese dragon.

1982 summer — *mistrusted symbolism*. "My" serpents too tame: characteristic of a masking construction. All symbolism is that.

This a.m. was thinking of my possessiveness of "my" children: at fundament of self felt a kind of hydra stir. Many — around like octopus, but attached to my fundament as a placenta is attached to the uterus, a pancake-flat-spreading-alive olive/black/green being/animal part of self. Sat quietly in a column, light coming in at top, allowing this animal to be attracted by light, allowing this animal *to be*.

Will work on this — get to know. Unformed or embryonic malformation. Anyway embryonic — and clot. Felt Sunday at top of self — laws open. In clot laws, lines of force, tangled, gangrene.

Feel *hopeful*. First time I've felt this part of self. Very alive and real. Trip opened me up — dissolved defenses I didn't know I had erected.

August 1

This morning — astonished and yet unastonished, as if arrived at an inevitable realization already implicit: lesson of life is *not submission* because that concept involves duality — submission *to* the divine will, individual entities — one to another.

Not submission, but *recognition* (by spontaneous and intuitive insight) that I (we) *am only* that to which I have been trying to submit: a particle (and that too separate a word) of the divine as a drop of mist *is* mist.

So the essence of what constitutes "me" is *in continuity with* the divine.

October 17

The gravel road, dry tan dirt last summer, was olive-green ahead as Canmore dropped behind and we began the climb up the valley to Engadine. Two men, husky in thick coats, sat stolidly in the front seat of the Land Rover in which they had just picked us up from some nonexistent airfield. We carried the edge of winter with us on our front fender, which sliced into

air suddenly very cold. The brilliant cobalt wedge of sky between bare steep rock striated by snow vanished as suddenly as if it had never existed. Ahead, sheets of sleet fell aslant upon us, wind made visible by ice. Miles up we had still to go, I remembered, before the lodge. And in darkness now, our earth freezing under us. Engadine, I thought, I am going back to Engadine! As if I were in the studio, making my way toward work coming toward me into visibility, I felt a calm beyond any need of confidence — and when waking overtook my dream it took the form of veils of color.

I need never go back. Borges was right: we can only lose what we have never had. The valley of Engadine is mine.

Last Sunday, John Dolan, the young photographer with whom I drove across the North American continent last summer, ocean to ocean on the Trans-Canada Highway, brought the pictures he had taken for me to see. He spread them out on the table in my studio. I saw with delight and curiosity what *he* had seen. Side by side in our little Honda car, we had for weeks moved through two worlds, his and mine, on parallel lines of experience stitched together only by anecdote. We think it necessary to think we understand one another — and John and I did, by imaginative osmosis — but the fact remains: we remain intractably individual.

# Interview with Jack Burnham, 1990

JACK BURNHAM: What were your early paintings like?

ANNE TRUITT: In 1961 I made a series of drawings in apricot color — strange, free-floating polygonal shapes set free in space. That was the only early painting, except for freehand works on newsprint with a Japanese brush with black ink and brown ink. I made hundreds of those in San Francisco.

James was in the State Department when we were married. At the time we were in San Francisco he was the chief correspondent for *Time* magazine. He liked San Francisco better than I. San Francisco was too frivolous for me. We lived in Belvedere Island — excruciatingly boring. I was frightfully severe then. Belvedere was completely fancy and completely boring. As soon as Mary was born in 1958 we went into San Francisco and bought a house, a wonderful house at 2119 Divisadero Street in Pacific Heights.

We moved back to DC in 1960. I was pregnant with Sam. At that time we were living at 1515 Thirtieth Street NW. It's my theory that babies are not born for one year. They remain in utero and they need a lot of loving attention and warmth — like a pearl. So when he was one year old I went away for the first time and I went to New York with Mary Meyer. And that was where I saw my first Barnett Newman and Ad Reinhardt. It was a group show, but I had been living in San Francisco and I had been isolated for about four or five years. It was an opportunity to see what was going on in New York. They were the first Newmans and the first

---

*Recorded in Anne Truitt's Washington, DC, studio on January 30, 1990. Typewritten transcript by Jack Burnham with notes in pencil by Truitt, box 51, folder 18, Anne Truitt Papers, Special Collections Department, Bryn Mawr College Library.*

Reinhardts that I had ever seen. I loved the space in the Newman paintings, which seemed to me ample — the kind of space that lived inside me. And I just loved the Reinhardts, that very close color. Which is exactly the way I perceive things. Just near misses all the time. Everything very orderly, close juxtapositions of events. So close that you scarcely discern one from another. For me it was exquisitely expressive color.

JB: Had you already met Clement Greenberg by this time?

AT: Yes, I met Clem in 1959 in San Francisco. He and Jenny [Greenberg, née Van Horne] came out and stayed. Tony Caro came later — I think he was on a British Arts Council grant. I met Kenneth Noland through V. V. Rankine, and David Smith through Ken — who also sent Clem to us. He didn't know that I made work then. We simply met them through Ken, who was a mutual friend. There was no question of art. I had met Ken Noland in January of 1949 at the Institute of Contemporary Art in Washington. We were both students there. He had just come back from Paris. The Institute of Contemporary Art was a school more or less patterned on Black Mountain, where Ken had been. It's no longer in existence. The school was transformed into a lecture series, which was of extreme interest to us at the time.

He had studied with Ossip Zadkine in Paris. The first time I laid eyes on Noland was when he came into the sculpture studio and knocked out a portrait head of a fellow student. I was floored by his facility. I thought, I better pay attention to that man if he can do that, and considering that he's a painter as well. Ken was very charismatic too. I began to follow his work. I first saw his painting in 1954. That was a long time later. By that time I had lived in Dallas for a year, working steadily when I could. We came back to Washington in 1952, and I found a studio in an alley and wanted to do life drawing. I looked around and saw that Ken was teaching at Catholic University. And I went out there and signed up for his course, and we started to be friends. Then he showed me his work in his studio, a little beat-up place in an alley off K Street. The first time I walked into his studio I saw that he was a great painter.

In 1952 he was married and living with Cornelia [Noland, née Langer] at 3025 M Street, or thereabouts. It was a little apartment up

some steep, splintery steps on the second or third floor right on M Street. He was doing great, huge expressionist canvases, jammed up against one another against the wall, and a single light bulb hanging from the ceiling. The main thing that I remember was that it was my first experience with great art in the making. One could feel the psychic electricity coming off the paintings. And that was the first time I realized what art could be. Then he moved to another little alley.

JB: Did you have a sense of a Washington Color School yet?

AT: It was a strange situation. In the first place, I was always off in left field. I'm sort of a loner by nature. I was very absorbed in my own studies, which at the time was making huge life-size figures in black cement, sort of slashed with color. I was busy welding and doing all sorts of other things. I was self-absorbed and self-assured. Ken taught at Catholic University. He taught Tom Downing, and gave lessons to Gene Davis, who was mostly taught by Jacob Kainen, who I didn't know then.

I remember going to Gene Davis's studio with Mary Meyer in 1962. He used to come in at 4:00 a.m., and he kept the radio on, some sort of jazz. He syncopated his colors. Sound and color went together. So the repetitive stripes, he said then, were reflections of the sounds in jazz. That was perfectly honest. My impression then was that if he had a more subtle eye, a serious feeling for what color can be, what color truly is — which is an awfully serious matter — they would have been beautiful. But my feeling was that the jazz disengaged that part of his mind that would have allowed him to act out of his own roots. I think he was bored, but he was indefatigable. He had totally abandoned his hand. He simply put the paint on flat as a pancake between the stripes, and the stripes were all done with tape. As I remember he made the stripes across. He'd pick out a green, that acid green that he was fond of, and he'd make green stripes at intervals across the canvas: green stripe, green stripe, green stripe. He'd paint all the greens, then all the reds, finally filling in all the interstices. I suppose until he ended up with one final stripe.

JB: Clem never gave him much support.

AT: Clem is an odd person. He's like litmus paper. He picks up clues. His responses are totally personal. It's beyond any rationality. He simply did not feel in Davis's paintings what he felt in [Morris] Louis's or Noland's.

Tom Downing I've only seen once. It was Ken who had the relationships with others. I was always way off in left field. And Morris I first heard of when we were in Ken's car, which was full of paint. I asked, "What kind of paint is that?" Ken replied, "That's Magna." Then he said, "There's a painter out in Silver Spring, named Morris Louis." Then James and I went to see the Morris exhibit at the Washington School of Art on New Hampshire Avenue in 1953 or '54. He was doing great big Abstract Expressionist paintings, leaning heavily on gold and silver, and my first impressions in walking into the room was a ship at sea. They looked like marine decorations — too decorative. I think they were all destroyed. They were what I would call "squishy."

JB: Did you have any idea of Greenberg's program or Color Field painting by 1960?

AT: I really didn't. In 1959 I was in San Francisco, came back here in 1960. Sam was born in November of that year. So I was pretty much homebound. I got a little studio on the third floor of a house across the street from 1515 Thirtieth Street NW, where we lived, and began to make drawings while Sam was a baby. I really was just working underground as usual. And I was making at that time pinched clay, quasi-Mayan rectangular abstract shapes. I never fired any of them because the revelation of my childhood — the fences from my childhood — overcame me in November of 1961. It was then that I decided to make only what I cared about most deeply, to make what I really loved and pay no attention to anything else. It was the whole landscape of my childhood, full of beautiful eighteenth- and nineteenth-century houses. And I grew up in two of them, along with fields and trees. I very nearly made trees. And the delicate differences which I noticed as a child, along with the powerful feelings of proportion. These are things that one notices when one is small and nearer the ground.

JB: The first pieces are very literal. There are cruciform shapes on the backs of some of the early pieces. Religious symbolism?

AT: Not a bit. It only had to do with structure. I don't have any symbolism at all. I don't have a symbolic bone in my body, nor do I have an aesthetic bone either. The first piece that I made in November 1961 was *First*. I came back to Washington, and the minute I returned I went straight to the five-and-dime store and bought a roll of white shelf paper. On the shelf paper I drew those three peaked boards. I didn't know anything about scale drawing — I drew it just as literally as I could. I then drew the two supports at the back to hold it up. Then I went back to my studio after getting the boards cut, glued it together using clamps, and painted it with white house paint.

By 1962 I was using Liquitex. I tried to call the president of Liquitex. I made two calls and finally got the vice president. He told me what he would do if he had to paint wood. Then I evolved my own method. I didn't know anything about anything at that point. I didn't know about mixing color. Everything I needed to know I learned as the problem arose. I used Liquitex gesso underneath. I didn't sand in those days.

By this time they were coming in very fast, so I went out to order some more boards. They were coming in as barn-like objects. I couldn't figure out how I was going to get them together. I had three young children, a huge house; James was very hospitable, so we had lots of dinner parties and we went out a lot. It was a very energetic, socially busy life. There were two children in school — one in primary school, one in nursery school — and Sam was a baby. Fortunately I had a live-in housekeeper, and I had the money that I had inherited from my mother. So I went back to get the boards a second time, and the man at the lumber yard said to me, you know you could have these fabricated. So I went across the street to the mill, and a man named Bill Lawrence suggested that I bring him scale drawings. I said, "What's a scale drawing?" He said, "Well, you need a scale ruler." So I went straight back to my studio and I made scale drawings. And I took them to Mr. Lawrence and he turned them into sculptures. He did everything after *First*.

JB: *Southern Elegy* [1962] is obviously not a picket fence. What did you have in mind?

AT: I had in mind to make what was coming into my mind. I didn't have anything in mind. These things appeared in my head — they appeared in threes. And they appeared very rapidly, and I simply kept up with everything as fast as I could. I just made samples of the many images that appeared in my head. I only did one tombstone, but I could have done a hundred. What happened is that the work flooded in on me — it was just like being under a waterfall. I hadn't learned how to hold off the work enough to make it possible to control it to some degree. So what I did was make examples of what came in my head. And I made one example of a tombstone.

JB: What about Ellsworth Kelly?

AT: I'd never even heard of him, not at least until 1965 or 1966. I wasn't aware of anything at all, except that I was under this waterfall of mental images. I'd inherited the money — thank god! So what I did, as soon as they said they could make the sculpture, was run to the bank instantly. I did everything quickly between car pools, dinner parties, houseguests, and all the things I had to do. I went to the bank and opened an "Anne Truitt Special Account," and I transferred from my principal money in ten- and five-thousand-dollar gollops. I used that money exclusively for my work, and kept using it until I separated from James in 1969.

JB: Did James resent your working on the sculpture?

AT: I think he thought it was a nice little hobby. I don't think he took it seriously until Clem Greenberg, Kenneth Noland, and David Smith came along and said, "Look, look!" Then, *then* he began to take it seriously. My impression is that he didn't so much resent my working on it as he did the changes that occurred in me when this strange thing happened to me. It was beyond my control. It was so absorbing, much worse than falling in love.

*Southern Elegy*, 1962. Acrylic on wood, 47 × 20⅞ × 6⅞ in. (119 × 53 × 17 cm).

I managed my life perfectly well in those days, with perfect equanimity. I had a lot of energy. The dinner parties and James's guests were a form of recreation actually. I never paid that much attention to them. I always knew that I would get up at 5:00 a.m. and get to work, and still have ample time left for the children and household.

JB: It seems to me that Greenberg felt some ambiguity about your work. On some levels he liked it, but on other levels it frightened him because its monolithic symmetry was what the formalist critics had begun to militate against.

AT: When Clem first visited my studio he simply said, "Now there will be three in Washington." I never remember him saying much about my work. I don't remember him saying much of anything. Now, when he saw *Hardcastle* [1962], the big, black sculpture with two red struts in cadmium red, he backed away from it and said, "It scares the shit out of me!" Excuse me, but that's the only time I ever heard Clem swear. Why did he swear? Because it loomed over him and it's intractable. André Emmerich hated it.

*Mary's Light* [1962] is the first sculpture in which I mixed color. I didn't think of color in the beginning — I thought only in terms of structure. And then I thought in terms of my childhood, which was either that dark lattice green or white. Then I began to get comfortable with Liquitex, and then I began to mix. I never made anything modular in my life except for *Ship-Lap* [1962].

In *Mary's Light*, the color goes around and in back. It's not applied color; it's solid. It goes right straight through. It's solid, like film color. At the same time, it's transparent and invisible.

*Two* [1962] was for Cord Meyer and his identical twin brother who was killed on Iwo Jima. Black and Hooker's green, inflected green.

The first one where the plinth is taken away, *Lea* [1962], comes out of Avonlea, a country house that belonged to my oldest friend. This is the first time that I ran the color around the column. By that time what I was beginning to realize is that what I was really fascinated by was proportion. And I could set the color free into three dimensions of proportion, in three literal dimensions so that the color could be penetrated by my hand. So I

had an independent, standing object. In those days they stood on the floor. It was René Drouin, at the opening at André Emmerich in 1963, who said to me, "There's some difficulty with the rug hitting the color. You know, you could put them up just a little tiny bit." And I went right straight back home and began to put quarter-inch risers on all the sculptures. *Lea* now has a quarter-inch rise, just a little tiny bit — a brilliant idea.

That's *Essex* [1962], very dark red and black. The color goes around and cuts into the solid shape. In such a way that it goes around the corner, so at the corners you have a change in hue at every single corner, although at every corner the color is on both sides the same. The color is set free in three dimensions just as if it were at once literal and solid but also transparent.

JB: I get the feeling that your things look best if there are very few in one room. They look stupid close together. They need a lot of breathing space.

AT: Absolutely, they look best just one piece in a room properly lit. André always wanted a show with one sculpture in the middle of the gallery. This is the first monolithic piece: *Bloomsday*. It came to be on Bloomsday, the 16th of June, 1962.[1]

JB: This was in the 1963 show?

AT: Yes.

JB: What was the response to the physical incisions and cuts that did not follow the painted patterns?

AT: I was counterpointing. The counterpointing came in very early with *Two* and in *Mary's Light*. I was counterpointing in my head, partly from music and partly from this business about the law of the horizontal and vertical.

---

1. Commemorating James Joyce's novel *Ulysses*, the narrative of which takes place on this day in 1904.

JB: Donald Judd wrote an uncharitable review of the 1963 show, in which he related it to Ad Reinhardt. He said that they look like "tombstones," and that the coloring was "not serious."[2]

AT: You know, I had never had a review before. I didn't have any idea what a review was supposed to be. I just responded by thinking, "Oh, that's what he thought!" It didn't deter me. I didn't know who Donald Judd was from a hole in the ground. It never occurred to me to take anybody's words too seriously. I never took criticism too seriously. It was so categorical. It was an imperative. I simply went ahead. I simply kept up with it as best I could. It was also a big choice because of the numbers of pieces that flooded my inner eye. Damn the torpedoes and full speed ahead!

*Watauga* [1962] wasn't included in the 1963 show. André's gallery on Sixty-Third Street was rather small. My recollection is that there wasn't room and we had to pick. For some reason it wasn't picked.

*Ship-Lap* is the only modular piece. It's five panels of black and green — the way they make ships.

*Catawba* [1962] was in the '63 Emmerich exhibition because Ken Noland insisted it should be. It's dark red at the bottom, olive green, black, and dark blue, with a line cutting just about two and a half inches above the black.

*Insurrection*'s [1962] back makes more sense. It has two struts in back and the color is thrown off. This balance of the color is very important to me — it balances it off so it won't settle. Instability, all the way through. You see, I can catch instability in stability. My experience is that nothing is stable. Because it's three dimensions and it stands on the floor like a person. It's a thing — instability caught in a kind of stability, which enables it to exist.

JB: A Heraclitan world in a Platonic matrix.

---

2. Donald Judd, "New York Exhibitions: In the Galleries," *Arts Magazine*, April 1963, 61.

AT: *Shrove* [1962] is dark red and very, very light tan. It's from Shrove Tuesday. My pieces have secret names, changing titles. What happens is the concepts become fuller. Fatter, deeper, they have more layers. But the names always refer to some specific area of emotion in me. It's stitched right into my life — it comes right out of me. I'm absolutely specific about my names.

JB: Why do you think your work vexed everybody, particularly Clem?

AT: I've always been completely baffled, but I always had the impression that it's been a huge vexation. That every time they saw it they got irritated. And I'm beginning to think from what you've said that they couldn't account for it with the canons that they were developing.

JB: The canon for sculpture that the formalists adhered to was a matter of dynamic equilibrium. It was essentially the tack taken by Smith and Caro — balance and disequilibrium. They could understand that, based on preceding sculptural values stemming from Cubism. Meanwhile Barbara Rose was talking about ABC sculpture, kooky things. John McCracken, Tony DeLap . . . technicolor lollipops.

You've taken up the challenge that Reinhardt and Newman had laid down, and you've followed it to its ultimate conclusions in three dimensions. It was like they were being hoisted on their own petard.

AT: It was as if my work was sticking into them like a thorn. They really didn't have much of a personal relationship with me. Their personal relationships tended to be based on work, what you might call "work partnerships." It had almost the nature of a cult. As if they wished to expand the members of the cult, and I never was a partner. Also I was female. Being female was a big disadvantage.

JB: Did Clem ever give you directions or hints as to where you should be moving?

AT: He tried to a couple times, but he might just as well not have. He would have liked me to change my shapes. He always felt that I should

go more for shape. Whereas he never really understood that the color so penetrated the structure as to set itself free. He never caught on to the fact that the sculptures were free, that the colors stood free.

JB: By shape do you mean Clem wanted more animation, more extension, asymmetry?

AT: Precisely. He wanted more going on. But the more you have going on, the more fussy it gets. And the less you align yourself with the intrinsic reality of color, which to me is a total mystery, but one that truly absorbs me. [Josef] Albers has nothing to do with the meaning of color, only with what you see.

If you manipulate color, its mysterious truth gives up. It won't play — it's just not true. I'm not interested in the eye per se, or what the eye sees. Consequently, I'm beginning to see why I'm not really connected with the Washington school of color manipulators. I don't want to manipulate. I'm very careful not to manipulate. And when my work succeeds, which it does now and then, it succeeds because I haven't pushed for an optical effect.

JB: Reading Greenberg from the late 1960s, after Reinhardt died, he sort of crossed him off as a painter with a small talent who had wasted it with the black paintings, which he saw as simply an attempt to make the same philosophical points over and over. Greenberg also realized, no doubt, that Reinhardt's program meant the closing down of formalism's options, as for instance when Reinhardt made his oft-repeated statement, "I'm simply making the last paintings that can be painted." Obviously this wasn't the case, but from the viewpoint of formalist reductivism it made sense.

For you to deny you're a formalist is like Harry Truman denying that he's a Democrat. But it gets your hackles up, obviously.

AT: What is your definition of a formalist? I guess I'm a formalist by nature but not by theory. I formulate them intuitively from distilled experience. It's the "ist" on the end of the term "formalist" that gets my hackles up. Because the formal values — value in the form, value in the color, value in proportion, and value in a certain kind of line — seem to be intrinsic.

Not an "ist" at the end of a word, not a theory, but a truth about art. The value is an intrinsic, personal experience. What is the point of making a work unless it comes out of some intrinsic experience?

JB: Minimalists are the super-formalists.

AT: Walter Hopps once explained to me that Judd didn't like my work because he wanted to make an art that was wholly American, a wholly new kind of art. That's a perfectly all right thing to want, but . . . I don't even think I feel any *but* about it, if that's what he wants.

JB: Michael Fried termed it "literalism" in referring to Minimalism. Judd used only manufactured materials, no titles, defined only by dimensions, date, and materials. That kind of sterile anonymity is what he considers "American." Maybe it is.

AT: I was surprised when you said that I should have made the box, six by six by six feet in black, which I saw in 1962 in my studio.[3] That box appeared in my studio, not in my head. There was no compulsion to make it because it didn't first appear in my head. I looked at it and said to myself, "How boring. I won't make that."

JB: Had you thought at all about scale in relation to your own body? Did you want to make them bigger or smaller?

AT: I went up to ten feet for the National Gallery. And when they asked me to make those two pieces it was Bill Seitz and Chuck Parkhurst who invited me to come down to the National Gallery. They said that they wanted a piece for the National Gallery. They said they wanted a big piece. I said I had always wanted to make a piece ten feet tall, and I never would have

---

3. Elsewhere Truitt speaks of having envisioned this work, only to later learn that Tony Smith had realized a virtually identical form with his *Die*, which he conceived of in 1962 and had fabricated in 1968. See also Anne Truitt, *Daybook: The Journal of an Artist* (New York: Pantheon, 1982), 94.

done it. They said very well, and so I made *Mid Day* and *Spume* [both 1972]. And then they were taken down to the National Gallery. Really, actually, the best time that I ever saw my work except for the Corcoran retrospective. Chuck Parkhurst took me down to see the two pieces where the acquisition committee was to see them, in a fountain courtyard. It was very mysterious: he punched a button and a rheostat, and then these two sculptures emerged out of the darkness. Both were facing each other in this narrow room, these two sculptures emerged out of the darkness — just these two by themselves coming out of the darkness. They wanted the committee to pick one. I told André about it and he got a donor for the other piece.

Ten feet is as high as I should go. Above ten feet is rhetorical. Then it becomes just a matter of prowess — anybody can do prowess. I also have reached a decision never to make pieces for outside, because scale is utterly thrown out.

JB: Technically, the only subject of contemporary outdoor sculpture is the sculptor. What gave you the impetus to do the early modular pieces like *Shrove*?

AT: Because it was counterpoint. I was counterpointing off the module. I wanted to see if it would "hold" the color. It made sense, and I did three of them. It held. And then there were so many other things coming along that I didn't have time for more. If I did more I would change the shape of the modules. I would vary the module, change the shape of the module — it wouldn't be a module anymore.

Counterpointing is a delicate process. I like the risk of that type of painting against form.

JB: Formalist critics couldn't take to you because your work was so minimal. At the same time, your work was exactly what the best formalist painting was all about.

You're in the art world but you're not *of* the art world. You're sort of in the literary world, but you're not *of* the literary world. You manage to maintain a foot in several camps while not being in them — it's

your strength and weakness. You were never really under the tutelage of Clement Greenberg; you're not hip to the New York art scene. You have your own bailiwick, your own interests. You really don't care.

AT: It's important to be responsible, and by god, I've tried to be. *Daybook* covered April 1975 to 1980. I was younger, not young. The older I've gotten the less self-protective I've become. The truth of the matter is that traumas do go away; they become part of the background tapestry of one's life. I like lucidity a lot.

JB: Any more remembrances about the Washington art world?

AT: The remembrances that I have are of Morris Louis. Morris and Marcella [Louis, née Siegel] were living on Legation Street, just a few blocks away from us. We went to see the *Unfurled* paintings, and they were rolled out on the floor of the living room. The smell of new paint was so strong that Jenny had to go out on the porch. And then Morris and Marcella came once after dinner, and again I was pregnant and went to bed early. I remember them sitting in the living room talking, and how silent Morris was. And then after his death James was one of his pallbearers. James was one of his friends — if he even had friends. But they were compatible and talked on the phone occasionally. You know, it was the day of Morris's funeral that André came down from New York. For me it was a sort of pivotal day. I drove André to the Louis house, and he offered me a one-shot show afterward, and then Marcella and I became friends after that.

Later, after the funeral, Clem and Jenny came to look at the paintings, and they stayed with us. In Morris's basement there were rolled up paintings up to my thighs, and in the guest room they were rolled up too, up to my knees. William Rubin was there, and Clem, and this little boy up on a ladder taking photographs. The paintings were laid out on the floor and we all looked at them, then we turned them over to see if Morris had written anything on them. If not, then Marcella would write on them to authenticate them. And then they would be rolled up again. There were four hundred and twenty-five, if I remember.

## "A First Impressionist": Review of *Berthe Morisot*, 1990

Toward the end of her life, the French Impressionist painter Berthe Morisot wrote, "There is a kind of elevation that does not depend on fortune; it's an indefinable air that distinguishes us and seems to destine us for great things; it's the value that we give ourselves imperceptibly. Especially to our spirit."

This sense of knowing one's own destiny is the spring of originality, but it is rarely reinforced by circumstances as auspicious as those that surrounded Berthe Morisot. And now fortune has smiled on her once more, for Anne Higonnet, an assistant professor of art at Wellesley College, has written Morisot's biography with a scrupulous honesty that resists the temptations of impertinent interpretation. Drawing on previously unpublished journals and letters, Ms. Higonnet delineates the facts of Morisot's life as if with an incisive etching tool; her cool, logical pen makes a contrast to the supple brush with which Morisot caught transient light.

Berthe Morisot was born into a confluence of conditions that were almost magically appropriate to her development as an artist. Even a technological detail contributed to her good fortune, for in the year of her birth, 1841, pliable paint tubes were invented, enabling artists for the first time to complete spontaneous paintings out-of-doors.

Morisot's grandmother and mother were women of lively intelligence, expressive and confident; her father was a prosperous civil servant. The family settled in Passy, a suburb of Paris, "then almost the countryside, a village still of seventeenth- and eighteenth-century garden pavilions and low white houses." She lived her entire life in Passy, was married there

---

Berthe Morisot *by Anne Higonnet (New York: Edward Burlingame/Harper & Row), reviewed by Truitt in the* New York Times, *June 3, 1990.*

and is buried there. She was so secure in its stable society that she could concentrate on developing her talents without material anxieties.

Morisot was the third of four children, with two older sisters and a younger brother. When she was sixteen years old, she and her sisters were given drawing lessons — her mother's idea being that her daughters could give their father drawings for his name day. Morisot immediately took charge of her career. She found the teacher dull, and at her insistence she and her sister Edma, two years older, began studying with Joseph Guichard, a painter whose wife ran a school for girls.

Guichard introduced Morisot and Edma to the work of a group of newspaper artists whose sketches recorded swift impressions of the lively Parisian scene; he also took them to study the masterpieces in the Louvre. Most art schools were closed to women (the exception being the free school funded by the city of Paris and run by Rosa and Juliette Bonheur). But because a casual ability to draw and paint was considered an embellishment of a woman's life, women were allowed to copy the works at the Louvre. There Morisot encountered male peers, students like herself. The most notable of these was Henri Fantin-Latour, who later introduced her to Édouard Manet.

After a few years, Morisot decided that she wished to be more than an amateur. In 1860, she insisted on moving outdoors to work; as a result, Guichard passed his pupils on to his friend Camille Corot, who taught them to paint views of the countryside and also became a welcome guest at their mother's soirees. "Berthe had taken the first step in a career pattern," Ms. Higonnet notes, "and she would under cover of family sociability continue cultivating professionals whose work she admired."

Morisot's "cover" was, however, natural to her placement in life, so natural that she seems in no way ever to have compromised her integrity. Rather, her seriousness of purpose attracted serious support. Every photograph and every portrait of Morisot declares her intention to be true to herself: there is a look of fierceness in her eyes.

All her life, people helped Morisot with her work by providing her with close, congenial, and loyal company. This devoted attention continued even beyond her death: Paul Valéry, who married her niece, wrote about her work, and her grandson, Denis Rouart, compiled and edited her correspondence.

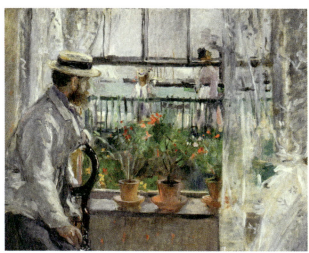

Berthe Morisot, *Eugène Manet on the Isle of Wight*, 1875. Oil on canvas, 18 × 14 3/16 in. (46 × 36 cm).

The path of Morisot's social life lay easily alongside that of the artists who would become known as the Impressionists. Fantin-Latour introduced her to Édouard Manet in 1868; his brother, Eugène Manet, became Morisot's husband in 1874. Degas, Renoir, and Monet were her devoted friends. Such friendships were, of course, partly based on compatibility, but these daring, bold and inventive artists were bound to her more significantly by their recognition that, like them, Morisot was a born painter.

The first Impressionist exhibition opened in Paris on April 15, 1874, and from then on the critics singled out six figures as core members of the movement: Degas, Monet, Camille Pissarro, Renoir, Alfred Sisley, and Morisot. "To no woman artist had such power ever before been ascribed," writes Ms. Higonnet. "One reason Impressionism was perceived as being so radical was undoubtedly that it included a woman."

The smooth intertwining of Morisot's art with her private life should, however, in no way be misunderstood as blurring the edges of her independence. She acted, as Ms. Higonnet remarks, "from a feminine distance," but she acted decisively. She exhibited under her maiden name, refusing the device, then common among women artists, of a male pseudonym. And her aim in her work was crystal clear. "My ambition," she says in a remark quoted by Charles F. Stuckey and William P. Scott in *Berthe Morisot: Impressionist*, the catalogue of a recent exhibition at the National Gallery of Art, "is limited to the desire to capture something transient, and yet, this ambition is excessive."

In a letter to her sister Edma, written from the countryside near Nice, she remarked that "this landscape is diabolical, with a line that doesn't allow any approximation and a light you can never capture." In her pursuit of that light, she danced right to the edge of nonrepresentational abstraction, anticipating the direction taken by twentieth-century painting.

Morisot suffered from minor but persistent ill health all her life, but as her impressive oeuvre attests, she never faltered. "I am back on my feet," she wrote to Monet in 1888, after her recovery from a bad case of flu, "and doing stern battle with my canvases."

Only one work, a pastel self-portrait dated 1885, reveals what her "stern battle" cost her. Here she literally ties herself to her femininity by the decorative black ribbon around her neck; her eyes, one perfectly

drawn, the other a single infinitely expressive stroke, look out of an aging face hauntingly dissolved.

Part of the cost of Morisot's labors was that her indefatigable industry, and her success, isolated her from people who were less firmly committed to a personal goal — most poignantly from her sisters. And she seems to have felt her isolation as a woman among her male peers. "I don't think there has ever been a man who treated a woman as an equal," she wrote in her notebook in 1890, "and that's all I would have asked, for I know I'm worth as much as they."

In Morisot's paintings, women are like Tiburce Morisot's description of his famous sister: "meditative, mysterious, like all those in whom silence is due not to deficiency of thought but to a disdain for its expression." Even side by side with their children, her subjects contemplate themselves apart, in an atmosphere of self-imposed solitude that lifts them above their circumstances.

However remote she may have been — the writer Henri de Régnier describes her as having "a sort of infinitely intimidating reserve" — Berthe Morisot was beloved. When she died of pneumonia, rather suddenly, in 1895, Renoir, who was in Aix working with Cézanne when he heard the news, had, as we learn from the Stuckey and Scott catalogue, "the feeling of being all alone in a desert."

Perhaps because she has a book forthcoming on Morisot's images of women, Anne Higonnet has for the most part refrained from detailed analysis of Morisot's painting in this admirably lucid biography, which serves as an important introduction to an extraordinary achievement. For above and beyond her work, Berthe Morisot left a legacy to all women and men who are artists: a life in which responsibility to herself as a person and responsibility to herself as an artist are as beautifully balanced as the structure and light in her painting.

## "An Art of Stone": Review of *Noguchi East and West*, 1992

Isamu Noguchi was born in Los Angeles in November 1904, almost to the day one year after the Wright brothers invented the airplane that would enable him to circle and re-circle the earth in an indefatigable binding of east to west. His father was Japanese, his mother American, and he inherited the legacy of both cultures. As if patterned on the mythical heroes about whom his mother read him in Japan — to which he moved with her at the age of two and where he lived until he was thirteen — he became a twentieth-century Mercury, wing-footed, bearing to wherever he touched down the gift of his art. A practical Mercury, however, for his wise mother saw to it that her son learned to ground himself: when he was a small child, she "assured his acquisition of the knowledge of tools by apprenticing him to a carpenter."

Mythical figures attract ire, and Noguchi did indeed do so in the course of a long and tempestuous life, but he has been granted a compensatory grace in his biographer. Dore Ashton, an art historian whose distinction matches that of her subject, has written a fascinating account of "the trajectory of his life." His personal friend, she adopts an attitude that is affectionate but devoid of sentimentality. Her voice is at once erudite and lyrical. Noguchi once remarked to her, "I have come to no conclusions — no beginning and no ending," and Ashton sees his life as "elliptical . . . all the circling back, the connecting of disparate sources." She connects these sources in an enchanting biography.

It is typical of artists' lives that they are elliptical and circle back. What lends Noguchi's its poignancy is the anguish of his split loyalties. For example, when World War II was declared and Japanese-American

---

Noguchi East and West *by Dore Ashton (New York: Knopf), reviewed by Truitt in the* Washington Post, *April 12, 1992.*

citizens were herded into barbed-wire encampments, Noguchi decided to join them for several months. Invited in 1952 to design a memorial in Hiroshima for the victims of the atom bomb, he submitted a plan that was refused. Similarly invited to design John F. Kennedy's tomb, he was again rebuffed. He writes in his autobiography, "I could not help feeling that I had been rejected by America as I had been in Japan."

However his emotional conflict may be read as central to the integration of complex elements that mark his art, though Ashton is happily free of any tendency to armchair psychoanalysis, his life was exemplary. From the "sea wave, in clay with a blue glaze" that he made before he was four until his final grand projects which render space itself a sculpture, he pursued his ends with an instant recognition of any opportunity, combined with an equally instant address to its possibilities.

When he was thirteen, his mother decided that he should continue his education in the United States, and he set out alone back across the Pacific Ocean and on to the prairie of Indiana. By the time he arrived, the Interlaken School, which was his destination, had abruptly closed. He was taken under the wing of a kindly educator, who saw to his schooling (under an Americanized name, Sam Gilmour) and sent him on to Columbia University as a pre-med student. But Noguchi had other ideas. He fell in with some Italian stonecutters and, in 1924, after mastering "the tricks of the trade of academic stonecutting," he simply set up his own studio under the name of Noguchi and became, he wrote wryly, "the hope of the academy." He did indeed exhibit in academic salons but soon picked up the exhilarating scent of avant-garde art in New York galleries.

The pattern of his career began to emerge in 1927. He received a Guggenheim Foundation grant for a trip to the Far East. When he got to Paris, he instead apprenticed himself to the radically abstract sculptor Constantin Brancusi. In Brancusi's studio, he made works in wood, stone, and metal, returned to New York, and showed them in 1929 in his first solo exhibition. He earned his living by sculpting portrait heads and in this way found friends, notably Buckminster Fuller, who saw him as "the unselfconscious prototype artist of the new cosmos," and Martha Graham, for whom he began to design innovative stage sets. But even as he began to find a footing in the New York art world, Noguchi's

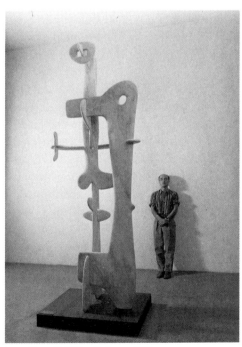

Isamu Noguchi, 1946, with *Kouros*, 1945.

305 "AN ART OF STONE": REVIEW OF *NOGUCHI EAST AND WEST*, 1992

characteristic restlessness led him into ever-broadening perspectives. He traveled — China, Japan, Mexico, Hawaii, Europe, the Middle East, India, Cambodia, Indonesia, Bali. Wherever he went, he studied and absorbed new forms of expression that influenced the sculptures he habitually returned to New York to exhibit. He began to design furniture and the Akari lamps that sold so successfully that he was relieved of want. His range was astonishing, from a domestic scale to immense public spaces that he organized according to the ancient tradition of Japanese gardens. He was wonderfully sensitive to the precise use of materials in sculpture, the proper material put to the proper use, and as enterprising in seeking what he needed as in his inventiveness. He had Greek marble cut to his specifications right in the quarry and shipped to New York. And when he found certain rocks on Tsukuba Mountain in Japan to be inaccessible, he "decided that there was nothing to do but to build a road for a distance of half a mile, down which the rocks skidded." When he found himself cramped in his Manhattan studio, he bought a factory building in Long Island City, which he later expanded into the Isamu Noguchi Garden Museum. In 1971, he established another studio in Mure, on the Japanese island of Shikoku.

Ashton traces Noguchi's steps attentively and analyzes his work with penetration, but it is the subtlety with which she addresses his intellectual development and spiritual evolution that makes her book singularly distinguished. Her sympathetic portrayal of the artist's visits to Japan is profoundly moving: his attempt to come to terms with his father; the friendships with Japanese artists which deepened his comprehension of traditional Japanese values; the growth of his instinctive identification with the rootedness of the Japanese, their sensitivity to the earth. "There is to each stone," he wrote, "a live and a dead side."

"I came to think of him as an authentic romantic," Ashton concludes; "he thought of the five senses as an opening to the world and balked at pure abstraction, although he was mightily tempted . . . [His] returns to the earth were . . . important to him." In the final balance of Noguchi's legacy of two cultures, the Japanese was the more critical. Two years before he died in 1988, he wrote a note to himself: "Seek the dead center of gravity."

## On Persistence, 1993

*Importance of persistence* because learning *requires time*: our sensory and intellectual apparatus is keyed *to* time, can only absorb *in* time.

The rolling stone experiences little save successive bumps and jerks out of which no sense can be made.

Have a feeling of having seen it all — all phenomena of whatever kind, a feeling of being exhausted with living — a fleeting impression of the ephemeral nature of actuality — as if the actual had ceased to interest me, and the virtual had silently usurped its place in my thought.

---

*Handwritten note dated March 23, 1993, box 1, folder 19, Anne Truitt Papers, Special Collections Department, Bryn Mawr College Library.*

## "Charmed Magic Casements": Review of *Utopia Parkway*, 1997

The frontispiece of this masterly biography is a photograph of an old man's back. He is hunched in a spare, cane-bottomed wooden chair perched uneasily in a bleak backyard, the bare sticks of a tree branch toward him; he is reading, hermetically sealed in concentration. He appears to be ordinary, but he is not. He is Joseph Cornell, who so ingeniously braided his life into his art and his art into his life that his work initiated an astonishing number of artistic currents. Beset as he was by restrictions, he was a lucky man with a knack for being in the right place at the right time; he found recognition and acclaim as readily as he found the thousands and thousands of eclectic objects he provocatively juxtaposes in his work. He is lucky too in his biographer. Deborah Solomon, the art critic of the *Wall Street Journal*, brings to his life a lucid intelligence, an incisive knowledge of art history, and a rare sensibility. Her generous understanding illuminates Cornell as a knight-errant of art.

He was a knight whose adventures were entirely in the realm of his imagination. Born in Nyack, New York, in 1903, he was buried there sixty-seven years later with his father, his mother, and his brother. His father died in 1917. His mother, by 1929 in reduced circumstances, bought a modest clapboard house at 37-08 Utopia Parkway in Flushing, Queens, across the East River from Manhattan. There he remained with her and his brother, Robert, for the rest of his days. A strange threesome. Mrs. Cornell, described as "a stout matron in a black dress with a lace collar, her gray hair in a bun," was so jealous of her son that when he was visited by the artist Yayoi Kusama she boiled the towels the beautiful young woman had used — "to sterilize them," Kusama said, "right in front of

---

Utopia Parkway: The Life and Work of Joseph Cornell *by Deborah Solomon (New York: Farrar Straus Giroux), reviewed by Truitt in the* Washington Post, *May 4, 1997.*

my eyes." Robert was born with cerebral palsy. Severely incapacitated, even unable to speak clearly, though he was, as filmmaker Stan Brakhage described him, "a very sweet man and lively in his eyes," he required constant care; his brother's tenderness seems rarely to have failed.

Although Cornell was sent to Phillips Academy at Andover, perhaps acquiring there the intellectual habits that steadied his later pursuits, the family's leisure time under his father's auspices was devoted to frivolous entertainment: vaudeville, Wild West spectaculars at Madison Square Garden, shows of acrobats, dancing monkeys, aquatic ballets. And — most memorably — Harry Houdini's magic vanishing acts, which had a special appeal to a child whose father "disappeared" early in death, whose brother was chained by illness, whose responsibility it became, he felt, to take care forever of his mother and brother. Thus shackled, Cornell "vanished" into daydreams and into solitary walks during which he took to examining and picking up little, old things, objects which held the past intact, a past into which they gave his yearning temperament a route of imaginative escape. By middle age, he had collected a basement-full of "dime-store debris . . . ceiling-high shelves literally sagged from the weight of his collectibles, the cardboard boxes stuffed to overflowing with shells, watch springs, cordial glasses, owl cutouts, rings, bells, maps — a galaxy of everyday objects."

In the course of noontime breaks from the routine job he took after graduating from Andover, Cornell wandered around Manhattan, wandered and looked. A confirmed "urban-gatherer," he catered to his secret life, collecting for his ever-expanding archive at Utopia Parkway "librettos, record albums, books, prints, souvenir photos, theater memorabilia, and ticket stubs, and filing any permanent material into 'dossiers.'" When, while prowling through galleries and museums, he discovered the new art movements of Surrealism and Assemblage, art that honored imagination and glorified the ordinary, he began in 1931 to make art himself.

The piece that set him off was by Max Ernst: *La femme 100 têtes*. A "collage-novel," it was composed of images cut out of old magazines, mixed up in a startling way and fastidiously collaged, glued, to make a "readymade object." As the art historian William Rubin has pointed out, this method "allowed people who were neither painters nor sculptors to enter the realm of art." After seeing *La femme*, Cornell hurried home to

Flushing, sat down at the kitchen table, cannibalized his collection of old books and made a series of collages for himself. One of these is *Schooner*; five by six inches, it depicts "a clipper ship aloft on calm waters, with a rose and a spider mysteriously sprouting from one of its sails." To see it is to laugh with delight! The course of Cornell's later work was set. It was Julien Levy, who was to include him in his first gallery exhibition, "Surrealisme," in 1932, who suggested to Cornell that he try "experimenting with shadow boxes." Five years later, Cornell made the first of the boxes that were to make him famous. In the meanwhile, he filled little pillboxes with "tiny shells, sequins, rhinestones, beads, scraps of blue paper . . . that hint at a very personal prescription for well-being." He also began to make the short, fantastic and irresistible films that enhanced his growing reputation.

Cornell's boxes were his most ambitious works. Usually about sixteen by twelve by four inches, they are essentially wooden "shells," awkwardly carpentered, stained, varnished, and painted with six or seven coats of house paint "until the surface looked crusty and acquired a seeming patina of age." Sometimes lined with blue velvet, old wallpaper, or magazine pages, they contain constructions of Cornell's fantasies of starry skies, of birds, of Renaissance princes, of long-dead divas with whom he has "fallen in love," sometimes of contemporary people — one is dedicated to Lauren Bacall. They are his dreams come true, and have the curious appeal of voyeurism — we look into Cornell's secret life — and of discovery — ordinary objects in surprising juxtaposition evoke mystery.

Once admitted to the gallery world in 1932, Cornell moved steadily toward fame. One-man shows on more or less successive years culminated in a retrospective exhibition at the Guggenheim Museum in 1967. By this time, he was an established figure on the art scene: an unpredictable, cranky, sometimes charming, sometimes alarming presence. Robert Rauschenberg once remarked that "Cornell . . . might say 'Hello,' and then six hours later, he would say, 'I'm going now.'" Visitors were drawn to Utopia Parkway with hopes of acquiring a box or collage or even an ornamented trinket. Admitted to the artist's sanctum, they might be offered "a lunch of pistachio ice cream." For Cornell lived on sweets; snacking in a diner, he enjoyed "banana cream pie, doughnut, and drink."

He had no intimate friends, only acquaintances whom he might welcome one day and dismiss with a curt note the next. For all his ardent yearnings toward women — he was continually enamored — he remained a virgin. Possessing only with his eyes, he tirelessly recorded in his diaries the comings and goings, the clothes and hairstyles, of women who caught his attention as he wandered about.

Cornell's work would have remained only clever had it not offered glimpses into the fascinating world of his brilliant imagination and rendered that world visible in extraordinarily inventive ways. For although it lacks the irony characteristic of much significant contemporary art, his work heralds its concerns. In 1931, long before the advent of Pop art in the 1960s, he extended iconography to include trivia; and images of popular icons, such as Greta Garbo and Carmen Miranda. He also recycled art images (for example, Watteau's 1721 painting of "Gilles," an actor in the commedia dell'arte) because, he claimed, "reproductions are suffused with desire: they make us long for originals we can never possess." In 1939, in his second solo show at the Julien Levy Gallery, he designed what Solomon describes as a room "to resemble a walk-in fairy tale" — a paradigmatic art installation. He made some of the first "artist's books." And in *Object 1941* he preempts Jackson Pollock: "The glass pane of the box is spattered with rivulets of white pigment in a 'drip' painting of sorts."

Just as each of his works slyly evokes an implicit narrative, Cornell's life — however "relentlessly middle-class" and devoid of drama — adds up to an absorbing story. Deborah Solomon's account of his role in his historical era is especially interesting. She has written a biography, amply illustrated and footnoted, that is not only scholarly but also a pleasure to read. A distinguished achievement, it is a meticulously researched and deeply considered examination of how Joseph Cornell's daily life contributed to his imaginative life — the only real life he knew.

## "Grand Allusion": Interview with James Meyer, 1997

JAMES MEYER: Your debut show at André Emmerich, in 1963, was one of the first exhibitions of large-scale geometric sculpture. How did you come to make some of the earliest "Minimal" art?

ANNE TRUITT: The question implies that I did it on purpose, which is not true. What happened is that I began to see how I could make exactly what I wanted to make in a new way. It was a complete about-face from my previous work. At the time I was making life-size figures of steel pipes with chicken wire and plastic and cloth. They were gothic figures and sort of bestial; I was also making casts of clay heads in very dark, colored cement, very ugly and very primitive. They had nothing to do with art in a way; they had to do with self-expression. In November 1961 I began to make the things I am making now.

JM: It all began with *First*, that modest little sculpture in the Baltimore Museum that resembles, but isn't, a white picket fence.

AT: It went in a rather literal progression. I did *First*, which is a perfectly straight picket fence that I put together myself. And then I did *Southern Elegy*, which is a perfectly straight tombstone structure, and then *Two*, and made a jump: I realized that changes in color induced, or implied, changes in shape. That though color and structure retained individuality, they could join forces rather as independent melodies can combine into a harmonic whole. And that when I combined them in a particular way, they had a particular content — particular to me, that is, a meaning that was important

---

*Recorded on July 11–12, 1997. A version of this interview was previously published in* Artforum, *May 2002, 156–61.*

to me. Once it had occurred to me that I could use color metaphorically for content, I realized that I could go ahead with new freedom. What I was doing dawned on me as the works got bigger: strange-looking objects that just stood there in the studio for almost a year, where no one came but me.

JM: Why were you dissatisfied with the figurative work?

AT: It was nowhere near broad or wide or deep or open enough. With abstraction you can go as far as you can go. But with the figure you are stuck because you're dealing with actuality.

JM: What was it about these simple shapes and fields of color that was going to be the language of your work?

AT: I'm sorry, I just don't think that way. It's as if you're asking me to put the cart in front of the horse when I have neither horse nor cart. I just thought, I must make these things.

JM: But why this form and that color to express a particular content?

AT: I never thought about it. The objects came in with their intrinsic subject matter — like baseballs thrown on a curve. I don't know how to put it into words.

JM: Well, I'm suggesting the forms you used weren't arbitrary. Your early work is mostly large, bulky shapes.

AT: I think you'd have to say that what I've been about is being alone in the world, looking around at it, and trying to absorb it, at first with extremely nearsighted eyes. I didn't see a damn thing until I was in fifth grade. Nobody knew I couldn't see. So when you talk about the big things that I made, I think what it may have been is this person going around through the world, either on her legs or on her bicycle, in a place confettied by large, anonymous structures — just big blocks of white or gray. I couldn't see anything except these big blocks. And I had to go on smell and sound.

JM: And tactility.

AT: And tactility. It's sort of a frightening way to grow up. I wandered around in a daze.

JM: You've said that you wanted to capture memory in a concrete form. Most of the artists who came to be called Minimalists purged their work of metaphor or subject matter. Some of the artists coming along in the '90s, such as Roni Horn and Felix Gonzalez-Torres —

AT: I know their work.

JM: — embraced a Minimalist vocabulary in reaction to Minimalism's desubjectivizing impulse. The cube and floor plane and modular repetition became a language for exploring personal content. In your work, the form was generated by the artist herself in order to contend with a particular subject matter. The relation of form and content is not imposed but inextricable. But what's interesting, what makes your work hard to place within the Minimalist arena yet extremely relevant now, is that you devised the form with an expressive aim.

AT: Let's not use the word "devised," because I didn't think. I did it intuitively.

JM: Whereas your peers came to a Minimalist vocabulary to purge their work of content and feeling.

AT: My idea was not to get rid of life but to keep it and to see what it is. But the only way I seem to be able to see what anything is, is to make it in another form, in the form in which it appears in my head. Then when I get it made I can look at it.

JM: When you had your first exhibition, at Emmerich, the work must have looked far out and strange.

AT: It was a strange distillation of a person's life. The works were not devised and they were not art. I didn't make them out of art. I've never understood people who made art out of art.

JM: What do you mean by "art"?

AT: You know. Something devised, something where people live to express themselves. I did that for twelve years — worked and worked and worked to make something on the outside that met and matched my inside.

JM: But I thought your work was expressive. You've mentioned that *Hardcastle* — one of your largest works, a tall black wall held up by red struts — alludes to a man who was run over by a train not far from your parents' summer home. It was a horrible event from your childhood.

AT: No. This was about trying to objectify my life. It wasn't about me myself. That was the whole virtue of it.

JM: How did [Clement] Greenberg come to see your work? Was it through Kenneth Noland?

AT: Yes. First it was Ken, who told David Smith. David was the biggest, strongest supporter anybody could ever have.

JM: So they were the first two people to see your work?

AT: Yes; and then Clem. Clem said, "Now there will be three in Washington."

JM: You, Noland, and Morris Louis, presumably. In his essay on Minimalism, "Recentness of Sculpture" [1967], Greenberg talks about how difficult your work was for him initially, how he had to go back again until he finally "saw" it. Yet you've said he was impressed right away.

AT: Right away. There was no question about it.

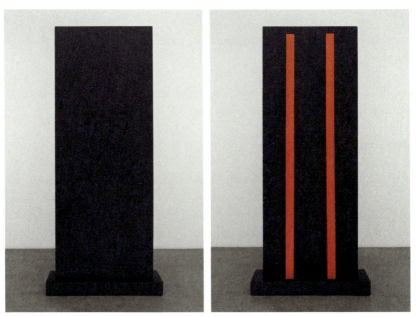

*Hardcastle*, 1962. Acrylic on wood, 93¼ × 42 × 16 in. (236.9 × 106.7 × 40.6 cm).

JM: He was particularly impressed by *Hardcastle*.

AT: He backed away from it and said, "Scares the shit out of me." That's the only time I ever heard Clem swear. I remember being startled.

JM: That essay and the one he wrote about you the next year, "Changer: Anne Truitt," marked you as "Greenberg's Minimalist." He characterizes your work as a welcome antidote to that of [Donald] Judd, [Robert] Morris, and [Carl] Andre. He praises the handmade quality of your sculpture and its intuitive color and attacks the industrial look of "orthodox" Minimalism. But you've also said that you later felt Greenberg was disappointed in you.

AT: He was not supportive all the way through; he was polite. I think he was disappointed — angry in a way — maybe because I didn't do what he thought I should do.

    Perhaps he thought that I should pay attention to him and ask him what to do. I'm not quite sure what he wanted. But he didn't want what I did — which was never to ask him any questions at all, never to ask his opinion, and to go my own way. Maybe what Clem wanted me to do was to stay safe within the language of sculpture, to retain sculptural checks and balances. Actually I just lost interest in that language after 1961. And now my sculptures pivot on the invisible line of gravity that holds them to the ground. I just got simpler.

JM: More "minimal," which he didn't like. He said that your work hovered on the look of "non-art," like Judd's.

AT: No, he didn't entirely like it. Maybe he thought I should use color in a Cubist fashion, should fit my work into that art-historical imperative.

JM: Like David Smith or Anthony Caro, whose welding and balancing of parts he traced straight to Picasso: a perfect modernist narrative.

AT: I said to myself, I'm not going to do it. And I just stayed down here in Washington and kept on working.

JM: You decided not to show *First* or *Southern Elegy*, which resembles a tombstone, at Emmerich. That decision presented you as a "pure" abstract artist in your first show. The figurative origins of your work — its allusive nature — were repressed. How was that decision made?

AT: I think it must have been made by Ken and Clem. They were sort of guiding me along. Ken was busy telling me the folk knowledge of what it was like to be an artist. He was as generous as he could be.

JM: You've described the first show as a success. How so?

AT: I guess in terms of comment. At that time Clem was really dominating things, and Ken was powerful. Helen Frankenthaler came to see my work and traded. There were all these people in this world around André Emmerich.

JM: And they were all at their height.

AT: It was the apogee for them. February '63, that was it, you know. There was nobody else around.

JM: Pop was just taking off, yet Greenberg was still calling the shots.

AT: Even I could see that I was at the center of a power game.

JM: Greenberg made you one of "his" artists. What was it like to put up a show with him? I ask because Judd, as you'll recall, criticized the Emmerich installation in a review. He described the arrangement as "thoughtless," implying that you didn't care about how the works were placed.

AT: Let me go back to February 1963, with these three men — Bill Rubin, Clem, and Ken — arranging the stuff in André's gallery. I was completely floored. I had never thought of the works together. I had simply thought of them as individual sculptures. I was astonished to see how they considered them in relation to one another. And they put two of them in the back room because they didn't "fit."

318

JM: So they installed your show. Did you agree with their choices?

AT: Well, for once in my life I was feeling rather passive. I was very conscious of being a neophyte. And they were very powerful; they were men in their own world.

JM: Much has been said about what an uphill battle women artists faced in the '60s. One looks at figures like you and Agnes Martin as something like survivors. Are the claims of sexism overrated or exaggerated?

AT: Underrated. Couldn't be exaggerated.

JM: Yet your shows got reviewed in all the magazines and by major critics. You've shown consistently for over forty years.

AT: I know, it's incredible.

JM: And yet you've told me that Greenberg and André Emmerich were disappointed that you never "took off" sufficiently. You didn't work your career.

AT: I never claimed my place. Louise Bourgeois stayed on the scene. She claimed her place day and night, year in and year out, and she has it and she should have it. Louise Nevelson claimed her place and stayed there and fought for it. Frankenthaler, too.

JM: Does your reserve on this score have anything to do with being a woman?

AT: Let's say that had I been a man, I would have been an equal. Also, I had been brought up never to call attention to myself.

JM: The successful women of your generation we can count on one hand.

AT: We didn't even finish a hand. It isn't that these artists made a great big ruckus — they just stayed in situ. I think they were right. There's nothing wrong with it. But my character and my work are very quiet. My work depends on my being quiet. Psychologically, I can't afford that kind of public attention. I don't have the temperament for it.

JM: You've lived quietly in Washington all these years. Why did you stay?

AT: The light is wonderful in Washington. And I have a lifetime of friends here. It's the latitude and longitude I was born on.

JM: You turned eighty last year. Has age, in some way, affected your work?

AT: I don't think age makes any difference except that it endows a person with freedom. Age cuts you off, untethers you. It's a great feeling. The other thing is, when you get to be eighty, you're looking back and down, out from a peak. I can look down and see my life from my own little hill; I see this plain, all the years of experience.

JM: Does that mean making the work is somehow easier?

AT: No, it's harder. It costs me much more; I have all those years that I have to face and it takes a certain amount of courage. It's not a light and foolish thing. Color is getting more complex and harder and harder to mix. There are more complexities in it because my own experience is much more complex.

JM: Is it physically more difficult to work?

AT: It's not more difficult to be faithful, but I have to be faithful to more and more. And I have less psychic energy as I get older. Heaven knows I have less physical energy!

JM: But it has not changed the fundamental process or ambition of the work. If anything, the ambition has increased.

AT: Yes, I would say, by leaps and bounds.

JM: And the laborious process you use — painting the wood support in layer after layer of crosshatched color — hasn't changed. What happens if you're not pleased with the result?

AT: I take the color off and begin again.

JM: All the color? The white undercoats?

AT: Take them all off. Go back to the wood and come forth again. You never make the same mistake twice. Next time I will have learned.

JM: How do you get rid of the twenty or so coats?

AT: It's a horrible job. You have to wear a mask and rubber gloves and use newspaper and paint remover to take off all the paint. And sand.

JM: To the bare wood.

AT: It's a patient business. Sometimes you can be on that very last coat and it'll go wrong. All of a sudden it just won't do anymore; my hand goes out. So it's always a question of attention, of waiting.

JM: Do you put the sculpture away?

AT: I take the color off it and begin again. Or I go in the house and wait. Or I move on to another sculpture and look at it out of the corner of my eye. At a certain point I'll go back to it. I don't exactly fix it. I just pick up where I am.

JM: And when the sculpture's ready?

AT: It's over. The whole thing is over as far as I'm concerned. Then I have to take care of the object itself. The reward is the making. I think all artists would agree with that.

"GRAND ALLUSION": INTERVIEW WITH JAMES MEYER, 1997

## The Title Tapes: An Excerpt, 1997–98

December 13, 1997

ALEXANDRA TRUITT: We are going to begin with the sculpture *First*.

ANNE TRUITT: I made *First* in late November, early December of 1961, immediately after a trip to New York. The title is absolutely descriptive — that is, I named it *First* simply because it *was* the first, and I felt that I was putting my foot on the beginning of a long line of work.

I did not have any particular vision before I put *First* together. I simply thought "fence," and then I made what was for me a generic fence. Once I began to draw the pickets, I made them about the height of my hand, a memory of walking along and touching the tops of the fences of my childhood. When I was about eight or nine or ten I used to walk along fences and look between the boards.[1] And because I've always been interested in how things are made, I would sometimes look at the other side. *First* is made the way most fences are made, except they're usually set into the ground. With *First* I couldn't put pickets into the ground, so I simply made a line of board under them to represent, to stand in, to substitute for the ground.

---

*Alexandra Truitt began keeping informal records of her mother's work in 1974. In the mid-1990s, with a view toward producing a catalogue raisonné, she initiated the first full inventory. To that end, in late 1997 through 1998, she interviewed her mother on several occasions with the specific intention of discussing the title, origin, meaning, material composition, and fabrication of each work. They spoke in Truitt's studio in Washington, DC, going over her entire output from 1961 to 1997, including all the major sculptures, works in series such as her* Arundel *paintings and small* Parva *sculptures, and some of her paintings and works on paper. This excerpt from the transcribed interviews focuses on the period from late 1961 through 1962, an intensely prolific time for the artist.*

1. Truitt lived in Easton, Maryland, until she was thirteen years old.

ALEXANDRA: Why did you make the middle picket higher?

ANNE: Because when I ran my eyes and my hands over the pickets when I was a child, the heights were all uneven. The spaces between the pickets were also always very slightly uneven. When I was little I often couldn't see over fences, so I became conscious right away of the spaces, the distances between the boards, the distances between things, and the intermittent nature of observation. The fact that I would see and then not see, see and then not see, see and then not see. These lengths of time were irregular.

ALEXANDRA: Does *First* have a definite front and a definite back?

ANNE: The front is the pickets, the white picket fence. If I could have thought of a way to make the pickets stand up on their own, I might not have put the back on it. But it's the horizontal boards on the back of the fence that hold the intervals together.

A perfectly literal fence. I've seen thousands of fences like that. If I were making a fence on my property, I'd make it that way.

ALEXANDRA: But you definitely view the front of *First* as if you were looking at it from the outside. You're not in the house or the yard looking out. You're on the outside looking in.

ANNE: Good idea — it never occurred to me. I think of myself as perpetually outside. Sort of . . . disembodied, walking around, eyes always on the level of my height, which is five foot six and a half. I never think of myself as being inside. Never.

I didn't have any particular vision before I made *First*. I just sort of automatically drew three boards on shelf paper. I took the yardstick from the house, took it over to the studio across the street, and drew the boards with it. I don't think I cared if they were straight or not, though I may have straightened them up along the side with a roll of [masking] tape. I took them down to the manager at Galliher Brothers, who cut the boards, and I bought glue and some clamps. And I took the boards and

the clamps and the glue back to my little studio across the street at Mr. Shoyer's, carried them upstairs, and put them together. And then I painted them with house paint, which I later took off and repainted with Liquitex. That's how *First* happened. I didn't have any fancy idea.

I might add that the installation at the Baltimore Museum, the current one Brenda Richardson made in the new wing about six months ago, made me realize that when I think of a fence I think of the light as coming from above. That's what she did — she put a light on *First* from the top, streaming down over it. When I saw her installation I thought, that's the way I had seen it, with the noon sun on top of it pouring down. There were no shadows. It was as if the light was inside it, so to speak.

I'm also interested in the fact that the fence in my imagination is vertical — that is, it goes between earth and sky — and also horizontal. So you have a kind of metaphor for what it is to be human. You strive upward on the vertical, and you're held in place by the practicality and the intractable physicality of the horizontal. And our feet do not go into the ground — we're rooted only in a very thin piece of individual experience. We can be pushed over any old time.

ALEXANDRA: What was the next sculpture you made?

ANNE: I thought I was going to do literal things, so then I drew a kind of a barn structure. There were two of them, and they were big, about six feet tall, and they had that irregular, slanting, diagonal line you see on the top of the old Third Haven Friends Meeting House in Easton.

I made two of these big drawings on shelf paper, and I didn't know how I was going to build them. I went down 30th Street to Galliher Brothers, and I showed him my drawings and said, "I'd like you to make the boards for these, please." And he looked at me and said, "You know, you don't have to make them yourself. You can just take these drawings across to Bill Lawrence in the mill, and he can make them." And I was just overcome. I had Mary with me in a little snowsuit, and I scooped her up and said, "Thank you, thank you." I grabbed up this great big roll of white drawings and I started back up the hill to our house, with Mary in my arms. And all of a sudden I just put her down on the snow,

put my arms around her, and said, "Oh, Mary, I can now make anything I want." I've never forgotten it. It makes me cry to remember it. Then I grabbed her up again and went back home, and went across the street to my studio and began to make drawings. The next day I went down to see Mr. Lawrence with my big roll of paper. And Mr. Lawrence looked at them and said, "You know, you don't have to do this with this shelf paper. You can make scale drawings." So I said, "Oh, I didn't know that." He said, "You need a scale ruler." So I went down to Muth's[2] and bought a scale ruler. And a young Black architectural student told me how to use it. I didn't know anything about scale, not a single thing. So I grasped the principles, and I bought some big sheets of cheap paper. Then I began to make scale drawings. That's the way it started. In the meanwhile my mind sort of clarified, and I began to see that if I could make anything I wanted, I could slow up a little bit and do what I wanted to do. And then I drew *Southern Elegy*.

ALEXANDRA: If it's 1962, and you made *First* at the end of 1961, then what part of 1962 is this?

ANNE: January. I did everything very fast. I made *Southern Elegy*, *White: Four*, and *White: Five*. I did the sculptures in threes.

So then what I did is I took my drawings down to Bill Lawrence and he began to make them. First I started bringing the sculptures back myself in my car. I had a convertible, so I could put the top down and stick these things in the back. Then he said, "Well, we can bring them up in a truck." So I began to have them delivered to the studio.

Round about then, in January, Ken Noland came back from New York for Christmas with his family, and we went to a party at his and Cornelia [Noland, née Langer]'s house. He said, "I'm moving to New York." So I said, "What's going to happen to your studio in Twining Court?" "I'm not going to do anything with it." "Well, let me have it."

---

2. The George F. Muth Company, founded in 1865, was one of the city's main purveyors of art supplies and wallpaper.

And he said, "Well, of course." I took down the landlord's name, and I paid him ten dollars a month. Then I had the room — the room to make these works. I kept it until we went to Japan in March of 1964.

ALEXANDRA: Where did the title *Southern Elegy* come from?

ANNE: *Southern Elegy* [1962] is a perfectly straightforward tombstone. It stands up the way tombstones are made to stand up, like the ones in the cemetery in Easton. I made a part on the bottom to hold it.

ALEXANDRA: Why a tombstone?

ANNE: Well, in my childhood I used to pay attention to cemeteries. Inky[3] and I used to go look at the Goldsborough family plot.[4] I've looked at cemeteries all my life, and I've thought about death. In the South they decorate their tombstones. In the South you're supposed to go and lay flowers on people's graves at regular intervals.

In life people don't pay attention to what is past. They don't often remember the reality of love — the poignancy of it, the shortness of it, the fact that it inevitably ends in separation. *Southern Elegy* has to do with the remembrance of what's important about people's lives, which is that they were alive. In the end it doesn't matter what they did. It doesn't matter whether they were lawyers or doctors or priests or women or men or children or anything. In the end what matters is that they were once alive and now are dead. So the bottom is very heavy and the top has a kind of sweet curve. At that time I was only thinking in terms of two colors — black and a very dark green. Black because it's generic and green from the lattices of my childhood.

And then I made *Two* [1962], which has the same sort of plan — that is, it has a bottom member out of which two slabs grow instead of one.

---

3. Anne Truitt's lifelong friend Helena Holmes.
4. Nicholas Goldsborough settled on Kent Island in 1670, establishing what would become one of the most prominent families in Maryland.

And that I made for Cord Meyer,[5] whose twin brother, Quentin, was killed at Iwo Jima. Cord was at Guadalcanal. I had twin sisters, so it's about my twin sisters too. It's about the concept of two — it's about marriage, about brother and sister, or brother and brother, or sister and sister. Or mother and daughter, mother and son, son and father. It's about two-ness.

Now, with *Two* I began to realize I could make the color metaphorical. The structure and color didn't necessarily have to be the same. The color could counter the structure. The color could be metaphorical, it could say more than the structure could alone. Together they could be eloquent. I was very surprised. So I ran the black and the dark green together. I let them come down in three layers, three slats over the sculpture. The color at once separates and unites *Two*, just as two are always separated and united. They teeter right on the edge of being completely separated.

The colors are the same on each side, but the proportions are uneven, so it's completely off balance. There's nothing particularly sweet about *Two*. *Two* can be really fierce. It's at once a fierce opposition and a unity. And also it's in agony because the two are stuck together. They can't get loose. Like my sisters. Or like a marriage that's gone wrong but the couple still has to stick together.

With *First* I didn't think in terms of eloquence. It was there, but it was deep inside myself. With *Southern Elegy* I began to feel eloquence, and with *Two* I began to see how color could be eloquent.

ALEXANDRA: While you were making *Southern Elegy* did you think of it as "Southern Elegy"?

ANNE: I titled it as I made it. I thought of a Southern cemetery, and then of course "elegy," because the more I looked at it and the more I thought about the concept, the more sad I felt. I made the title as an homage.

---

5. Founder of the United World Federalists and a high-level official in the CIA, Cord Meyer was married to Mary Pinchot Meyer, Truitt's close friend and artist colleague.

ALEXANDRA: The same with *Two*?

ANNE: *Two* came in as a concept. Cord Meyer and his twin brother, and my twin sisters — I was thinking of them. And I had begun to realize I could make much more complicated concepts. I saw *Two* as a whole before I made it. That's when the sculptures began to come to me whole with their color. The next one I saw, I think, was *Lea* [1962]. "Lea" refers back to Avonlea.[6] I changed the word, which is typical of what I've done all the way along. I just took the "Avon" off and kept the "Lea." "Lea" also is an ancient English word for meadow. I took the light of the Eastern Shore and just let it flood down on a column.

*Lea* is yellow and white. It didn't occur to me yet that I could wed one color to the other. If I were making it now, it would be like the *Avonlea* I made in 1991, where the color is wedded in. But *Lea* is yellow and white, very pale yellow and white, and it's just light I saw.

But let me just make a little jump. Let's skip *Two* and go backward. After *First* I made *White: One*, *White: Four*, *White: Five*, *Seven*, and *Green: Five* [all 1962]. All those sculptures were made for me by Bill Lawrence. He used to be right down at the foot of 30th Street, down by the river. On the right was Smoot's Sand and Gravel, where I used to buy my gravel and sand and cement, but on the way down, on the right, was Galliher's Lumber Yard. And on the left was their mill, Galliher's Lumber Mill. So there, right on the street I lived on, right by the Potomac River, were the two things I needed.

ALEXANDRA: So *White: One*, *White: Four*, *White: Five*, *Seven* —

ANNE: Those are all fences. And the titles are just descriptive. Everything came out of *First*. Things were just coming in to me so fast, and Mr. Lawrence was so quick. I made all these panel works before I took over the Twining Court studio.

---

6. Helena Holmes's childhood home near the Tred Avon River on Maryland's Eastern Shore.

328

ALEXANDRA: Rather than talking about the chronology, since that is recorded in the Corcoran catalogue and is part of the record, let's just talk about the titles alphabetically. Tell me about the title of each work.

ANNE: *19 Sept. 62* — I made that small sculpture for James Truitt in 1962, the nineteenth of September, which was our fifteenth wedding anniversary. Two shades of green for freshness and renewal. I was hopeful.

Then *20 Oct. 62* — there are two of those small sculptures. I made them for my two sisters. There are two colors for those sculptures — a dark, deep ochre and a very deep, dark brick pink. I made them as beautiful as I could, with deep, warm colors running up and down. And I made the proportions of the colored areas different. One was a very dark, sort of beautiful golden yellow with panels of darker pink. And the other was vice versa. Yes, they were beautiful little sculptures. Nobody really knew what I was doing. Everybody just thought I was sort of batty.

*Bloomsday* [1962] I thought of when James and I went to spend a weekend with Ken [Noland], Clem [Greenberg], and Jenny [Greenberg, née Van Horne] at Sam Kootz's[7] place up in upstate New York. I went off while they were swimming and I drew *Bloomsday*. June 16th, 1902, wasn't it? The day of *Ulysses*, James Joyce. *Bloomsday* is for Leopold Bloom. And that's the reason why it's such a plump sculpture. And on the top of it, concealed from view, I made the complexity. It's black and ochre, and on the top, where nobody can see it, not even the tallest person, I made the complexity. Leopold Bloom is dear to my heart, and his complexities were hidden from other people. To most people he just looked like a rotund, rather boring man. But actually to me he's just magical.

I think I drew *Catawba* [1962] the same day as *Bloomsday*. When I say "drew," I should explain that when the things came down into my head, so to speak, they usually came in in threes, and I would then make a scale drawing for each. In technical terms I got to be more skillful in translating what I saw in my head into real life. "Catawba" is Thomas

---

7. New York gallerist, notable for being one of the first to champion Abstract Expressionism

Wolfe's name for Asheville in *Look Homeward, Angel*. "Catawba" means you can't go home again.

The title doesn't have anything to do with my own life. It has to do with the mountains. And the colors on it are terribly sad, because actually those North Carolina mountains are really, really sad. I don't know what went on there before Asheville.

*Essex* [1962] is for my mother. I didn't know which street in Boston my mother was born on, whether it was Dartmouth or Essex. It was one of those streets bisecting Commonwealth Avenue beginning at the Public Garden. In my mind *Essex* also refers to a terribly sad house that my grandfather — my mother's father — had built in Cohasset, Massachusetts, overlooking an estuary to the Atlantic Ocean. That's where they were living when my uncle — my Aunt Nancy's twin brother — died. And where my grandmother became crippled with arthritis and took to her bed. But it was a very beautiful house with a billiard room, a very elegant life. One night during dinner, which was always formal, a man came in and told my grandfather his brother had died, and my mother said that her father burst into tears. At the time, he was using one of those little pearl-handled knives that I still have, my pearl-handled fruit knives. That's the reason why my mother told me the story, because one day we were using those pearl-handled fruit knives. All that painting, all that I could get into it — it's dark red and black, very austere. *Essex* is tall and thin like my mother.

*Green: Five* I'm really very fond of. I am very fond of it. And it's the only sculpture I made that has that proper green on it, that real lattice green. It's a green fence akin to *White: Four*, *White: Five*, and *Seven*. Wish I'd made more. It's the right shape, too. I think that's one in which the shape absolutely fits what I wanted to do. It's light, and there's something about it — it just fits. Sometimes by the grace of God something happens, and it's right.

*Hardcastle* [1962] is named for a man named Hardcastle who lived somewhere near Lee Haven, which is a country house that my parents took for the summer when I was five and my sisters were three. Or maybe I was seven and my sisters were five. But around that age. I was young. Now, the first I heard about it was a rustle in the nursery, and Deena,

who was the nurse, and my mother were talking in whispers to my father. Everybody was upset. There was a dirt road from Easton that led past the point where Lee Haven was situated. Lee Haven was one of three houses that I know were out there, and I think Mr. Hardcastle lived in one of the other houses. Now this man, Mr. Hardcastle, had gotten drunk and had gone to sleep or was stalled on the train track that crossed this little dirt road. And he was killed by the train. It was horrifying. Whether I heard the crash in the middle of the night I don't know. I seem to remember a crash, but I don't actually remember it in real life, so I may have made it up.[8] But he was killed. And that's the first death, the first violent death, that I ever heard about. I was just scared to death. I don't know whether my sisters really knew what had happened. But in some way I ferreted out what happened. I think I made the nurse tell me. I pushed at it until I found out. Or else my mother told me. She didn't believe in not telling the truth. In fact, she told me the truth if I asked her. I understood it all right. He had had too much to drink. He wasn't in his right mind.

The two reds struts on the back of *Hardcastle* one could think of as railway tracks, but I didn't. I simply thought blood.

*Insurrection* [1962] is insurrection. "Insurrection" means that sometimes you just have to plain rise up for what's right and make a war, the way my ancestors did in this country.[9] "Insurrection" means you don't give in. It's the indestructible vincibility. Their indestructible vincibility. The fact that they were always unconquerably struggling. The absolute necessity to rise up.

*Lea* is Avonlea. It's very, very early. As I said earlier, I cut off the "Avon" and just kept the "Lea." And I wedded in the ancient English

---

8. Art historian Miguel de Baca has attempted to locate any public record that would confirm Truitt's narrative regarding the death of "Mr. Hardcastle." Although he found no registered death of a man named Hardcastle in Talbot County during this period, he did locate a newspaper story from 1928 that recounted a similar incident involving a railroad foreman named Howard Porter. See Miguel de Baca, *Memory Work: Anne Truitt and Sculpture* (Oakland: University of California Press, 2016), 44–48.
9. One of Truitt's ancestors on her mother's side, Captain Robert Pierce Williams (b. 1753), served in the Continental Army throughout the American Revolutionary War.

concept of the meadow with Avonlea. I made it just as beautiful as I could make it, with white and yellow. I tried to get into it something of the feeling you have when you're very young, around three, that everything is possible. The innocent conviction that everything is possible. Loving conviction that everything is possible.

ALEXANDRA: All these titles you've been talking about — *Bloomsday, Catawba, Essex, Hardcastle, Insurrection, Lea* — these works came simultaneously with their titles? Or did you title them later?

ANNE: *Bloomsday* came in with its title. And I think the day that I made it was June 16th — Bloomsday.

ALEXANDRA: But these came in with titles, and then you made them?

ANNE: With *Catawba* I was making the mountains of Asheville. Mountains are extraordinary in that they give you a feeling of strength. But they also give you a feeling of constriction, because the weight of the earth is so un-liftable. And I used to practice feeling the mountains going up and down to Asheville from Bryn Mawr on the train. That's where I learned about mountains. That's where I learned about sculpture. And I tried to get that into *Catawba*. I used to go back north down the mountain to Old Fort. They had one little single-track train, and it twisted round and round and round, back and forth, in loops and loops and loops. On my way back to college I'd go down at night and watch the sun leave the earth, the sky. And I would practice being the mountains. I would go in and out of that feeling.

*Mary's Light* [1962] was for Mary Meyer.[10] And it was the first of the five very plain structures that I made: *Mary's Light*; the sculpture of Mary

---

10. Meyer was a painter associated with the Washington Color School and a highly visible member of Georgetown society. Truitt shared a studio space with Meyer in the early 1950s, and later recounted a trip the two took to New York in November of 1961, during which Truitt had a kind of artistic epiphany while encountering works by Barnett Newman and Ad Reinhardt at the Guggenheim Museum. See Anne Truitt, *Daybook: The Journal of an Artist* (New York: Scribner, 1982), 154–57.

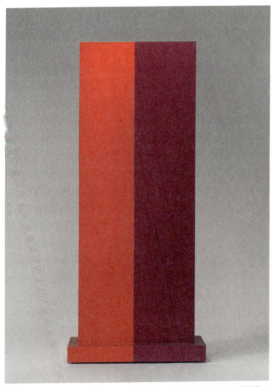

*Insurrection*, 1952. Acrylic on wood, 100½ × 42 × 16 in. (255.3 × 106.7 × 40.6 cm).

McKinley,[11] which was two shades of red and which has disappeared; *Muir* [1962]; *Mignon* [1962]; and *One*, which I made in 1962. Those are those little paneled sculptures. I just restored *Mary's Light* for Cord last summer. I made it very early in 1962. I made all those panels early in 1962. And I made it across the street at Mr. Shoyer's. I made it for Mary Meyer and gave it to her. She put it in the back of her convertible and took it home and put it in her dining room. *Mary's Light* was Mary's light. She just had this wonderful glow. She enhanced life for other people. A wonderful, radiant person. Her spirit was very light.

December 14, 1997

ANNE: *Mignon* is one of the five armatures I made in early 1962 — *Mary's Light*, *Mignon*, *Muir*, *One*, and the one that was lost that I made for Mary McKinley. Two shades of red — I don't think I ever gave it a title. I may just have called it "McKinley." I gave it to her, and she took it to her house on O Street, and I never saw it again. We moved to Japan, and Big Mary got sick. She got cancer, died soon after we got back from Japan. And I don't know what happened to it. And *Mignon* comes from "*Mignonne, allons voir si la rose / Qui ce matin avoit desclose / Sa robe de pourpre au Soleil*" — the poem by [Pierre de] Ronsard, the sixteenth-century French poet. And *Mignon* combines that with mignonette, which is a lovely, sweet-smelling, herb-like pale flower, an Elizabethan flower, in my imagination. *Mignon* is related in tone to *Damask* [1980], which is a sculpture I made later on, I'm not quite sure when. *Damask* deals with Elizabethan roses, and *Mignon* has that sort of cottage-garden mignonette feeling, too, because of its armature, because of its shape, structure. *Muir* comes from John Muir and the Muir Woods in San Francisco, north of Belvedere, which I never saw. It's the northernmost stand of redwood in the United States, I think. (I'm not sure about that at all — I might be quite

---

11. The Truitt family housekeeper, hired after the birth of Truitt's second child, Mary, in 1958. She remained part of the Truitt household until they relocated to Japan in 1964.

wrong about that.) But it's a big redwood forest. And I think the reason why I'm thinking about southern and northern is that there was a stand of redwood on our land in Big Sur, which we bought in 1958, that was the southernmost stand of redwood in the United States. But *Muir* is those woods, and John Muir, and also what I remembered of Yosemite Park, which scared me to death. Yosemite Park was so narrow. *Muir* — there's no quarter given by nature. There's no quarter given by nature. There never is any quarter given by nature. There's no way to live really with nature. Nature just doesn't care at all about human beings. It's completely inimical — or indifferent.

That's an idea I should have pursued more, and maybe I will, too. The sculpture I'm just about to make [is one] in which that idea comes back in on me again, the fact that beauty is, if not inimical, indifferent. And dangerous. Beauty is dangerous. But *Muir* also has a concept of constriction. I think Yosemite is one of the most constricted places I've ever been in. I was really unhappy in it. I don't like that place. I don't like that valley. And it reminded me too of the town Guanajuato in Mexico, where James and I went, a silver mining town near San Miguel de Allende — all closed in. I don't like the idea of being closed in, constricted. It's frightening to me. So *Muir* to me is slightly frightening — relieved by the fact that the mountain, the river, the forests are beautiful, and the structure is beguiling. That structure to me is beguiling.

*One* I made in very early 1962. I made it right away, and I gave it to my cousin Adeline Furness Altman right after it was made. And Adeline didn't understand what it was about at all. She simply didn't like it. And she put it down underneath the back porch, and it got all rotted out in her house. Then when she moved finally, leaving her house in Washington behind her, I said, "What happened to *One*?" And she said, "Oh, I put that in the garden. I put it under the back porch." [*laughs*] And I said, "Well I better go look at it, I think." So I looked at it, and Adeline was very embarrassed. And I said, "Well, if you'll pay me to have it reconstructed, I will remake it, and we'll call ourselves quits." I was sort of a little bit miffed, but not very, because I knew Adeline didn't care about objects. And she was a little bit embarrassed, but not very, because we're devoted to each other and understand each other. So she paid me $150 or something, and

I had it reconstructed. And then I repainted it. There's a beautiful picture John Gossage took of it, one of the best pictures ever taken of my work, standing on the stairs at the Corcoran. If there's one picture of my work that really does say what my work's about, it's that picture.

*Platte* [1962] was in the first exhibition in New York, in 1963. *Platte* is about the Platte River, and it's about the anguish, the danger, the persistence, the courage, the perseverance, the invincibility, the sorrows, the losses of the people who moved this country west. It's the most beautiful of all the American rivers, in my head. More beautiful than the Mississippi. I don't know much about the Mississippi. I don't feel much about it. But the Platte I feel a great deal about. I have great feelings of companionship with the pioneers. And one of my tests of people is whether they would have persisted on that trek, and how resourceful they would have been. It's definitely one of my tests of people. And one of the reasons why I liked Kenneth Noland is because he was resourceful and he would have kept on. He would have rearranged the wheels on the wagons and kept on going across the country. I think James Truitt would have done it too, probably, but I'm not quite so sure about James Truitt. I'm pretty sure about Kenneth Noland. I think it took tremendous resources to get across the country. I've been in situations where I had to bear down for months on end, and it's terribly difficult. And I was never in a situation with as much physical danger and as much loss, potential loss, as *Platte*. Particularly the women who lost baby after baby. And they had to keep making the meals, and this and that. I'm just full of admiration for it. So that's the Platte River. Plus the fact, again, like *Muir*, the absolute indifference of nature. Plus a third thing, which is a book I read by Loren Eiseley about floating down the Platte River, which has been tremendously useful to me.[12] Just one little passage. I'm not mad for Loren Eiseley, but I thought this was a wonderful thing to do. He got into the Platte River stark naked and lay down — I guess he was stark naked, I hope he was — and lay down perfectly flat on his

---

12. Loren Eiseley, "The Flow of the River," in *The Immense Journey: An Imaginative Naturalist Explores the Mysteries of Man and Nature* (New York: Vintage, 1946), 15.

back and floated down the river. And had somebody pick him up down the river. It wasn't like the pioneers who didn't know who would pick them up. In other words, he protected himself, and I don't particularly like that about him. But my image is, whenever I have to do something very difficult, like go to the dentist or undergo a caesarean section or something, I simply lie down in the Platte River. And on top of me, the sycamore trees — I've got it all arranged in my head — the sycamore trees arch over. It's noon, and the sun flickers down through the sycamore trees on me and on the river, and the river bears me along. I think it's very beautiful. I love the Platte River. I've never laid eyes on it in my life. It's all entirely imagination. [*laughs*] It's funny.

*Primrose* [1962] is one of those *Mignon, Damask* sculptures. I made three sculptures composed of modules, and the one with five was *Primrose*. *Platte* was seven, and *Shrove* [1962] was six. *Primrose* has to do with being prim. Its structure, its armature, is very prim, small. Primrose is one of the first flowers that blooms in spring. It's a gentle little sculpture. I like it. Primrose is a little flower that lies near the ground, one of my very favorite flowers. It comes in many, many different vivid colors. And the purple that underlies *Primrose* is the purple of the rich, rich, royal earth out of which flowers emerge, and the funny streaks that primroses have. This is not the kind of primrose that comes on a long stem. This is the sort of primrose that's short and fat and low.

*Ship-Lap* [1962] is five modular twelve-by-twelve-inch colors joined together by shiplap. Shiplap is as if you took your two hands and did this. A shiplap is the tightest lap you can get, and it's what holds ships together. I'm awfully fond of that word, "shiplap." I like the idea of ships. Now *Ship-Lap* is black. It's one of the few modular sculptures I made in which the color does not counterpoint. It does not counterpoint. I think it may be the only one I ever made where it did not counterpoint.

ALEXANDRA: When you say the color is in counterpoint, how about *Hardcastle*, where the back support is red. Is that not counterpoint?

ANNE: It's not modular, so you could think of the red as punctuated. On the back of *Hardcastle* those struts punctuate and emphasize — it's pure

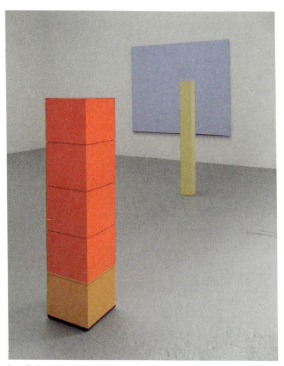

Installation view of "Painting: Now and Forever, Part II," Matthew Marks Gallery, New York, 2008. From left: *Primrose*, 1962; *Harvest Shade*, 1996; *Memory*, 1981.

blood running through the black. That's what it is — death. Sudden, violent, unexpected, cruel death. Surmounted.

*Ship-Lap* is about ships. It really is amazing — I mean, I never thought about it before, but I know it's all true — *Ship-Lap* is about order, the order that is necessary to do something dangerous. Ships are always in danger. There's no point in talking about it as if they weren't — they are. And again, the sea is inimical. If it's not inimical, it's indifferent, to go back and use the same phrase. *Ship-Lap* is about *Moby Dick*. It's about Captain Ahab. Because of the black, it's about the fearsomeness of disorder in a situation in which order is essential for survival — which is really every breath we draw. I thought so at the time, anyway. There I was, I had three young children to bring up by myself, and I really felt that order was absolutely critical. And I felt frightened, and I felt threatened. I was afraid. And I made a very strong, plain, tight sculpture. I wasn't then bringing up the children on my own, but I was awfully frightened because I could see that my marriage was going to come to an end. It hadn't come to an end yet, but it was going to. And there was no way that I was going to be able to stop it. And that order, the order that I found in *Ship-Lap*, I later relied on for the rest of my life. I think *Ship-Lap* is an OK sculpture.

They're very simple. The trouble is, all my ideas are very simple really. They're all very primitive, and they have to do with what it is to be alive. They're not dealing with great big fancy material, and they're not dealing with rhetoric, and they're not dealing with theory. They're dealing with things like getting from day to day — making up beds and doing the dishes, getting the children fed, taking care of things.

*Shrove* is a happy sculpture. In the 1970s or 1980s it came back to me to be repaired, because it had gotten dirty. So back it came into my studio. I kept it for about six months, not because I hadn't finished restoring it — I just restored it to its old color, washed it, fixed it up, repainted it — but I didn't send it back for some time because it was such a happy sculpture. I liked to have it in my house. It has to do with Shrove Tuesday, with pancakes and running [*laughs*] and being happy. What the shrove means to me is the happiness and release in forgiveness. The pleasure, the pleasure that comes from being happy and innocent. It's always been a blessed sculpture.

*Sprig* [1962] is related to *Mignon*. It has to do with the very first shoots or sprigs of spring. *Sprig* is just early spring, and, again, it's related to *Damask* and *Primrose* and *Mignon*.

*Thirtieth* [1962] is a very particular sculpture. *Thirtieth* refers to the 30th of October, 1962, which was the night of the opening of the Washington Gallery of Art, and to other things that happened on the 30th, which I'll keep to myself. *Thirtieth* is one of those blessed sculptures, like *Shrove*, that just went straight to somebody's house. That's my dream of glory. Straight from me to somebody's house and stay there, somebody's family.

*Three* [1962] I think has the same dimensions as this little armature that I was using all the time in the early 1960s. I made it before I moved into Ken's studio, into Twining Court. And *Three* is simply that little paneled armature with three lines on it. What does *Three* refer to? Well, it refers to my two sisters and myself. It refers to birth. It's a birth of three innocent little girls, three who were alike in my family, and first the innocence, the innocence of childhood. Since the panels are identical — but not really, because it's impossible to make two things that are identical. Nothing can be identical to anything else, just like three children in a family, three little girls in a family. It refers, too, to the multiplicity of boards in the house. Three moving it beyond two. Two is particular. I never made two panels, because two is too particular. It doesn't refer to infinity. Three gives the idea that there's more to come. It's more open. I think three is a more interesting idea than two. Just as an idea.

*Tor* I made at the same time that I made *Watauga* and *Catawba*. I think those three came in together. And *Tor* I made in 1962. *Tor* is related to Big Sur, and it's the only sculpture I made about Big Sur. In Old Saxon "tor" means a high hill, and I'd also seen, years ago in New York, a play called *High Tor*, written by Maxwell Anderson. *High Tor* was extremely depressing to me. It was one of the first plays I ever saw, and it was the effect of the people on the stage, their feelings coming out toward me, and the terrible desperation, the tragedy of life right in front of me. And of course Big Sur was tragic. It was a tragic place — a place of terrible storms and people dying and people falling off cliffs and driving off cliffs in drunkenness, and a great many excesses. And it's the most beautiful

place I've ever lived. I used to wake up in the middle of the night just to be happy. I just adored it. So that's *Tor*.

ALEXANDRA: Let's talk about *Watauga*.

ANNE: In 1934 I was thirteen, and my family had a complete and total breakdown. They just really completely disintegrated. Really fell apart in my hands, right before my eyes. I was in the eighth grade. My mother got very sick. Dr. Palmer operated on her in Easton Hospital, and by God, she seemed to be OK again. She had an operation and she seemed to me to be OK. I thought, my God, thank God that's over. Then my father began to drink worse than ever. The Depression had come upon us, and my father lost all his money. He depended on an income from securities in St. Louis, from the Ludlow-Saylor Company, which his father had in some way been connected with — which more or less went into bankruptcy. His father owned a railroad in St. Louis. His income came to a total end. And then my mother got sick again. God knows what was wrong with her. It was called "neurasthenia," and she went into a hospital in Baltimore where she stayed for about six months. We had a maid called Florence and a gardener named Frank and a cook called Hester, and the household ran very well. Hester and I had grown up together — she had been there for a long time. While my mother was in Baltimore I ordered all the meals and I ran the house. My father was drunk and he stayed in his room. And we had a trained nurse — the doctor said that we had to have a trained nurse. I put her upstairs on the third floor.

ALEXANDRA: And you were thirteen?

ANNE: I was thirteen. I put her on the third floor and I made sure that she got her meals separately and everything was protected — her honor was protected. She took care of my father when my mother was in Baltimore.

ALEXANDRA: What started the whole thing? Your mom's being sick or your father losing his money? Or did it all just happen at the same time?

ANNE: I'm not quite sure. You see, I was only a child. My mother's income was greatly reduced too, and then the Depression wiped it out. The Depression wiped out people who lived on their income from securities. People like that never came back because they had no earning power. My father had no earning power. He'd only gone through high school. He was a sort of hippie, really. He left St. Louis and he went west. He was one of six children — the sixth of six children.

ALEXANDRA: So it all kind of happened simultaneously.

ANNE: Simultaneously. Everything happened. And I was left in this great big huge house. I used to look after my father and sisters *and* look after the trained nurse. And I used to do my homework at night on a French desk in the library in the dark. The house was pitch dark, and it seemed to me it was awfully cold, but I think that may have been psychological. My parents broke down. Then what happened is my mother's sister, my Aunt Nancy, stepped in. We all went down to spend the summer of 1934 with Aunt Nancy and Uncle Jim on their farm in Virginia, on top of a hill, on Stony Point Road outside of Charlottesville, Virginia. We spent the summer there, and my parents were still sick. So it was decided that they would come down and be paying guests next door — this is one of the worst times in my whole life — and they came and lived at "The Riggory" owned by Cousin Peter and his wife, who were poor as church mice so they took in paying guests. My mother and father stayed there and they were just miserable. We were very unhappy. My Uncle Jim's father was William Alexander Barr, and he was a very distinguished Episcopalian minister. He had had a breakdown of some sort and he had been taken to Asheville, North Carolina, to the Highland Hospital, which was run by Dr. Robert Carroll, who had great success looking after people with nervous breakdowns. He broke down and he went down there, and he got well. He didn't get completely well, but he got reasonably well. So, when my father began to drink very badly at The Riggory, my Uncle Jim suggested that he go down to this Asheville hospital. So down he went as an alcoholic into the Highland Hospital. And then my mother broke down, my mother got more and more and more nervous, and she went

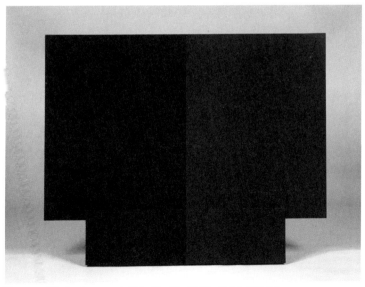

*Watauga*, 1962. Acrylic on wood, 46¼ × 56 × 7 in. (117.5 × 142.3 × 17.8 cm).

down and joined him. So there they were, both in the hospital. It was truly terrible. Really terrible. My sisters were too young to pay much attention.

ALEXANDRA: Did your mom drink?

ANNE: No, she didn't drink. And *he* didn't drink all that much. If present facilities had been available, my parents would have gone to counselors. They weren't all that sick. I know from experience now that they would have gone to counselors. Alcoholism is very well understood now. My father was an alcoholic but not a *rampant* alcoholic. Every now and then he'd just get drunk. He was very unhappy.

ALEXANDRA: So he went in, and then she started to get agitated, and she —

ANNE: No, not agitated. She just got sort of sad, what they called "neurasthenic." She stopped eating. She always had trouble keeping her weight up. I don't know whether you call it depression — I suppose you could call it a reactive depression. I don't know what they actually called it. Neurasthenia was what it was called when I was a child. That means you just get weak — like Alice James.

ALEXANDRA: So they both went into Highland Hospital in Asheville. And where were you?

ANNE: Well, the twins and I stayed with Aunt Nancy and Uncle Jim. We spent the summer there and then we stayed on for the winter. That's what saved my life. I mean, I don't know what would have happened. Both my parents were sick as dogs.

ALEXANDRA: And Aunt Nancy was your mother's sister?

ANNE: My mother's younger sister. Her twin brother died. Little Robin was killed. He was twelve I think, or fourteen. He went to camp, and he and a boy were playing in a cave and it caved in on them. He died, and the other boy was crippled for life. My grandfather and grandmother

gave a memorial, a beautiful stained-glass window to the church, and his face is one of the little faces among the angels. My mother had a picture of it. Yes, it was terrible.

ALEXANDRA: So your parents went in this hospital and you were staying at Aunt Nancy's.

ANNE: Yes. And they got well, theoretically. [*laughs*] They did get well, in fact. My father stopped drinking. It was a regime. Now, Highland Hospital was based on absolutely nothing in the way of psychiatry. It was based on "health." Robert Carroll was kind of kooky, only he wasn't kooky. He believed in *mens sana in corpore sano* [a sound mind in a sound body], and *corpore sano* is what he emphasized. You had to walk ten miles a day, up and down. They had two hills — one was steeper than the other — and you walked up and down these hills twenty-five times a day or something. And then you had calisthenics, you had exercises for two hours in the morning, and then you — that's where I recovered from my appendicitis. I played volleyball with Mrs. [Zelda] Fitzgerald. That's where Mrs. Fitzgerald died.

ALEXANDRA: At Highland Hospital?

ANNE: She died at Highland Hospital. Central Hall burned down and she was stuck on the top floor. And when my parents steadied off, they did a thing which they shouldn't have done, but I would never in my life criticize them for it. In the end of that year they went back to Easton — I was too young, I couldn't stop things happening, I couldn't do anything but just simply abide by it — and they sold the house in Easton, the big house, for $5,000. It was still the Depression. And they moved to Asheville. Now, my mother's motivation was to keep my father healthy. They moved, lock, stock and barrel, to Asheville. My beautiful house and my beautiful land was taken from me. Easton was taken from me — I was just exiled. No wonder I cling to it. I was just picked up. My best friends were all borne away from me, and everything that I knew was taken away. I was just taken away ruthlessly. If I hadn't had the space and time at Aunt Nancy's,

I don't know what would have happened to me. But I did have it. My sisters never felt it as much as I did — they were much younger. It's very sad, isn't it? It really was sad, and I've never told anybody living about this. I mean, I've never talked about it before. You didn't know that's what we were getting into.

ALEXANDRA: No wonder you didn't want to talk about it.

ANNE: So then they sold the house, Mother sold all the Canton china, which I was so sad to see go. And then she sold all the decanters because she didn't want my father to be reminded of alcohol. Beautiful decanters. She sold everything. She sold as much furniture as she could lay her hands on. She just laid waste to what she had built up. No wonder I talk about the King Lear syndrome.

ALEXANDRA: How old were they?

ANNE: I was born when my mother was thirty-two, so she was forty-six. My father was fifty-six, ten years older. My mother was from New England. She was not enterprising. She was frightened. And that Asheville hospital, Highland Hospital, had no concept of what *I* would call "health." They had a concept of "regime," and I think they gave the impression to my mother that if my father stayed on a regime his alcoholism would never return, which of course is sheer nonsense. It was a misunderstanding of mental illness. A misunderstanding of the fact that alcoholism is an illness.

ALEXANDRA: Thinking that it was a matter of self-will.

ANNE: Yes. It wasn't a complete misunderstanding, because it was true that as long as he was on this very strict regime he was OK — as long as he led a very strictly limited life. The cure for alcoholism then was a strictly limited life. It's what they did to F. Scott Fitzgerald. That's what they did to everybody. If they ran rampant they were considered immoral, low-grade people who fail and were cowards. My mother could have just

scorned her husband, but she was a lady, so to speak, and she had married him so she stuck with him. That's what she did.

ALEXANDRA: So they moved to Asheville and bought a house? And you and the twins went back to stay with them?

ANNE: Yes, we drove down with Aunt Nancy. My parents had left the hospital and were staying in a boarding house on Watauga Street, which was around the corner from the hospital. We all spent two or three nights there, and it depressed me more than I'm able to say. And then we moved into a house on Pearson Drive, and then we lived on Montford Avenue, and then they bought a house on Pine Tree Road — and that's where my mother died. And then my father sold that house and moved into a little house some place near Cousin Wilson, who was Adeline's father. Cousin Wilson was the only ray of light in Asheville. But of course I had friends. Because I've always had friends. But it was not the same as Easton.

So that's *Watauga*. I got a lot into the sculpture, didn't I?

## Visiting Artist Lecture, Bryn Mawr College, 1998

Thank you, Dr. Cast. I also thank Dr. Carl Grunfeld and his family, who established the fund supporting this event in memory of Miriam Schultz Grunfeld, Class of '69. I thank the faculty of Bryn Mawr, who invited me here, and in their name thank their predecessors, who taught me to formulate my experience in the context of humanism.

I have been asked to talk about my life, and I am going to draw the line of that life as clearly as I can. While I am doing so, I will be showing you slides of some of the work I have made while living it, and I hope that you will stop me in my tracks if you find that something is unclear. I also will be happy to answer questions after I have finished talking. The slides are in chronological order, beginning in 1961. In 1974, while preparing for a retrospective exhibition at the Whitney Museum of American Art in New York, I destroyed virtually all the sculptures I had made from 1949, when I began to study art, to 1961. And with them all the sculptures I had made in Japan from 1964 to 1967. The dates of the work that you will be seeing are like the rings of a tree's growth, a record of the climatic conditions of my life.

I was born in 1921, and grew up in the small town of Easton on the tidewater Eastern Shore of Maryland. At that time, the only way to get to this peninsula was by way of a ferry from the mainland at Annapolis. Few of the outlying roads were paved. Most were made of crushed oyster shells or of logs cut into lengths and laid down horizontally on the ground to make it viable — "corduroy roads," they were called, because they were so bumpy. Some rectangular black automobiles, wooden wagons — ice,

---

*Part of the Miriam Schultz Grunfeld Visiting Lecturer Series, presented on April 1, 1998. Printed transcript, box 28, folder 13, Anne Truitt Papers, Special Collections Department, Bryn Mawr College Library.*

for example, was cut out of the rivers during the winter and arrived at our house in a dripping cart drawn by a horse whom we children got to know. Easton was a graceful little town: white clapboard buildings, a few classical brick. The people who had arrived there in the early seventeenth century seemed still to live in that era: quiet people, largely related to one another. So I grew up in a place that echoed an American pioneer settlement.

Had I been a native I might never have left, but I was a foreigner. My mother came from Boston, my father from St. Louis. They met in Cuba, and again during World War I in France, where my father was in the army and my mother a Red Cross nurse. They married as soon as the war was over, and decided to live in Easton for reasons that have never been entirely clear to me. Neither was ambitious, but in their persons they represented what I recognized when I read Marcel Proust as "the Guermantes way" — the way of the world, in contrast to "the Méséglise way" — the provincial way of Easton. I myself picked up ambition by implication: from their conversation, their books, their French furniture, the Chinese tapestries and Canton china and New England clipper-ship atmosphere of the house. I also picked up some sort of unspoken sorrow from them, as well as from the townspeople I came to know as I explored on my bicycle. I grew to understand when I was very young that what I most wanted to do in my life was to relieve this inarticulate human pain.

So, in the footsteps of my grandmother, who was in the first graduating class of Smith, and of my mother, who had graduated from Radcliffe, I came to Bryn Mawr to train myself. I had decided to major in psychology before I came, and when I graduated in 1943 I planned to go to Yale to continue my training. I was an intent student. It did not occur to me that I might change behind my own back, so to speak, but that is what happened during the summer after I graduated. Again in the footsteps of my mother, I became a Red Cross nurse's aide. When I began to work with patients, I began to get in touch with a part of myself that had been hidden to me, a part that yearned over the patients, that loved to care for them with my own hands. By this time my mother had died. My father's principal contribution to my life was always his faith in me: "You must do what you think best, Annie dear," he used to say lovingly. So when I got the letter accepting me

for graduate work at Yale, I consulted nobody. I simply went for a walk and thought things over. I sat down on a green slope overlooking a lake in Asheville, North Carolina, where we were then living, and it slowly dawned on me that what I most dearly treasured in my experience was experience itself, *personal* experience that would not, I thought, be nourished by more academic study. By the time I got to my feet, I had decided not to go Yale, instead to go to Boston, where my mother had been born and my two younger twin sisters were living, and to get a job in psychology.

I worked at Massachusetts General Hospital in Boston until the end of World War II. During the day I did research in the psychology lab, partly with civilian psychiatric patients, partly with military men who had been flown back from the war zones with a diagnosis of "combat fatigue," a euphemism for emotional breakdown in the stress of battle. At night I was a Red Cross aide on the hospital wards. Oppressed both day and night by the pervasive knowledge that great patches of people were killing each other all over the face of the earth, and by the poignant endurance of the patients I tended in one way or another, exacerbated by the anxiety I felt for the man I expected to marry — a doctor in the Pacific fighting — I began to write. Poetry — very bad poetry, now in my archive here at Bryn Mawr, included because I promised Leo Dolenksi, who had invited me to deposit this archive, to "leave nothing out." And short stories. Lame writing, looking back on it, because I was relieving myself by expressing myself, the easiest way to make banal art.

When my fiancé returned at the end of the war, he told me that he did not want to marry me. In the focus of this shock, I left my job at the hospital, moved from Cambridge to Boston, got myself an apartment — a cold-water flat that cost me $16 a month — found myself a part-time job in a bookstore, and continued to write. I thought seriously of becoming a doctor, having by that time realized that if I were to address myself to the alleviation of suffering I must go at it from a higher level than that of a psychologist. But the more I considered medicine, the more I came to feel that it did not suit my temperament. And the more I wrote, the more clearly I realized that I had once again changed behind my own back: I had become enchanted by beauty. And then, suddenly, while riding back to Boston from a concert at Tanglewood, alone in the rumble seat of a

roadster, watching the trees flickering in the late afternoon sunlight above my head, the music still ringing in my ears, it came to me as if on a lance of light from the sky that aspiration was *catching*. That by being faithful to the pursuit of the austere truth that I had begun to understand was intrinsic to beauty, I might be able to *lift* people from *above*. I saw that instead of being in the position of the little Dutch boy who stuck his finger in the hole in the dike to keep out the encroaching ocean, instead of trying to *mitigate* human pain, I might devote myself to art with the hope of evoking in others *their own* aspiration, eliciting in them a lift of spirit.

When I met James Truitt, fresh from the Pacific campaigns, the gold stripes on his naval uniform tarnished by salt air, yellow-haired, bright-blue-eyed, deft, quick, intelligent, witty, I gradually fell in love with him entirely. We were married in 1947, and I moved to Washington where he was in the State Department. There I continued to write. I struggled with two intractable factors. The first was my inability to free what I wanted to say from the grip of time: words remained relentlessly linear. The second was an increasing indifference to a course of events: the sequence of narrative felt to me merely anecdotal. I was standing in the sunshine of our living room one morning when it suddenly came to me perfectly clearly that a sculpture stood in the same way — on a line of gravity that disarmed time. Stood alone as a person stands alone, bathed in the light that marks the passage of time, not *subject* to time but *illuminated* by it.

I studied sculpture for a little over one year, then set up my own studio and henceforward was in apprenticeship to myself. I learned whatever I found I needed to know: life-drawing, cement casting, different kinds of construction, welding. I worked and worked and worked, always with the idea that meaning would somehow emerge out of the changing forms of the various materials in my hands. I haunted museums and art galleries, looked and looked, asked myself questions for which I found no answers. My husband and I moved, in the course of his career as a journalist, to Texas, to New York, to San Francisco. I studied the lie of land. I particularly remember a drive I took alone — from San Antonio to Midland over the flat plain of the Texas panhandle, driving all night, as solitary as if I had ceased to exist on the dark land, now and then a light way off in the distance, itself solitary.

It was during these years — from 1947 to 1955, when the first of my three children was born — that I fully developed the orderly habits of independent work, habits that I had begun to acquire while I was a child in school, reenforced by those I learned while here at Bryn Mawr. Had I been able to bear children, as I yearned to do, when I was first married, I would not have had the time to form the structure on which my subsequent life has been based. This period of sterility was the result of a ruptured appendix in November of my freshman year here; it nearly killed me, and prevented my return to college until the following September. What seemed to me a tragedy was in fact a gift — an example of how circuitously teleology determines the course of a life.

In 1960, in yet another of our peregrinations, we moved back to Washington, and in November 1961, when my last child was one year old, I went for the first time in many years to New York. A confluence of impressions abruptly changed the way in which I thought about art, and set my feet on the path that has led me to you today. I saw three works in the Guggenheim Museum: a small Burgoyne Diller wooden wall construction, an Ad Reinhardt painting with very closely valued color, and a grand Barnett Newman painting. I was so excited that I couldn't sleep. I sat up most of that night in the middle of my bed like a frog on a lily pad and suddenly I saw that I had made a mistake about the *source* of art: I had thought that art would emerge of its own accord out of physical material, whereas these three artists had arbitrarily put matter into the service of *concept*. This "tip of balance from the physical to the conceptual . . . set me thinking about my life in a whole new way. What did I *know*, I asked myself. What did I *love*? What was it that meant the most to me inside my very own self? The fields and trees and fences and boards and lattices of my childhood rushed across my inner eye as if borne by a great, strong wind. I saw them all, detail and panorama, and my feeling for them welled up to sweep me into the knowledge that I could make them. I knew that that was exactly what I was going to do and how I was going to do it."[1]

---

1. Anne Truitt, *Daybook: The Journal of an Artist* (New York: Pantheon, 1982), 51–52.

I returned to Washington and immediately set about making the sculptures which you have been looking at while I have been talking. I rented a room across the street from our house in Georgetown, and when Kenneth Noland moved to New York a month or so later I took over his studio — an old two-storied carriage house in an alley — so that I would have room to make the ever-larger structures which had begun to pour into my mind as if flooding it from above in a kind of torrent. My way opened in front of me, for when concepts are clear they bear with them the means of their execution. I devised an orderly method: I made scale drawings of sculptures, had a lumber mill construct them for me, had them hoisted into the hayloft of my studio, and then painted them, moved them into another part of the carriage house — and ordered some more. I opened a special bank account and supported my work with my inherited money. I invested in myself, and have continued to do so. It is a privilege to invest in one's own life, then to underwrite it with one's own effort.

It has been my experience that honest work in art magnetizes recognition. But I was well placed. My husband supported our household, by 1961 very lively. We were both hospitable; guests poured in and out to laughter and good conversation; our children flourished, began to go to school and to have guests of their own. An invaluable housekeeper was a member of our family. I worked in my two studios as best I could — sometimes for hours, sometimes for only minutes between car pools.

Some of the people who came and went were connected with art — Kenneth Noland, Clement Greenberg, David Smith. It was these three who brought my work to the attention of the New York dealer André Emmerich, and in October 1962, on the day of Morris Louis's funeral, in which my husband was a pall bearer, André came to my studio and promptly invited me to have an exhibition, to take place in February 1963. "A one-shot deal," he said when making his offer, but we remained together until 1997, when he had joined with Sotheby's and I decided to move to another New York gallery, newly opened by a friend, Renato Danese.

By that time the pleasant security of the '60s was a thing of the past. James Truitt and I were separated in 1969 and divorced in 1971. So when my daughter Alexandra was fourteen, my daughter Mary eleven, and my son Sam eight, I undertook to bring them up alone. And largely to support

them too, by teaching at the University of Maryland. I bought a house in Washington and built a studio in the back yard with the money from a Guggenheim fellowship. Our lives fell into a new pattern that became over the years one of infinitely sustaining mutual affection. Now all my children are married and I have six grandchildren, ranging in age from one to nineteen.

The retrospective exhibition at the Whitney Museum in 1974 was immediately followed by one at the Corcoran Gallery of Art in Washington. Both were curated by Walter Hopps. By the time that he had rooted out and examined every piece of work I had ever put my hands on, I felt extremely uneasy. I decided one morning to get a notebook, the same kind I had used for class notes here at Bryn Mawr, and simply to record every day of my life for one year. The result was a manuscript published by Pantheon in 1982, *Daybook*. Publication made me as uneasy as the retrospectives — even modest success is hard to adjust to — and I wrote *Turn* from 1982 through 1984; by that time my editor, Nan Graham, had moved to Viking, which published *Turn* in 1986. Another retrospective, at the André Emmerich Gallery in 1991, started me writing again, and *Prospect* was published in 1996, by Scribner, where Nan Graham had become editor-in-chief.

Again, honest work had magnetized recognition. I want to emphasize that once more: if you want to make work, make it; if you want to write a book, write it. Leave worldly results to fate, which is, I've observed, far more startling than can be imagined. Not that recognition is, or ever could be, commensurate with the effort of the artist, the unremitting, single-minded effort of a whole lifetime. It is not recognition that rewards the artist. Rather it is the sharp delight of watching what has been inside one's own most intimate self materialize into visibility. It is in that exquisite moment when what has been subjective becomes, as if by magic, objective, whole, separate from one's self. Although I in no way equate my work in art with the birth of my children — infinitely more enlightening, infinitely — every time I finish something I have the same feeling I had when I first saw my babies — "Oh, it was *you*."

All lives are adventures into unknown territory. As Albert Camus remarked, an artist "stands in the midst of all, in the same rank, neither

higher nor lower, with all those who are working and struggling." But because an artist's work is predicated on a subtle attunement to an unknown self, it seems to me to require a particular self-confident zest. I've sometimes taken heart from Daniel Boone, who when asked if he had ever been lost, replied, "No, but I once was bewildered for two weeks." In 1961 and 1962, when my work looked to me so peculiar and strange and I had no idea where I was going — though I knew how to put one foot in front of the other — I used to think to myself, "Well, they aren't going to hang me in the public square for making these things."

I haven't been hung, but I have had to develop a kind of hardihood in order to take responsibility for, and to, my work in the world. Because I have made a lot of *things* — sculptures and paintings — I have to be my own quartermaster. I pay $400 a month to store the work that has not sold. And unless an artist's products are elevated to the rank of "blue-chip" commodities worth hundreds of thousands of dollars, the money to continue working is a perennial problem. When I started exhibiting in 1963, the dealer's commission was 30% of the sale price; now it is 50%. So if I sell a work for, say, $10,000, my dealer takes $5,000, and I take $5,000, reduced by taxes to $2,500. This attrition is disheartening. I have sometimes felt as if I were trying to climb a glass mountain.

I make careful decisions about where and how to show my work. For example, I refuse to be in exhibitions restricted to women because I reject the ghetto of gender. Not that gender has not operated in my life as a political factor; it has, to my detriment, in matters like salary and recognition. Artists who happen to be women tend to be, actually still *are* to an appalling degree, discounted. It's as if they were like Johnson's dog, who was not so much praised for dancing well as for dancing at all. My solution for this discrimination is a sturdy determination to proceed undaunted. Every life has limitations for which self-pity is no answer. And times are changing — to the benefit of men as well as women: the burden of supporting a family single-handedly can fall hard on a young man.

I have had to ask myself whether an artist's life is useful to society at large. A life devoted to the expression of very personal urges is in a sense selfish, not the life of direct service that I envisioned for myself when I was young. But artists do, I think, serve. Their work initiates cultural changes

in a society by revealing what is going on in a handful of individuals living in it who are picking up intimations of change. Cubism, for example, points to the flux of matter we now take for granted. Just as the art being made today — often violent, offensive, strident and threatening — points to the painful disorientation implicit in a transit from the quasi-pioneer seclusion of the Easton I grew up in to the unguessable reach of our little planet's future as a unit among other units in a universe among other universes. And art is essentially and always idealistic. The very raising of an individual voice is in itself a cry of hope.

The personal source of art remains a mystery to me. I know where to find it in myself but I do not know what it is. I wonder about it all the time. I think of Murasaki Shikibu, a Japanese lady in the Heian court in the tenth century who invented the novel all by herself: "The Tale of Genji," a long, consistent, continuous narrative without precedent. I like to think of her in her elaborate embroidered kimono, brushing character after character for years on end, all for her own satisfaction. And of Jane Austen too, writing on her lap, and as she wrote hiding her work when she was warned that people were approaching by a conveniently creaking door.

I have come to think of art as a heuristic pursuit. If not temperamentally given to the representation of the natural world, if they have an abstract turn of mind, artists are forced to discover their own iconography within themselves. But why experience organizes itself into works of art remains inscrutable. Something in me silently accumulates what happens to me and how I feel about it, both consciously and unconsciously, and simply holds on to it, sometimes for years and years, and then, to my surprise, peremptorily presents itself to me to be made. My life in this sense fascinates me. I pay attention to it, tend it, trust it, and, apparently independently, it distills into my work.

I end with a note of gratitude to Bryn Mawr, to which I came as if indeed to a "High Hill," at the age of seventeen, sixty years ago.

The pursuit of art is so intensely personal that artists stand in peculiar danger of solipsism. Because their work evolves out of a mysterious core in themselves that they must respect, examine, and guard — as a matter of life or death — they can become ferociously self-centered. If they have not been trained to regard the checks and balances of objective criteria, the

very ingenuity with which they make their work makes it easy for them to invent for themselves a mental cage within the rationalizations of which their development becomes so idiosyncratic that gift is rendered hermetic. Such a narrow point of view fails to recognize the responsibility to one another that each of us inherits equally, the birthright that confronts us all at the moment of death. In contrast, artists who have had the good fortune to be well educated tend to retain a lively curiosity that keeps them open-minded. They can factor ever-renewing experiences into their work as long as they live. It was here at Bryn Mawr that I began to embrace the enhancing and exhilarating complexity of humankind. So to this college I owe a debt that I can never repay, can only take this opportunity to acknowledge, with infinite gratitude.

## Studio Notes, 2001

Now 1) *setting paint free*

2) *setting edge free*

Paint = Materials
Edge = Form
Hand = Human

Layered paint before because thought of it as color — used paint in the service of color. Now in service of itself.

Used to use myself in the service of concept, now *self set free* in hand — have *never* been able to use my hand this expressively before.

*Notes on a handwritten three-by-five index card from Truitt's studio at Yaddo, dated October 2001. Estate of Anne Truitt, South Salem, New York.*

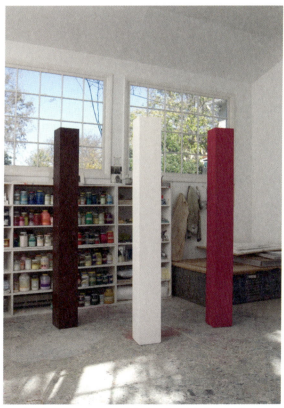

Anne Truitt's studio, Washington, DC, 2004. From left: *Genesar*, *Amaranth*, and *Return*, all 2004.

## Letter to Alexandra Truitt, 2003

October 6, 2003
Yaddo

Dearest Alexandra,

Still dark — 6:15 a.m. — and I write sitting up in my little (white iron with brass knobs, a child's or servant's) bed, my mug of hot coffee to hand. Have "done" my eye drops and warm compresses; they are still not healed; if not by tomorrow (one week) will call the doctor.

This is to thank you for all that you did to make our visit to Vermont a true satisfaction; all both seen and unseen as I know the self-control and tact you sometimes had to exercise. Celia wrote here to say that she missed us!

Something strange is happening to me. Certain ways in which I have made my work ever since 1961 have simply — *very* simply, silently and without saying goodbye — departed from me. Shape, structure (other than armature in the sense of objectness), proportion, and color except for *amount* or *force*, now are gone. It's as if a person had decisively walked quietly out of a room I am used to living in and in which I was thoroughly accustomed to a powerful presence. I am surprised. What is left is "sound," some kind of energy without name. More force, no name. Yesterday while walking around "my" familiar lakes — thirty years of looking — it occurred to me that the "name" of the things I am making out of the beautiful delicate strong paper from Indiana is *Sound*. Will number them as I wrap them — there's no place on them for my name — but they are essentially just sounds.

*Handwritten letter on yellow legal paper, Estate of Anne Truitt, South Salem, New York.*

Installation view of "Anne Truitt: Sound," Matthew Marks Gallery, New York, 2020.

I wish David Smith were alive, an old artist along with me.

6:40 a.m. Will arise, dress, and go to the studio, dawn just coming in in streaks. I'm afraid that your *Parva* will not be like *Hardcastle* after all. But it will be one you choose from this stuff I am making. The *Parva*s only need one more undercoat, should go into color today.

Jem Cohen is here! He looks strained; takes me carefully home at night, so dear of him, but walked alone last night as am at pains not to be a problem. A lively group of guests. One I like very much, find congenial, English poet. Don't worry dearest daughter, am taking care.

Love, R. S. Mother

## Selected Chronology

**1877**
Truitt's father, Duncan Witt Dean, is born on September 28. The youngest of six children, he will grow up in St. Louis, Missouri. The Dean family was originally from the Boston, Massachusetts, area. Major John Pulling (1737–1787), an ancestor, held one of the two lanterns in the Old North Church in Boston, signaling the British invasion to Paul Revere. Major Pulling later avoided capture by the British by hiding in a half-full barrel of potatoes.

**1887**
Truitt's mother, Louisa Folsom Williams, is born on September 11 to an established Boston family, whose investments are primarily in the publishing, textile, and shipping industries. Louisa's grandfather, Alexander Williams II, was a publisher and a founder of Boston's Old Corner Bookstore, a meeting place for Ralph Waldo Emerson, Nathaniel Hawthorne, Henry Wadsworth Longfellow, and Henry David Thoreau. Louisa will graduate from Radcliffe College, Cambridge, Massachusetts, in 1909, following in the footsteps of her mother, Anna Louise Palmer, who in 1879 was in the first graduating class of Smith College, Northampton, Massachusetts.

Truitt's first American ancestor on her mother's side, Robert Williams, was born circa 1598 and immigrated to Boston in 1634. He was one of the first men to protect his family against smallpox. Another ancestor, Captain Robert Pearce Williams (b. 1753), served in the Continental Army throughout the Revolution, and was later shipwrecked near Arabia, where he drank pond water to stay alive. Although he was presumed dead by his family back in Boston, he had been captured by nomadic Bedouin, who kept him as a translator until freeing him five years later. As a child, Truitt will recall reading the letter he wrote to his wife upon his release.

**1920**
After meeting in 1916 in Havana, Cuba, where Duncan Dean was employed by the United Fruit Company, Truitt's parents meet again on the front lines of wartime France. Duncan is stationed as a stretcher-bearer with the US Army's 42nd Division, and Louisa serves as a Red Cross nurse. They marry at Trinity Church in Lower Manhattan and move to the town of Easton on Maryland's Eastern Shore.

**1921**
The artist is born Anne Dean in Baltimore, Maryland, on March 16. She will live in Easton until the age of thirteen.

**1922**
Truitt's twin sisters, Louise and Harriet, are born in Easton on October 20.

**1931**
Truitt enters fifth grade. The artist's nearsightedness is discovered when she is unable to read the blackboard.

That summer, the Dean family travels to England, visiting Westminster Abbey, where Truitt is impressed by the construction of the church, tombs, and memorials.

**1933**
Truitt's mother is diagnosed with neurasthenia and spends the winter in a Baltimore hospital. With her mother hospitalized and her father also unwell, Truitt is obliged to manage the household.

**1934**
Truitt and her sisters are sent to live on her maternal Aunt Nancy and Uncle Jim Barr's farm outside Charlottesville, Virginia. Truitt attends St. Anne's Convent School in Charlottesville for one year. Jim's brother is historian and author Stringfellow Barr, who will co-found the Great Books program at St. John's College in Annapolis, Maryland, in 1937.

**1935**
Early in the year, Duncan Dean undergoes voluntary treatment for alcoholism at Highland Hospital in Asheville, North Carolina, a facility that advocates a progressive program of occupational therapy, exercise, and diet. Louisa Dean joins her husband at Highland, playing tennis with Zelda Fitzgerald, a fellow patient, as part of their physical therapy.

The Dean sisters move from Charlottesville to Asheville. Truitt is enrolled at St. Genevieve of the Pines, where she learns French and begins to write poetry.

**1938**
Entering Bryn Mawr College at age seventeen, Truitt is a year younger than most of her fellow students. In November, she almost dies from peritonitis brought on by a ruptured appendix. She is required to leave Bryn Mawr College to recuperate for the rest of the year.

**1939**
As part of her physical recovery, Truitt takes a rehabilitative exercise course at Highland Hospital during the summer. This firsthand experience with progressive treatments furthers her nascent interest in psychology.

Truitt resumes her freshman year in the fall. Among the subjects that Truitt studies are Greek literature in translation, Renaissance and modern art, philosophy, psychology as taught by Désiré Veltman, and creative writing as taught by Edith Finch, who would later marry Bertrand Russell.

**1941**
Louisa Dean dies on October 27.

**1943–44**
Truitt graduates cum laude with a BA in psychology from Bryn Mawr College. She returns for the summer to her father's house in Asheville, where she works as a Red Cross nurse's aide.

Truitt is admitted to Yale University to pursue her doctorate in psychology, but she declines to attend, realizing that she prefers to work directly with people. She joins her sisters in the Boston/Cambridge area and begins a job at Massachusetts General Hospital in the psychiatric lab. She takes a second job at night as a nurse's aide in the same hospital: "The more I observed the range of human existence — and I was steeped in pain during those war years when we had combat fatigue patients in the psychiatric laboratory by day and I had anguished patients under my hands by night — the less convinced I became that I wished to restrict my own range to the perpetuation of what psychologists would call 'normal.' . . . I honestly do not believe that I would be an artist now if I had not been first a nurse's aide."[1]

---

1. Anne Truitt, *Daybook: The Journal of an Artist* (New York: Pantheon, 1982), 65–66.

Truitt continues to write poetry and short stories.

## 1944–45

Truitt and several friends enroll in a course on sculptural modeling with Franz Denghausen at the Cambridge Center for Adult Education in Cambridge, Massachusetts.

One of Truitt's friends in the course and a fellow boarder at her rooming house is Doris Bry, who will later become Georgia O'Keeffe's assistant and representative. Bry introduces the artist to James McConnell Truitt in 1945. Born in Chicago, Illinois, on June 17, 1921, James grew up in Baltimore and was named after his mother's brother, James Rogers McConnell, a fighter pilot who was killed in action in 1917 while serving in the Lafayette Escadrille in France before the United States entered World War I. His father, Ralph Truitt, was a prominent psychiatrist, active in the mental hygiene movement and an advocate for the rehabilitation of the criminally insane. James Truitt graduated summa cum laude in English from the University of Virginia in 1943. He served as a lieutenant in the US Navy in the Pacific during World War II.

## 1946

In the spring, Truitt becomes aware of the limitations of her role in professional psychology during a psychiatric testing session with a patient. She leaves her position as a psychiatric assistant but continues her job as a nurse's aide.

## 1947

The artist marries James Truitt on September 19 in Washington, DC, where he works for the US Department of State.

## 1948

Truitt accompanies her husband to New York when he leaves the Department of State to work as a journalist for *LIFE*. While in New York, she works administering psychological tests. James Truitt is transferred back to Washington, DC, in September. From February 1948 to October 1949, Truitt keeps a journal that chronicles her growing frustration with the limitations of narrative writing and her increasing interest in the visual arts as a means of expression.[2]

## 1949

On February 8, Truitt begins attending the Institute of Contemporary Art in Washington, DC, where she studies sculpture with Alexander Giampietro.

## 1950

The Truitts move to Dallas, Texas, when James Truitt becomes chief of the *LIFE* bureau there. Truitt studies for several months at the Dallas Museum of Fine Arts (now the Dallas Museum of Art) with Octavio Medellín, who teaches her an additive process for building life-size clay forms that are buttressed in order to be freestanding — a process that will influence her later work.

The Truitts travel to Mexico, visiting various archeological sites including Teotihuacán and Tula. Her encounters with ancient Mesoamerican architecture will influence the form and sensibility of artworks made shortly thereafter.

They also spend time in Ajijic, near Lake Chapala, where she becomes acquainted with a community of writers and artists, among them anthropologist Tobias Schneebaum, who will remain a lifelong friend.

---

2. Although Truitt wrote in *Daybook* that she "abandoned writing for sculpture in 1948," 43, Truitt's journal from the time indicates that she continued to pursue both writing and art-making simultaneously until well into 1949. See "Journal Excerpts, 1948–49" in this volume, pp. 5–24.

**1951**
The Truitts move to New York in January when James Truitt is named chief of *LIFE* correspondents for the United States. Truitt studies life drawing with Peter Lipman-Wulf and learns to carve wood. She sees the work of David Smith, Louise Nevelson, and Jackson Pollock, as well as pieces by Pierre Bonnard, Constantin Brancusi, Alberto Giacometti, and Piet Mondrian.

When James Truitt is made the Washington bureau chief of *LIFE* in October, the couple return to Washington, DC.

**1952**
Truitt uses a small coach house in Georgetown as a studio. During the years she spends at this studio, Truitt will work in many different ways: building figures, including life-size torsos, out of colored cement, clay, and Sculpmetal, as well as carving stone. She also begins to layer and solder wire into geometric constructions, painting some sections.

The artist is involved with the Institute of Contemporary Art. The Institute will invite a range of speakers whom the Truitts entertain in their Georgetown home, including Truman Capote, Marcel Duchamp, Naum Gabo, Bernard Leach, Alberto Moravia, Isamu Noguchi, Sir Herbert Read, Hans Richter, D. T. Suzuki, Rufino Tamayo, and Dylan Thomas.

**1953**
Truitt co-translates Germaine Brée's book *Du Temps perdu au temps retrouvé: Introduction à l'oeuvre de Marcel Proust* (*Marcel Proust and Deliverance from Time*) from French.

**1954**
Truitt's work is included in an exhibition of Washington artists at the National Collection of Fine Arts in Washington, DC, in February, where juror David Smith awards Truitt's sculpture *Elvira* third prize.

New York gallery owner André Emmerich tries to acquire one of Truitt's sculpted heads after seeing it at an exhibition of area artists at the Baltimore Museum of Art in Maryland in April, but it has already been sold.

James Truitt moves from *LIFE* to *Time* magazine.

**1955**
Truitt gives birth to a daughter, Alexandra, on December 2.

**1956**
Truitt begins teaching studio art part-time at the Mount Vernon Seminary in Washington, DC.

**1957**
Truitt's father, Duncan Dean, dies on January 5.

The family moves to San Francisco, California, where James Truitt is made bureau chief for all *Time* publications. They build a house in Belvedere, California, with a room for the artist to use as a studio. Here, she makes clay constructions reminiscent of the forms of Mexican archeological sites.

**1958**
Truitt's second child, Mary, is born on March 27.

**1959**
By 1959, the family has moved to San Francisco's Divisadero Street. A room on the third floor serves as Truitt's studio, where she makes drawings in black, brown, and pink ink on newsprint. Truitt socializes with artists and writers, including Anthony Caro, Richard Diebenkorn, Clement Greenberg, Louisa Jenkins, and David Sylvester. The Truitts also take frequent trips to Big Sur, where they own land on Partington Ridge, and spend time with archeologist Giles Healey, who was the first non-Maya to see and photograph the Maya site of Bonampak in 1946.

## 1960

The Truitts return to Washington, DC, in July when James Truitt accepts a position as assistant to Philip Graham, publisher of the *Washington Post*; by 1963, he will have been appointed vice president of that company and publisher of *ARTnews*, which at that time is owned by the Washington Post Company. The couple is part of a lively social circle of journalists, artists, politicians, and government officials, based largely in Georgetown. At a dinner party at Mary Pinchot Meyer's house, the artist meets David Smith. He will become a friend and an important source of information about making a life as a sculptor.

Samuel (Sam), Truitt's third child, is born on November 12.

## 1961

On a visit to New York in November, Truitt views the work of Ad Reinhardt, Barnett Newman, and Nassos Daphnis for the first time, in the Guggenheim's "American Abstract Expressionists and Imagists" exhibition. She will later observe that this encounter exposed her to the conceptual possibilities of art.

## 1962

Truitt rents a carriage house at Twining Court near DuPont Circle in Washington, DC. There she makes or initiates at least thirty-five sculptures and a number of works on paper over the course of the year.[3]

André Emmerich and curator William Rubin separately visit Truitt's studio. Emmerich offers, and Truitt accepts, a solo exhibition early the following year.

## 1963

Truitt's first solo exhibition at André Emmerich Gallery[4] in New York opens February 12. Donald Judd, whose work will become closely affiliated with the emerging Minimalist aesthetic but will not be the subject of a solo exhibition until December 1963, briefly reviews Truitt's show for the April edition of *Arts Magazine*, observing that "The work looks serious without being so."[5] Michael Fried also mentions the show in a review for *Art International*.

## 1964

Truitt's work is included in the group exhibition "Black, White and Grey," organized by Samuel Wagstaff for the Wadsworth Atheneum in Hartford, Connecticut.

James Truitt accepts a position as Far East Bureau Chief for *Newsweek* in Japan. The family moves to Tokyo in March, remaining there until 1967.

Taking over a temporary studio that had been previously occupied by Jasper Johns before moving into a more permanent space, Truitt will make twenty-three sculptures and more than one hundred and fifty drawings in nine distinct categories while in Japan.

Truitt develops a friendship with American sculptor and performance artist James Lee Byars, who is living in Kyoto, and whose work has also been included in "Black, White and Grey."

The Minami Gallery in Tokyo organizes a solo show of Truitt's sculpture that opens October 19.

---

3. Records kept by the artist account for thirty-five works dating to 1962, including an unpainted panel, while Truitt recalled making thirty-seven works in *Daybook*, 153.
4. From 1963 to 2004 Truitt is represented by and regularly exhibits at André Emmerich Gallery.
5. Donald Judd, "In the Galleries: Anne Truitt," *Arts Magazine*, April 1963, 61; James Meyer, *Minimalism* (London: Phaidon, 2000), 194.

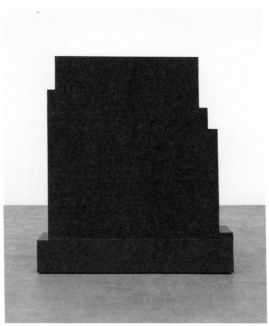

*New England Legacy*, 1963. Acrylic on wood, 82¼ × 72¼ × 14⅞ in. (208.9 × 183.5 × 37.8 cm).

**1965**
Truitt returns to New York briefly for the February opening of her second solo exhibition at André Emmerich Gallery.

**1966**
Truitt's work is included in "Primary Structures: Younger American and British Sculpture" at the Jewish Museum in New York, organized by Kynaston McShine. During an overseas trip to Washington, DC, in the spring, Truitt meets curator Walter Hopps.

**1967**
Truitt's second solo show at Minami Gallery, Tokyo, runs from February through March. It is the first time the artist exhibits drawings and paintings with surfaces achieved by applying paint with rollers rather than brushes.

Truitt's work is included in the exhibition "American Sculpture of the Sixties," organized by Maurice Tuchman and on view at the Los Angeles County Museum of Art, California, and at the Philadelphia Museum of Art, Pennsylvania. Clement Greenberg mentions Truitt in his essay "Recentness of Sculpture," which is included the exhibition catalogue. Michael Fried references the artist's work in his article "Art and Objecthood," which appears in the June issue of *Artforum*.

The Truitt family returns to Washington, DC, in June when James Truitt becomes a general correspondent for *Newsweek* and the first editor of the *Washington Post*'s Style section.

Truitt is invited by her friend V. V. Rankine to co-teach an art class at the Madeira School, a boarding school for girls in McLean, Virginia. Truitt incorporates art history into studio art instruction and will continue to teach at Madeira until 1972.

**1968**
By January, Truitt is working from a studio in the basement of the family's home on Tilden Street in Washington, DC. Truitt has returned to the columnar format that she had started exploring before moving to Japan. She also begins to sand surfaces to obtain more subtle color.

Clement Greenberg writes an article on Truitt, accompanied by photographs by Lord Snowdon, for *Vogue*'s May issue focusing on "The American Woman." The article's publication precedes the artist's solo exhibition at André Emmerich Gallery in October. She is also included in the "1968 Annual Exhibition: Contemporary American Sculpture" at the Whitney Museum of American Art in New York.

**1969**
The Truitts separate in February, although their divorce will not become official until March 1971. Truitt takes primary custody and financial responsibility for all three children. In May, she buys a house in the Cleveland Park area of Washington, DC, where she will live for the rest of her life.

**1970**
In April, Truitt receives a Guggenheim Fellowship; she uses the funds to build a studio. Her work is included in the "1970 Annual Exhibition: Contemporary American Sculpture" at the Whitney Museum of American Art.

**1971**
Following the completion of her studio, Truitt returns to making large-scale sculptures. She receives a National Endowment for the Arts Fellowship. Her first solo exhibition at Ramon Osuna's Pyramid Gallery in Washington, DC, opens in April.

**1972**
Truitt receives a fellowship award from the Corcoran Gallery of Art. Truitt has made paintings on linen as early as 1969, and now, returning to painting, she makes works on canvas.

**1973**
Continuing to investigate the possibilities of working on canvas, Truitt begins a numbered series of graphite-and-white acrylic paintings, which she will later title *Arundel*.

The Whitney Museum of American Art mounts a retrospective of Truitt's sculpture and drawings, primarily organized by Walter Hopps, from December to January 1974.

**1974**
On April 21, an expanded version of Walter Hopps's retrospective of Truitt's sculptures and drawings opens at the Corcoran Gallery of Art. On a trip to Arizona in June, Truitt begins the journal that will later become *Daybook*.

On the recommendation of artist Helen Frankenthaler, Truitt is invited to Yaddo, an artist's residency program in Saratoga Springs, New York, for the first time. She will return to Yaddo throughout her life, working on sculptures, drawings, and the manuscripts for all four of her books.

**1975**
Truitt exhibits the *Arundel* paintings in "White Paintings" at the Baltimore Museum of Art. The exhibition, organized by Renato Danese and John Gossage, opens January 21. A public debate develops, with some visitors and a vocal art critic writing for one of Baltimore's newspapers labeling Truitt's paintings overly conceptual.

In March, Truitt spends two weeks in residence on Ossabaw Island, Georgia, and comes to realize that her journal begun in June 1974 might become a viable manuscript (*Daybook* will be published in 1982). She visits Yaddo for another residency.

Truitt teaches a class at the Corcoran School of Art and Design during the fall semester and also begins as a part-time lecturer at the University of Maryland, College Park, in September. During her years at the University of Maryland, she will teach advanced drawing classes, integrating art history into studio courses. Early on in her time at the university, Truitt will also develop an innovative graduate seminar, combining art theory, art history, and literature.

**1977**
Truitt is awarded a National Endowment for the Arts Fellowship.

**1980**
Truitt is promoted to tenured full professor at the University of Maryland, College Park.

**1981**
Truitt serves as an Australian Arts Fellow in Sydney for the month of June.

In September, while at Yaddo, she writes her forward for *Daybook*.

On November 17, James Truitt commits suicide at his home in San Miguel de Allende, Mexico.

**1982**
Truitt begins writing the journal that will become her second book, *Turn*. Pantheon Books publishes Truitt's first book, *Daybook: The Journal of an Artist*, on October 12.

**1983**
After discovering salary inequities between herself and a male colleague at the University of Maryland, College Park, Truitt initiates litigation against the university, hoping that this action might establish greater pay equity for other female professors. In early September, faced with the financial drain of a prolonged court case, Truitt drops the lawsuit.

**1984**
The artist begins a year-long sabbatical from the University of Maryland, College Park. She takes a trip to Paris, France; Asolo, Italy; and London, England, which she will write about in *Turn*. Truitt serves as acting executive director of Yaddo from April 1 to December 31.

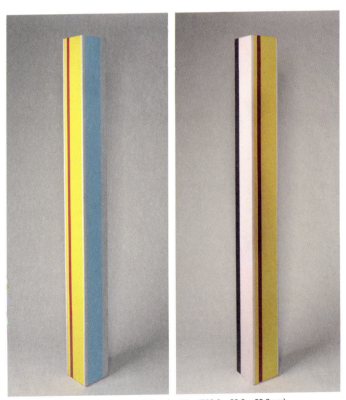

*First Requiem*, 1977. Acrylic on wood, 90 × 8 × 8 in. (228.6 × 20.3 × 20.3 cm).

373   SELECTED CHRONOLOGY

**1985**
In October, Truitt is invited to Lincoln, Nebraska, to give a series of talks on Willa Cather as well as her own work at the Sheldon Memorial Art Gallery and the Lincoln City Library. Truitt visits Yaddo from December 13 to 23 and completes final revisions of *Turn*.

**1986**
Viking Penguin Books publishes Truitt's second book, *Turn: The Journal of an Artist*.

**1987**
Truitt donates her papers to Bryn Mawr, her alma mater.

**1989**
Truitt and photographer John Dolan set out from Boston, Massachusetts, to drive across Canadian Route 1 to Vancouver, British Columbia, and then to Seattle, Washington.

**1991**
Truitt is made a professor emerita at the University of Maryland, College Park, although she will continue to teach for another five years. She also teaches at the Maryland Institute College of Art during the fall.

Drawing upon journals begun two weeks before her retrospective and kept during her 1989 trip across Canada, Truitt works on her third book, *Prospect*, while in residence at Yaddo from December 18 to January 5, 1992.

**1992**
"Anne Truitt: A Life in Art," a retrospective of Truitt's work organized by Brenda Richardson, is held at the Baltimore Museum of Art.

**1995**
Truitt submits the final manuscript of *Prospect*.

**1996**
In October, Scribner publishes *Prospect: The Journal of an Artist*. After the fall semester, Truitt retires from teaching at the University of Maryland, College Park.

**1998**
Truitt's first solo show at Danese Gallery in Manhattan opens February 10. The Academy of Arts (now Academy Art Museum) in Easton, Maryland, exhibits a selection of Truitt's sculpture and works on paper.

**1999**
Truitt is in residence at Yaddo from October to November. During this residency, filmmaker Jem Cohen records an interview with the artist, along with footage of her working in her studio, which will become the short film *Anne Truitt, Working*, 2009.[6]

**2000**
Truitt teaches at the Santa Fe Art Institute, New Mexico, during the month of October.

**2001**
During her residency at Yaddo, from September to October, Truitt works on the *Piths*, a numerically titled series of individual canvas works painted in black acrylic on both sides. She will continue working on this series for the next three years.

James Meyer's book *Minimalism: Art and Polemics in the Sixties* discusses Truitt's sculpture in relation to Minimalist aesthetics and theory.

Truitt begins the journals that will become the manuscript for her final book,

---

6. *Anne Truitt: Working*, directed by Jem Cohen, 16mm film, 13 minutes (Brooklyn, NY: Gravity Hill Films, 2009).

*Yield: The Journal of an Artist*, the fourth volume of Truitt's memoirs.

## 2003
The University of Nebraska awards Truitt the Cather Medal for service to humanity. A selection of Truitt's sculptures is exhibited at the Sheldon Memorial Art Gallery in Lincoln, Nebraska. Truitt delivers a lecture in Red Cloud at the invitation of the Willa Cather Foundation.

From October 1 to November 2, Truitt is in residence at Yaddo, where she makes two series of works on paper, titled *Sound* and *Waterleaf*.

## 2004
"Anne Truitt: Early Drawings and Sculpture 1958–1963," organized by James Meyer and Margaret Schufeldt, opens at the Michael C. Carlos Museum at Emory University in Atlanta, Georgia.

Truitt's work is included in "A Minimal Future? Art as Object 1958–1968," organized by Ann Goldstein for the Museum of Contemporary Art, Los Angeles, California.

She completes several sculptures, and finishes the *Pith* series of paintings on canvas.

Anne Truitt dies in Washington, DC, on December 23, leaving one unfinished sculpture.

## Selected Bibliography

### Writings by Anne Truitt

**2022**
Truitt, Anne. *Yield: The Journal of an Artist*. Edited by Alexandra Truitt. With an introduction by Rachel Kushner. New Haven: Yale University Press.

**2013**
Truitt, Anne. *Daybook: The Journal of an Artist*. Read by the author. New York: Audible Studios.
———. *Daybook Turn Prospect: The Journey of an Artist*. With an introduction by Audrey Niffenegger. New York: Scribner. E-book.
———. *Prospect: The Journal of an Artist*. Read by Alice Rosengard. New York: Audible Studios.
———. *Turn: The Journal of an Artist*. Read by the author. New York: Audible Studios.

**1997**
Truitt, Anne. "Charmed Magic Casements." Review of *Utopia Parkway: The Life and Work of Joseph Cornell* by Deborah Solomon. *Washington Post*, May 4.

**1996**
Truitt, Anne. *Prospect: The Journal of an Artist*. New York: Scribner.

**1992**
Truitt, Anne. "An Art of Stone." Review of *Noguchi East and West* by Dore Ashton. *Washington Post*, April 12.

**1990**
Truitt, Anne. "A First Impressionist." Review of *Berthe Morisot* by Anne Higonnet. *New York Times Book Review*, June 3.

**1989**
Truitt, Anne. "Painted Lady of Paris." Review of *Utrillo's Mother* by Sarah Baylis. *Washington Post*, April 30.

**1986**
Truitt, Anne. *Turn: The Journal of an Artist*. New York: Viking-Penguin.

**1982**
Truitt, Anne. *Daybook: The Journal of an Artist*. New York: Pantheon Books. Reprinted with an introduction by Audrey Niffenegger. New York: Scribner, 2013.

### Books and Catalogues

**2021**
Trommer, Vivien. *Im Zeichen der Erfahrung. Der Skulpturbegriff von Anne Truitt*. Berlin: Logo.

**2018**
Schreyach, Michael. *Anne Truitt Paintings*. New York: Matthew Marks Gallery.

**2016**
de Baca, Miguel. *Memory Work: Anne Truitt and Sculpture*. Berkeley: University of California Press.
Dubay, Rebecca. "Anne Truitt: Painting in Three Dimensions." In *In Terms of Painting*, edited by Eva Ehninger

and Antje Krause-Wahl, 104–23. Berlin: Revolver.

## 2015
Lovatt, Anne. *Anne Truitt in Japan*. New York: Matthew Marks Gallery.
Williams, Gilda. *Anne Truitt: Drawings*. London: Stephen Friedman Gallery.

## 2013
Wagner, Anne M. *Anne Truitt: Threshold*. New York: Matthew Marks Gallery.

## 2012
Richardson, Brenda. *Anne Truitt: Drawings*. New York: Matthew Marks Gallery.

## 2011
Lovatt, Anna. *Anne Truitt*. London: Stephen Friedman Gallery.

## 2009
Hileman, Kristen, et al. *Anne Truitt: Perception and Reflection*. Washington, DC: Hirshhorn Museum and Sculpture Garden.

## 2008
Kleeblatt, Norman L., ed. *Action/Abstraction: Pollock, de Kooning, and American Art, 1940–1960*. New York: Jewish Museum.

## 2003
Meyer, James. *Anne Truitt: Early Drawings and Sculpture, 1958–1963*. Atlanta: Michael C. Carlos Museum.

## 2001
Armstrong, Philip, et al. *As Painting: Division and Displacement*. Columbus, OH: Wexner Center for the Arts.
Meyer, James. *Minimalism: Art and Polemics in the Sixties*. New Haven, CT: Yale University Press.
Wilkin, Karen, and Bruce Guenther. *Clement Greenberg: A Critic's Collection*. Portland, OR: Portland Art Museum; Princeton, NJ: Princeton University Press.

## 2000
Meyer, James. *Minimalism*. London: Phaidon.

## 1993
Strickland, Edward. *Minimalism: Origins*. Bloomington: Indiana University Press.

## 1991
Livingston, Jane. *Anne Truitt: Sculpture 1961–1991*. New York: André Emmerich Gallery.
Perl, Jed. *Gallery Going: Four Seasons in the Art World*. New York: Harcourt Brace Jovanovich.

## 1990
Colpitt, Frances. *Minimal Art: The Critical Perspective*. Seattle: University of Washington Press.

## 1986
Berger, Maurice. *Beyond Formalism. Three Sculptors of the 1960s: Tony Smith, George Sugarman, Anne Truitt*. New York: Hunter College Art Gallery.

## 1984
Johns, Elizabeth B., et al. *350 Years of Art and Architecture in Maryland*. College Park: University of Maryland Art Gallery.
Sarton, May. *At Seventy*. New York: W. W. Norton.

## 1982
*Grace Hartigan, Morris Louis, Clyfford Still, Anne Truitt: Inaugural Exhibition*. Baltimore: Baltimore Museum of Art.
Rubinstein, Charlotte Streifer. *American Women Artists: From Early Indian Times to the Present*. New York: Avon.
Varian, Elayne H. *20/20: Twenty Galleries, Twenty Years*. New York: Terry Dintenfass Gallery/Grace Borgenicht Gallery.
*Vassar College Art Gallery: Sculpture*. Poughkeepsie: Frances Lehman Loeb Art Center.

### 1979

Munro, Eleanor. *Originals: American Women Artists*. New York: Simon & Schuster.

Sims, Patterson. *Decade in Review: Selections from the 1970s*. New York: Whitney Museum of American Art.

Withers, Josephine. *Women Artists in Washington Collections*. College Park: University of Maryland Art Gallery & Women's Caucus for Art.

### 1976

Armstrong, Tom. *Two Hundred Years of American Sculpture*. New York: Whitney Museum of American Art.

Carmean, E. A. *Sculpture and Drawings*. Charlottesville: University of Virginia Museum.

### 1975

Andersen, Wayne. *American Sculpture in Process: 1930–1970*. Boston: New York Graphic Society.

### 1974

Hopps, Walter. *Anne Truitt, Retrospective: Sculpture and Drawings, 1961–1973*. Washington, DC: Corcoran Gallery of Art.

Prokopoff, Stephen. *Five Artists: A Logic of Vision*. Chicago: Museum of Contemporary Art.

*Recent Acquisitions*. Washington, DC: National Gallery of Art.

Warrum, Richard L. *Painting and Sculpture Today, 1974*. Indianapolis: Contemporary Art Society.

### 1973

Baur, John I. H. *Biennial Exhibition: Contemporary American Art*. New York: Whitney Museum of American Art.

### 1971

Cone, Jane Harrison. *Truitt*. Washington, DC: Pyramid Gallery.

### 1970

Johnson, Diana F. *Washington: Twenty Years*. Baltimore: Baltimore Museum of Art.

### 1967

Tuchman, Maurice. *American Sculpture of the Sixties*. Los Angeles: Los Angeles County Museum of Art.

### 1966

McShine, Kynaston. *Primary Structures: Younger American and British Sculptors*. New York: Jewish Museum.

Norland, Gerald. *Seven Sculptors*. Philadelphia: Institute of Contemporary Art, University of Pennsylvania.

### 1963

Afriat S. N. *Art Has Many Facets: The Artistic Fascination with the Cube*. Houston: Fine Arts Gallery, University of St. Thomas.

## Articles

### 2022

"Briefly Noted: *Yield*." *New Yorker*, August 15.

Davis, Jensen. "Anne Truitt: White Paintings." *Air Mail*, February 17.

O'Grady, Megan. "How a Sculptor Made an Art of Documenting Her Life." *New Yorker*, June 15.

Quinn, Bridget. "On *Yield: The Journal of an Artist* by Anne Truitt." On the Seawall, August 9. https://www.ronslate.com/on-yield-the-journal-of-an-artist-by-anne-truitt/.

Rifkind, Donna. "*Yield* Review: Anne Truitt's Days in Full Color." *Wall Street Journal*, August 26.

### 2020

Dafoe, Taylor. "Before She Died, Artist Anne Truitt Completed a Series of 'Sound' Paintings. Now, They're Seeing the Light of Day for the First Time." *Artnet News*, November 19.

Yau, John. "Anne Truitt's Spiritual Quest." *Hyperallergic*, December 5.

## 2018

Block, Louis. "Anne Truitt: Paintings." *Brooklyn Rail*, October.

Freudenheim, Tom L. "Totemic Titan of Color." *Wall Street Journal*, January 16.

O'Grady, Megan. "Women Land Artists Get Their Day in the Museum." *New York Times Style Magazine*, November 21.

## 2017

Battaglia, Andy. "Dia Art Foundation Acquires Anne Truitt Works." *ARTnews*, February 2.

Kennicott, Philip. "An Artist Who Stood Apart from D.C. Intrigue and the New York Whirl." *Washington Post*, December 7.

## 2016

Mugaas, Hanne. "Top Ten." *Artforum*, February.

## 2015

Gopnik, Blake. "At Matthew Marks, Anne Truitt Is Modest as a Picket Fence." *Artnet News*, December 7.

Hudson, Suzanne. "Anne Truitt." *Artforum*, September 1.

## 2013

Goodman, Jonathan. "Anne Truitt *Threshold*: Works from the 1970s." *Brooklyn Rail*, November 5.

## 2012

"Anne Truitt: Works from the Estate, Stephan Friedman Gallery."*Artlyst*, July 5.

Heinrich, Will. "Transcendental Sublimation: Anne Truitt: Drawings at Matthew Marks." *New York Observer*, February 21.

Martin, Alison. "Anne Truitt's Personal Drawings in Chelsea Gallery." *Examiner*, February 7.

Pincus-Witten, Robert. "Anne Truitt." *Artforum*, April.

"Retrospective of Anne Truitt's Works on Paper Opens at Matthew Marks in New York." *Artdaily*, February 5.

## 2011

"Anne Truitt, Hannah Wilke at Alex Zachary." *Contemporary Art Daily*, July 28.

Hinton, John. "Smithsonian Exhibition Headed for Reynolda House This Fall." *Winston-Salem Journal*, July 28.

Rosenberg, Karen. "Anne Truitt and Hannah Wilke." *New York Times*, July 7.

## 2010

Dault, Julia. "Anne Truitt." *Border Crossings*, December.

Diehl, Carol. "Anne Truitt: The Columnist." *Art in America*, March.

Esplund, Lance. "Let Color and Form Breathe." *City Arts*, June 15.

Rosenberg, Karen. "Art in Review: Anne Truitt: 'Sculptures 1962–2004.'" *New York Times*, June 25.

Wagner, Anne M. "Disarming Time." *Artforum*, January.

## 2009

Berlow, Ellen. "Minimalist Artist Anne Truitt." *What's Up?* September 10.

Berman, Mark. "A Dutiful Wife Who Sculpted Her Own Identity." *Washington Post*, October 11.

Byrd, Anne. "Anne Truitt: Perception and Reflection." *Brooklyn Rail*, December.

Cavanaugh, Amy. "Weekend Pass: Painting in Solid Colors." *Express*, October 8.

Cohen, Jean Lawlor. "Less Is More." *Where Magazine*, October.

Coleman, Michael. "Simply Truitt." *Washington Diplomat*, December.

Dietsch, Deborah. "Truitt's Abstractions in 3-D Focus of Hirshhorn Retrospective." *Washington Times*, October 18.

Esplund, Lance. "Maximal Results, Minimal Means." *Wall Street Journal*, December 10.

Johnson, Ken. "Where Ancient and Future Intersect." *New York Times*, December 11.

June-Friesen, Katy. "Anne Truitt's Artistic Journey." *Smithsonian Magazine*, September 30.
Rosenberg, Karen. "Week Ahead: Anne Truitt: Perception and Reflection." *New York Times*, October 4.
Rousseau, Claudia. "Seeing the Varied Dimensions of Anne Truitt." *Gazette*, December 16.
Turvey, Lisa. "Anne Truitt: Perception and Reflection." *Artforum*, September.
Wilson, Meaghan, and Talea Miller. "Art Beat: Beloved Sculptor Anne Truitt Gets Her Due." *PBS*, October 27.

2007
Green, Tyler. "Revisiting Anne Truitt." *Blouin Art Info*, July 30.

2004
Auslander, Philip. "Anne Truitt, Michael C. Carlos Museum, Emory University." *Artforum*, May.

2003
"Anne Truitt." *New Yorker*, February 3.
Blee, John. "Art Wrap." *Georgetowner*, February 6.
Bolcun, Urszula. "Truitt's Meticulous Minimalism Graces Sheldon." *Daily Nebraskan*, April 3.
Esplund, Lance. "Anne Truitt at Danese." *Art in America*, July.
Halasz, Piri. "Three Fine Gallery Shows in Manhattan." *From the Mayor's Doorstep*, March.
Harrison, Rachel. "Anne Truitt." *Time Out New York*, January 30.
Naves, Mario. "Beauty Made with Slender Means Shows Life Distilled, in Focus." *New York Observer*, January 27.
Robinson, Walter. "Weekend Update." *Artnet*, February 6.

2002
Heiser, Jorg. "On Plain Surfaces." *Frieze*, March.

Karmel, Pepe. "What It Meant to Be Minimal." *Art in America*, January.
Meyer, James. "Grand Allusion." *Artforum*, May.

2001
Chave, Anna. "Review of James Meyer, Minimalism: Art and Polemics in the Sixties." *Tate: The Art Magazine*, Autumn.
Cohen, David. "Anne Truitt at Danese." *Artcritical*, March.
Cotter, Holland. "Anne Truitt." *New York Times*, March 9.
Gragg, Randy. "Critical Eye." *Portland Oregonian*, July 13.
Nadelman, Cynthia. "Home Truths: Review of Daybook." *ARTnews*, November.
Reyea, Lane. "What You Say Is What You See." *Artforum*, October.
Robinson, Walter. "Weekend Update." *Artnet*, February 20.
Rubinstein, Raphael. "Import/Export: Opening the Field." *Art in America*, October.

2000
Johnson, Ken. "Art in Review: 175th Annual Exhibition." *New York Times*, March 24.
Naves, Mario. "Where Art Places Third, Behind the Scene and the Self." *New York Observer*, March 27.
Pagel, David. "Truitt's Sculptures Tease Notion of Reality." *Los Angeles Times*, April 21.

1998
Cognita, Vernita. "Anne Truitt." *Cover*, March.
Halasz, Piri. "Anne Truitt." *NY Arts*, June.
Naves, Mario. "Anne Truitt." *New Art Examiner*, June.
Smith, Roberta. "Art in Review: Anne Truitt." *New York Times*, March 13.
Wilson, Laura. "Anne Dean Truitt." *Sunday Star*, March 29.

1997
Lovelace, Carey. "Weighing in on Feminism." *ARTnews*, May.

## 1996

Bell, J. Bowyer. "Anne Truitt." *REVIEW Art*, June.

Cotter, Holland. "Anne Truitt." *New York Times*, June 7.

Glueck, Grace. "The Ashcanners' New York; Memento Mori, the Satire." *New York Observer*, June 3.

"It's All about Color." *New York Observer*, June 3.

See, Carolyn. "Anne Truitt's Hard-Won Vision." *Washington Post*, March 8.

———. "Artist's Despair, Ecstasy." *San Jose Mercury News*, March 24.

Shulna, Alix Kates. "Portrait of the Artist as an Old Woman." *Los Angeles Times Book Review*, April 28.

Sinkler, Rebecca Pepper. "Sensory Perception." *New York Times Book Review*, April 14.

Ziv, Laura. "The Mysterious Murder of JFK's Secret Mistress." *Marie Claire*, March.

## 1994

Dorsey, John. "Truitt's Works Display Her Unerring Eye for Form." *Baltimore Sun*, April 9.

Sandell, Renee. "Talking about Art: From Past to Present, Here to There." *Art Education* 47, no. 4 (July):18–24.

## 1992

Donohoe, Victoria. "Sculptor Displays Her Gentle Mastery." *Philadelphia Inquirer*, May 24.

Dorsey, John. "Anne Truitt Colors Her Art with Layers of Illusion." *Baltimore Sun*, February 5.

———. "Landscape and Illusion Mingle in Truitt's Two Shows." *Baltimore Evening Sun*, February 5.

———. "Maximalist or Minimalist: Artist Layers Experiences in Abstract Sculptures." *Baltimore Sun*, February 2.

Guiliano, Michael. "A Life in Art." *Baltimore City Paper*, January 31.

———. "Truitt's Colors Shine at BMA." *Baltimore Columbia Flier*, February 13.

"Illusion and Emotion." *Baltimore Sun*, February 8.

Plagens, Peter. "The Heart of the Matter." *Newsweek*, March 30.

Sheldon, Louise. "Colors Unknown to Us." *Baltimore Chronicle*, April 1.

Weil, Rex. "Anne Truitt: Works on Paper from the 60s." *City Paper*, May 22–28.

Wilson, Janet. "Anne Truitt: Defining Definition." *Washington Post*, March 5.

## 1991

Adams, Brooks. "Solid Color." *Art in America*, October (cover).

"Anne Truitt." *Art in America*, August.

"Goings on about Town: Self Portrait." *New Yorker*, June 10.

Gookin, Kirby. "Anne Truitt." *Artforum*, November.

Grove, Nancy. "In the Galleries: Opposites Attract." *Art & Antiques*, September.

Handy, Ellen. "New York in Review." *Arts Magazine*, October.

Mahoney, J. W. "Report from Washington, DC, Dreaming." *Art in America*, February.

Smith, Roberta. "Anne Truitt." *New York Times*, June 28.

Welzenbach, Michael. "Paintings in Three Dimensions." *Washington Post*, March 16.

## 1989

Finnegan, Patrick. "Star Search: Washington Has Its Art Gurus and Gray Eminences." *Museum and Arts Washington* 5, no. 5 (September–October).

Rose, Barbara. "André Emmerich: A Passion for Art." *Journal of Art* 2, no. 1 (September–October): 20–21.

## 1987

Abels, David. "I Am Myself." *Diamondback*, March 12.

"Anne Truitt, Faculty Member, 1967–72." *Madeira Today*, Spring.

Barbiero, Daniel. "Anne Truitt: Recent Paintings." *Washington Review* XII, no. 5: 25.

Dawson, Victoria. "Anne Truitt: The Color of Truth." *Washington Post*, March 14.

"Journal Writing Turns Artist into Author." *Outlook*, February.

Kurtzman, Sally. "Turn: The Journal of an Artist." *San Diego Magazine*, March.

Perl, Jed. "Jottings along the Way." *New Criterion* (March): 57–62.

Princenthal, Nancy. "Reviews: Anne Truitt at André Emmerich Gallery." *Art in America*, February.

"Turn: The Journal of an Artist." *American Artist*, November.

Welzenbach, Michael. "Truitt, Staying in Shapes." *Washington Post*, April 18.

### 1986

Adams, Lucia. "Honest, Forceful Feelings." *Chicago Tribune*, December 25.

Aminoff, Tonia. "Charting Progress of an Artist's Soul." *San Francisco Chronicle*, December 21.

"Anne Truitt's Journal of an Artist." *Washington Book Review*, December.

Mairs, Nancy. "Portrait of an Artist." *Washington Post*, December 5.

Melvin, Tessa. "How to Fill Out the Day of a 'Summerfare' Night: A Rich International Array of Art This Summer." *New York Times*, July 11.

"Neuberger Shows Truitt Sculptures." *Greenwich Times*, *Stamford Advocate*, August 2.

Raskin, Barbara. "Bookmaker." *Washington Woman*, December.

Robb, Christina. "Life Made into Art." *Boston Globe*, November 14.

Russell, John. "Anne Truitt at André Emmerich Gallery, New York." *New York Times*, November 28.

Swift, Mary. "Interview with Anne Truitt." *Washington Review* 11, no. 6 (April/May): 3–6.

"Turn: The Journal of an Artist." *Washington Woman*, December.

"Well-Sculpted-Words." *Los Angeles Times Book Review*, October.

Zimmer, William. "Three Exhibitions of Spare and Refreshing Work." *New York Times*, August 31.

### 1985

Opocensk, Virginia. "Anne Truitt: Woman, Mother, Artist." *Lincoln Sunday Journal/Star*, October.

Ulrich, Linda. "Artist in Lincoln." *Lincoln Journal*, October 9.

### 1984

Moyer, Linda Lancione. "Coping with the Quotidian." *Christianity and Crisis*, June 10.

Tillim, Sidney. "The View from Past 50." *Artforum*, April.

### 1983

Aminoff, Tonia. "Day by Day." *Boston Phoenix*, January 25.

Berlind, Robert. "The Horse's Mouth." *Art in America*, March.

Blades, Barbara. "Daybook." *New Art Examiner*, January.

"Daybook: The Journal of an Artist." *Bryn Mawr Alumnae Bulletin*, Winter.

Feild, Ann. "Journal Tells of Seven Years in the Life of an Artist." *Baltimore Sun*.

Mandelbaum, Sara. "Daybook: The Journal of an Artist." *New York Magazine*, February.

Merritt, Robert. "Three Books Display a New Awareness." *Richmond Times Dispatch*, January 2.

Murray, Megan Baldridge. "Daybook: The Story of a Collaboration between Artist and Editor." *Madeira Alumnae Magazine*.

Robb, Christina. "The Roots of Ambition. Mother, Daughter, and Success." *Boston Globe*, May 3.

### 1982

"Anne Truitt, Daybook: The Journal of an Artist." *Kirkus Review*, August 1.

"Baltimore Art Gallery Reborn." *Annapolis*, October 21.

"Baltimore Renovates, Rebuilds, Revitalizes." *ARTnews*, October.

Brenson, Michael. "Baltimore Museum Adds New Wing." *New York Times*, October 19.

Carren, Lorraine. "Permanent Exhibit Is Well Chosen." *Baltimore Capital*, September 2.

Cotton, Judith. "Anne Truitt … Artist, Professor, Author, Mother." *Vogue Australia*, October.

"Daybook: The Journal of an Artist." *Booklist*, September.

"Daybook: The Journal of an Artist." *Publisher's Weekly*, September.

"Exhibits Change in New Wing." *Washington Times Magazine*, October 22.

Forgey, Benjamin. "A Wing and a Fare." *Washington Post*, October 22.

Havice, Christine. "Anne Truitt's Daybook." *Woman's Art Journal* 3, no. 2 (Fall/Winter): 36.

"Museum of Art Opens New Wing." *Howard County News*, September 23.

Robb, Christina. "An Artist Looks Back with Fine Perceptions." *Boston Globe*, October 15.

Russell, John. "57th Street: A Double Birthday Party." *New York Times*, January 15.

"Sculpture in America: Connoisseur's Corner." *Wall Street Transcript*, August 2.

Slung, Michele. "The Books under the Tree." *Washington Post*, December 26.

Sozanski, Edward J. "Work of Four Natives in First Exhibition, Baltimore Wing." *Philadelphia Inquirer*, November 14.

Stevens, Elizabeth. "Four-Star Show Opens Museum's New Wing." *Baltimore Sun*, October 17.

Tassi, Nina. "A Dream Realized." *Messenger*, October 15.

Wittenberg, Clarissa. "Daybook: The Journal of an Artist." *Washington Review*, December.

Wood, Susan. "Art and the 'War between Desire and Dailiness.'" *Washington Post*, November 7.

### 1981

Fleming, Lee. "Visual Arts–Washington's Museum Quality Artists." *Washingtonian* 17, no. 1 (October): 57–61.

Forgey, Benjamin. "The Spirit of Mexico's Silver Art." *Washington Star*, June 26.

Lewis, Jo Ann. "Bursts of Living Color." *Washington Post*, June 26.

Mahoney, J. W. "Anne Truitt." *New Art Examiner*, October.

Shaw-Eagle, Joanna. "Keep Your Eye on American Women in Sculpture." *Harper's Bazaar*, August.

### 1980

Frank, Elizabeth. "Anne Truitt at Emmerich." *Art in America*, May.

Russell, John. "New Sculptures by Anne Truitt." *New York Times*, March 7.

### 1979

Jessup, Sally. *Art/World*, March 19–April 18.

Richard, Paul. "Anne Truitt's Subtle, Saintly Images." *Washington Post*, May 19.

———. "The Art Scene: City Portrait." *Portfolio*, June/July.

Zito, Abby. "Of Sculpture and Related Affairs." *Art Speak*, March 13.

### 1978

Arnebeck, Bob. "The Art Game in Washington." *Washington Post Magazine*, November 17.

Tannous, David. "Those Who Stay." *Art in America*, July/August.

### 1977

Forgey, Benjamin. *Washington Star*, November 13.

Russell, John. "A Miscellany of the 1960s." *New York Times*, January 10.

### 1976

Forgey, Benjamin. "The Corcoran Gallery Celebrates Itself as Well as Art." *Washington Star*, January 25.

Fox, Howard. "Interview with Anne Truitt." *Sun & Moon*, no. 1 (Winter): 37–60.

Margulies, Stephen. "Anne Truitt: Fragile Sculptured Fortresses Against the Army of Sensation." *Charlottesville Cavalier Daily*, November 16.

Simon, Joan. "Tending to Art in Washington and Baltimore: The Itinerant Curator and the Museum." *Art in America*, July/August.

## 1975

Bell, Jane. "Anne Truitt." *Arts Magazine*, June.

"Black Paintings? A Helpful Suggestion." *Baltimore News American*, February 16.

Bourdon, David. "American Painting Regains Its Vital Signs." *Village Voice*, March 7.

Forgey, Benjamin. "White on White on White." *Washington Star*, February 7.

Gold, Barbara. "A Towering Disappointment." *Baltimore Sun*, February 9.

Harriss, R. P. "White Paintings Fit for That Emperor." *Baltimore News American*, February 9.

Hess, Thomas B. "They Don't Pussyfoot." *New York Magazine*, June 2.

Johnson, Lincoln. *Baltimore Sun*, February 6.

"Let's Be Serious (But Not Stupid, Too)." *Baltimore News American*, February 23.

Richard, Paul. *Washington Post*, February 13.

Schoettler, Carl. "Anne Truitt's White Paintings Make Some People Very Angry." *Baltimore Evening Sun*, February 25.

"White on White on White." *Baltimore Sun*, February 9.

## 1974

"Anne Truitt at the Corcoran." *Art in America*, July/August.

Baro, Gene. "Truitt Brings Color to Corcoran." *Washington Post*, April 20.

Flander, Judy. "Evolution of an Artist." *Washington Star-News*, April 24.

Forgey, Benjamin. "Difficult, First-Rate Work." *Washington Star-News*, April 24.

Gilbert-Rolfe, Jeremy. "Anne Truitt, The Whitney Museum." *Artforum*, March.

Prokopoff, Stephen. "A Logic of Vision." *Arts Magazine*, September.

"Reviews." *ARTnews*, February.

## 1973

Forgey, Benjamin. "Women Artists in a Group of Local Shows." *Sunday Star*, April 8.

Kramer, Hilton. "Whitney Uptown: Sculpture in Wood." *New York Times*, December 22.

Richard, Paul. "Galleries: Rectangles of Color That Contain Vast Spaces." *Washington Post*, April 24.

## 1972

Forgey, Benjamin. "Work of a Wavering Hand." *Evening Star*, June 2.

Richards, Paul. "Unified Juxtaposition." *Washington Post*, May 23.

## 1971

Forgey, Benjamin. "It Takes Time to See the Obvious." *Evening Star*, May 4.

Richard, Paul. "Truitt's Box-Sculptures: Now You See Them." *Washington Post*, April 24.

Tannous, David. *Georgetown Spectator*, April 29.

## 1970

Richard, Paul. "A Depressing Exhibition of Washington Artists' Work." *Washington Post*, May 17.

## 1969

Gold, Barbara. "Art Notes: What Is a Museum's Role?" *Baltimore Sun*, March 16.

Mellow, James R. "New York Letter." *Art International*, April 20.

Nemser, Cindy. "Reviews of Art Exhibitions." *Arts Magazine*, March.

Richard, Paul. "Minimal Likeness." *Washington Post*, March 30.

Schjeldahl, Peter. "The Vicissitudes of Sculpture." *New York Times*, February 9.

Wasserman, Emily. "Corcoran Biennial." *Artforum*, April.

## 1968

Greenberg, Clement. "Changer: Anne Truitt, American Artist Whose Painted Structures Helped to Change the Course of American Sculpture." *Vogue*, May.

## 1967

Burnham, Jack W. "Sculpture's Vanishing Base." *Artforum*, November.

Fried, Michael. "Art and Objecthood." *Artforum*, June.

Greenberg, Clement. "Recentness of Sculpture." *Art International*, April 20.

Griffin, Stuart. "Meeting the People: Anne Dean Truitt." *Tokyo Mainichi Daily News*, March 21.

Krebs, Betty Dietz. "Call This Art What You Will, But It's NOW." *Dayton Daily News*, September 15.

Last, Martin. "Reviews and Previews." *ARTnews*, March.

Meeker, Hubert. "Art Institute Gives Minimal Sculpture Its Day." *Dayton Journal Herald*, September 13.

Rees, Jane. "Anne Dean Truitt to Show Drawings." *Asahi Evening News*, February 24.

———. "Anne Truitt's Drawings Shown." *Mainichi Daily News*, March 1.

———. "Here in Tokyo." *Tokyo Asahi Evening News*, March 3.

———. "Three Artists of Note Showing Latest Work: Gouaches by Anne Truitt." *Japan Times*, March 1.

Tuten, Frederic. "American Sculpture of the Sixties: A Los Angeles Super Show." *Arts Magazine*, May.

## 1965

Campbell, Lawrence. "Art in New York." *Time*, February 19.

———. "At the Galleries, New Exhibitions." *Village Voice*, February 25.

———. "Reviews and Previews." *ARTnews*, April.

"Color and Space Exhibit." *Japan Interior Design*, November.

Raynor, Vivien. "In the Galleries." *Arts Magazine*, April.

Rose, Barbara. "A B C Art." *Art in America*, October/November.

## 1964

"Art Shows by Jenkins, Miss Truitt." *Tokyo Mainichi Daily News*, October 29.

"Interview with Anne Truitt." *Asahi Shimbum*, March 22.

Judd, Donald. "Black, White and Grey." *Arts Magazine*, March.

## 1963

"Art: Seven New Shows: Subtle…Simple… Sure…Surprising." *Newsweek*, February 18.

Fried, Michael. "New York Letter." *Art International*, April 25.

Johnston, Jill. "Reviews and Previews: New Names This Month — Anne Truitt." *ARTnews*, March.

Judd, Donald. "New York Exhibitions: In the Galleries: Anne Truitt." *Arts Magazine*, April.

## 1955

Smith, Marie D. "19 Winners Named in Corcoran Exhibit." *Washington Post & Times Herald*, January 9.

## 1954

Berryman, Florence. "Art News — SWA 62nd Annual on Display." *Sunday Star*, February 7.

"McAdams' Painting 1st in Artists' Show." *Washington Post & Times Herald*, February 3.

Wharton, Carol. "Bright and Lively as Easter Bonnet." *Baltimore Sun*, April 11.

# Index

Page numbers in italics refer to illustrations.

abstract art, xvi, 15, 115, 122, 137, 207, 208, 247, 286, 301, 304, 313, 318
Abstract Expressionism, 48, 143, 144, 286, 329, 369
acrylic paint, 80n9, 108, 148
action painting, 143, 144
Agee, James, 138
Ahab, Captain, 339
Ajijic, Mexico, 367
Albemarle County, 260
Albers, Josef, 294
alcoholism, 256, 342, 344, 346, 366
Almit Company, Tokyo, 130
Altman, Adeline Furness, 335
aluminum, use of in Japan, 43, 80, 91, 129, 130, 147, 148, 176
"American Abstract Expressionists and Imagists" (Guggenheim Museum, New York, 1961), 121n7, 122, 249, 352, 369
"American Sculpture of the Sixties" (Los Angeles County Museum of Art, 1967), 371
American University, Washington, DC, 100
Anderson, Maxwell: *High Tor*, 340
Andre, Carl, xvi, 317
André Emmerich Gallery, New York, 31, *32*, 34, 35, 42, 61–63, 91, 168, 174, 291, 292, 312, 318, 354, 368, 369, 371
"Anne Truitt: Sculpture and Drawings" (Corcoran Gallery of Art, Washington, DC, 1974), 170, 174–*79*, 296, 354, 372
"Anne Truitt: Sculpture and Drawings, 1961–1973" (Whitney Museum of American Art, New York, 1973), 92, 168, *169*, 348, 354, 372
appendicitis, 345, 352, 366
Arensberg, art collection, 93, 94
armature, 111, 112, 172, 247, 334, 337, 340, 360
Arnason, H. H., 121n7
*Art and Architecture*, 69
*Artforum*, 157n4, 312, 371
*ARTnews*, 44, 47n1, 100, 156n3
*Arts Magazine*, 155n2, 292n2, 369
*Arundel* paintings, 135, 158, 182, 322, 372
*Asahi Shimbun*, 42
Asheville, North Carolina, 49–51, 97, 174, 330, 332, 345–47, 350, 366; Highland Hospital, 25, 342, 344–46, 366; St. Genevieve of the Pines, 366
Ashton, Dore, 303, 304, 306
Austen, Jane, xiii, 356
Australia, visiting artist, 193, 238, 372
Avonlea, 290, 328, 331, 332

Bacall, Lauren, 310
Baltimore, Maryland, 69, 108, 128, 341, 365–67
Baltimore Museum of Art, Maryland, 312, 324, 368, 374; "White Paintings" (1975), 133–35, 372
barns, 23, 60, 92, 124, 125, 287, 324
Barr, farm of Aunt Nancy and Uncle Jim, 247, 260, 330, 342, 344, 345, 347, 366
Barr, Stringfellow, 366
Barr, William Alexander, 342
Baylis, Sarah, 254, 256, 257
Bellamy, Richard, 84
Belvedere, California, 283, 334, 368
Bennington College, 88
Bergeret, Pierre-Nolasque, 186, 188
Beuys, Joseph, 202, 251
Big Sur, California, xv, 38, 64, *65*, 70, 71, 79, 85, 86, 335, 340, 368
Black Mountain College, North Carolina, 284
"Black, White and Grey" (Wadsworth Atheneum, Hartford, 1964), 369
Bolton Landing, New York, 55, 59, 90, 102
Bonnard, Pierre, 368
book reviews, ix, 254, 298, 303, 308
Boone, Daniel, 199, 355
Borges, Jorge Luis, 282
Borofsky, Jonathan, 200
Bourgeois, Louise, 319
Brakhage, Stan, 309
Brancusi, Constantin, 304, 368
Braque, Georges, 247
Brée, Germaine: *Marcel Proust and Deliverance from Time*, 29, 368
Brenner, Marcella, 183. *See also* Louis, Marcella (née Siegel)

386

brushstroke, 142, 143, 167
Bry, Doris, 92, 95, 367
Bryn Mawr College, Pennsylvania, ix, x, xii, 29, 30, 94, 138, 215, 221, 237, 243, 247, 248, 260, 332, 348–50, 352, 354, 356, 357, 366, 374
Burnham, Jack, 283–97
Byars, James Lee, 38, 40, 41, 68, 73, 78, 80, 83, 84, 369; Kyoto Independent Exhibition (1967), *39*; *The Giant Soluble Man* (1967), 84n10

Cambridge Center for Adult Education, sculpture class at, 95, 367
Campbell, Lawrence, 156
Camus, Albert, 354
*Canada* journal (1989), xii, 258–82, 374
Canaday Library, Bryn Mawr College, xiii
cantilevered forms, 101, 102
Capote, Truman, 368
Carmean, E. A., xii, 180–82
Caro, Anthony, 61, 63, 106n6, 153, 284, 293, 317, 368
Carroll, Dr. Robert, 342, 345
Cather, Willa, 195–98, 374, 375
Catholic University, Washington, DC, 48, 51, 98, 118, 284, 285
Cedar Tavern, New York, 52, 118
cement, early use of, 43, 48, 98, 101, 136, 137, 248, 249, 285, 312, 351, 368
Cézanne, Paul, 184, 190, 302
Chicago, Judy, 163; *Through the Flower*, 163n1
clay, early use of, 15, 22, 43, 48, 97–99, 101, 136, 137, 172, 249, 286, 312, 367, 368
Clemente, Francesco, 200
Cohen, Jem, xiii, 362, 374, 376
Coleridge, Samuel Taylor: *The Rime of the Ancient Mariner*, 205

Color Field painting, 286
color: in Frankenthaler's art, 153; in Italian Renaissance painting, 94, 95, 121, 125; in Louis's art, 110; metaphorical use of, 313, 327; mixing of, 287, 290, 320; in Noland's art, 48, 49; perceived closeness of, 83; in Reinhardt's art, 122, 249, 284, 352; and structure, 42, 43, 77, 91, 147, 151, 159, 172, 181, 182, 290, 296, 312, 327, 337; studies, 139; surface treatment of, 142, 143, 148, 176, 321, 371; in Truitt's impressions of the Eastern Shore of Maryland, 81, 250; in Truitt's impressions of Japan, 43, 44, 69, 129, 176
columnar form, 43, 148, 172, 176, 223, 290, 328, 371
Connolly, Cyril: *Enemies of Promise*, 11, 13
Conrad, Hunt and Marion, 38
Corcoran Gallery of Art, Washington, DC, 170, 174, 176, 178, 204, 296, 329, 336, 354, 371, 372
Corcoran School of Art, 372
Cornell, Joseph, 308–11
Corot, Camille, 299
correspondence, ix, x, xii, xv, 64. See also letters from Truitt
Courbet, Gustave, 197
crosshatch effect, 142, 321
Cubism, 247, 293, 317, 356
Cucci, Enzo, 200

Dallas, Texas, 98–100, 136, 284, 367; Truitt in her studio (1950), *14*
Dallas Museum of Fine Arts School, Texas, 98, 136, 367
Danese, Renato, 353, 372, 374
Dante, Alighieri, 138, 146
Daphnis, Nassos, 122, 369; *No. 32–61 M* (1961), 122n8
Davis, Gene, 54, 104, 118, 181, 285, 286

*Daybook: The Journal of an Artist* (Truitt), x, xv, 5, 29, 182n2, 295n3, 297, 332n10, 352n1, 354, 366n1, 367n2, 369n3, 372
Dean, Duncan Witt, 16–18, 25, 28, 138, 331, 341, 342, 344–47, 349, 365, 366, 368
Dean, Harriet, 8, 365
Dean, Louisa Folsom (née Williams), 6, 17, 25, 26, 50, 87, 101, 215, 234, 287, 330, 331, 341, 342, 344–47, 349, 350, 365, 366
Dean, Louise (later Crelly), 365, 366
de Baca, Miguel, xiii, xiv, 331n8
Degas, Edgar, 256, 301
DeLap, Tony, 293
Deleuze and Guattari, 277
de Nagy, Tibor, 115
Denghausen, Franz, 96, 367
de Pury, Simon, 228
de Régnier, Henri, 302
destruction of art, 53, 88, 101n4, 106, 108, 137, 147, 176, 181, 182, 246, 286, 348
Dewey, Albert Peter, 260, 261
Diebenkorn, Richard, 106n6, 368
Diller, Burgoyne, 352
discipline, 138, 139, 143, 149, 217
distillation (of experience), 133, 166, 215, 243, 249, 250, 267, 294, 356
Dolan, John, 258–78, 282, 374
Dolenski, Leo, ix, 350
Downing, Tom, 54, 104, 118, 181, 285, 286
drawing, 77, 79, 96, 99, 158, 283, 286, 322, 368; from life, 48, 49, 98, 100, 136, 284, 351; to scale, 124, 130, 141, 142, 165, 170, 250, 287, 324, 329, 353, 368; working, 139, 140, 224
Drouin, René, 34, 291
Duchamp, Marcel, 368
*duende*, 247, 248

387

Eastern Shore of Maryland, 81, 94, 122, 128, 170, 195, 211, 246, 250, 328, 348, 365
Easton, Maryland, 94, 195, 258, 322n1, 324, 326, 331, 341, 345, 347–49, 356, 365, 374
edge: of canvas, 28, 77; setting free, 358; using tape to mask, 69
Eiseley, Loren, 336
Emerson, Ralph Waldo, 147, 365
Emmerich, André, 31, 33, 35, 61, 91, 106, 140, 174, 188, 250, 290, 318, 319, 353, 368, 369. See also André Emmerich Gallery
Engadine, Mount, 272, 273, 275, 281, 282
Engels, Frederick, 229
Ernst, Max: La femme 100 têtes (1929), 309
Evans, Walker, 138
exile, 265, 273, 345
expression: and the hand of the artist, 44, 358; and materials, 43; need for, 21, 315, 350; self, 42 144, 312, 355

failure, 6, 21, 22, 66, 67, 176, 187
faith, 2, 62, 172, 185, 198, 200, 215, 219, 225, 231, 241, 279, 320, 351
fame, 157, 231
Fantin-Latour, Henri, 299, 301
Faulkner, William, 13
feminism, 31, 162, 226, 227, 293
fence (as sculptural motif), 60, 124, 125, 170, 225, 250, 286, 288, 312, 322–24, 328, 330, 352
figuration (in early work), 88, 95, 96, 98, 99, 225, 248, 285, 312, 313, 318, 368
film color, 142, 290
Finch, Edith, 366
Fischl, Eric, 200
Fitzgerald, F. Scott, 25, 346

Fitzgerald, Zelda, xiii, 25–28, 345, 366
Flavin, Dan, xiv
Forge, Andrew, 31
formalism, 181, 290, 293, 294, 296
Fox, Howard, 136–59
Francis, Sam, 73, 115
Frankenthaler, Helen, 52, 57, 59, 61, 73, 153, 318, 319, 372
Freud, Sigmund, 15, 163
Fried, Michael, 181, 295, 369, 371
Fuller, Buckminster, 67–69, 73, 74, 304; Dymaxion Air-Ocean World Map (1952), 75

Gabo, Naum, 368
Galliher Brothers Lumber, 124, 323, 324, 328
Garbo, Greta, 311
gender, xii, 163, 165, 226, 252, 355
geometric compositions, 77, 312, 368
George F. Muth Company, 124, 325
Georgetown: social circle, 332n10, 353, 368; studio, 48, 98, 369
George Washington University, Washington, DC, 183, 185
Giacometti, Alberto, 100, 368
Giampietro, Alexander, 15, 47, 97, 136, 138, 367
Gilbert-Rolfe, Jeremy, 157
Giotto, 93–95, 121, 125
Goldstein, Ann, 375
Gonzalez-Torres, Felix, 314
Gorman, Herbert, 24
Gossage, John, 336, 372
Gottlieb, Adolph, 193
Graham, Martha, 304
Graham, Nan, 354
Graham, Philip, 125, 369
Greed (1924), 22
Greenberg, Clement, 33, 34, 47–62, 106–11, 113, 118, 144, 155, 284–86, 288, 290, 294, 315, 318, 319, 329, 353, 368; "Changer: Anne Truitt," 317, 371; on Color Field painting, 286; "Recentness of Sculpture," 315, 371; in Tokyo, 74, 76; tutelage of, 129, 293, 294, 297
Greenberg, Jenny (née Van Horne), 34, 54, 108–10, 284, 297, 329
Guanajuato, Mexico, 335
Guggenheim Fellowship, 80, 304, 354, 371
Guggenheim Museum, New York: "American Abstract Expressionists and Imagists" (1961), 121n7, 122, 249, 352, 369
Gurdjieff, George, 209
Guston, Philip, 200

Happenings, 40
Haring, Keith, 200, 259
Hawthorne, Nathaniel, 365
Healey, Giles, 71, 368
Healey, Sheila, 71
Heraclitus, 117, 292
heuristic pursuit of art, 138, 194, 249, 356
Higonnet, Anne, 298, 299, 301, 302
Hill, Riqui, 29
Holmes, Helena (Inky), 326, 328n6
Homer, 138, 146, 147, 196, 224
honorarium, refusal of, 31, 168, 252
Hopkins, Gerard Manley, 226
Hopps, Walter, x, 92–132, 295, 354, 371, 372
Horace, 240
Horn, Roni, 314
Houdini, Harry, 309
house paint, 124, 125, 170, 287, 310, 324

images: dissolving into images, 227; inception of, 288; relative to background, 77, 78; sensationalism of in contemporary art, 220

388

Imperial Hotel, Tokyo, 36, 38
Impressionism, 95, 298, 301
independence, artist's need for, 35, 189, 192, 211, 237, 246, 247
inner eye, 205, 227, 250, 251, 292, 352
installation, process of, 34, 129, 318, 319, 324
Institute of Contemporary Art, Washington, DC, 15, 47, 96, 98, 136, 153, 284, 367, 368
Iwo Jima, island of, 172, 290, 327

Jackson, Martha, 113, 116
Jaffé, Aniela, 213, 214n2
James, Alice, 344
James, Henry, 12
Japan. *See* Kyoto and Tokyo
japanned lacquer, 142
Jenkins, Louisa, xii, xv, 38, 64–87, 106n6, 368; in her studio on Partington Ridge, Big Sur (1959), *65*
Johns, Jasper, 369
Johnson, Eastman, 160; *The Hatch Family* (1870–71), *161*
Johnson, Samuel, 31, 355
Joyce, James, 24, 96, 117, 138; *Ulysses*, 291n1, 329
Judd, Donald, xiv, 144, 146, 155, 156, 292, 295, 317, 318, 369
Jung, Carl Gustav, 213, 214

Kainen, Jacob, 285
Kansas City Art Institute, 199, 201, 202
Kawashima, Ruri, 36
Kelley, Edward, 54
Kelly, Ellsworth, 288
keynote address, 186–92
Kiefer, Anselm, 200
Kline, Franz, 143; *New Year's Wall Night* (1960), 152
Kootz, Samuel, 329, 293, 345
Krisher, Bernard, 36
Krushenick, Nicholas, 115
Kusama, Yayoi, 308
Kyoto, Japan, 38, 68, 369

landscape: Australian, 193; Bolton Landing, 58, 59, 103; of childhood, 211, 250, 286; Eastern Shore of Maryland, 246, 345; internal, 203, 211; Monet's, 265; Saskatchewan prairie, 268–71; where land meets water, 81, 124, 195, 266; Yaddo, 238
Lannan, J. Patrick, 113, 115, 116
latitude and longitude, 128, 168, 263, 264, 275, 320
lattice, 290, 326, 330, 352
Lawrence, Bill, 124, 287, 324, 325, 328
Lawrence, D. H., 272
Leach, Bernard, 368
Lebron, Jim, 34, 61
Lee Haven (house), 330, 331
Letters from Truitt: to Carmean, E. A., 180–82; to Emmerich, André, 91; to Greenberg, Clement, 47–62; to Jenkins, Louisa, 64–87; to Truitt, Alexandra, 360–62; to Truitt, Ralph, 45, 46
Levi, Primo, 226, 230, 231, 252
Levy, Julien, 310, 311
LeWitt, Sol, 146
*LIFE* magazine, 367, 368
life-size figures, 58, 225, 248, 285, 312, 367, 368
Lincoln, Nebraska, 195, 196, 374, 375
Lipman-Wulf, Peter, 99, 100, 368
Lippmann, Walter, 259
Liquitex paint, 80, 125, 129, 130, 148, 287, 290, 324
literalism, 181, 250
Long, Richard, 41
Longfellow, Henry Wadsworth, 365
Longo, Robert, 200, 201
Lorca, Federico García, 247, 248
Los Angeles County Museum of Art, 41, 47n1, 78, 371
Louis, Marcella (née Siegel), 33, 61, 109–12, 119, 120, 183, 297. *See also* Brenner, Marcella.
Louis, Morris, 53–55, 60, 104, 106–13, 115–20, 153, 154, 170, 181, 183, 286, 297, 315; funeral of, 31, 33, 61, 106, 353; Magna paint, 108, 286; *Trellis* (1953), 119; *Unfurled* paintings, 109, 116, 181, 297; *Veil* paintings, 110
LSD, 71
Lüpertz, Markus, 200

Madeira School, McLean, Virginia, 160, 371
"Made with Paper" (Museum of Contemporary Crafts, New York, 1967), 84n10
mahogany, as material, 88, 141
Manet, Édouard, xiii, 207, 299, 301
Marcuse, Herbert, 119
Marini, Marino, 100
Martin, Agnes, 319
Marx, Karl, 229
Maryland Institute College of Art, Baltimore, 374
Masaccio, 94, 95
Massachusetts General Hospital, Boston, 6, 11, 95, 96, 247, 350, 366
Matthew Marks Gallery, New York, xiii, 186; "Anne Truitt Sculpture 1962–2004" (1971), *244*; "Painting: Now and Forever, Part II" (2008), *338*; "Anne Truitt: Sound" (2020), *361*
Maugham, Somerset, 12
McConnell, James Rogers, 367
McCracken, John, 293
McKinley, Mary, 334
McShine, Kynaston, 371
McSorley's Old Ale House, 11
Medellín, Octavio, 98, 101, 367
Mehring, Howard, 54, 104, 118, 181
Melzac Collection, 108
Metropolitan Museum of Art, New York, 92n1, 160

Meyer, Cord, 290, 327, 328, 334
Meyer, James, xiii, 312–21, 369n5, 374, 375
Meyer, Mary Pinchot, 48, 57n2, 59, 60, 63, 66n2, 67, 103, 121, 122, 132, 283, 285, 327n5, 332, 334, 369
Michael C. Carlos Museum, Atlanta, Georgia, 375
Mills, Mark, 70
Minami Gallery, Tokyo, 36, 73, 369, 371; installation view of "Anne Truitt 1967" (1967), 82
"A Minimal Future? Art as Object 1958–1968" (Museum of Contemporary Art, Los Angeles, 2004), xiv, 375
Minimalism, xiv, 144, 156, 247, 252, 295, 312, 314, 315, 317, 369, 374
Miranda, Carmen, 311
Miró, Joan, 96
Mitchell, Joseph, 11n1
*Moby Dick*, 339
modernism, 42, 146, 317
Modigliani, Amedeo, 49
modular structure, 156, 174, 290, 292, 296, 314, 337
Mondrian, Piet, 368
Monet, Claude, 265, 301
Moravia, Alberto, 368
Morisot, Berthe, xv, 207, 298, 299, 301, 302; *Eugène Manet on the Isle of Wight* (1875), 300
Morris, Robert, 128, 130, 317
Motherwell, Robert, 59, 61, 73; *Untitled* (1966), *In Black and Pink, with the Number Four* (1966), 56
Mount Vernon Seminary, Washington, DC, 368
Mozart, Wolfgang Amadeus, 278
Muir, John, 334, 335
Museum of Modern Art, New York, 73, 74n8, 84, 92

National Endowment for the Arts, 189, 212, 371, 372
National Gallery of Art, Washington, DC, xii, 180n1, 295, 296, 301
nearsightedness, 246, 313, 365
neo-constructivism, 176
*Neurotica* (magazine), 13
Nevelson, Louise, 319, 368
Newman, Barnett, 47, 115, 128, 153, 170, 181, 249, 251, 283, 284, 293, 332n10, 352, 369; *Onement VI* (1953), 121n7
newsprint, works on, 283, 368
*Newsweek*, 36, 42, 44, 369, 371
New York School, 47
New York State University, Buffalo, 201
*New York Times*, 298
Nicoll, Maurice, 83
Nippon Paint Company, 129
Noguchi, Isamu, 303, 304, 306, 368; with *Kouros* (1945), 305
Noland, Kenneth, 31–34, 57, 59–61, 63, 83, 88, 110–12, 115, 120, 122, 170, 180, 288, 315, 325, 329, 336, 353; influence of, 47–55, 97–99, 103–108, 117, 118, 124, 129, 153, 154, 181, 284–86, 292, 318
Noland, Cornelia (née Langer), 49, 51, 117, 284, 325
Nordland, Gerald, 154

object, art as, 77, 78, 91, 135, 140, 146, 147, 156, 188, 191, 214, 250, 360
Orwen, Mary, 48
Ossabaw Island, Georgia, 372
Osuna, Ramon, 371
Ouspensky, P. D., 81
Ovid, 240
Owings, Nathaniel, 70, 72, 73
O'Keeffe, Georgia, 92, 206–208, 367; *White Canadian Barn II* (1932), 92n1

painting: on canvas, 135, 158, 167, 178, 182, 203, 204, 209, 224, 224, 227, 233–39, 283; hard edges, 69, 70; on paper 178, 227, 234, 360; on sculpture, 43, 79, 122, 124–25, 129, 130, 141–44, 148, 151, 168, 170, 172, 176, 209, 287, 296, 321, 324, 336, 339, 353
paint in service of itself, 358
Palmer, Anna Louise, 236, 365
Parker, Ray, 61
Parkhurst, Charles, 295, 296
Partington Ridge, California, 86, 368
*Partisan Review*, 13
perception, delicacy of, 30, 80, 109
Pericles, 202
Picasso, Pablo, 247, 317
picket fence, 124, 288, 312, 322, 323
Piero della Francesca, 57, 94, 103, 121, 125
Pissarro, Camille, 301
plaster, early use of, 97, 98, 136, 172
plastilina, 95
Plato, 93, 117, 155, 277, 292
plinth, xiv, 290
plywood, 88, 141, 203
poetry, early, ix, xiv, 2, 27, 96, 248, 350, 366, 367
Politec paint, 80
Pollock, Jackson, 52, 143, 181, 311, 368
Poussin, Nicolas, 239
Pratt, Julie, 23n4, 34
preconception, avoidance of, 52, 183, 184, 199, 200, 214
pregnancy, 29, 103, 108, 162, 226, 283, 297
primary structure, 126, 127
"Primary Structures: Younger American and British Sculpture" (Jewish Museum, New York, 1966) 371
proportion, relative to color, 125, 139, 174, 184, 249, 250, 290, 294, 327, 329, 360
*Prospect: The Journal of an Artist* (Truitt), x, xv, 203, 258, 354, 374

390

Proust, Marcel, xiii, xv, 29, 30, 138, 349, 368
psychology, early study of, ix, 30, 44, 94, 95, 199, 237, 247, 349, 350, 366, 367
Puvis de Chavannes, Pierre, 254

quartermaster, artist as, 190, 355

Radcliffe College, Cambridge, Massachusetts, 101, 349, 365
Rankine, V. V., 48, 100, 284, 371
Rannit, Aleksis, 217
Rauschenberg, Robert, 188, 202, 310
Read, Sir Herbert, 368
reductivism, 294
Reik, Theodor, 48
Reinhardt, Ad, 181, 249, 283, 284, 292–94, 332n10, 352, 369; *Abstract Painting–1961* (1959–61), 122n9
Renoir, Pierre-Auguste, 93, 254, 256, 301, 302
repainting, 324, 336, 339
retrospectives, 176, 258, 296, 310, 348, 354, 372, 374
Richardson, Brenda, 324, 374
Richman, Robert, 15
Richter, Hans, 368
Riggon, The, 342
Rilke, Rainer Maria, 6, 28
risers under sculptures, 34, 291
Ronsard, Pierre de, 334
Rose, Barbara, 61, 132, 293
Rothenberg, Susan, 200
Rothko, Mark, 193
Rouart, Denis, 299
Royal Academy of Painting and Sculpture, Paris, 188, 189
Rubin, Lawrence, 110, 120
Rubin, William, 31, 33, 34, 61, 106, 107, 110, 111, 120, 297, 309, 318, 369
Ruisdael, Jacob van, 24n6
Russia, 227–29

Rutgers University Press, New Brunswick, New Jersey, 29, 254

Sachiko, Taki, 40, 68, 73, 78, 80, 81, 84
Salle, David, 200
sanding, 142, 176
San Francisco, California, 38, 48, 63, 66, 68, 76, 85, 99, 106n6, 125, 181, 283, 284, 286, 334, 351, 368
Santa Fe Art Institute, New Mexico, 72, 374
Sawyer, Kenneth, 108
Scharf, Kenny, 200
Schnabel, Julian, 200
Schneebaum, Tobias, 367
School of the Museum of Fine Arts, Boston, 235n9, 242
Schufeldt, Margaret, 375
Seitz, William, 295
Sennett, Mack, 61
sensory apparatus, 245, 246, 307
serialism, 144, 156
shape: and color, 42, 44, 77, 83, 182, 291, 312, 313; and form and texture, 7
Sheean, Vincent, 215, 216
Sheldon Memorial Art Gallery (now Sheldon Museum of Art), Lincoln, Nebraska, 374, 375
shelf paper, 124, 170, 250, 287, 323–25
Shelley, Percy Bysshe, 21
Sherman, Cindy, 200, 201
"Seven Sculptors" (Institute of Contemporary Art, Philadelphia, 1965), 88
Shikibu, Murasaki, 356
Shikoku, Japan, 37, 306
Shimizu, Kusuo, 36
Sisley, Alfred, 301
Sloan, Joseph, 30
Smith, David, xiii, xv, 33, 49, 52, 54, 55, 57–61, 63, 66n3, 88–90, 102–104, 107, 115, 117, 120, 153, 199, 248, 284, 288, 315, 317, 353, 362, 368,

369; with *Royal Incubator* (1949), 89
Smith, Jean (née Freas), 103, 117
Smith, Tony, 146; *Die* (1962/68), 295n3
Smith College, Northampton, Massachusetts, 235, 365
Snowdon, Earl of (Antony Armstrong-Jones), 371
Socrates, 117
solipsism, 188, 230, 242, 272, 356
Solomon, Deborah, 308, 311
space: artwork's occupation of, 168, 170, 233, 246; between pickets, 323; and color, 77, 182, 224; displacement of, 78, 91, 183; in Newman's work, 121, 249, 284; two-dimensional, 135, 234, 283
steel, as material, 102, 148, 249, 312
Stella, Frank, 59, 61
Stieglitz, Alfred, 92, 93, 207
Still, Clyfford, 117, 118
stone, carving, 98, 99, 136, 137, 368
struts, xiv, 290, 292, 315, 331, 337
Styron, William, 34
subject matter, xii, 42, 44, 193, 194, 249, 313, 314
surface of sculpture, 142, 148, 233, 371
Suzuki, D. T., 368
Sydney College of the Arts, 193, 372
Sylvester, David, 368
symbolism, ix, 23, 281, 287

Talbot County, Maryland, 93n3, 331n8
Tamayo, Rufino, 368
Tapié, Michel, 116
taping lines, 69, 70, 77, 79, 285, 323
Tawney, Lenore, 200, 202
Taylor, Bill, 48, 97
teaching, x, 30, 208, 209, 354, 368

391  INDEX

Teilhard de Chardin, Pierre, xiii, 66, 71, 83, 232, 269, 270, 277; *Phenomenon of Man, The*, 64
temperament, 163, 219, 225, 232, 237
Theocritus, 240
theosophy, 81
Third Haven Friends Meeting House, Easton, Maryland, 324
Thomas, Dylan, 368
Thoreau, Henry David, 365
threes, works conceived in, 288, 325, 329
*Time* magazine, 283, 368
titanium white, 158
titles of works, 151, 152, 293, 322, 332
Title Tapes, the, 322–47
Tokyo, 40, 46, 53, 56, 62, 64–69, 71–74, 76, 77, 86, 103, 106, 126–30, 147, 148, 154, 165, 176, 178, 204, 211, 326, 334n11, 348, 369, 371; arrival in, 36–38; interview, 42–44; studio, 65
Tolstoy, Leo, xiii, 203; *War and Peace*, 72
tombstone form, 155, 288, 292, 312, 318, 326
*torii*, 43
Toulouse-Lautrec, Henri de, 254, 256
translation, 15, 20, 21, 29, 61, 329, 366. *See also* Brée, Germaine
transparency, 80, 290, 291
Truitt, Alexandra, ix, x, xii, xiii, xvi, 37, 45, 51, 55, 67, 74, 83, 322, 353, 360, 368
Truitt, Anne: artworks by, *19 Sept. 62* (1962), 329; *20 Oct. 62* (1962), 329; *Albemarle* (1975), 182; *Amaranth* (2004), *359*; *Amica* (1979), *164*; *Arundel* series (1973–99), 135, 182, 322, 372 (*see also* "White Paintings," 133–35, 372); *Avonlea* (1991) 328; *A Wall for Apricots* (1968), *150*, *169*; *Bloomsday* (1963), *175*, 291, 329, 332; *Bonne* (1963), 43, *175*, 182; *Breeze* (1987), 223; *Carson* (1963), *169*, 174, *177*; *Catawba* (1962), *173*, 174, *179*, 292, 329, 330, 332, 340; *Chrysalis* (1988), 236; *Cleave* (1989), 240; *Come Unto These Yellow Sands* (1979), *164*, *179*; *Damask* (1980), *179*, 334, 337, 340; *Dawn City* (1963), 174, *175*, *177*; *Down* (1964), *177*; *Elvira* (1953), 88, 101, 368; *Essex* (1962), *179*, 291, 330, 332; *Finian* (1963); 151; *First* (1961), 170, *171*, 250, 287, 312, 318, 322–25, 327, 328; *First Requiem* (1977), *373*; *First Spring* (1981), *viii*, *244*; *Foxleigh I* (1975), *179*; *Genesar* (2004), *359*; *Gloucester* (1963), *169*, *175*; *Goldsborough* (1974), 170, *171*; *Green: Five* (1962), 170, *171*, 328, 330; *Hardcastle* (1962), xiv–xvi, *32*, *169*, 172, 290, 315, *316*, 317, 330–32, 337, 362; *Harvest Shade* (1996), *viii*, *244*, *338*; *Hyphasis* (1986), *179*; *Insurrection* (1962), 292, 331, 332, *333*; *Keep* (1963), 129; *King's Heritage* (1973), *179*; *Knight's Heritage* (1963), *131*; *Knot* (1983), *179*; *Landfall* (1970), *218*; *Lea* (1962), 172, *173*, 179, 290, 291, 328, 331, 332; *Mary's Light* (1962), *169*, 172, *173*, 290–91, 332, 334; *McKinley* (1962), 334; *Memory* (1981), *338*; *Mid Day* (1972), 296; *Mignon* (1962), 334, 337, 340; *Morning Child* (1973), *169*, 170, *171*; *Morning Choice* (1968), 176, *177*; *Muir* (1962), 334–36; *Nicea* (1977), *164*; *New England Legacy* (1963), *370*; *Odeskalki* (1963), *169*, *175*; *One* (1962), *169*, 334, 335; *Painted Wire Construction* (1952), 102n5; *Parva* sculpture series (1974–2004), 224, 322, 362; *Parva LXXII* (2004), *398*; *Pilgrim* (1979), *164*; *Pith* series (2001–2004), 375; *Platte* (1962), *32*, 336, 337; *Portal* (1978), *164*, 212; *Prescience* (1978), *244*; *Primrose* (1962), 174, 337, *338*, 340; *Promise* (1989), 239; *Quest* (1988), 227; *Return* (2004), *viii*, *244*, *359*; *Sandcastle* (1963), 129, 174, *177*; *Sand Child* (1979), *164*; *The Sea, The Sea* (2003), *244*; *Sentinel* (1978), *164*; *Seven* (1962), 328, 330; *Ship-Lap* (1962), *32*, *179*, 290, 292, 337, 339; *Shrove* (1962), 174, *175*, 293, 296, 337, 339, 340; *Sound* series (2003), 360, *361*, 375; *Southern Elegy* (1962), 288, *289*, 312, 318, 325–27; *Sprig* (1962), 340; *Spring Snow* (1974), 167; *Spume* (1972), 296; *Still Memory* (1987), 223; *Summer Child* (1973), *169*; *Summer Sentinel* (1963), 149, 151, *175*; *Summer Treat* (1968), 178, *179*; *Sun Flower* (1971), *244*; *Thirtieth* (1962), *32*, 340; *Three* (1962), *123*, *169*, 340; *Threshold* (1997), *viii*, *244*; *Tor* (1962). *145*, 340, 341; *Tribute* (1962), *32*, 42; *Twilight Fold* (1971), *179*; *Twining Court II* (2002), *viii*, *244*; *Two* (1962), 172, *173*, 290, 291, 312, 326–28; *Watauga* (1962), 174, 292, 340, 341–42, *343*, 345–47; *Waterleaf* series (2003), 375; *White: Five* (1962), *169*, 325, 328, 330; *White: Four* (1962), 325, 328, 330; *White: One* (1962), 328; *Winter Dryad* (1973), *179*

Truitt, James McConnell, 6, 8, 15, 23, 31, 33, 36–38, 40–42, 44, 47, 67–69, 71–74, 76, 77, 79, 81, 83, 86, 92n2, 103, 107, 110, 125, 126, 134, 135, 225, 283, 286–88, 290, 297, 329, 335, 336, 351, 353, 367–69, 371, 372
Truitt, Mary, xiii, 37, 41, 45, 81, 124, 169, 172, 173, 221, 283, 290, 324, 325, 334, 353, 368
Truitt, Ralph P., 69 45, 46, 367
Truitt, Sam (Samuel), xiii, 36, 37, 45, 76, 81, 103, 108, 121, 258, 283, 286, 287, 353, 369
Truman, Harry, 294
Tuchman, Maurice, 41, 78, 371
Tucson, Arizona, 158, 179
*Turn: The Journal of an Artist* (Truitt), x, xv, 29, 221, 354, 372, 374
Twining Court studio, Washington, DC, 49, 51, 60, 105, 145, 325, 328, 340, 369
"Two Decades of American Painting" (National Museum of Modern Art, Tokyo, 1966), 56, 74n8
twins, 162, 172, 273, 290, 327, 328, 330, 344, 347, 350, 365
two-dimensional, 135, 172
Twombly, Cy, 202
two-ness, concept of, 327
Twerkov, Jack, 187

Uccello, Paolo, 57
undercoat, 223, 321, 362
universe, the, 3, 223, 356
University of Maryland, College Park, x, xiii, 186–92 186, 189, 191, 22 , 239, 354, 372, 374
University of Nebraska, Lincoln, 375
University of Virginia, Charlottesville, 166, 180n1, 367
Utrillo, Maurice, 254, 256

Valadon, Suzanne, 254, 256, 257; *Marie Coca with Arbi* (1927), 255

Valéry, Paul, 299
value (luminosity), 81, 91, 93, 127, 184, 206, 224, 249, 352
Veltman, Désiré, 366
Virgil, 138, 146, 147
*Vogue* magazine, 10, 371

Wadsworth Atheneum, Hartford, Connecticut, 365, 369
Wagstaff, Samuel, 369
Washington, DC, 55, 63, 76, 79, 86, 97, 100, 103, 107, 108, 117, 136, 170, 180, 183–85, 203, 240, 259, 279, 283, 294, 297, 315, 317, 320, 335, 367–69, 371, 375; Truitt's studios in, 33–35, 48, 49, 53, 57, 60, 61, 105, 112, 114, 124, 125, 145, 153, 154, 164, 174, 178, 179, 218, 224, 248, 284–87, 290, 322–25, 328, 340, 351–54, 359, 371
Washington Color School, 47n1, 154, 180, 285, 294, 332n10
Washington Gallery of Modern Art, 44, 340
*Washington Post*, 44, 125, 228n5, 254, 303, 308, 369
Washington Workshop Center for the Arts, 107, 181
Watteau, Jean-Antoine, 311
Watts, Alan, 71
weight, sense of in sculpture, 43, 63, 94, 234, 246, 275
welding, 43, 59, 100, 102, 136, 137, 249, 285, 317, 351
Westminster Abbey, formative visit to, 101, 234, 365
"White Paintings" (Baltimore Museum of Art, 1975), 133–35, 372. See also *Arundel*
White, Patrick: *Voss*, 193
Whitney Museum of American Art, New York, 157n4, 168, 348, 354, 371, 372; "1968 Annual Exhibition: Contemporary American Sculpture" (1968), 371; "1970 Annual Exhibition:

Contemporary American Sculpture" (1970), 371; "Anne Truitt: Sculpture and Drawings, 1961–1973" (1973), 92, 168, 169, 348, 354, 372
Whittemore, Helen and Reed, 22
Williams, Captain Robert Pearce, 264, 331n9, 365
Williams, Charles: *Descent into Hell*, 18, 20
Wolfe, Thomas, 138, 330
Woolf, Virginia, 20, 96, 138
works on paper, xiv, 178, 224, 227, 234, 322, 369, 374, 375
World War I, 349, 365, 367
World War II, 6, 95, 172, 215, 216, 247, 261, 303, 350, 366, 367
Wright, Frank Lloyd, 36
writings by Truitt, ix, x, xi, xii–xv. See also *Daybook*; *Prospect*; *Turn*; *Yield*

Yaddo, Saratoga Springs, New York, 203, 214, 238, 279, 358, 360, 372, 374, 375
Yale University, New Haven, Connecticut, xii, xiii, 31, 92n2, 168, 349, 350, 366
*Yield: The Journal of an Artist* (Truitt), x, xiii, xv, 375
Yosemite Park, California, 335

Zadkine, Ossip, 47, 284
Zoroaster, 20, 21

## Credits and Copyrights

**Text Credits**

p. 254: "Painted Lady of Paris," *Washington Post*, April 30, 1989 (Rights reverted to author, © Anne Truitt)
p. 298: "A First Impressionist," *New York Times*, June 3, 1990 (Rights reverted to author, © Anne Truitt)
p. 303: "An Art of Stone," *Washington Post*, April 12, 1992 (Rights reverted to author, © Anne Truitt)
p. 308: "Charmed Magic Casements," *Washington Post*, May 4, 1997 (Rights reverted to author, © Anne Truitt)
p. 312: © "Grand Allusion: James Meyer Talks with Anne Truitt," *Artforum*, May 2002
p. 322: © Alexandra Truitt

**Photo Credits**

Unless otherwise credited, all photos: © annetruitt.org/Bridgeman Images

Artwork by Anne Truitt: © annetruitt.org/Bridgeman Images

p. 65 (right): Photo by J. R. Eyerman/The LIFE Picture Collection/Shutterstock
p. 75 The Fuller Projection Map™ Dymaxion AirOcean World RALEIGH EDITION design is a trademark of the Buckminster Fuller Institute. ©1938, 1967 & 1992. All rights reserved, www.bfi.org.
p. 89: © Phillip Harrington/Alamy Stock Photo
p. 161: The Metropolitan Museum of Art (Gift of Frederic H. Hatch, 1926)
p. 171 (top left): Image copyright © The Metropolitan Museum of Art (Anonymous Gift, 1975). Image source: Art Resource, NY
p. 173 (top): © Yale University Art Gallery. Given in memory of Cord Meyer, BA 1943, and his twin brother, Quentin Meyer, BA 1944, by Cord Meyer's sons Quentin and Mark Meyer
p. 173 (middle left): Angleton/Khalsa Family. The National Gallery of Art, Washington, DC
p. 173 (bottom): Digital Image © The Museum of Modern Art/Licensed by SCALA/Art Resource, NY
p. 177 (bottom): Saint Louis Art Museum, Gift of Mrs. Marcella Louis Brenner
p. 218: © Paul Feinberg
p. 255: Private Collection/Photo © Christie's Images/Bridgeman Images
p. 262: © John Dolan
p. 289: Anne Truitt, *Southern Elegy*, 1962. Acrylic on wood, 47 × 20⅞ × 6⅞ in. (119 × 53 × 17 cm) © annetruitt.org, courtesy Matthew Marks Gallery.
Photo: Ron Amstutz. Glenstone Museum, Potomac, Maryland
p. 300: Musée Marmottan Monet, Paris, France/Bridgeman Images
p. 305: Photo by Eliot Elisofon/The LIFE Picture Collection/Shutterstock
p. 333: Corcoran Collection (Gift of Mr. and Mrs. Phillip Stern), The National Gallery of Art, Washington, DC
p. 398: © Jem Cohen

**Collection Information**

Unless otherwise cited below, all Anne Truitt works are in private collections.

pp. viii, 244: *Twining Court II*, 2002. The National Gallery of Art, Washington, DC. Gift of Mary and John Pappajohn, 2018.134.1
p. 32: *Thirtieth*, 1962. Delaware Art Museum. Wilmington, DE. Gift of Lynn Herrick Sharp, 2010.2
pp. 32, 179 (middle): *Ship-Lap*, 1962. The Baltimore Museum of Art, Baltimore, MD. Gift of Marcella Louis Brenner, Chevy Chase, MD, 1977.56
pp. 123, 169 (middle): *Three*, 1962. The Baltimore Museum of Art, Baltimore, MD. Gift of Helen B. Stern, Washington, DC, 1984.52

p. 131: *Knight's Heritage*, 1963. The National Gallery of Art, Washington, DC. Gift of the Collectors Committee, 2011.19.1

pp. 150, 169 (bottom): *A Wall for Apricots*, 1968. The Baltimore Museum of Art, Baltimore, MD. Gift of Helen B. Stern, Washington, DC, 1984.57

pp. 169 (top and bottom), 177 (top): *Carson*, 1963. The Baltimore Museum of Art, Baltimore, MD. Gift of Helen B. Stern and Henry S. Stern, Washington, DC, 1984.56

pp. 169 (middle), 175 (top): *Odeskalki*, 1963. The Baltimore Museum of Art, Baltimore, MD. Gift of Helen B. Stern, Washington, DC, 1984.55

p. 171 (top left): *Goldsborough*, 1974. The Metropolitan Museum of Art, New York, NY. Anonymous Gift, 1975, 1975.425

p. 171 (middle): *First*, 1961. The Baltimore Museum of Art, Baltimore, MD. Gift of the Artist, Washington, DC, 1995.70

p. 171 (bottom): *Green: Five*, 1962. San Francisco Museum of Modern Art, San Francisco, CA. Collection SFMOMA. Purchase, by exchange, through a gift of Peggy Guggenheim, 19.041

p. 173 (top): *Two*, 1962. Yale University Art Gallery, New Haven, CT. Given in memory of Cord Meyer, BA 1943, and his twin brother, Quentin Meyer, BA 1944, by Cord Meyer's sons Quentin and Mark Meyer, 2001.73.1

pp. 173 (middle right), 179 (middle): *Lea*, 1962. The Baltimore Museum of Art, Baltimore, MD. Gift of Helen B. Stern, Washington, DC, 1984.53

pp. 173 (bottom), 179 (middle): *Catawba*, 1962. The Museum of Modern Art, New York, NY. Given Anonymously, 115.1973

p. 175 (top): *Summer Sentinel*, 1963. The Milwaukee Art Museum, Milwaukee, WI. Gift of Jane Bradlee Pettit, M1980.193; *Bonne*, 1963. Portland Museum of Art, Portland, OR. The Clement Greenberg Collection, Museum Purchase: Funds provided by Tom and Gretchen Holce, 2001.1.148

p. 175 (middle left): *Shrove*, 1962. Glenstone Foundation, Potomac, MD

p. 177 (top): *Sandcastle*, 1963. University of Michigan Museum of Art, Ann Arbor, MI. Gift of Mrs. H. Gates Lloyd, 1984/2.57

p. 177 (bottom): *Morning Choice*, 1968. Saint Louis Art Museum, St. Louis, MO. Gift of Mrs. Marcella Louis Brenner, 42:1969

p. 179 (top): *Summer Treat*, 1968. University of Arizona Museum of Art & Archive of Visual Arts, Tucson, AZ. Gift of Mrs. James Angleton, 1969.006.001

p. 179 (middle): *Essex*, 1962. The Kreeger Museum, Washington, DC. Gift from the Trustees of the Corcoran Gallery of Art

p. 179 (bottom): *Winter Dryad*, 1973. Boca Raton Museum of Art, Boca Raton, FL. Gift of Dr. and Mrs. Marvin Mordes, 1994.119; *Damask*, 1980. Albright-Knox Art Gallery, Buffalo, NY. The Panza Collection and George B. and Jenny R. Mathews Fund, by exchange, George B. and Jenny R. Mathews Fund and Charles Clifton Fund, by exchange, 2008 2008:53.66; *Come Unto These Yellow Sands*, 1979. Dallas Museum of Art, Dallas, TX. Gift of Shonny and Hal Joseph in Honor of Cindy and Armond Schwartz, 2002.55

p. 218: *Landfall*, 1970. Dia Art Foundation, New York, NY, 2016.017

p. 244: *The Sea, The Sea*, 2003. Oklahoma City Museum of Art, Oklahoma City, OK. Museum purchase with funds provided by the Kirkpatrick Family Fund and Kirkpatrick Foundation in memory of Joan Kirkpatrick, 2010.026; *Sun Flower*, 1971. Thoma Foundation, Chicago, IL

p. 289: *Southern Elegy*, 1962. Glenstone Museum, Potomac, MD

p. 333: *Insurrection*, 1962. The National Gallery of Art, Washington, DC, Corcoran Collection. Gift of Mr. and Mrs. Phillip Stern, 2014.136.284)

p. 338: *Memory*, 1981. Oklahoma City Museum of Art, Oklahoma City, OK. Museum purchase with funds provided by the Kirkpatrick Family Fund and Kirkpatrick Foundation in memory of Joan Kirkpatrick, 2010.027

p. 343: *Watauga*, 1962. The Baltimore Museum of Art, Baltimore, MD. Gift of Helen B. Stern, Washington, DC, 1984.54

p. 373: *First Requiem*, 1977. The Museum of Modern Art, New York, NY. Gift of Robert B. and Mercedes H. Eichholz, 1205.2013

Copyright © 2023 by Anne Truitt LLC.
All rights reserved.

This book may not be reproduced, in whole or in part, including illustrations, in any form (beyond that copying permitted by Sections 107 and 108 of the U.S. Copyright Law and except by reviewers for the public press), without written permission from the publishers.

"Preface," "The Title Tapes: An Excerpt, 1997–98," and "Selected Chronology" copyright © 2023 Alexandra Truitt.

yalebooks.com/art

Designed by Katy Nelson for Joseph Logan Design

Set in Sabon and Helvetica Neue

Printed in China by 1010 Printing International Limited

Library of Congress Control Number: 2022944354
ISBN 978-0-300-26041-0
e-book ISBN 978-0-300-26990-1

A catalogue record for this book is available from the British Library.

This paper meets the requirements of ANSI/NISO Z39.48-1992 (Permanence of Paper).

10 9 8 7 6 5 4 3 2 1

Cover illustration: Anne Truitt, passport photo, 1964. © annetruitt.org/Bridgeman Images.

Frontispiece: Anne Truitt, Dallas, Texas, 1950. © annetruitt.org/Bridgeman Images.

Following page: Studio view of *Parva LXXII*, 2004. Acrylic on wood, 27 × 4 × 4 in. (68.6 × 10.2 × 10.2 cm). © Jem Cohen.

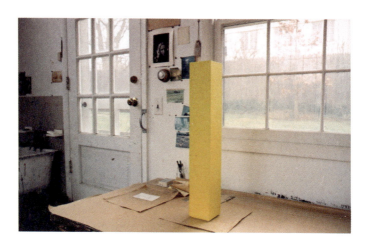